THE PARTHIANS

This volume provides a comprehensive overview of the history and culture of the Parthian Empire, which existed for almost 500 years from 247 BC to 224 AD.

The Parthians were Rome's great opponents in the east, but comparatively little is known about them. *The Parthians* focuses on the rise, expansion, flowering and decline of the Parthian Empire and covers both the wars with the Romans in the west and the nomads in the east. Sources include the small amount from the Empire itself, as well as those from outside the Parthian world, such as Greek, Roman and Chinese documents. Ellerbrock also explores the Parthian military, social history, religions, art, architecture and numismatics, all supported by a great number of images and maps.

The Parthians is an invaluable resource for those studying the Ancient Near East during the period of the Parthian Empire, as well as for more general readers interested in this era.

Uwe Ellerbrock has been studying the Parthian Empire for more than 30 years. His book *Die Parther*, written with archaeologist Sylvia Winkelmann, was published in 2012 (revised edition 2015).

PEOPLES OF THE ANCIENT WORLD

This series stands as the first port of call for anyone who wants to know more about the historically important peoples of the ancient world and the early middle ages.

Reliable, up-to-date and with special attention paid to the peoples' enduring legacy and influence, *Peoples of the Ancient World* will ensure the continuing prominence of these crucial figures in modern-day study and research.

The Mycenaeans
Rodney Castledean

The Trojans and their Neighbours
Trevor Bryce

The Persians
Maria Brosius

The Neanderthals
Stephanie Muller and Friedemann Shrenk

The Carthaginians
Dexter Hoyos

The Greeks, 3rd edition
An Introduction to their Culture
Robin Sowerby

The Huns
Hyun Jin Kim

The Romans, 4th edition
An Introduction
Abigail Graham and Antony Kamm

The Parthians
The Forgotten Empire
Uwe Ellerbrock

www.routledge.com/Peoples-of-the-Ancient-World/book-series/PAW

THE PARTHIANS

The Forgotten Empire

Uwe Ellerbrock

Routledge
Taylor & Francis Group

LONDON AND NEW YORK

First published 2021
by Routledge
2 Park Square, Milton Park, Abingdon, Oxon OX14 4RN

and by Routledge
52 Vanderbilt Avenue, New York, NY 10017

Routledge is an imprint of the Taylor & Francis Group, an informa business

British Library Cataloguing-in-Publication Data
A catalogue record for this book is available from the British Library

Library of Congress Cataloging-in-Publication Data
Names: Ellerbrock, Uwe, author.
Title: The Parthians: the forgotten empire/Uwe Ellerbrock.
Other titles: Parther-die vergessene Grossmacht. English
Description: First edition. | New York : Routledge Taylor & Francis Ltd, 2021. |
Series: Peoples of the ancient world | Includes bibliographical references and index. |
Identifiers: LCCN 2020043449 (print) | LCCN 2020043450 (ebook) |
ISBN 9780367481902 (hardback) | ISBN 9780367473099 (paperback) |
ISBN 9781003038559 (ebook)
Subjects: LCSH: Parthians. | Arsacid dynasty, 247 B.C.-224 A.D. |
Parthia–History. | Art, Parthian. | Iran–History–To 640.
Classification: LCC DS285 .E55413 2021 (print) |
LCC DS285 (ebook) | DDC 939/.6–dc23
LC record available at https://lccn.loc.gov/2020043449
LC ebook record available at https://lccn.loc.gov/2020043450

ISBN: 978-0-367-48190-2 (hbk)
ISBN: 978-0-367-47309-9 (pbk)
ISBN: 978-1-003-03855-9 (ebk)

Typeset in Bembo
by Newgen Publishing UK

To my wife Ingrid

All human beings are members of one frame,
Since all, at first, from the same essence came.
When time afflicts a limb with pain
The other limbs at rest cannot remain.
If thou feel not for other's misery
A human being is no name for thee.

Saadi Shirazi
Persian Poet (c. 1209 – c. 1291 AD)[1]

1 This well-known verse of Saadi is woven into a carpet that adorns the wall of the United Nations in New York (www.un.org/sg/en/content/sg/statement/2012-08-30/secretary-generals-remarks-school-international-relations).

CONTENTS

Detailed table of contents		*ix*
List of figures		*xv*
List of tables		*xxi*
Image credits		*xxii*
Foreword		*xxiv*
Glossary of historic place names		*xxvi*

1	The Parthian Empire: a first approach	1
2	History of the great empires in Iran	13
3	History of the Parthian Empire	22
4	The structure of the Parthian Empire	71
5	Vassal states and kingdoms under Parthian influence	103
6	The Parthian Empire and the peoples of Eurasia	115
7	Cities and architecture in the Parthian Empire	125
8	Trade and business in the Parthian Empire	158

9 Insights into social life in Parthia 181

10 Parthian art: art in the Arsacid kingdom 213

11 The Parthian Empire and its religions 254

Bibliography *298*
Recommended websites *320*
General index *321*
Names index *327*
Geographical names index *329*

DETAILED TABLE OF CONTENTS

1 The Parthian Empire: a first approach 1
 1.1 Documentary sources from within the Parthian world 4
 1.2 Greek – Roman – Chinese literary sources 5
 1.3 Ancient sources: historical truths or distorted images? 7
 1.4 The Parthians: nomads – Hellenes – Iranians? 8
 1.5 Geography of the Parthian Empire 10

2 History of the great empires in Iran 13
 2.1 The empire of Elam 13
 2.2 The Medes and Persians 15
 2.3 The empire of the Achaemenids 16
 2.4 Alexander the Great (356–323 BC) – the Hellenistic period 18
 2.5 The empire of the Seleucids 20

3 History of the Parthian Empire 22
 3.1 Phase 1: Development from a Seleucid vassal state to the Parthian
 Empire: from Arsaces I to Phraates I (c. 247–165 BC) 24
 3.1.1 Arsaces I (c. 247–211 BC) 27
 3.1.2 Arsaces II (c. 211–191 BC) 28
 3.1.3 Phriapatius (c. 191–176 BC) 28
 3.1.3.1 Arsaces IV (c. 170–168 BC) 28
 3.1.4 Phraates I (c. 168–164 BC) 28
 3.2 Phase 2: Expansion of the Parthian Empire: from Mithradates I to
 Darius of Media Atropatene (c. 165–70 BC) 29
 3.2.1 Mithradates I (c. 165/ 164–132 BC) 31
 3.2.2 Phraates II (c. 132–27 BC) 32

3.2.3 *Inter- regnal Issue (c. 127 BC)* 33
3.2.4 *Artabanus I (c. 127–123 BC) – Arsaces X (122–121 BC)* 33
3.2.5 *Mithradates II (c. 121–91 BC)* 34
3.2.6 *Gotarzes I (c. 91–87 BC)* 36
3.2.7 *Orodes I (c. 90–80 BC)* 36
3.2.8 *Unknown King I (c. 80 BC) and Unknown King II*
 (c. 80–70 BC) 36
3.2.9 *Sinatruces (c. 93/ 92–c. 69/ 68 BC)* 36
3.2.10 *Darius (?) of Media Atropatene (c. 70 BC)* 37
3.3 Phase 3: Parthia as a great power: from Phraates III to Vonones II
 (c. 70 BC–c. 51 AD) 37
3.3.1 *Phraates III (c. 70–57 BC)* 40
3.3.2 *Mithradates III (c. 57–54 BC)* 41
3.3.3 *Orodes II (c. 57–38 BC)* 41
3.3.4 *Pacorus I (c. 39 BC)* 43
3.3.5 *Phraates IV (c. 38–2 BC)* 43
3.3.6 *Queen Musa and Phraataces, c. 2 BC–4 AD* 46
3.3.7 *Tiridates I (c. 29–26 BC)* 47
3.3.8 *Orodes III (c. 6 AD)* 48
3.3.9 *Vonones I (c. 8–12 AD)* 48
3.3.10 *Artabanus II (c. 10–38 AD)* 49
3.3.11 *Tiridates II (c. 35–36 AD)* 50
3.3.12 *Vardanes I (c. 40–45 AD) and Gotarzes II (c. 40–51 AD)* 51
3.3.13 *Gotarzes II (c. 40–51 AD)* 52
3.3.14 *Vonones II (c. 51 AD)* 52
3.4 Phase 4: Phases of stability – inner turmoil – decline of the
 Parthian Empire: from Vologases I (c. 51–79 AD) to Artabanus IV
 (c. 216–224 AD) 52
3.4.1 *Vologases I (c. 50/ 51–79 AD)* 56
3.4.2 *Son of Vardanes (c. 55–58 AD) = Vardanes II (Sellwood)* 58
3.4.3 *Vologases II (listed by Sellwood, but did not exist)* 58
3.4.4 *Pacorus II (c. 75–110 AD)* 58
3.4.5 *Artabanus III (c. 80–80/ 81 AD)* 59
3.4.6 *Vologases III (c. 105–147 AD)* 60
3.4.7 *Osroes I (c. 109–129 AD)* 60
3.4.8 *Parthamaspates (c. 116 AD)* 61
3.4.9 *Mithradates IV (c. 129–140 AD)* 61
3.4.10 *Unknown King III (c. 140 AD)* 61
3.4.11 *Vologases IV (c. 147–191 AD)* 61
3.4.12 *Osroes II (c. 190 AD)* 62
3.4.13 *Vologases V (c. 191–208 AD)* 62
3.4.14 *Vologases VI (c. 208–228 AD)* 63

 3.4.15 Artabanus IV (c. 216–224 AD) 63
 3.4.16 Tiridates III (c. 216 – 224 AD?) 64
 3.5 Ardashir I and the newly founded Sasanian Empire 64
 3.6 The end of the Parthian Empire – reasons for the downfall 65

4 The structure of the Parthian Empire 71
 4.1 The king 72
 4.1.1 The ruler's image as an agent of propaganda 73
 4.1.2 The king's image – iconography on Parthian coins 73
 4.1.3 Investiture of the kings 78
 4.1.4 Ancestral cult of the Parthian kings – were kings deified as gods? 82
 4.2 The nobility 83
 4.3 The Parthian army – standing army – Parthian shot 83
 4.3.1 War tactics – light cavalry – cataphracts – elephants 85
 4.3.2 Weapons – depictions of weapons – finds of real weapons 89
 4.3.3 Parthian legionnaires in the service of Rome – Parthian soldiers on the Rhine? 94
 4.4 Administrative structure of the empire 95
 4.4.1 The Parthian language and the unification of administrative structures in the empire 96
 4.5 Parthian queens and marriage policy 97
 4.5.1 Clothing of women / of goddesses shown on coins 98

5 Vassal states and kingdoms under Parthian influence 103
 5.1 The kingdom of Osrhoene 103
 5.2 The kingdom of Commagene 105
 5.3 Gordyene 107
 5.4 Adiabene and Media Atropatene 107
 5.5 Characene 109
 5.6 Elymais 110
 5.7 Persis 111
 5.8 The kingdom of Hatra 112

6 The Parthian Empire and the peoples of Eurasia 115
 6.1 Migration of peoples from China to the eastern border of Parthia – the construction of the Great Wall and its influence as far as the Parthian Empire 116
 6.2 Saka 117
 6.3 Sarmatians 118
 6.4 Graeco-Bactrian kingdom 119
 6.5 Indo-Greek kingdom 120
 6.6 Indo-Scythian kingdom of the Saka 121

6.7 Indo-Parthian kingdom 121
6.8 Kushan Empire 122

7 Cities and architecture in the Parthian Empire 125
 7.1 Structure and architecture of the cities 125
 7.1.1 *Circular cities 125*
 7.1.2 *Iwan 126*
 7.1.3 *Dome 126*
 7.1.4 *Stucco technique and stucco decoration 127*
 7.2 Cities in the homeland of the Parthians and in Iran 128
 7.2.1 *Nisa 128*
 7.2.2 *Merv 136*
 7.2.3 *Herat 137*
 7.2.4 *Shahr- e Qumis (Hecatompylos) 137*
 7.2.5 *Rhagae 138*
 7.2.6 *Ecbatana 138*
 7.2.7 *Susa 138*
 7.3 Cities in Syria and Mesopotamia 139
 7.3.1 *Seleucia on the Tigris 140*
 7.3.2 *Ctesiphon 141*
 7.3.3 *Dura- Europos 143*
 7.3.4 *Hatra 146*
 7.3.5 *Palmyra 152*

8 Trade and business in the Parthian Empire 158
 8.1 Parthian coins and the genealogy of Parthian kings – basic
 information 160
 8.1.1 *Cataloguing Parthian coins according to Sellwood and Assar 160*
 8.1.2 *Parthian denominations 166*
 8.1.3 *Value of Parthian money 167*
 8.1.4 *Mints 168*
 8.1.5 *Inscriptions on coins 169*
 8.2 Mineral resources – mining 175
 8.3 Agriculture in Parthia 175
 8.4 Wine and trade 176
 8.5 Water management – underground qanats in Parthia 177
 8.6 Cattle breeding among the Parthians 178
 8.7 Parthian markets 179

9 Insights into social life in Parthia 181
 9.1 The Parthian language 181
 9.2 Parthian literature – an epic with heroes 183

9.2.1 *The Hymn of the Pearl 184*
9.2.2 *The story of Vis and Ramin 185*
9.2.3 *Shāhnāme – heroic legends 186*
9.2.4 *Parthian literature and Europe 186*
9.3 Equality between men and women – women and law – property 187
9.4 Education 187
9.5 Slaves and prisoners of war 189
9.6 Music of the Parthians 189
9.7 Medical knowledge in Parthian times 191
9.8 Living conditions – income – salary payments 194
9.9 The kitchen of the Parthians: recipe for chicken in Parthian style 194
9.10 Clothing in Parthia: kandys – chlamys – tunic and trousers 196
9.10.1 *Kandys 196*
9.10.2 *Chlamys 196*
9.10.3 *Parthian tunic and trousers 198*
9.10.4 *Women: beauty and clothing: chiton/himation/peplos 199*
9.11 Astronomy – calendars 203
9.11.1 *The Seleucid calendar 205*
9.11.2 *The Parthian calendar 205*
9.11.3 *The Zoroastrian calendar 207*
9.11.4 *Year and month dates on Parthian coins 207*
9.11.5 *Coins with intercalated years/months (ΕΜΒΟΛΙΜΟΥ) 208*
9.11.6 *Conversion of the Seleucid Era into the Dionysian or Common Era 209*
9.11.7 *Conversion of the Parthian Era into the Dionysian or Common Era 210*

10 Parthian art: art in the Arsacid kingdom 213
10.1 Art finds in Nisa – rhyta – sculptures 215
10.2 Rock reliefs 221
10.3 Stone reliefs 221
10.4 Mural painting – frescoes 231
10.5 Sculptures 233
10.6 Jewellery: torque, earrings, belt buckles and other art 234
10.7 Parthian vessels – bowls – glass 235

11 The Parthian Empire and its religions 254
11.1 An overview of Zoroastrianism and the Avesta 254
11.1.1 *The religious concept of Zoroastrianism 256*
11.1.2 *Magi – priests of the Medes – the wise men from the east 257*
11.1.3 *Zoroastrianism in Achaemenid times 258*
11.1.4 *References to the Zoroastrianism of the Parthians 259*

11.1.5 *Mithra 261*

11.1.6 *Anahita 263*

11.1.7 *Nana – Nanaia 264*

11.1.8 *Ardochscho (= Ashi) 265*

11.1.9 *Verethragna – Heracles 265*

11.1.10 *Khvarenah 269*

11.1.11 *The sacred fire of the Zoroastrians – archaeological finds 270*

11.1.12 *Fire cult: archaeological evidence in the Parthian Empire 271*

11.1.13 *Funerals performed by Zoroastrians 272*

11.1.14 *Burials in Parthian times 274*

11.2 Iconography of Parthian coins – references to the Zoroastrian
faith, Deities on Parthian coins, Gods in Hellenistic robes –
Parthian deities?, Summary: Zoroastrianism among the Parthians 278

11.2.1 *Deities on Parthian coins 278*

11.2.2 *Phase 1: Arsaces I to Phraates I (c. 247–171 BC) 278*

11.2.3 *Phase 2: Mithradates I to Phraates III (c. 165–70 BC) 281*

11.2.4 *Phase 3: Phraates III to Vonones II (c. 70 BC–51 AD) 283*

11.2.5 *Phase 4: Vologases I to Artabanus IV (c. 51 AD to the end of the
Parthian Empire in 224 AD) 285*

11.2.6 *Inscriptions with divine epithets 285*

11.2.7 *The transformation from the 'Hellenistic Tyche' to the
'Parthian Tyche' 285*

11.2.8 *Gods in Hellenistic robes – Parthian deities? 287*

11.2.9 *The 'Parthian Tyche' – which Zoroastrian goddess is meant to be
portrayed? 289*

11.2.10 *Summary: Zoroastrianism among the Parthians 289*

11.3 Manichaeism – religion with Parthian origins 289

11.4 Mithraism – Mithras cult 291

11.5 Judaism in Parthia 291

11.6 Christianity in Parthia: the proselytising of the Apostle Thomas 293

LIST OF FIGURES

Frontispiece 'Prince of Shami', bronze statue. National Museum of
 Iran, Tehran xxix
1.1 The Parthian Empire c. 114 AD 2
1.2 Parthian monument, c. 169 AD 8
2.1 Ziggurat Chogha Zanbil near the town of Susa/Iran 14
2.2 Persepolis, Royal Palace, Apadana 17
2.3 Persepolis. General view of the archaeological site 17
2.4 The so-called 'Alexander Sarcophagus' 19
3.1 A + B Mithradates II, AR tetradrachm, S 24.3 34
3.2 A + B Mithradates II, drachm, S 28.5 35
3.3 A + B Orodes II, drachm, S 48.9 42
3.4 Emperor Augustus, white marble, 1st century AD 44
3.5 Phraates I, AR tetradrachm, S 50.8, variant 46
3.6 Queen Musa and Phraataces, AR drachm, S 58.9 47
3.7 Letter from Artabanus II to the town of Susa, marble stone with
 Greek inscription 50
3.8 Vologases V, silver drachm, S 86.3 62
4.1 A + B Arsaces II, AR drachm, S 6.1 73
4.2 A + B Mithradates II, AR drachm, S 26.1 74
4.3 A + B Mithradates II, AR drachm, S 28.1 variant 74
4.4 A + B Mithradates I, AR drachm, S 10.1 76
4.5 A + B Mithradates I, AR drachm, S 11.1 76
4.6 A + B Vologases I (c. 51–79 AD), AR tetradrachm, S 68.9 77
4.7 Detail of a coin of Phraates II, S 16.11 77
4.8 A + B Orodes II (c. 57–38 BC), AR drachm, S 47.31 78
4.9 Detail of a coin of Mithradates I, S 10.1 79

4.10 Investiture of Ardashir I by Ahura Mazda, rock relief, Naqsh-e-
 Rostam, Iran, dating from 28 April 224 AD 80
4.11 A + B Phraates IV, AR drachm, S 54.7 80
4.12 A + B Phraates III, AR tetradrachm, S 39.1 81
4.13 A + B Pacorus II (c. 75–110 AD), AR tetradrachm, S 75.4 81
4.14 Cataphract, graffito from Dura-Europos 86
4.15 Sarmatian cataphracts, detail of Trajan's column, Rome, completed
 113 AD 86
4.16 Riding Parthian with lance, Gotarzes relief, Bisotun, Iran 87
4.17 Scythian asymmetrical composite bow, detail of a coin
 Mithradates II, S 27.1 88
4.18 Parthian archer on horseback, terracotta relief, c. 1st–3rd
 century 88
4.19 Metope, terracotta, c. 2nd–1st century BC, find spot:
 palace of Nisa 90
4.20 A + B Phraataces, AR tetradrachm, S 57.4 90
4.21 Stone relief of Antiochus I Theos (69–36 BC) with Heracles,
 Arsameia on the Nymphaios 91
4.22 'Prince of Shami', with a four-lobed dragger at the right hip 91
4.23 Pacorus II (c. 75–110 AD), AR tetradrachm, S 73.2 92
4.24 The remnants of the decorations of a shield 92
4.25 King Mithradates I Kallinikos of Commagene with a long sword,
 relief stele from Arsameia on Nymphaios 93
4.26 Parthian long sword, find spot: Iran 93
4.27 Mithradates II, AR tetradrachm, S 23.2 99
4.28 Detail of a tetradrachm of Gotarzes II, S 65 99
5.1 Vassal states, kingdoms, provinces and cities in the west of the
 Parthian Empire, c. 64 BC 104
5.2 Nemrud Dagh, Commagene, view from the west terrace 106
5.3 Nemrud Dagh, Commagene, oversized heads fallen from
 their bases 106
6.1 Parthia and the empires in the east during the reign of
 Mithradates I (c. 165/164–132 BC) 116
6.2 A + B Phraates IV, silver drachm, S 91.13 118
6.3 Sarmatian cataphract, aquatint 119
7.1 Metope with a Seleucid anchor, terracotta, find spot: Nisa 128
7.2 Metope with a lion's head, terracotta, find spot: Nisa 129
7.3 Parthian stucco, find spot: Nisa 129
7.4 Parthian Palace complex in Nisa 130
7.5 Plan of Old Nisa 131
7.6 Model of the Parthian castle in Nisa 132
7.7 Round Hall 132
7.8 Coloured wall stucco, find spot: Parthian Palace, Nisa 133
7.9 Wall stucco, find spot: Parthian Palace, Nisa 134

7.10 Parthian vessels, find spot: Nisa 134
7.11 Round Hall, Nisa 135
7.12 Seal found in the Treasury of Mithradatkart, find spot: Nisa 135
7.13 Walls of Gyaur Kala, Merv 136
7.14 Ruin of the Sasanian Palace, Ctesiphon 142
7.15 Fresco from Dura-Europos synagogue, c. 245–256 AD 144
7.16 Figurine of mounted Parthian horseman, Dura-Europos 145
7.17 The iwan complex in Hatra, 2nd century AD 146
7.18 Ancient Parthian relief carving of the god Nergal, find spot:
 Hatra, c. 1st or 2nd century AD 148
7.19 Entrance to the iwan complex, Hatra 150
7.20 Ulugh Beg Madrasah (left), Registan Place, Samarkand,
 Uzbekistan 150
7.21 Marble statue, temple III, Hatra, first half of 2nd century AD 151
7.22 Door lintel 152
7.23 Temple of the god Bel, Palmyra 153
7.24 Gravestone depicting a funeral meal, find spot: Palmyra 154
7.25 Gravestone depicting a man with Parthian-influenced clothes,
 who lies on a kline, find spot: Palmyra 155
7.26 Palmyrian deities: Aglibol, Baalshamin and Malakbel, limestone,
 middle of the 1st century AD, find spot: Bir Wereb, Wadi Miyah,
 near Palmyra 155
8.1 A + B Nominal values of Parthian coins 167
8.2 Iran in the Parthian age, with archaeological sites and mint
 locations in relation to today's countries or cities 168
8.3 A + B Orodes II, S 45.1, variant 170
8.4 Arsaces I, AR drachm, S 3.1 172
8.5 Parthian inscriptions on coins of various Parthian kings 172
8.6 Mithradates IV (c. 129–140 AD), AR drachm, S 82.1, variant 173
8.7 Artabanus IV (c. 216–224 AD), AR drachm, S 89.1 173
8.8 A + B Vologases VI, AR drachm, S 88.19 174
8.9 Parthian servant (?), who may be presenting gold or silver bars on
 a tray, local limestone, find spot: Koblenz, second half of
 2nd century AD 174
9.1 Parthian inscriptions on coins of Parthian kings 183
9.2 Ostracon, Parthian script, find spot: Nisa, c. 1st century BC 183
9.3 Parthian belt buckle 188
9.4 Parthian musicians, terracotta, find spot: Iran 191
9.5 Musician, terracotta, Parthian era, c. 1st–2nd century AD 192
9.6 Ladle, Parthian, Mesopotamia, c. 2nd century BC–3rd century AD 195
9.7 Silver bowl, Parthian period 196
9.8 A large rhyton and four bowls or cups form a group of silver
 vessels, 1st century BC 197
9.9 Arsaces I (c. 247–211 BC), AR drachm, S 3.1 197

9.10 A + B Mithradates I, AR drachm, S 11.1 198
9.11 A + B Pacorus II, AR tetradrachm, S 73.2 199
9.12 'Prince of Shami', bronze statue 200
9.13 'Prince of Shami' with a four-lobed dagger 201
9.14 Sheepskin boots, Parthian era 201
9.15 Parthian youth, inscription: Aphrahat, cast, find spot: Hatra 202
9.16 Palette for cosmetics, stone, Parthian era, c. 1st century
 BC–1st century AD 202
9.17 Mithradates II, AR tetradrachms, S 23.2 203
9.18 Tyche. Detail of a tetradrachm of Gotarzes II, S 65 204
9.19 Abbu, wife of Sanatruk II, with a floor-length dress and a
 high head-dress, Hatra, 1st half of the 3rd century AD 205
9.20 Artabanus I, AR drachm, S 22.2 206
9.21 Orodes II, tetradrachm, S 46.7 209
9.22 A + B Gotarzes II, AR tetradrachm, S 65 210
10.1 Rhyton, detail, lion-gryphon with horns, Nisa, c. 2nd
 century BC 216
10.2 Rhyton, detail, upper part of the rhyton, the lower part of
 which is shown in Fig. 10.1 217
10.3 Rhyton, detail, a centaur 217
10.4 Rhyton, detail, women with a goat 218
10.5 Rhyton, detail, a woman catches animals with a net 218
10.6 Rhyton, detail, women representing muses 219
10.7 Rhyton, detail, a seated goddess 219
10.8 Portrait of a bearded man, Nisa 220
10.9 Head of a warrior, sun-baked clay, found in the Square Hall
 at the Palace of Nisa 222
10.10 Head of a Parthian 223
10.11 Small figurine of semi-nude goddess (Aphrodite Anadyomene?),
 marble, found in the Square House at the Palace of Nisa 224
10.12 Woman, find spot: Square House, Nisa 225
10.13 Parthian chair leg made of ivory 226
10.14 Winged sphinx with the head of a woman 226
10.15 Winged gryphon 226
10.16 Athena 227
10.17 Winged Eros 227
10.18 Eagle 228
10.19 Head of a satyr, Nisa 228
10.20 Ceremonial hatchet, Nisa 228
10.21 Siren, silver, Nisa 229
10.22 'Vologases relief', king sacrificing on an altar, Bisotun, Iran 229
10.23 Rock relief, Hung-i-Nauruzi, Iran 230
10.24 Rock relief, find spot: Bard-e Nishandeh 230
10.25 Fresco, Dura-Europos, 194 AD 231

10.26 Modern painting of the fresco shown in Fig. 10.25,
 Dura-Europos, 194 AD 231
10.27 Fresco, found in the Temple of Baal at Dura-Europos 232
10.28 Parthian tomb mosaic from Edessa, early 3rd century AD 233
10.29 Head of a man from Susa, stone, Parthian era, find spot:
 Royal City of Susa 234
10.30 Head of a man, Parthian, find spot: Bard-e Nishandeh 235
10.31 Head of a woman, marble, find spot: Susa 236
10.32 Head of a woman, marble, Parthian era, Susa 236
10.33 Young noble warrior, Parthian, early 3rd century BC 237
10.34 Parthian noble, shown in strict frontality, basalt, find
 spot unknown 238
10.35 Statue, without head, Masjid-e Suleiman, Elymais, Iran 239
10.36 Young man in a Parthian-style robe, sarcophagus lid, find
 spot: Palmyra 239
10.37 Relief, stone, from Bard-e-Nishandeh, Elymais, Iran 240
10.38 Parthian, sacrificing, Masjid-e Suleiman, Temple of Heracles,
 Elymais, Iran 240
10.39 Terracotta relief, Parthian, Susa, 2nd–1st century BC 241
10.40 Terracotta relief, Parthian, Susa, 2nd–1st century BC 241
10.41 Terracotta cast, original: first half of the 1st century AD 242
10.42 Parthian rider, bearing a child (?) in his arms 243
10.43 Mithradates III, S 40.2 244
10.44 Orodes II, S 48.10, variant 244
10.45 Artabanus I (c. 127–124 BC), S 20.1, detail 244
10.46 Earring in the form of a three-lobed wineskin, find spot:
 Mesopotamia, said to be from Nineveh, 2nd–1st century BC 244
10.47 Earring, gold, 1st–2nd century AD 245
10.48 Belt buckle depicting a Parthian riding 245
10.49 Parthian silver pin, couple, banquet scene at a funeral (?) 246
10.50 A + B Fragments of an ivory box decoration, find spot: Shami,
 west Iran 246
10.51 Golden necklace with three oval plaques, Dailaman (?),
 1st–3rd century AD 247
10.52 Necklace with different gemstones, Parthian era 247
10.53 Woman's head, limestone, find spot: Palmyra, Parthian era:
 mid-2nd–early 3rd century AD 248
10.54 Silver bowl, Parthian 249
10.55 Glass bowl, Parthian era 249
10.56 Rhyton, terracotta, Parthian era 250
10.57 Zoomorphic vessel, Parthian, 1st century BC–2nd century AD,
 find spot: Region d'Ardebil (Azerbaijan/or Iran) 250
10.58 Zoomorphic vessel, shaped like a bird, Parthian, Iran,
 2nd century BC–2nd century AD 251

10.59	Parthian pilgrim's bottle, clay with traces of blue glaze, find spot: Tella Meaïn (Mesopotamia), end of 2nd century BC–beginning of 3rd century AD	251
10.60	Jug with typical blue-green glaze, Parthian era, Iran	252
10.61	Amulet (?), naked woman, carved bone, Parthian, c. 1st–2nd century AD	252
11.1	The Three Magi, Byzantine mosaic, c. 565 AD	258
11.2	Woman in a half-reclining position, possibly the goddess Ishtar, Mesopotamia, Parthian period, c. 3rd century BC–3rd century AD	260
11.3	Terracotta representation of a reclining Parthian, Iran or Mesopotamia, c. 1st century BC–1st century AD	262
11.4	Relief stele depicting King Antiochus I and Apollo/Epekoos, find spot: Sofraz Köy	263
11.5	Investiture of the Sasanian king Ardashir II (379–383 AD), rock relief, Tag-e-Bostan, Iran	264
11.6	Nemrud Dagh, Head of Heracles	266
11.7 A + B	Bronze Heracles with a Greek-Parthian bilingual inscription, found in Seleucia on the Tigris	267
11.8	Heracles–Verethragna (?), limestone, find spot: Masjid-e Suleiman, Iran	268
11.9	Royal Palace, Persepolis	269
11.10 A + B	Fire holder with a bowl for the sacred fire, bone plaque, Mele Hairam	270
11.11 A + B	Ritual implements, bone plaque, Mele Hairam	271
11.12 A + B	Worshippers, one holding a longsword, bone plaque, Mele Hairam	272
11.13 A + B	Zoroastrian priest in front of the mortar, bone plaque, Mele Hairam	272
11.14	'Towers of Silence', Yazd	273
11.15	Glazed fired-clay coffin, possibly for a child or a teenager, find spot: Warka, southern Iraq, c. 1st–2nd century AD	274
11.16	Parthian coffin lid, c. 3rd century AD	275
11.17	New Nisa, badly ruined Parthian ramparts	276
11.18	Tomb of Xerxes I (or Artaxerxes I), Naqsh-e-Rostam, Iran	277
11.19	Mithradates I, tetradrachm, S 13.2	282
11.20 A + B	Phraates II, tetradrachm, S 17.1	283
11.21	Mithradates II, tetradrachm, S. 23.2	286
11.22	Tyche, goddess of Commagene, Nemrud Dagh, Commagene, 1st century BC	288
11.23	Cult relief of Mithras slaying the bull (Tauroctony), limestone, 168/169 AD	292
11.24	Relief of the Magi Kirdīr, Naqsh-e Rajab, south-western Iran, near Persepolis	294

LIST OF TABLES

3.1 List of Parthian rulers 23

3.2 Unnatural and natural deaths of Parthian kings between 70 BC and 51 AD 40

3.3 Timetable for Vologases I, Pacorus II and Artabanus III according to Sinisi 54

3.4 Parthian kings named Artabanus 59

8.1 Comparison of the genealogy of Parthian kings provided by Sellwood and Assar 161

8.2 Nominal values of Parthian coins 166

8.3 Greek inscriptions on Parthian coins 171

9.1 Year dates in Greek letters 207

9.2 Monthly names in various calendars used 208

11.1 Representation of gods and goddesses on Parthian tetradrachms and drachms as they occur at different periods 279

11.2 Inscriptions with divine epithets on Parthian coins 280

11.3 Distribution of sun-star-moon symbols on Parthian silver coins 281

IMAGE CREDITS

Schatz, Forum Ancient Coins:[5] 8.6; 8.7
Stierlin, Henri: 11.7 a+b
Yale University Art Gallery: 7.16; 11.23

All other images: Dr Uwe Ellerbrock

FOREWORD

The Parthian Empire, Rome's enemy in the east, which the Romans could never defeat, is little known to the general reader. This book is intended to place the Parthian Empire, which in today's language was a 'global player' between east and west, in the light it deserves in history.

This book is based on the revised and expanded second edition of *Die Parther – die vergessene Großmacht* (*The Parthians – the forgotten superpower*), by archaeologist Sylvia Winkelmann and myself, published by Zabern Verlag, Germany in 2015. For the present edition, the book was revised and in parts re-edited and translated into English by the author. More than 90 new photos have been added, some of which I took on my trip to Turkmenistan, the 'homeland of the Parthians', in 2015, where I had the opportunity to visit and photograph archaeological finds and Parthian sites. The excavations in Old Nisa, a royal sanctuary, formerly thought to be one of the capitals of the Parthians, but also the remains of the huge Parthian city walls in Merv, impressed me greatly.

It is still difficult to get a clear picture of the Parthians, as there is not enough archaeological evidence of their realm. The view of this empire is also affected by the fact that the literary testimonies of the Greeks and Romans are inadequate. In addition, either for lack of knowledge or due to the political views of Western writers, a distorted image of the Parthian Empire has been created. As a result, the Parthians were long represented as uncultivated and as barbarians. This view has now been abandoned. L. Gregoratti, an Italian historian, writes: 'The Parthian Empire, a state lasting for five long centuries, has recently emerged slowly from the shadow of history to regain its cultural and historical identity.'[1] This book aims to highlight the Parthian Empire and its importance in the ancient world. Parthia was

1 Gregoratti, L., 2018 (1): p. 53.

not only an evenly matched opponent of Rome but also an important link in trade between Rome and China. The importance of the Empire for cultural exchange between east and west is only slowly becoming clearer.

I am especially grateful to Mrs Vesta Sarkhosh Curtis, Curator of Middle Eastern Coins, British Museum, London, for her support when I wrote and published my first article in 2013: 'Religious iconography on Parthian coins: The influence of political and social changes on the image of the goddess Tyche in the Parthian Empire'.[2] My thanks also go to Peter Alexander and Jonathan Hoare for reading my draft and putting it into more idiomatic English. I also thank all those who have supported me and willingly answered my questions, also giving me valuable tips or assigning me their rights to photos.

Wrongly, the Parthian Empire has fallen into oblivion in general knowledge. I hope that this book, which is addressed to the wider public of learned and interested readers, will restore the memory of the Parthian Empire, 'the forgotten superpower'.

2 Ellerbrock, U., 2013 (1): pp. 253–311.

GLOSSARY OF HISTORIC PLACE NAMES

Historic places	*Today's state / town / information*
★	= shown in maps
Achal-Oases	Turkmenistan, near Ashgabat★
Ai Khanoum★	Afghanistan, north of Kabul
Amu-Darya★	River Oxus (ancient name)
Ardashir Khurra (Ardashir-Khwarrah)	Iran, north-west of Firuzabad★
Arshak	Iran, north-east, Astauene Region
Ashgabat★	Turkmenistan
Assur★	Iraq
Astauene★	Iran, north-east
Babylon★	Iraq
Bactra	Afghanistan, ancient principal of Bactria, today's Balch
Balandy 2★	Fortified complex from the 1st millennium BC, 40 km from Tchirik Rabat, Kazakhstan, east of the Aral Sea★
Bard-e Nishandeh★	Iran, Elymais★
Bisotun★	Iran, west, Kermanshah Region★
Carrhae★	Turkey, south-east
Ctesiphon★	Iraq, on the Tigris
Charax-Spasinu★	Iraq, at the confluence of the Euphrates and Tigris
Dailaman (Deylaman)	Southern edge of the Caspian Sea, Elburz Mountains
Dal'versin Tepe	Kushan city on Syr-Darya, east of Tashkent in Uzbekistan, with Buddhist monastery
Darabgerd★	Iran, Fars, near Darab

Dura-Europos★	Syria
Ecbatana★	Iran, near Hamadan
Elymais★	Iran, south-east, towards the Persian Gulf
Fars★	Iran, south, towards the Persian Gulf
Firuzabad★	Iran, Fars
Gandhara★	Eastern Afghanistan/north-west Pakistan
Garry Kjariz	Turkmenistan, near Nisa★
Göbekly-Depe★	Turkmenistan, near Merv
Gonabad★	Iran, north-east
Gyaur-Kala	Turkmenistan, Margiana★
Hatra★	Iraq
Herat★	Town in Afghanistan
Hecatompylos★	Sad Darvazeh = Shahr-e Qumis, near Damghan, Iran
Hung-e Kamalwand	Iran, Elymais★, near Izeh
Hung-e Yar-e Aliwand	Iran, Elymais★, near Izeh
Hyrcania	Area south-east of the Caspian Sea
Igdi-Kala	Turkmenistan, Karakum Desert
Istakhr★	Iran, near Persepolis
Izgant	Turkmenistan, near Ashgabat★
Kalan	Parthian fort near Hamadan (Ecbatana★), Iran
Kangavar★	Iran, Kermanshah Region★
Kerman★	Iran, town, south-east
Kermanshah Region★	Iran, west, Zagros Mountains
Khorasan★	Region in ancient Iran (east)/Afghanistan
Khorhe	Iran, Khuzestan★, south-west
Khurab	Iran, approx. 200 km south of Ashgabat★ (Turkmenistan)
Khuzestan★	Iran, region in the south
Kirk Maghara	Osrhoene
Koj-Lrylgan Kala	Choresmian Fort in northern Uzbekistan
Kuh-e Dasht Region	Near Hecatompylos★, northern Iran
Kuh-e Khwaja★	Iran, Seistan Region, south-east
Kuh-e Taraz	Iran, Elymais★
Kuh-e Tina	Iran, Fars★ Region
Kunja-Kala	Turkmenistan
Mansur-Depe★	Turkmenistan, near Nisa
Margiane (Margiana)★	Ancient region/southern Turkmenistan, Region of Merv★
Masjid-e Suleiman (Masjed Soleyman)★	Iran, Elymais
Merv★	Turkmenistan
Minab	Iran, near Hormuzgan★, Persian Gulf
Nakhl-e Ebrahim	Iran, near Hormuzgan★, Persian Gulf

Naqsh-e-Rostam★	Iran, Fars
Nehbandan	Iran, South Khorasan
Niniveh★	Iraq
Nisa-Mithradatkart★	Turkmenistan, near Ashgabat
Nurabad	Iran, Fars★
Osrhoene★	South-east Turkey, northern Syria
Parthyene★	Region near Ashgabat, Turkmenistan
Persis	Settlement area of the Persians, region of Fars★
Phraaspa	East Azerbaijan, Iran, capital of the Atropatene
Qal'ah-e Yazdigird	Iran, Kermanshah Region
Rhagae★	Iran, today Ray, 15 km from Tehran
Sarab-e Mort	Iran, Kermanshah Region★
Sarpol-e Zohab★	Iran, Zagros Mountains, Kermanshah Region
Shatt-el Arab	Iraq, at the confluence of the Euphrates and Tigris
Shushtar	Iran, Khuzestan★, south-west
Seistan★	Iran, south-east
Seleucia (on the Euphrates) (Zeugma)	Turkey, near Edessa★
Seleucia (on the Tigris)★	Iraq, 30 km south of Baghdad
Shami★	Iran, Elymais, east of Susa
Shahr-e Qumis★	Iran, east of Tehran (the Seleucid Hecatompylos)
Shovaz	Iran, near Yazd★
Sogdia★	Middle-Asia, south-east of the Aral-Sea
Spasinu Charax★	Iran, formerly at the confluence of the Euphrates and Tigris
Sumatar Harabesi	Turkey, near Harran (Sanliurfa, old Edessa)
Susa★	Iran, Khuzestan
Syr-Darja★	Ancient name of the river Jaxartes
Tagisken	Kazakhstan
Takht-e Suleiman★	Iran, north-west (ancient area of the Atropatene)
Tang-e Butan	Iran, Khuzestan, 60 km north-east of Masjid-e Suleiman★
Tang-e Sarvak★	Iran, Elymais
Taxila	Pakistan, north-west of Islamabad
Tedžen river	Iran, Karakum Desert
Tepe Sialk	Iran, near Kashan, north of Isfahan
Termiz★	South Uzbekistan
Tillya-Tepe★	North Afghanistan
Turfanoase	China, Xinjiang Province
Uruk★	Iraq
Yazd★	Iran
Yazdigird★	Iran, Kermanshah Region
Zahhak★	Iran, East Azerbaijan
Zarand	Iran, Zagros Mountains★

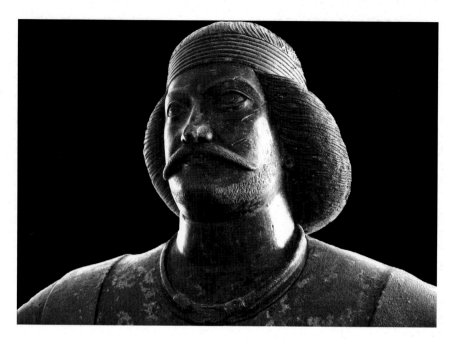

Frontispiece: 'Prince of Shami', bronze statue. National Museum of Iran, Tehran

1

THE PARTHIAN EMPIRE

A first approach

The Parthian Empire existed for almost 500 years (c. 247 BC–224 AD) and, at its peak, it extended from today's Syria to India and from the Caspian Sea to the Persian Gulf. The Parthians were Rome's great opponents in the east, who were able to check the supremacy of the Roman Empire. But while the Roman Empire is always present in today's historical consciousness, little is known to the European reader about the great empire of the Parthians. Under the Parthian king of kings, Orodes II, the Romans were defeated in the famous Battle of Carrhae (53 BC). Twenty thousand Romans fell, 10,000 were captured, and only a small part of the Roman army returned to Rome. Parthia could never be conquered by Rome, despite numerous border wars. Why has this great empire been so largely forgotten and only in recent decades came increasingly into the limelight?

A. Invernizzi, a major researcher into the Parthian kingdom, emphasises in his writings, that the Parthian Empire, which spread between Europe and Asia 2000 years ago, constitutes not only one of the most important periods in Iranian history, but also one of the most significant sections of ancient history ever.[1] At the time of the great Parthian king Mithradates II (c. 121–91 BC), trade along the Silk Road[2] stretched from Europe as far as China, Parthia being an important trading partner between east and west. In modern terms, one could say that Parthia was at the centre of a globalisation that extended from Rome to China.

The Parthian Empire arose from a small group of Scythian nomads, the Parni, who lived south-east of the Caspian Sea and who from c. 250 BC onwards invaded the Seleucid satrapy Parthia, which lay west of their settlement area. Their leader was Arsaces I, who gradually took control of this satrapy. It took another 70 years for the Parthian Empire to develop and consolidate from these beginnings. The name 'Parthian' is often equated with the term 'Arsacids'. The name 'Arsacids' derives from the first ruler of the Parthians, Arsaces I, while the name 'Parthian' has its roots in the province Parthia, which the nomadic Parni once invaded.

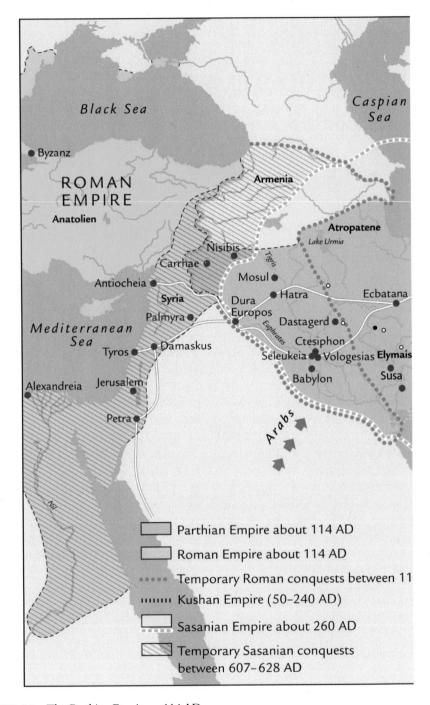

FIG. 1.1 The Parthian Empire c. 114 AD.

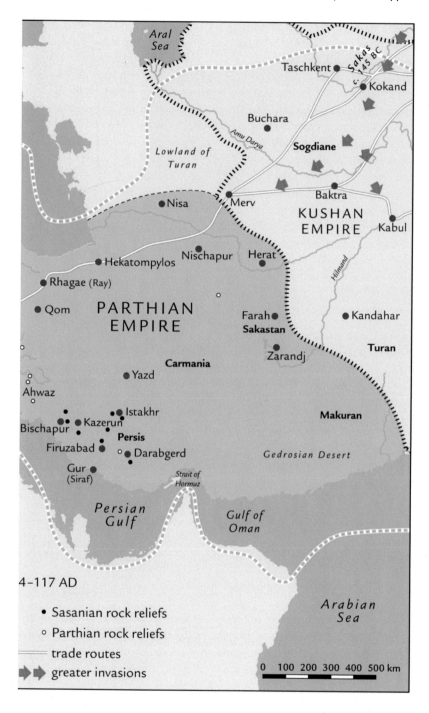

Aral
Sea

Taschkent

Sakas
c. 145 BC

Kokand

Buchara

Lowland of
Turan

Amu Darya

Sogdiane

Baktra

Nisa

Merv

KUSHAN
EMPIRE

Kabul

Hekatompylos

Nischapur

Herat

Hilmand

Rhagae (Ray)

Qom

PARTHIAN
EMPIRE

Farah

Kandahar

Sakastan

Turan

Carmania

Zarandj

Yazd

Ahwaz

Istakhr

Makuran

Kazerun

Bischapur

Persis

Firuzabad

Darabgerd

Gedrosian Desert

Gur
(Siraf)

Strait of
Hormuz

Persian
Gulf

Gulf of
Oman

4–117 AD

Arabian
Sea

- Sasanian rock reliefs
∘ Parthian rock reliefs
— trade routes
▶▶ greater invasions

0 100 200 300 400 500 km

The Parthian Empire consisted during its peak period of individual kingdoms dependent on the Parthian king of kings, where for the most part no Parthians or Iranians lived. At least at the beginning of the conquests, the local rulers remained on their thrones, while just a small number of Parthian government officials took control of government affairs and Parthian troops took over military control.

Historians have wondered whether the term 'empire' is the correct name for such a political entity. Sommer defines an 'empire' as follows: 'In empires, power radiates, hierarchically stratified, from the center to the periphery. Power decreases with distance.'[3] But does such a definition apply to the Parthian Empire? The situation described – of various kingdoms integrated into Parthia – does not correspond to the definition of an empire. To take this into account, the more fitting term 'Parthian Commonwealth' has recently been introduced.[4] More about this can be found in Chapter 4. Since the term 'Parthian Empire' is still anchored in the general knowledge of history and because this book aims for a wider public, this term has been retained for the sake of simplicity.

1.1 Documentary sources from within the Parthian world

Our knowledge of the history and culture of the Parthian Empire is minimal. The reason for this is the lack of sources from within the Parthian world. Those sources include all archaeological finds, be these city remains, works of art or written documents. Many of the cities, which the Parthians built or took over from their predecessors, have been destroyed. Such is the case with Ctesiphon, once the Parthian capital in Mesopotamia. Archaeological finds are rare; written documents are rarer still.

For the 3rd/2nd century BC, the outstanding finds from Nisa (in today's Turkmenistan, near its capital Ashgabat), a royal residence and sanctuary of the Parthians, are some of the most important and almost the only sources available to us (see 7.2.1 and 10.1). Thus, we have hardly any significant sources for the first 100–150 years of the whole Parthian Empire. The situation for archaeological finds dating to the 1st century BC in Iran and Mesopotamia is better, but still not adequate. Only for the period after the turn of the century is the number of better excavated Parthian towns larger, and the find material more extensive.

The number of Parthian inscriptions found on rock reliefs, other reliefs, sculptures and seals is small. The available written documents are in no way sufficient for us to elicit historical or cultural statements about the Parthian Empire. And while in Nisa, over 2500 ostraca (inscribed potsherds), with inscriptions mostly relating to winegrowing and its administration, were found (see 8.4), they date from the 1st century BC, and therefore give information only about a limited period and a small segment of daily life.[5]

We get significant information from cuneiform tablets, especially from the astronomical diaries found in Babylon and Uruk. The texts date from the 7th century BC to the 1st century AD. These writings provide information about meteorological

phenomena or observations of the sun, moon and stars. Based on the Babylonian calendar, important political or social events are also mentioned. Regarding the Parthian Empire, the texts provide information about the conquest of Mesopotamia (141 BC) by Mithradates I and list names of the Parthian kings up to the year 75 AD. However, we lack the records of many years, so that information is only available for a total of 54 years of Parthian rule.[6] We have hardly any information about the administrative structure of the Parthians in Babylonia. From the available written records, however, we can see that the Parthians did not intervene in Babylonian culture and allowed the local population to practise their own religion.

The number of texts on parchment or leather from Parthian times is also extremely low. The best-known are the three Avroman parchments found in Iranian Kurdistan, of which two are written in Greek and only one in Parthian.[7] These documents record the sale of a vineyard at various times to three different owners. In the year 88 BC, half of the vineyard cost 30 silver drachms. By 53 AD, the price had risen to 65 silver drachms.[8] Only a Greek-Parthian inscription on a statue of Heracles from Seleucia on the Tigris (Fig. 11.7 A + B) names a historic event (150/151 AD): the victory over and expulsion of Miradate (Meredat), king of Characene (c. 130–151 AD), by the Parthian king Vologases IV.[9] An extensive collection of Parthian texts and their translation into German can be found in the three-volume work *Quellen zur Geschichte des Partherreiches* by U. Hackl, B. Jacobs and D. Weber. This extensive work contains the most important other Roman, Greek and Chinese sources, also in German translation.

Parthian coins are among the most important sources for the Parthian Empire. Like no other finding, these give information about the whole period of the Parthian Empire. The sequence of Parthian kings could not have been adequately clarified without the analysis of Parthian coins. Despite recent research, however, many details remain unresolved; they are mainly discussed in 8.1 (genealogy of the Parthian kings). Coins are not only important for the genealogy of Parthian kings, but also for giving us clues to the culture of the Parthians by showing clothing, weapons, gods or inscriptions. Because of the importance of the coins for understanding the history and culture of the Parthian Empire, a separate section of the book (8.1) is devoted to them.

1.2 Greek – Roman – Chinese literary sources

Since documentary sources from within the Parthian world are inadequate for gaining a satisfactory insight into the Parthian Empire with its culture, politics and religion, we must focus on ancient literary sources from outside the Parthian world, such as Greek, Roman or Chinese documents.

The problem with these sources, however, is that in most cases the authors themselves had never been to Parthia. In addition, most of them were authors who were not eyewitnesses themselves but reported on past events and therefore had to rely on older reports. Another difficulty arises from the fact that information from the beginning of the Parthian Empire is inadequate. The same, albeit to a lesser extent,

also applies to the final phase of the empire. Most of what we know about the history of the Parthian Empire and its culture comes from Roman sources, which are much more extensive than the Greek reports.

Among the most important Greek written sources about the Parthians are the works of Strabo, Plutarch and Polybius. Strabo (c. 63/64 BC–25 AD) informs us about the geography of Parthia, and Plutarch (45 AD–c. 120 AD) describes the Battle of Carrhae (53 BC), which was the first great confrontation between Parthia and Rome. Although Plutarch sees the Parthians as barbarians (see 1.3), we still get hints regarding the Parthian military and its tactics. Polybius (c. 200–120 BC) became famous by writing the *Historiai*, containing the history of the Romans and mentioning the Parthians.

The most famous Roman writers from whom we learn the most about the Parthians are Pliny the Elder, Tacitus, Cassius Dio, Suetonius and Justin. Whenever wars raged between Rome and the Parthians, these writers provided references to the political situation between the two empires.

As described in more detail in the following section (1.3), it should always be remembered that such writings do not always reflect reality. It can often be observed that in these works political statements are made that only serve the writers' own political interests. For example, Justin (Latin: M. Junianus Justinus Frontinus) tries to portray the Roman defeat at Carrhae in 53 BC as a Roman success.[10] Another example is Publius Cornelius Tacitus (c. 56/57–120 AD), who was an important Roman historian and politician. His focus on the Parthians is influenced by Roman politics and it is not surprising that he describes the Parthians as overbearing, deceitful and fickle.[11]

Lucius Claudius Cassius Dio (c. 164–235 AD) was a Roman senator, consul, writer and historian. He published 80 books about Roman history, written in Greek, which have survived only in fragments. The sources used by Cassius Dio come mainly from older writings, of which only a fragment is known to us. Part of these writings deal with the Battle of Carrhae in 53 BC, in which the Roman army under Marcus Licinius Crassus was crushed. For Dio, the Parthians are powerful opponents of the Romans. although they are often referred to as barbarians. But he also describes that in some cases the Parthians even offered the Romans military help (see 3.3). Justin also left significant information about the Parthian Empire based on the history of Pompey Trogue (Latin: Gnaeus Pompeius Trogus), whose works are unfortunately completely lost.[12] Justin most likely lived in Rome at the end of the 2nd century AD. He wrote about the Parthian Empire from its beginning to the return of the Roman standards, conquered by the Parthians at the Battle of Carrhae, to Emperor Augustus in 20 BC.

Justin, who drew on information from earlier authors, likewise considers the Romans superior to the Parthians. The Parthians are described as cruel, overbearing, deceitful, but also courageous. Justin's writings thus shaped a Parthian image, which was to last until the 20th century.[13] Only recent research corrects this partially distorted picture. Such recent investigations are now shaping the image of a nomadic people, from which emerged a self-confident, well-functioning empire.

The upper Parthian classes, at least, were smartly dressed, spoke Greek and Parthian, and enjoyed theatrical performances.

Pliny the Elder (23/24–79AD) describes in his major work *Naturalis historia*, among other things, the geography of the Parthian Empire, and provides information about the silk trade between China and Rome, in which the Parthian Empire played an important role. He also reports that the kingdom of the Parthians consisted of 18 kingdoms (Chapter 5).[14]

Another important group of sources for details about the Parthian Empire comes from the Turfan[15] oasis in the Chinese province of Xinjiang.[16] Between 1902 and 1914, Albert Grünwedel and Albert von Le Coq, two German archaeologists, made four expeditions to the oasis and there found many valuable ancient writings that testify to the diverse cultures of the ancient Silk Roads. At the time of the deciphering of the finds, unknown languages emerged, e.g. Tocharian, Sogdian, Saka and Parthian. The writings deal predominantly with religious themes (Buddhist, Manichaean, Christian). As laboratory studies using the C14 method have shown, the oldest evidence dates from the 2nd century AD, the most recent from the 14th century.

1.3 Ancient sources: historical truths or distorted images?

When reading Roman or Greek sources, one must consider the political circumstances of their origins and the personal motivations of the writer. When assessing the credibility of the statements, we must accept that they are often distorting or inaccurate.[17] Notwithstanding such difficulties, these testimonies are a necessary enrichment, as they can provide important additional information about the Parthian Empire, without which knowledge would be incredibly scarce.

Many contemporary reports and pictorial representations were politically coloured, or even distorted. Rome's wars against the Parthians, often ultimately lost, were often celebrated as victories. A good example of this is the well-known Parthian Monument at Ephesus, which was likely created after 169 AD and refers to the Parthian campaign of Lucius Verus (Fig. 1.2).[18] The monument shows fighting between Roman and Parthian soldiers, in which the superiority of the former is displayed in a manner akin to propaganda. The contemporary artist did not convey a realistic picture of the Parthians, for in these illustrations some of the Parthians are depicted as wearing only loincloths and a Phrygian cap. One Parthian soldier is even naked. Parthians are shown in close combat; their faces are sometimes painfully distorted and express fear. By contrast, Roman soldiers are portrayed as superior, standing upright or sitting on a horse. Of course, the Parthian soldiers did not go into battle naked or wearing loincloths but wore their riding costume with its typical Parthian trousers. In battle, the Parthians used longer lances than the Romans. They were more skilled, too, in the use of bows and arrows atop the back of their fast horses. Thus, the monument does not show the true picture of a military exchange, but depicts the Parthians as inferior, barbarous people. This was done with the clear intention of reinterpreting defeats as supposed victories, with the aim of not revealing Rome's own weaknesses.

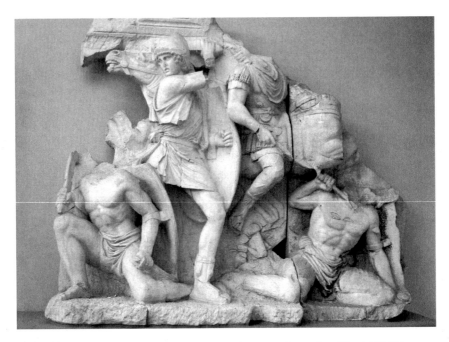

FIG. 1.2 Parthian monument, c. 169 AD. Find spot: Ephesus. Inv. Nr.: 10/6/77, 51/61/90, Museum Selçuk, Turkey. Part of the monument is a copy. Two Parthians, wearing loincloths, are shown defeated by Roman soldiers.

In general, the Romans knew little about the Parthians. However, the few contacts between Rome and Parthia, e.g. through merchants, could do nothing to change the image that the Romans generally had of strangers from the Orient. There was little reliable information about the Parthian Empire, and the Romans adhered to the typical, stereotypical ideas that had existed before: the Parthians possess tremendous wealth and live in pompous waste, are brutal despots and sexually overactive.[19]

At the time of Emperor Augustus, another view of the Parthians prevailed. Parthian servants worked in the houses of wealthy Romans, as sculptures of Parthian servants or slaves in Roman society show.[20] Although the servants came from the fairy-tale world of the Orient, recognisable by the oriental trousers they wore, they certainly had to adapt to Roman ideas. Consequently, they wore well-groomed longer hair and were clean-shaven. A marble figure, found in the Casa del Camillo in Pompeii, shows such a luxury slave, who is depicted with knee-length robe and trousers, holding in his hand a wine ladle and obeying orders from the guests.[21]

1.4 The Parthians: nomads – Hellenes – Iranians?

The Parthians were Central Asian nomads who invaded areas that Alexander the Great had invaded and in which the Seleucids had ruled for about 60 years. But

these were also the areas in which the Iranian empires had developed over thousands of years.

The question of the influence of Hellenism, defined as the period between the death of Alexander the Great (356–323 BC) and the conquest of the Greek states by the Romans (30 BC), on the Parthians and the development of their culture and religion has been and is still one of the most difficult and at times controversial in science. The reasons for these different perspectives are essentially due to three factors. The first is the repeated lack of archaeological finds, especially from the core land of the Parthians. The second is the large number of vassal states ruled by the Parthians, in which there was not only a Parthian influence, but where we also find regional influences. In addition, all Hellenistic influences seen in these areas before Parthian rule have to be taken into account. N.L. Overtoom defines the region between the Levantine coast, Syria, northern Mesopotamia, and Armenia in the west, and the central Asian steppe and the Indus River valley in the east as 'Hellenistic Middle East', where the Seleucid Empire established their power.[22] Naturally this Hellenistic influence had a lasting impression of the different states ruled by the Seleucids. Thirdly, the almost-500-year period of the Parthian Empire must be considered, which of course has brought about a diverse mix of influences.

What are the criteria for determining which nomadic, Hellenistic or Iranian influences existed and survived? And when and for how long? And what changes have they gone through? The Parthians clearly ruled over areas that were previously ruled by the great kingdoms: the Elamites, the Medes, the Persians and the Achaemenids. Just as clearly, their cultures may have had a lasting influence on the nomadic Parthians in addition to the Hellenistic influences that came from the west.

Since insufficient Parthian written documents are available, we have to rely primarily on the existing archaeological evidence of the Parthians to answer this question. The testimonies of Greek and Roman writers can ultimately only provide limited help. In the early days of archaeological excavations in Iran and Mesopotamia in the mid-19th century, based on the few finds from the Parthian period, it was assumed that the items found were made only in a Hellenistic style. This was partly because systematic excavations were not carried out in the 19th and early 20th centuries and the search for the gold treasures of the Persians took priority over the 'insignificant' Parthian strata.

How much the question of Parthian art has occupied scientists in the last 50 years can be seen from the contradicting opinions regarding whether there was an independent Parthian art or not. French archaeologist Roman Girshman is a representative of the conviction that there was an independent Parthian art. In contrast, English historian Malcolm Colledge assumes that the Parthians did not produce any independent art (see Chapter 10).

The question of Hellenistic influences on the Parthians naturally pertains not only to art, but also to all areas of social life, urban planning, architecture and especially religion. At first glance, a clear Greek influence seems to be predominant, at least in the first two centuries of the Parthian Empire. The archaeological finds in Hatra, Dura-Europos, Susa and Seleucia show at least a partial Greek influence

(more on this in Chapter 7). Inscriptions on coins are Greek and the iconography of the early Parthian coins is based on the Seleucid-Hellenistic style. Furthermore, Roman sources tell us that the Parthian kings spoke fluent Greek as well as Parthian.

But the first impression is deceptive. Indeed it is striking that in Nisa, in the heartland of the Parthians, in the residence of Parthian kings, over 2500 ostraca were found, all of them written in Parthian, none in Greek.[23] The earliest of these inscriptions is dated c. 100 BC; the most recent are from 12 AD. On the other hand, we know that Parthian deities found in Nisa were represented in a Hellenistic way. How are these two details reconciled? As the representations of gods are characterised by a Hellenistic style, is this a clear indication that the Parthians believed in the Greek gods?

A quick and probably too easy answer would be 'no'. The various chapters of this book attempt to answer these questions and show what changes took place, e.g. in art, religion, architecture, urban design, clothing and language writing, and how the culture of the Parthians changed over the course of centuries.

An important approach in assessing the culture of the Parthians is to see what we know about the Parthians at the end of the Parthian Empire. There is a clear decrease in Hellenistic influences. On the coins the names of the kings are now written in Parthian. The Parthian kings present themselves wearing Parthian clothing. The Parthians continue to fight using their nomadic technique, with bows and arrows from the backs of their horses, and Roman combat technology has not been adopted. Even if we have only a weak picture of the religion of the Parthians, the consensus is now that the Parthians ultimately never turned away from their religion of Zoroastrianism.

Overall, by the end of their rule, the Parthians had developed into an essentially Iranian people, but had also retained Hellenistic influences and in part remained with their nomadic roots. Olbrycht writes on this: 'Nonetheless basically the Parthian's elite and the ruling dynasty were representatives of the Iranian stock and in many matters looked back to the tradition of Iran and the heritage of the Central Asian steppes.'[24]

1.5 Geography of the Parthian Empire

In its heyday, the Parthian Empire stretched from Syria to India and from the Caspian Sea to the Persian Gulf, encompassing a region of approximately 2500 km from east to west and 1400 km from north to south. In terms of today's country borders, this corresponds to an area stretching from south-eastern Turkey, Syria, Iraq and Iran to the Turkmenistan region, Afghanistan and further to Pakistan and the northern region of India. The enormous size of the Parthian Empire becomes clear when you realise that it was almost 15 times as large as today's Great Britain.

At the beginning of the empire, around 247 BC, the Parthians were confined to a small area in the south-east of the Caspian Sea. This is where the satrapy of Hyrcania, which was one of the most important arable tracts of ancient northern

Iran, was situated. The largest part of the heartland of the later Parthian Empire corresponds to today's Iran. This heartland includes the Zagros Mountains (up to 4500 m altitude) in the west and the Elburz Mountains (up to 5600 m altitude) in the north. Each range includes a plateau with low, rainy steppes and rocky and salt deserts like the large Dasht-e-Kavir in the north-east. In the south is the Dasht-e Lut, the largest salt desert in the country, and one of the largest in the world. At the edges of the plain and between the mountain ranges, there are fertile valleys. Even today, in Iran, 80 per cent of all people live in mountainous regions and use the fertile valleys for agricultural production.

With the conquests under the Parthian kings Mithradates I (c. 171–138 BC) and Mithradates II (c. 121–91 BC), the Parthians expanded their empire significantly to the west and east. In the west, they occupied fertile Mesopotamia with the Euphrates and Tigris rivers. Assur on the right bank of the Tigris, and Ctesiphon on the left bank, opposite Seleucia, became Parthian cities. Susa, located in the lowlands of today's Khuzestan in Iran, became one of the Parthians' major capitals. The Parthians thus dominated areas in which the advanced civilisations of the Assyrians, the Babylonians and the Elymians had previously prevailed.

Through their conquests, the Parthians reached the territory of today's Syria and even that of south-eastern Turkey, where in 53 BC the famous battle against the Romans took place at Carrhae. Towards the east, in the course of their imperial history the Parthians conquered the Hindu Kush in present-day Afghanistan and occupied large parts of the Graeco-Bactrian Empire and northern India.

Notes

1 Invernizzi, A., 2002: p. 231.
2 The name 'Silk Road' came into use in the 19th century.
3 Sommer, M., 2010: p. 218.
4 E.g.: De Jong, A., 2013: p. 143; Dirven, L., 2013 (1); Gregoratti, L.: 2018 (1): pp. 52–72.
5 A list of all ostraca inscriptions can be found in: Bader et al., 1976–2001.
6 Böck, B., 2010: p. 31 ff.
7 Thommen, L., 2010: p. 467 ff.
8 Weber, D., 2010: p. 566 f.
9 Thommen, L., 2010: p. 462 (Parthian: mtrdt/Mithradates); Schuol, M., 2000: p. 348 ff.
10 Justin 43.1.2.
11 Thommen, L., 2010: p. 388 with references.
12 Thommen, L., 2010: p. 244.
13 Thommen, L., 2010: p. 245 with references.
14 Pliny, *Naturalis historia* 6.112–113.
15 Also named 'Turpan'.
16 www.bbaw.de/forschung/turfanforschung/uebersicht.
17 Schneider, R.M., 1998: p. 95 ff; also: Hackl, U., 2010: p. 25; Gregoratti, L., 2019.
18 Oberleitner, W., 2004: Zum Parthermonument von Ephesos.
19 Lerouge, Ch., 2007: p. 339 ff.
20 Schneider, R.M., 1998: p. 95 ff.
21 Schneider, R.M., 1998: p. 95 ff, table 14: 14.2.

22 Overtoom, N.L., 2019: p. 111. For more, see Overtoom's *Reign of Arrows* (2020). Unfortunately, this important book on the Parthians by Overtoom could not be adequately taken into account as it was published after my book was largely completed.
23 Olbrycht, M.J., 2014 (1): p. 132.
24 Olbrycht, M.J., 2014 (1): pp. 132–133; see also: Hackl, U., 2010: pp. 174–181.

2

HISTORY OF THE GREAT EMPIRES
IN IRAN

Before discussing the Parthians and their empire, this chapter provides a brief over-
view of pre-Parthian history in Iran.

> Empire of Elam (c. 3100–640 BC)
> Medes and Persians (c. 1500–550 BC)
> Achaemenid Empire (c. 559–333 BC)
> Empire of Alexander the Great (c. 333–323 BC)
> Seleucid Empire (c. 311–64/63 BC)
> Parthian Empire (c. 247 BC–224 AD)
> Sasanian Empire (c. 224–651 AD)

Being of Greek origin, the empire of Alexander the Great and the empire of the
Seleucids, founded after Alexander's death in 323 BC by Seleucus I in 312 BC, do
not belong among the Oriental empires. Both these empires were of approximately
the same size as the empire of the Persians.

2.1 The empire of Elam

The empire of Elam was the first highly cultured civilisation in the south-west
of today's Iran. The Elamites settled there in two regions: in Khuzestan with Susa
as capital, and in the region of Anshan, the plateau of Fars, with Anshan (Tall-i
Malyan) as capital. Susa was also an important city in the Parthian Empire (see 5.6
and 7.2.7). To date, it is not clear whence the Elamites originated, their language
not being related to any neighbouring languages.[1]

The history of this empire is divided into four periods: the so-called Proto-
Elamite Period (c. 3100–2600 BC), the Old-Elamite Period (c. 2600–1600 BC),
the Middle-Elamite Period (c. 1600–1100 BC) and the Neo-Elamite Period

(c. 1100–640 BC). Urban centres originated here as early as the 4th millennium BC. Cuneiform writing was already in use in the early phase of the sixth century. Its characters were replaced by Akkadian cuneiform in the 2nd millennium BC. The Elamite language was preserved.

In Mesopotamia, the advanced cultures of the Sumerians and Akkadians developed in the same period. An intensive economic and cultural exchange took place here, which extended as far as the Near East, India and Central Asia. The basis was the rich raw material deposits of Iran. Near the city of Susa, the well-preserved ruins of the city of Chogha Zanbil with its significant Ziggurat (Fig. 2.1) can still be admired. This bears witness to the architecture of that time under the reign of the Middle-Elamite king, Untasch-Napirischa (1275–1240 BC).

In 1213 BC, the Elamites conquered Babylonia. Now in the Louvre, the well-known Code of Hammurabi of Babylon, one of the earliest surviving codes of law in recorded history, was robbed and taken to Susa. In return, the Babylonian king Nebuchadnezzar I (reigned 1124–1104 BC) destroyed the city of Susa. Until c. 800 BC, Elam sank into insignificance. The short flowering of the Neo-Elamite Empire ended in 640 BC, when the Assyrian king Assurbanipal conquered the empire. During the period of the Persian Empire that assumed power, the Elamite language was still cultivated, and the Elamite administrative institutions were maintained. We encounter the former Elam region again, now named 'Elymais', in the Parthian period (see 5.6).

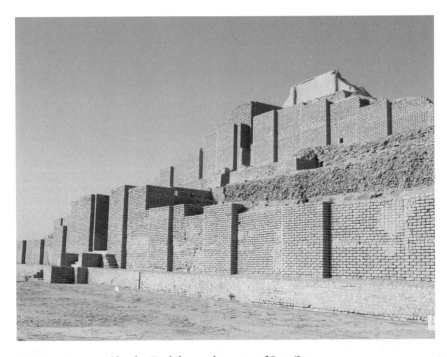

FIG. 2.1 Ziggurat Chogha Zanbil near the town of Susa/Iran.

2.2 The Medes and Persians

The Medes and Persians are to be numbered among the Indo-Iranian peoples who emigrated to the territories of Iran from the 2nd millennium BC onwards. The Medes settled mainly in the Zagros Mountains, as well as in north and north-eastern Iran, whereas the Persians settled in the region of Fars, today's south Iran, with Shiraz as its capital. Sources of information about the Medes can be found in Assyrian texts, but also in Achaemenid inscriptions. Ancient writers like Herodotus (Herodotus 1.101) inform us about the Medes and their capital Ecbatana. Ecbatana was later made a residence for the Achaemenid kings, and became the capital of the Parthian Empire. The city of Ecbatana has not yet been found by archaeologists, but was probably located near today's Hamadan in Iran, about 300 km west of Tehran.

References to the Medes can also be found in the Bible, for instance in the Old Testament in the book of Esther (1:14) or in the book of Daniel (5:26–28). The New Testament also refers to the Medes. In the story of the Apostles, in which the descent of the Holy Spirit (Pentecost, Acts 2:9), is reported, the Medes and the Elamites (see 2.1) are mentioned in addition to the Parthians.

The history of the Medes is far from fully understood. Historians previously thought it to be a kingdom, but nowadays a conviction prevails that it was a confederation of numerous smaller regions and tribal unions, which were united under the Median ruler Cyaxares I at the end of the 8th century BC. Numerous wars with neighbouring states were conducted in the subsequent period, especially with the Assyrians. Around 650 BC, Scythians invaded the Median realm, ruling there for about 25 years. Herodotus reports that Scythian influence caused the Medes to learn how to shoot arrows while on horseback (see 4.3).[2] Under Cyaxares II, the Medes freed themselves from the Scythians, and an expansion of the army followed. Cyaxares II finally entered into an alliance with the Babylonians, and together they attacked the Assyrian Empire. Nineveh, the capital of the Assyrians, was destroyed in 614–612 BC, as was the royal city of Assur, which gave its name to the Assyrian Empire. This was the end of the Assyrian Empire.

We know little about the religion of the Medes. The writings of Herodotus are of importance, although modern research assumes that much of the information provided by him is to be treated with caution. Herodotus reports on the 'Magi', a Median tribe, a priestly caste that transferred knowledge within the family from father to son (see 11.2). These Magi not only had religious duties, but also played a consultative role at the court of the Medes. They were experienced in dream interpretation, but also had good astronomical knowledge. One of the gods they worshipped was Ahura Mazda (see 11.1).

The above-mentioned Persians settled in the region of Pars, which formerly belonged to the Elamite Empire, and corresponds to the territory of today's Shiraz. To start with they remained under the rule of the Medes. Like the Medes, the Persians never had a kingdom, but also like the Medes were a confederation of tribes. Although the influence of the Medes on the Persians was probably dominant for a long time, this changed under Cyrus II of Persia – also known as Cyrus

the Great – who reigned from 559 to 530 BC. He defeated the Medes in around 550 BC. Cyrus the Great thus created the Persian Empire of the Achaemenids; the inhabitants were named Parsi, Persians, after Pars.

2.3 The empire of the Achaemenids

The names Isfahan, Shiraz, or Persepolis can instantly be associated with the splendour of the Orient, with the scent of spices, or with the image of camel caravans travelling through the desert. These places are also connected with the legendary empire of the Achaemenids, the realm of the Persians, whose gold treasures we can admire in museums.

The Persian king Cyrus the Great (559–530 BC), who later named himself 'The Great King, King of Kings, King of Anshan, King of Media, King of Babylon, King of Sumer and Akkad, King of the Four Corners of the World', conquered Ecbatana in c. 550 BC and defeated the Medes. This was the beginning of the Achaemenid Empire, named after Hakhamanisch (Greek: Achaimenes), an ancestor of Cyrus the Great. During his reign Cyrus the Great conquered Babylonia and Lydia in the west, while Bactria and Sogdia were subjected in the east. In Pasargadae, which he made the first capital of the Persian Empire, one can still visit his grave. His successors Cambyses II (c. 530–522 BC) and Darius I the Great (c. 522–486 BC), made numerous conquests. At its height, the Persian Empire included Asia Minor, Egypt, and stretched east to Central Asia.

With the expansion of the Achaemenid Empire came a need to integrate many different cultures into the empire. It was particularly important to respect the different religions of the peoples and to give people religious freedom. Near Pasargadae, Persepolis, the ceremonial capital of the Achaemenid Empire, was founded by Darius I, also named Darius 'The Great' (c. 521–486 BC). The completion of Persepolis, with its magnificent pillars and stone carvings, took over 100 years (Figs. 2.2 and 2.3). The name is of Greek origin, composed of Pérsēs and polis – the city of the Persians. However, Persepolis was not a city in the true sense of the word, but rather a large complex of buildings in honour of the Persian kings. It was the ritual centre of the Achaemenid Empire. On the walls of the entrance to the Apadana, the great audience hall, people of many different nations belonging to the empire are shown, bringing gifts to the king and thereby proving their dependency (Fig. 2.2). The idea among earlier historians that the *norooz* festival, the Spring Festival, was celebrated in Persepolis has nowadays been abandoned.[3] Later, the Persians moved their capital to Susa (see 7.2.7). Ecbatana, formerly the capital of the Medes, became the summer residence of the Persian kings. After the conquests of the Parthian king Mithradates I, Ecbatana became one of the most important Parthian cities, where a large quantity of Parthian coins were minted (see 7.2.6).

The expansion of the Achaemenid Empire brought inevitable clashes with the Greeks. Having started in 499 BC, the Graeco-Persian Wars ended in c. 469 BC. Ultimately, Persia lost control of Asia Minor, Macedonia and Thracia. In 402 BC, the Egyptians liberated themselves from the Persian yoke. However, the land

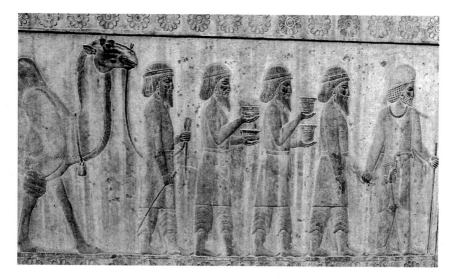

FIG. 2.2 Persepolis, Royal Palace, Apadana. Delegation from Bactria.

Note: The attributions of the represented delegations to the various peoples is not yet clear in all cases.

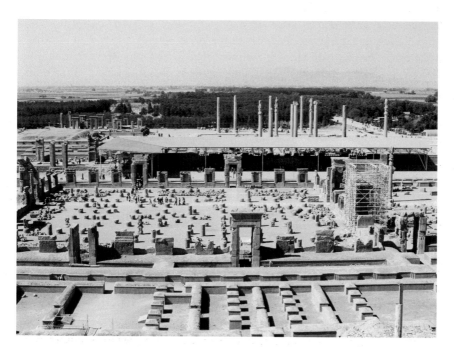

FIG. 2.3 Persepolis. General view of the archaeological site.

was reconquered under the Persian king Artaxerxes in 343 BC. The end of the Achaemenid Empire came unexpectedly through the conquests of the Macedonian Alexander the Great.

2.4 Alexander the Great (356–323 BC) – the Hellenistic period

The period between the death of Alexander the Great (356–323 BC) and the conquest of the Greek states by the Romans (30 BC) is defined as the 'Hellenistic Period'.[4] By definition, one characteristic of this epoch is the cultural penetration of the Orient by Greek culture, but conversely also of Oriental influence on the west. However, one needs to be aware that even before this period, there were cultural influences between them. Proof exists that the Oriental civilisations (the aforementioned empires of Elam, the Medes and the Persians, and the Achaemenids) had a dominant influence on the west, transferring their knowledge of science, medicine and astronomy. This changed with the rise of Greek culture and Greek philosophy, which expanded from the mid-8th century to the mid-6th century, when the settlements of Asia Minor reached the border with the Orient.

During the period of the foundation of the Persian Empire (539 BC), Greece became increasingly detached from the east, to the extent that the Greeks eventually saw their neighbours as barbarians.[5] Europe's detachment from Asia, which continues to this day, had its beginnings at this time. The conflicts between the Greeks and the Persians finally led to the Persian Wars (500–479 BC). The rise of Macedonia under the father of Alexander the Great, King Phillip II (359–336 BC), was a crucial turning point in world history. He subdued the Greeks and prepared to prosecute a war against the Persians in pursuit of the idea of the political unification of all Greeks (pan-Hellenism). The assassination of Philip II in 336 BC only delayed this attack for a short time. His son Alexander succeeded to the throne, enforced his claim to leadership and only two years later began the war against the Persians.

Alexander the Great's victory over the Persians at the battle of Issus in 333 BC and the decisive battle of Battle of Gaugamela (close to the modern city of Dohuk in Iraq) in 331 BC shattered the existing world structure. In just ten years, Alexander created a huge empire, which stretched in the east to the upper Indus valley in today's Pakistan. When his troops refused to move further east, the troublesome return journey began. From the mouth of the river Indus, part of the force took ships westward, the larger part being obliged to take the land route. Many of the troops gathered in Susa, now in Iran, and a mass wedding between 10,000 Persian women and Alexander's warriors was celebrated there. On the way back, Alexander fell sick. He still reached Babylon but died there in June 323 BC at the age of not quite 33 years. The intention was to bring Alexander's body back to his home in Macedonia, but Ptolemy captured it and took it to Memphis in Egypt. The sarcophagus was later moved to Alexandria. The 'Alexander Sarcophagus', shown in Fig. 2.4, never contained Alexander's remains, but its name derives from the

FIG. 2.4 The so-called 'Alexander Sarcophagus'. Istanbul Archaeological Museum. Alexander the Great (left), wearing a lion's head, fighting the Persians in the battle of Issus, 333 BC.

Note: It is assumed that this is a portrayal of Alexander as the rider wears a lion's head.

bas-reliefs, which are believed to depict Alexander and his companions fighting the Persians.

Alexander the Great's campaigns led to enormous social upheavals that could be felt from Greece to Bactria, located in present-day Afghanistan. Greek became the world language, and there was an intense exchange and tremendous upswing in science, art and literature. Ground-breaking new insights were gained in mathematics, geography and technology. But what had Alexander the Great wanted to achieve by his campaigns? In recent research, the idea prevails that Alexander sought an equal connection between the two peoples. The spread of Greek culture in the east was not the primary intention, even if that was the ultimate result. Persians' influences on the Macedonian court in the period before the Persian Wars are readily demonstrated. Alexander not only had a Greek-influenced education but was also raised in early youth with Iranian culture and Iranian ideas. His attitude was pro-Iranian. During his campaign to the east, he promoted marriages between Persians and Macedonians. He adopted Achaemenid attitudes and wore the Persian royal costume. From his subjects he demanded gestures of submission in the form

of prostration and hand kissing (proscynesis), which caused displeasure among his friends and army commanders.

After Alexander's death one of his former commanders and his successor in the east, Seleucus I, broke with the idea of continuing the Achaemenid line – his attitude was not pro-Iranian, even if he adopted well-established Achaemenid practices in the organisation of the empire.

2.5 The empire of the Seleucids

Alexander the Great had not settled his succession, and in the years following his early death at the age of 33, a power struggle, the so-called Wars of the Diadochi, meaning 'successors' in Greek, ensued. Three great dynasties finally emerged: the Ptolemies in Egypt, the Antigonids in Macedonia and parts of Greece, and the Seleucids in the east. From 312 BC onwards, Seleucus I, founder of the Seleucid Empire, assumed power in the east of the empire as far as Bactria (in the region of today's Afghanistan, Tajikistan and Uzbekistan). Babylon became its capital, and Seleucus I, bearing the epithet 'Nicator' (meaning 'Victor') legitimised his rule by marrying the Bactrian princess Apame. Around 305 BC, the city of Seleucia on the Tigris in Mesopotamia was raised to become the capital. As a result, many Greeks settled in Mesopotamia and in Bactria. At the battle of Ipsus (301 BC), Seleucus I conquered the eastern parts of Asia Minor and the northern parts of Syria. Antioch on the Orontes then became his new capital. Seleucus I died in 281 BC.

As a result of the conquests, the Seleucid Empire became a major centre of Hellenistic culture. Administrators, merchants and wealthy citizens populated the new cities. Not only were Greek administrative structures introduced by the elite of the new rulers, but also the Greek way of life was adopted. The upper classes – either of Greek origin or Greek-influenced locals – wore Greek clothing and enjoyed Greek art, music and theatre. The degree to which the Greeks influenced this area in later times is demonstrated by Parthian coins, which bore Greek inscriptions until the beginning of the 2nd century AD.

Antiochus I Soter (the epithet Soter means 'the Saviour') succeeded his father Seleucus I on the throne (c. 281 – 2 June 261 BC). In the middle of the 3rd century, the Seleucid Empire encompassed the entire east of Alexander's former empire. The Seleucids controlled the major trade routes to China and India. The focal point was Seleucia on the Tigris, where trade flourished. Native tribes and regions were the carriers of such trade. Although they participated in the profits, they also tried to seek independence.

Rule over such a large empire became more and more difficult for the Seleucids. Antiochus II Theos (reigned 261–246 BC) was increasingly involved in wars (the first and second Syrian Wars) against Pharaoh Ptolemy II, who reigned in Ptolemaic Egypt from 283 to 246 BC. Aggravating conflicts with the Celts in Asia Minor also weakened the Seleucids. In the third Syrian War (246–241 BC), the Ptolemies under Ptolemy III inflicted a severe defeat on the Seleucids, and the Seleucid Empire was

severely destabilised. These wars led to a power vacuum in the east of the Seleucid Empire, as Seleucid troops were stuck in the west.

Ultimately, some of the regional rulers in the east became, to varying degrees, independent. This was the case with Bactria (see 6.4) and the satrapy Parthia, located in the area south-east of the Caspian Sea. The satrapy of Parthia was headed by Andragoras, who had been established there by the Seleucid ruler Antiochus I (281–261 BC). Andragoras had succeeded in uniting the former satrapies of Parthava (today's Khurasan, Iran) and Hyrcania (today's Gorgan, Iran). Coins bearing his portrait indicate that he probably strengthened both his power and his independence from the Seleucids.[6] The satrapy of Parthia was to play a significant role in the emergence of the Parthian Empire as eastern nomads, the Parni, succeeded in conquering it and established their power there (see 3.1).

Much has been discussed regarding the decline of the Seleucid Empire. One of the most important causes certainly lies in the strengthening of both the Roman Empire and the Parthian Empire. While it was formerly believed that the Romans played an important part in the decline of the Seleucids, it is now assumed that the expansion of the Parthian Empire had a bigger impact on it.[7]

Notes

1 Potts, D.T., 2013: p. 571: the language is unrelated to Sumerian and is neither Semitic nor Indo-European.
2 Herodotus I, 73.
3 Imanpour, M.T., 2006: p. 115.
4 General information on the Hellenistic age: Thonemann, P., 2016; Strootmann, R., 2014, discusses Hellenistic imperialism and the use of 'Great king of kings' in Hellenistic times, pp. 38–61.
5 Hackl, U., 2010: p. 8.
6 Overtoom, M.L., 2016: p. 993 f. On the other hand, minting coins with his own name does not mean that Andragoras intended to create an independent state. For this, see Jacobs, B., 2010: p. 38 ff.
7 Overtoom, M.L., 2019: p. 112.

3

HISTORY OF THE PARTHIAN EMPIRE

The history of the Parthian Empire can be divided into four periods. The first phase (c. 247–165 BC) covers the period from Arsaces I to Phraates I. However, it must not be assumed that an empire had already been established in this first phase. Rather, in the beginning it was probably still a vassal state of the Seleucid kingdom, in which the 'Parthians may have been the most uncontrollable vassals' the Seleucids ever had.[1]

Only from the beginning of the second period (c. 165–70 BC), from Mithradates I to Darius of Media Atropatene, the expansion phase, could one speak of a Parthian Empire. R. Strootman places the rise of Parthia after the death of Antiochos III (187 BC) or even Antiochos IV's death in 164 BC.[2] From then on, the power of the Parthians grew and in the 140s Mithradates I conquered the Seleucid core provinces of Media and Babylonia, thus starting the further decline of the Seleucid Empire.

The third phase covers a period of about 120 years (c. 70 BC–c. 51 AD), during which Parthia established itself as a world power: from Phraates III to Vonones II. During this period the first conflicts with the Roman Empire arose and repeated wars with the Romans as well as countries in the east and north continued. In the fourth period (c. 51–224 AD), from Vologases I to Artabanus IV, phases of stability alternated with wars and/or periods of inner turmoil – which in the end led to the decay of the Parthian Empire and the rise of the Sasanian Empire.

As previously emphasised, archaeological finds or writings that provide information about the Parthian Empire are scarce. The creation of the genealogy of the Parthian kings would not have been possible without the analysis of Parthian coins, which are therefore among the most important sources.[3] Parthian coins also give us clues to the culture of the Parthians, as they portray weapons, clothing, gods or inscriptions.

The list of Parthian kings used in this book is mainly based on the second edition of David Sellwood's book *An Introduction to the Coinage of Parthia*, published in 1980. As described in more detail in Chapter 8 (see 8.1), G.R.F. Assar has, on the strength of his numerous and extensive investigations, created a new list of Parthian kings (published in: *Sunrise Collection*[4]), which is now increasingly used. A comparison of the different data on the kings, given on the one hand by Sellwood and on the other hand by Assar, can be found in Table 8.1. Some of Assar's results are shared by other authors, some of his considerations are not.[5] Owing to the general problem of Parthian genealogy, the project *Sylloge Nummorum Parthicorum* was founded in 2010 under the direction of M. Alram (Austrian Academy of Sciences) and V.S. Curtis (The British Museum, Department of Coins and Medals).[6] The first volume of a planned nine-part series was published by F. Sinisi in 2012 (for detailed information see 3.4). A second volume (*Mithradates II*) was published in October 2020, but could not be taken into account. Thus the author had decided to continue using the Sellwood classification as a basis.

Some necessary changes resulting from recent investigations by Sellwood himself, but also by other authors (e.g. Assar, De Callataÿ, Dąbrowa, Sinisi, Olbrycht, Wolski),[7] which are now generally recognised, have been incorporated into the list (Table 3.1).[8] More details are given when discussing the individual kings.

TABLE 3.1 List of Parthian rulers.

Reign	Principal Line of Succession	Joint Rulers	Rival Claimants
c. 247–211 BC	Arsaces I		
c. 211–191 BC	Arsaces II		
c. 191–176 (?) BC	Phriapatius		
c. 168–164 BC	Phraates I		
c. 165/64–132 BC	Mithradates I		
c. 132–127 BC	Phraates II		
c. 127–125 BC	Inter-regnal issue regnum/Bagasis		
c. 127–124 BC	Artabanus I		
c. 121–91 BC	Mithradates II		
c. 91–87 BC	Gotarzes I (Son of Mithradates II)		
c. 90–80 BC	Orodes I		
c. 80 BC			Unknown King (I)
c. 80–70 BC	Unknown King (II)		
c. 93/92–69/68 BC			Sinatruces, intermittently
c. 70–57 BC	Phraates III		
c. 70 BC			Darius of Media Atropatene
c. 57–54 BC	Mithradates III		

(*continued*)

TABLE 3.1 Cont.

Reign	Principal Line of Succession	Joint Rulers	Rival Claimants
c. 57–38 BC	Orodes II		
c. 39 BC		Pacorus I	
c. 38–2 BC	Phraates IV		29–26 BC Tiridates I
c. 2 BC–4 AD	Phraataces – Queen Musa		
c. 6 AD	Orodes III		
c. 8–12 AD	Vonones I		
c. 10–38 AD	Artabanus II		
c. 35–36 AD			Tiridates II (not by Sellwood)
c. 40–47 AD	Vardanes I		
c. 40–51 AD	Gotarzes II		
c. 50–65 AD			Sanabares
c. 51 AD	Vonones II		
c. 50–79 AD	Vologases I		Vologases II: did not exist
c. 55–58 AD			Son of Vardanes I
c. 75–110 AD	Pacorus II		
c. 80–82 AD	Artabanus III		
c. 105–147 AD	Vologases III		
c. 109–129 AD		Osroes I	
c. 116 AD			Parthamaspates
c. 129–140 AD			Mithradates IV
c. 140 AD			Unknown King (III)
c. 147–191 AD	Vologases IV		
c. 190 AD			Osroes II
c. 191–208 AD	Vologases V		
c. 208–228 AD	Vologases VI		
c. 216–224 AD		Artabanus IV	
c. 224–228? AD			Tiridates III? (Not by Sellwood)

Source: The list is based on data from Sellwood (1980), by courtesy of Chris Hopkins, www.parthia.com.

Note: Owing to recent research, the list has been slightly modified; for details see information given on the individual kings.

3.1 Phase 1: Development from a Seleucid vassal state to the Parthian Empire: from Arsaces I to Phraates I (c. 247–165 BC)

The first phase of the development from a Seleucid vassal state to the Parthian Empire covers approximately 80 years. We are insufficiently informed about the beginnings and the development of the Parthians based on sources from Greek and Roman writers.

What we know is that the Parni, a group of nomads, belonging to the Dahae, a community of Central Asian nomads, lived in the area of Khorasan, a region that comprised the territories of today's Afghanistan (Herat being one centre), north-eastern Iran (Nishapur being the centre) and today's Turkmenistan (with Ashgabat as centre).

The Parni, according to Justin's reports, had been pushed by the Scythians to the western steppe area near to the satrapies of Bactria and Parthia, which were Seleucid vassal states.[9] Owing to this pressure, they sought a new home by invading neighbouring areas, occupying them and then defending the conquered areas with military power. In c. 280 BC, the Parni invaded Margiana, which was under the command of the Seleucid satrap Diodotus (also named Diodotus I Soter, meaning 'the Saviour', c. 285–235 BC), who reigned in Bactria, but also in Margiana. The invasion failed, and the Parni were pushed back by the Seleucids. Nevertheless, the Parni remained a constant threat in the border area with the satrapy of Bactria but also the neighbouring satrapy of Parthia, which was under the command of the Seleucid satrap Andragoras.

In c. 239/38 BC, the Parni under the rule of their leader Arsaces I invaded the satrapy of Parthia and succeeded in conquering this area and there established power. In his analysis, R. Strootman comes to the conviction that in this early phase Parthia can not have been more than a regional vassal state of the Seleucids, who probably had little influence on the Parthians now ruling in parts of that region.[10] One can imagine that initially occupation of the satrapy was incomplete, but over the course of the first decade more and more areas came under the influence of the Parni and only slowly did the takeover proceed. Nowadays there is a wide consensus that the whole satrapy of Parthia came under the rule of the Parni at the earliest around 239/38 BC.[11]

How was a once insignificant nomadic tribe able to form such a strong empire? One significant reason was that at the beginning of the 3rd century it was no longer possible to govern the Seleucid Empire, with its enormous size and numerous vassal states, without problems and that various satraps, particularly in the east, tried to become independent. A recent approach used by N.L. Overtoom to better understand the development of the Parthian Empire, as well as the neighbouring realms, is to apply the ideas of 'International Relations Theory and the theoretical framework of Realism'.[12] In this concept, Realists claim that

> survival is the principal goal of every state. Foreign invasion and occupation are thus the most pressing threats that any state faces. In such an anarchic system, state power is the key – indeed, the only – variable of interest, because only through power can states defend themselves and hope to survive.

Realists further claim, that 'states will seek to maximize their power relative to others'.[13]

The 'power transition crisis' of the 240s BC, as N.L. Overtoom calls it, was one of the key reasons that led to the emergence of the Parthian Empire.[14] In the east

of the Seleucid Empire, a power vacuum had arisen as a result of Antiochus II's fighting in the west, thus neglecting control of the east. In uprisings or wars in the east, the Seleucid satrapies could hardly expect quick military aid from the king's army and their own defensive strength was insufficient to ward off enemy attacks.

Likewise, satrapies could create their own independence without having to reckon with rapid intervention by the Seleucid king. This applies to Diodotus, satrap in Bactria. Diodotus used this power vacuum and in 255 BC successfully revolted in Bactria against Antiochus II and became the founder of the Graeco-Bactrian kingdom (see 6.4). This also applies to the satrap Andragoras, who in c. 245 BC revolted and established his own rule in the Seleucid satrapy of Parthia, as coins with his name show.[15]

However, Andragora's military strength was not enough to fend off an attack by the Parni in 239/38, and the Seleucid King Antiochus II (265–225 BC) was unable to provide the necessary swift aid. The successful invasion by the Parni of the satrapy of Parthia was supported by the indigenous people, the 'Parthians', who were so named after the title of the satrapy.[16] This might explain why the Parni later appropriated the name 'Parthians' and even adopted their language (see 11.1). This was the beginning of the Parthian Empire, currently still an unstable political structure and by no means an empire.

Antiochus III (the Great, c. 241–187 BC), the son of Antiochus II, attempted to recapture the satrapy of Parthia around 210 BC. In the end, in 208 BC, it came to an agreement with the Parthians, as Justin reports.[17] The result was a loss of power for the Parthians. Most of Hyrcania and Parthia returned to the Seleucid government, with only the mountain regions remaining under Parthian command. In addition, the Parthians had to pay tribute. However, hardly another 20 years passed before the Seleucid Empire suffered a disastrous weakening. The cause was the strengthening of the Roman Empire: in 190 BC, at the battle between Antiochus III and the Romans at Magnesia (in the western part of today's Turkey, near Selçuk), the Seleucids suffered a tremendous defeat, from which the Seleucid Empire could not recover. The result was another power vacuum in the east, which provided the Parni, under the Parthian kings Phriapatius (c. 191–176 BC) and Phraates I (c. 176–171 BC), the opportunity to consolidate power in and thus conquer the satrapy of Parthia and also to conquer the western satrapy of Hyrcania. Through their conquests the Parni came into direct contact with the western-oriented and Greek-speaking Seleucid upper class, with whom they had to deal. The ability of the nomadic Parni to embrace these challenges and yet remain in power may have been a key factor in their success.

The process of adopting the local, west Iranian language is likely to have taken place during the first decades of the Parni's takeover (see 4.4.1).[18] This is supported by the fact that the new rulers were now no longer called Parni, but Parthians. It is unclear which city in the early days could have served as the Parthians' capital, but Hecatompylos seems to be a likely candidate.[19] Another important city of the young state was probably Asaak in Astauene, that is, the north-eastern part

of today's Iran, c. 150 km north-west of Mashhad), for there, as Isidore of Charax tells us, the first ruler of the Parthians, Arsaces I, was crowned (see 3.1.1). The royal Parthian residence in Nisa (see 7.2.7) probably attained importance only under Mithradates I.

Archaeological finds of this period are largely missing; the most helpful are coin finds. Using the inscriptions on the coins one can try to grasp the early ruler structure more closely. Thus, the first ruler, Arsaces I, refers to himself as 'Arsaces autocrat', while only the name 'Arsaces' is written on coins of Arsaces II. This underlines the idea that the Parthians were still a dependency of the Seleucids. However, coins are not available of all the Parthian rulers in the first phase. Thus, we have no coins of Phriapatius and Phraates I, if we follow Sellwood's attribution system (Assar gives different dates for their reigns; see details on each king and 8.1.1). We don't even know when these coins were minted as they bear no date. The succeeding kings (phase 2) use the term 'great king', which goes on to be replaced by the term 'king of kings'. In any case, such stability was achieved in the early phase of the Parthian Empire and from 165 BC onwards, extensive conquests under Mithradates I were possible in Mesopotamia and the eastern part of the empire.

3.1.1 Arsaces I (c. 247–211 BC)

Arsaces I (c. 247–211 BC)[20] was the first ruler of the newly created vassal state (Fig. 8.4). Isidore of Charax, who lived at the end of the 1st century BC, states that Arsaces I was crowned in Asaak in 247 BC,[21] and that the yearly count of the Parthian calendar started from that date. However, one has to be aware that this foundational date may have been set in later times, probably by the Parthian king Mithradates I.[22] It is still unknown where the city of Asaak was located, but it is assumed that it was in the Astauene area near the Caspian Sea. An 'immortal fire', which can be linked to the Zoroastrian belief of the Parthians, and which possibly had significance for the coronation of the king, is said to have burned in this city (see 11.1).[23]

It is likely that, at that time, only parts of the satrapy of Parthia were under the control of the Parthians. The entire territory of the Seleucid satrapy of Parthia, which was under the rule of Andragoras, was probably conquered by the Parthians by 239/238 BC.[24] Strengthened by his victory over Parthia, Arsaces I and his followers then conquered the satrapy of Hyrcania. According to Justin, Arsaces died in old age.[25]

The Parni (or Aparni), who had now become the rulers of Parthia and Hyrcania and established their power in the ensuing decades, adopted the Parthian language spoken there.[26] The Parthians' name has its roots in the name of the province Parthia, while their other name, the Arsacids, refers to their first leader, Arsaces. The first three rulers, Arsaces I, Arsaces II and Phriapatius, did not yet call themselves kings. On his coins, Arsaces I names himself 'ΑΥΤΟΚΡΑΤΟΡΟΣ', an autocrat who had made himself a ruler.

3.1.2 Arsaces II (c. 211–191 BC)

Arsaces II (c. 211–191 BC), son of Arsaces I, followed his father, taking power in about 211 BC. According to Assar, Arsaces II reigned from 211 BC to 185 BC and bore the name Artabanus I. In the following years, the Parthians probably tried to achieve greater independence from the Seleucids but did not succeed. This shows the battle of the Seleucid king Antiochus III (The Great) against the Parthians in c. 210 BC with the territory formerly conquered by the Parthians now falling again under Seleucid rule. According to Justin, a contract between both was negotiated, but the agreement would not last long.[27] Owing to the defeat of Antiochus III in a war with Rome, a power vacuum again emerged, on which the Parthians capitalised in order to regain the newly lost areas. Presumably, the Parthians' dominion was even extended.

3.1.3 Phriapatius (c. 191–176 BC)

Phriapatius was a grandson of Tiridates, the brother of Arsaces I.[28] Our knowledge of his reign (c. 191–176 BC according to Sellwood, 185–170 BC according to Assar) is limited. Justin simply states that Phriapatius reigned for 15 years and that Phraates I succeeded him on the throne.[29] Normally, Parthian kings transferred the crown to their sons, but in this case, the family lineage was changed, possibly due to Arsaces II having no heirs, or because they had died. According to Sellwood, no coins are extant from this ruler or from Phraates I. In contrast, Assar assigns some coins (S 8.1, S 8.2) to this ruler.[30] Under Phriapatius and his successor Phraates I the Parthians succeeded in stabilising their power in the satrapy of Parthia and in conquering the western satrapy of Hyrcania.

3.1.3.1 Arsaces IV (c. 170–168 BC)

Assar states that from c. 170 BC to 168 BC a king, named Arsaces IV by him, reigned Parthia. Assar attributes the coins S 9.1–2 to this king.[31]

3.1.4 Phraates I (c. 168–164 BC)

Phraates I, whose reign Assar dates to c. 168–164 BC (Arsaces V), and Sellwood to c. 176–171 BC, was the eldest son of Phriapatius, and came to the throne after the death of his father.[32] Isidore of Charax reports that Phraates I waged a war against the Mardi, who lived in the Elburz Mountains south of the Caspian Sea. Some of the Mardians, being captured in the war, were moved to Charax in the Rhagiane after the end of the war.[33] Shortly after these conquests, Phraates I died, and his brother Mithradates I became his successor. This is remarkable, because the order of succession among the Arsacids was usually regulated in such a way that the eldest son would become king. Obviously, Phraates I considered his brother more capable than his sons. According to Sellwood, no coins of Phraates I are extant, an

absence he explains by the fact that during the reign of Phraates I, the Parthians constituted a Seleucid dependency and had lost their right to mint coins. Assar, however, attributes some coins to Phriapatius as well as to Phraates I.[34]

3.2 Phase 2: Expansion of the Parthian Empire: from Mithradates I to Darius of Media Atropatene (c. 165–70 BC)

It was the Parthian king Mithradates I (c. 165/164–132 BC,[35] according to Sellwood c. 171–138 BC), a brother of Phraates I, who by his victories in the east and west laid the foundation for the final stabilisation of the Parthian Empire. His first conquests were made in the eastern part of the Parthian Empire, extending the Parthian realm to Bactria, in the area of today's Afghanistan. The archaeological finds in Mithradates' royal residence of Mithradatkart in Nisa (see 7.2.1) give us a better, but still far from adequate, insight into the Parthian Empire and its development during this phase.

How was the Parthian Empire able to expand so successfully in the following years? A look at Syria reveals that the Seleucid king Demetrius I had to struggle with uprisings in his own country throughout his entire reign (162–150 BC). The Seleucid Empire once more experienced a dwindling of its power, when Alexander Balas, a usurper, succeeded in gaining the throne in Syria in 150 BC after defeating Demetrius I in battle. It took only five years for Demetrius I's son, Demetrius II, to defeat Alexander Balas and to retrieve the throne. These struggles in Syria, but also weakness in Demetrius II's leadership led to a power transition, which enabled the expansion of the Parthian Empire.[36] In addition to these important geostrategic reasons, the Parthians' military superiority (4.3) over the Seleucids explains the successful conquests of Seleucid areas. It should be emphasised that, unlike the Seleucids, the Parthians had an equestrian army, which was supplemented by cataphracts, who were able to break through the rather rigid battle lines right at the beginning of the clash of armies (see 4.3). It was this military power that brought the disastrous defeat to the Romans in 53 BC at Carrhae.

We are well informed about Mithradates I's wars in Mesopotamia by Roman writers. Furthermore, from the period after 141 BC, when Babylonia was conquered by the Parthians, we have supplementary information through Babylonian cuneiform writing. The triumphal march of the Parthians to the west took place in a short time. In approximately 158 to 155 BC, Mithradates I conquered Media.[37] At the latest in 145 BC Ecbatana, the capital of Media, was under Parthian control, as revealed by coins of the Parthian king, which were minted there. The conquest of the Median capital gave Mithradates I the opportunity to invade Mesopotamia with his troops and by the middle of 141 BC, large parts of Mesopotamia were conquered by the Parthians, and the important cities of Babylon and Seleucia came under Parthian power. Challenges against the not yet stable Parthian state were particularly great around 140 BC, as the Saka invaded in the east – an attack that was successfully repelled by the Parthians. A major problem for Mithradates I was the submission of Elymais.

Mithradates I's successor, Phraates II (c. 132–127 BC) probably achieved a final victory over Elymais, as made evident by the fact that in the period between 127 and 82 BC no coins were minted by the local rulers of Elymais (see 5.6). After the death of Mithradates I, wars between the Seleucids and the Parthians continued. The victory of the Parthian king Phraates II against the Seleucid ruler Antiochus VII Euergetes in 129 BC would weaken the Seleucid Empire so much that this can be regarded as the beginning of its decline. Mithradates I did not yet describe himself as 'king of kings' on his coins (he is only referred to as such in a Babylonian cuneiform inscription). Only Mithradates II bears this title on his coins. Even if the inscriptions are in Greek, it can be assumed that this title was used in the style of the Achaemenid kings' title.[38]

A brief phase followed in which two Parthian kings reigned only for a short time before Mithradates II (c. 121–91 BC) came to the throne. Mithradates II must be regarded as one of the most important and powerful kings of Parthia. He faced difficult challenges as the Parthian Empire had to be secured in the east. However, it is unclear to what extent he could pacify the eastern territories.[39] In this phase, confrontations with the Roman Empire began. One of the reasons for this was that Mithradates II had extended Parthian influence to Armenia, presumably in around 120 BC.[40] However, data for this are unsatisfactory.

Another war was prosecuted by Mithradates II against Armenia in about 97 BC, in which Tigranes II, son of Tigranes I, was captured by the Parthians and lived as a hostage with the Parthians for several years. Around 94 BC Mithradates II crowned Tigranes II (also known as Tigranes the Great) as king of Armenia, in return receiving 70 valleys in Armenia.[41] Rome could not accept this invasion of Parthia into Rome's sphere of influence. From here on there would always be wars between Rome and Parthia; this was all about gaining dominance in Armenia. Wars between the two empires would continue until the end of the 2nd century AD.

At this juncture the Roman Empire had problems with the king of Pontus to solve. This king, Mithradates VI the Great, who bore the epithet Eupator (meaning 'of a noble father' (c. 121/120–63 BC), had invaded the neighbouring Cappadocia and expelled Ariobazanes, who had been made king by the Romans (Mithridatic Wars). The later Roman dictator L. Cornelius Sulla, who was at that time praetor in the Roman province, expelled Mithridates from Cappadocia using military pressure. Finally, negotiations took place between Sulla and Ariobazanes, to which the Parthians were also invited. How important it was for the Parthian king to have good relations with Rome can be see by the fact that in 96 BC Mithradates II, for the first time in the history of both empires, sent his Parthian ambassador, Orobazos, to the Roman general Sulla to commence negotiations. The negotiations took place in the area of the Upper Euphrates, as we are informed by Plutarch.[42]

Titus Livius, a Roman historian (also named Livy, 64 or 59 BC–12 or 17 AD), uses for the description of the outcome of these negotiations the term *amicitia*, a term which on the one hand expresses 'friendship' but simultaneously suggests that the Parthians are subordinate to the Roman Empire.[43] This term was usually used by Romans to characterise the dependency of its client states. Today it is assumed

that the Parthians in no way made themselves dependent on Rome in these nego-
tiations and one can rather assume that such a description was pure propaganda.
This also applies to a further report that the Parthian king sentenced Orobazos to
death for having accepted to be seated in a lower chair than Sulla.[44] Presumably,
the Romans were not yet aware of the greatness and power of the Parthian Empire
at this time; perhaps they were more concerned with the growing power of
Mithridates VI, the king of Pontus.[45] As a result of this meeting the Euphrates was
agreed upon as the border between the two empires, a result, which largely survived
until the end of the 2nd century AD. Mithradates II had created a vast empire over
which he now reigned as a supreme king, bearing the title 'Basileos Basileon' king
of kings. Individual vassal states with their own local kings were now subordinate
to him. Thanks to his military success, there was also an economic upswing, rec-
ognisable from the economic relations that developed between Parthia and under
the Chinese emperor Wu of Han. We are not well informed about the following
roughly twenty years; the period between c. 90 and 70 BC is often referred to as a
'dark age' (see 3.2.7–3.3.3).

3.2.1 Mithradates I (c. 165/164–132 BC)

With his conquests in both the west and the east, Mithradates I (c. 165/4–132
BC, according to Assar; c. 171–132 BC, according to Sellwood[46]), a brother of
Phraates I, created the basis for the Parthian Empire. In the east the Parthian king
conquered parts of the Graeco-Bactrian Empire. The city of Herat, located in
today's Afghanistan, was conquered by Mithradates I and was used as an essen-
tial base for the strategic expansion of his empire to the east. By 155 BC, he had
extended his power to Margiana with the city of Merv (today's east Turkmenistan,
near Mary, Fig. 7.13), and Aria, a region west to the Arius river. The remarkable
remains of a circular ring of fortifications around the town built by the Parthians
are still evident. After the Battle of Carrhae, in which the Parthians defeated the
Roman army in 53 BC, ten thousand Roman soldiers, who had been captured,
were taken to Merv, where they had to carry out further work on the ring. The
expansion of the empire under Mithradates I extended to the region of today's
Mazar-i Sharif – the ancient territory of Khorasan, today in northern Afghanistan.
The Parthians also captured Bactra, the capital of Bactria (today: Balkh), which is
about 13 miles from Mazar-i Sharif.

As early as 158 BC and no later than 155 BC onwards, Mithradates I began to
invade Media.[47] In 148/147 BC[48] he conquered Ecbatana, once the capital of the
Medes, the Achaemenids and the Seleucids, and made it the capital of the mean-
while Parthian province of Media. At the latest in c. 145 BC, the first Parthian
coins were minted in Ecbatana. From this time onwards, Ecbatana developed into
one of the most important cities of the Parthian Empire. From the beginning of
the 1st century AD, most Parthian coins were minted here. With the conquest of
Babylon and of Seleucia on the Tigris in July 141 BC, parts of Mesopotamia came
under Mithradates I's rule.[49] Characene and Elymais put up considerable resistance

during his advance to the Persian Gulf, but he and his succesor finally succeeded in subduing these territories. Mithradates' first tetradrachms (S 23) were minted in Seleucia, the Seleucid coinage serving as a model for him. On his coins he names himself 'ΒΑΣΙΛΕΩΣ ΑΡΣΑΚΟΥ ΜΕΓΑΛΟΥ ΦΙΛΕΛΛΗΝΟΣ' ([Coin of] the great king, Arsaces, friend of the Greek).

The rising Parthian Empire had to fight wars on two fronts at this time, because in the east conflicts arose with the Graeco-Bactrian king Heliocles, whom Mithradates I succeeded in defeating. Around the year 140 BC, Mithradates I then led a battle against the Saka, who invaded in the north, and successfully expelled them.[50] After a brief rest in his royal residence in Hyrcania, Mithradates I had to return to the west, where his generals fought against the Seleucids, and in 138 BC succeeded in capturing the young Seleucid, Demetrius II (born 160 BC). The king's march with his armies had been an immense achievement, considering that within a brief time he had to cover more than 1500 miles between east and west. Demetrius II was imprisoned in the Parthian fortress, but also enjoyed certain liberties, as evidenced by his marriage to Rhodogune, the daughter of Mithradates I. Such a marriage, however, certainly represesented a political decision on the part of the Parthian king. Mithradates I then suffered a stroke and was unable to reign and died in 132 BC at an advanced age, as Justin (41.6.9) states.

The conquests of Mithradates I had laid the foundations for the creation of the Parthian Empire, which at the end of the 2nd century BC also included all of Mesopotamia. On his coins he is not yet known as 'Basileos Basileon' (king of kings), but a cuneiform text shows that he already bore this title.[51] He founded Ctesiphon as a new capital, situated on the other side of the Tigris, opposite Seleucia (about 30 km from today's Baghdad).

3.2.2 Phraates II (c. 132–27 BC)

Phraates II, the son of Mithradates I, ruled from c. 132 to 127 BC, according to Assar, and from c. 138 to 127 BC, according to Sellwood.[52] On his coins he names himself 'The great king Arsaces'. Some of his coins also bear the epithet 'ΦΙΛΟ ΠΑΤΟΡΟΣ' (Who loves his father) and 'ΘΕΟΠΑΤΟΡΟΣ' (Of divine descent/ whose father is a god). His mother Ri-'nu initially took over the government business for the still young prince.[53] In c. 130 BC, Phraates II was compelled to fight the invading Saka in the east, while in the same year a new threat arose in the west. The Seleucid ruler Antiochus VII Euergetes (also named Sidetes, 139/8–129 BC), brother of Demetrius II, had assembled a huge army and tried to recapture the territories conquered by Mithradates I. It was the last great attempt by the Seleucids to regain their power in the east and put a halt to Parthia's expansion. It would not succeed.

According to data provided by Justin, his army consisted of 80,000 warriors and 300,000 men, figures which experts now regard as an exaggeration.[54] The Seleucid king succeeded in recapturing Babylon and Media in 130 BC and quartered his troops in Ecbatana in the following winter. Phraates II sought peace negotiations,

but the required tribute payments were so high that he did not respond. Phraates therefore decided to send Demetrius II back to Syria with a Parthian army, hoping that a fratricidal war would ensue. In the meantime, however, there had been riots in Media, triggered by the burden of billeting and supplying the Seleucid troops. When Phraates II heard of this, he allied himself with the residents of the Seleucid garrison towns, and – with their assistance – in the spring of 129 BC he was able to defeat Antiochus VII and his troops.[55] This example once again shows that the Parthians were able to act tactically and effectively in their favour. The Seleucid king fell in this battle and his son Seleucus was captured.

This victory by the Parthians prompted the decline of the Seleucid Empire, and Mesopotamia finally fell under Parthian domination, while the Seleucids had to confine themselves to the territories of northern Syria and east Cilicia. During these battles in the west, between 130 and 128 BC, nomadic Scythian peoples, the Saka and the Tocharians, once again invaded Bactria and the north-eastern part of the Parthian Empire. Phraates II was therefore again forced to fight back in the east. The Greeks, captured in the war against Antiochus VII, were obliged to take part. Probably in the year 128/127 BC, the Parthian army was defeated, presumably because the Greek soldiers defected to the enemy.[56] Phraates II was killed in this conflict.

3.2.3 Inter-regnal Issue (c. 127 BC)

The situation regarding data on the period between the death of Phraates II and the beginning of the rule of Artabanus I (around 127 BC) is not quite clear. Sellwood speaks of an 'Inter-regnal Issue', but he is unsure to whom the S 18 types should be assigned. The image of the depicted king resembles both Mithradates and Phraates I.[57] Sellwood postulates that after the death of Phraates II, the workers in the mint had probably used a fictional image of a king; this could therefore be a posthumous coin issue. Assar reaches other conclusions, but these are controversial due to the lack of information.[58] Without going into more detail, this example illustrates the difficulties of assigning coins to a king and of creating a detailed genealogy.

3.2.4 Artabanus I (c. 127–123 BC)–Arsaces X (c. 122–121 BC)

Historically, little is known about Artabanus I. Different attributions are made to his genealogy; Assar calls him Artabanus III (Arsaces IX), he is a brother of Mithradates II.[59] He had to fight against invading nomads in the north, but also had to deal with uprisings in Elymais as well as in Characene (= Mesene). He managed to quell these by c. 124 BC. Artabanus I is said to have been killed by a poisoned arrow in September/October 123 BC during his battle against the Tocharians, nomads from the Eurasian area, a Scythian people.[60]

Owing to tetradrachms (S 23, attributed to Mithradates I by Sellwood) showing the bust of a young prince, Assar postulates that the young prince is probably a son of Artabanus III (Arsaces IX) and ruled from 122 to 121 BC.[61]

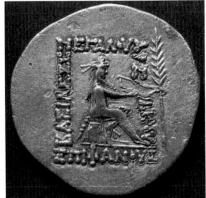

FIG. 3.1 A + B Mithradates II, AR tetradrachm, S 24.3. Obverse: long bearded bust with a diadem, pending ties, the hair ending in curls. Torque ending in a pellet, dotted border of his Parthian tunic, circular border of pellets. Reverse: beardless archer seated right on omphalos, wearing a bashlyk, holding a symmetrical bow, palm branch on right. Inscription: ΒΑΣΙΛΕΩΣ ΜΕΓΑΛΟΥ ΑΡΣΑΚΟΥ ΕΠΙΦΑΝΟΥΣ, [Coin of] the great king, Arsaces, the manifest. Original size: 31 mm, weight: 14.99 g.

3.2.5 Mithradates II (c. 121–91 BC)

Mithradates II can be regarded as one of the great rulers of the Parthian Empire. He continued his predecessors' policy of conquest by subduing other areas of Mesopotamia as well as Characene.[62] The dates of Mithradates' reign and his family line, as given by Sellwood in 1980, have been corrected by recent investigations. According to Sellwood, Mithradates II reigned c. 123–88 BC and was a son of Artabanus I.[63] Contrary to this, Assar and Dąbrowa state that Mithradates II was a son of Phriapatius and a brother of Mithradates I, and who reigned from approximately April 121 until September 91 BC.[64] Mithradates II was probably married to several women, the queens Siake, Azate and Aryazate, something permitted under Zoroastrian law.[65] Siake and Azate were his half-sisters; at the royal court a marriage among relatives or even siblings was apparently possible.

In the east, Mithradates II defeated the Saka (a Scythian-related Iranian people), with whom Artabanus I had already been struggling, and made them tributary. In the west, in about 97 BC, Mithradates II invaded Armenia and succeeded in capturing Tigranes II, the son of Tigranes I. In the following years, Tigranes II lived as a hostage of the Parthians. Tactically clever, in about 95 BC Mithradates II crowned Tigranes II (also known as Tigranes the Great) as king of Armenia, thus securing his influence in Armenia and receiving 70 valleys in the territory. The Parthian king of kings, as Mithradates II is titled on his coins, also conquered the territories of Adiabene, Gordyene and Osrhoene, thus making the Euphrates the western boundary of the Parthian Empire. Armenia held special meaning for

Mithradates II insofar as geostrategic rule over Armenia meant the security of northern Mesopotamia, a region now ruled by the Parthians.

Through these conquests, Armenia, Adiabene, Gordyene and Osrhoene became an area permanently disputed with the Romans, who tried to extend their supremacy to these regions. A first official meeting between Rome and Parthia took place in 96 BC, which was probably a precautionary demarcation of points of interest.[66] As a result of these negotiations between Sulla and the Parthian ambassador, Orobazos, the Euphrates was defined as a border between the two empires. Rome certainly underestimated the strength of the Parthian Empire at this time,[67] an error of judgement that probably still existed in the year 53 BC, when the Romans under Crassus waged their campaign against the Parthians, and which resulted in them suffering a heavy defeat.

To the east of the Parthian Empire, after their victory over the Huns, the Chinese had extended their sphere of influence into the Ferghana Valley in Central Asia (today's eastern Uzbekistan, southern Kyrgyzstan and northern Tajikistan), thus becoming direct neighbours of the Parthian Empire. A peaceful relationship seems to have developed between the two realms at that time, as indicated by the delegation to build up trade relations, sent by the Chinese emperor Wu of Han to the Parthians in about 115 BC.[68] After Mithradates' victories in the east and in the west, intensive trade took place, using existing and further developed trade routes along the Silk Road. With his conquests, Mithradates II had created a vast empire. His first coin issues still bear the title 'ΒΑΣΙΛΕΩΣ ΜΕΓΑΛΟΥ' (the great king), though later he uses the title 'ΒΑΣΙΛΕΩΣ ΒΑΣΙΛΕΩΝ ΜΕΓΑΛΟΥ' (Basileos Basileon Megalou = great king of kings) on his coins.[69] He had created a kingdom, over which he now reigned as a supreme king, the individual vassal states with their own local kings now being subordinate to him.

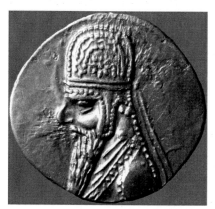 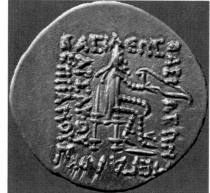

FIG. 3.2 A + B Mithradates II, drachm, S 28.5. Obverse: the king presents himself with a tiara, the emblem of eastern kings. Reverse: sitting archer. Inscription: ΒΑΣΙΛΕΩΣ ΒΑΣΙΛΕΩΝ ΜΕΓΑΛΟΥ ΑΡΣΑΚΟΥ ΕΠΙΦΑΝΟΥΣ. [Coin of] the great king of kings, Arsaces, the manifest. Original size: 20 mm, weight: 4.13 g.

3.2.6 Gotarzes I (c. 91–87 BC)

Dating of the Parthian ruler Gotarzes (c. 91–87 BC according to Assar, c. 95–90 BC according to Sellwood) is difficult. This is revealed, for example, by the fact that Sellwood attributed the S 33 coins to Sinatruces in his first edition (1971), then to Gotarzes I in his second edition. In the meantime, the S 33 coins have been reattributed to Sinatruces.[70] Sellwood assumed that Gotarzes I was not a direct descendant of Arsaces and ruled c. 95–90 BC. A cuneiform text now shows, according to Assar, that Gotarzes I was the son of Mithradates II and that he reigned after the death of his father, from c. August/September 91 to July/August 87 BC.[71] According to Assar's research, Gotarzes I became a direct successor in Babylon following the death of his father Mithradates II, while at the same time Sinatruces dominated the central areas of Parthia and Susa. A cuneiform document also contains the name of Gotarzes' wife: Ashiabatar, the queen.[72] There were frequent military conflicts between the two rulers.

The 'dark age' of Parthia (c. 90–57 BC)

The period between c. 90 BC and the reign of Orodes II (57 BC) is often referred to as the dark age of Parthia, as we have only rare information for this period.

3.2.7 Orodes I (c. 90–80 BC)

According to Sellwood, king Orodes I reigned around 90–80 BC. Assar, based on his research, postulates that Orodes I is a son of Gotarzes I,[73] while Sellwood speaks of a prince named 'Orodes' who expelled Gotarzes. Sellwood states: 'Since Orodes wears exactly the same tiara as Mithradates II, the latter may be the object of Orodes' affection.'[74] Sellwood refers here to the inscriptions on his coins, reading: 'ΒΑΣΙΛΕΩΣ ΜΕΓΑΛΟΥ ΑΡΣΑΚΟΥ ΥΤΟΚΡΑΤΟΡΟΣ ΦΙΛΟΠΑ ΤΟΡΟΣ ΕΠΙΦΑΝΟΥΣ ΦΙΛΕΛΛΗΝΟΣ' ([Coin of] the great king, Arsaces, the autocrat, who loves his father, the manifest, the friend of the Greek).

3.2.8 Unknown King I (c. 80 BC) and Unknown King II (c. 80–70 BC)

Our knowledge of the Unknown King I (c. 80 BC) is as limited as it is for the Unknown King II (c. 80–70 BC). We only know them through coins.

3.2.9 Sinatruces (c. 93/92–c. 69/68 BC)

Sellwood himself admits to being unsure about the attribution of these coins, designating Sinatruces as a probably younger brother of Mithradates I. According to Sellwood, he reigned c. 75 BC. According to Assar,[75] supported by Dąbrowa,[76] Sinatruces reigned intermittently from c. 93/92 BC to 69/68 BC and was the

half-brother of Phraates II and the son of Mithradates I. Because of turmoil, or due to the fact that Phraates II had succeeded Mithradates I, Sinatruces lived for a long time with the Saka. In 77/76 BC, he succeeded to the throne at the age of about 80 with the help of the Saka people, and reigned for about seven years.[77] He may have ruled, however, more in the east of the Parthian Empire, as the Babylonian cuneiform inscriptions do not mention anything about him.

3.2.10 Darius (?) of Media Atropatene (c. 70 BC)

The data is also problematic for this ruler. Sellwood therefore sets a question mark behind the royal name (S 35 – S 37). Possibly, Darius of Media Atropatene was only a local governor.[78]

3.3 Phase 3: Parthia as a great power: from Phraates III to Vonones II (c. 70 BC–c. 51 AD)

In its third phase, Parthia presents itself as a leading and dominant superpower, between Rome and China, though it could not prevent wars with Rome. Rome's expansion to the east sooner or later inevitably led to conflicts with Parthia. The situation escalated when the Roman Consul Lucius Licinius Lucullus in 69 BC fought against the army of the kingdom of Armenia, led by King Tigranes the Great. In the Battle of Tigranocerta, Tigranes was defeated and the Armenian capital city of Tigranocerta captured. Armenia, which until then had been a buffer state between Rome and Parthia, thus became a ball game between the two major powers. Until the end of the Parthian Empire, the question of dominance in this area would again and again lead to wars between the two empires.

After Lucullus was replaced by Pompey in 66 BC, there was initially peace between Rome and Parthia. Pompey had negotiated territorial concessions to the Parthians, thus encouraging the Parthian king Phraates III to invade Gordyene. However, Pompey did not keep his promises and attacked the Parthians in return. Ultimately, in 64 BC, Pompey set up an arbitration commission that temporarily brought peace. The winner of this political game (see 3.3.1) was Pompey, who made Armenia a Roman vassal state. Tigranes kept Gordyene while Phraates III received Adiabene.

Proof of the tension between the two powers is provided by the series of diplomatic contacts that took place between them. For instance, peace agreements confirming the Euphrates as a border between the two empires did occur several times between Rome and Parthia. This was the case with Sulla in 96 BC (see 3.2, introduction), with Lucullus in 69/68 BC and with Pompey in 64 BC. All these diplomatic efforts did not prevent the first major war between Rome and the Parthians in 53 BC, a war that the Parthians, at least, had not wanted.

In the spring of 53 BC, the Roman governor of Syria, Marcus Licinius Crassus (c. 114–53 BC), had begun preparations for war against the Parthians. Although the Parthian king of kings Orodes II had tried to prevent the Roman attack by sending

a diplomatic delegation to Crassus (see 3.3.3), he could not be stopped. The reason for Crassus' campaign against the Parthians was perceived as his unscrupulous quest for power and to gain the same reputation and influence as Caesar and Pompey.[79]

This first major clash with the Parthians brought the Roman Empire the greatest defeat in history – a defeat that the Romans would never overcome. For the first time, Rome had to recognise that the Parthian Empire had become an equivalent great power. The Roman army had also lost several legionary eagles in battle, which was an enormous humiliation for Rome. Emperor Augustus negotiated their return 33 years later. The psychological significance of the return was so important for Augustus that he had the handover scene depicted on his breastplate (see 3.3.5, Fig. 3.4). However, one has to wonder whether the image that Roman historians portray of Crassus withstands close scrutiny. Overtoom comes to the conclusion that while Crassus played a major role in the defeat, it was the strategic and tactical superiority of the Parthians that led to the outcome.[80] The Romans needed a guilty party, and that was Crassus.

Parthia's victory over the Romans also brought about a power shift among the smaller states between the two empires. It is therefore not surprising that the Parthian king Orodes II married Laodice, the daughter of Antiochos I Theos (69–36 BC), the king of Commagene. One can assume that it was at least a political marriage, since Commagene secured a western base for the Parthians. The kingdom of Osrhoene, which was previously under Roman power, came again under Parthian sovereignty, thus becoming one of the Parthians' most important western bases.

Analysis of the wars waged between the two empires shows that most of the aggression usually came from Rome and the Parthians only responded to it.[81] Vologases IV (c. 147–191 AD) was probably the only king who formally declared war on the Romans. The Parthians themselves apparently never made any special effort to undertake an open attack on the Roman Empire or even to conquer it. However, there was always a struggle for supremacy in Armenia. Despite all the battles between the two powers, the Euphrates border remained a dividing line until the end of the 2nd century AD.

It should be assumed that in this phase the Parthians were always set against Rome. It is therefore even more astonishing that during the Roman civil wars, Parthian troops fought for the Romans. The reason for this is probably the fact that the Parthians did not have a fixed army, but only raised troops when necessary. In times of peace, when soldiers were not needed, numbers of them were hired as mercenaries – ultimately they didn't care whether they were fighting for Rome or for the Parthians.

Thus, in the conflicts between Cassius Longinus and Brutus against the 2nd triumvirate, formed by Octavian, later Emperor Augustus, Marcus Aemilius Lepidus and Mark Antony, Cassius sought the support of Parthian troops, which he requested from the Parthian king Orodes II.[82] In the decisive battle of Philippi on 3 October 42 BC, Cassius' army, many Parthian soldiers among it, was defeated. To evade captivity, Cassius and Brutus were killed voluntarily by their slaves.

In 40 BC the Parthian king Pacorus I allied himself with the Roman general Quintus Labienus, crossed the Euphrates and invaded Syria and attacked Apamea. Although the attack initially failed, Pacorus I and Labienus finally managed to capture Apamea because more Roman troops had joined Labienus. The alliance between Pacorus and Labienus did not last long. Quarrels between the two soon broke out. In 39 BC, Mark Antony sent Ventidius Bassus, who was governor of Syria, to lead a counterattack against Labienus and the Parthians troops.[83] Bassus succeeded in this war. Labienus was able to flee but was soon captured and killed. A year later Pacorus' troops suffered a defeat, and Pacorus I was killed in the conflict.

With Mark Antony's May 36 BC campaign against the Parthians, another war broke out between the two great empires (more details in 3.3.5). However, the Parthian king of kings, Phraates IV, successfully fended off this attack. Tensions between Rome and Parthia were only resolved when Emperor Augustus' diplomatic efforts in 23 BC succeeded in bringing about an agreement between the two empires. However, it would take another three years before the Parthians returned the standards and the prisoners.[84] In this case, too, however, the Roman historians described Parthia as dependent and submissive, thus contributing to a distorted picture of the Parthians

The Roman attitude is also clearly illustrated in one of Augustus' breastplates. Here a Parthian (the Parthian king?) is shown in a submissive posture as he hands over the standards (see Fig. 3.4). These agreements would bring peace between the two empires for some decades. As part of the negotiations with Augustus, it was decided that a son of the Parthian king, who had lived in Rome in a form of exile, would be released together with Parthian prisoners. In the entourage was a Roman slave named Musa, who eventually became the wife of Phraates IV. When their son Phraataces was grown up, they both had Phraates IV killed. Finally, mother and son married. This made Musa the only Parthian queen to gain central power, but only for a few years. More about this unbelievable story is to be found in 3.3.4.–3.3.5.

The skill of Parthian king of kings Artabanus II (c. 10–38 AD) was able to bring stability to the Parthian Empire over a nearly 30-year period. The local dynasties in Media Atropatene, Persis, Elymais and Characene were eliminated and members of the Arsacid line were installed on the throne instead.[85] Such a political decision enabled the Parthian king of kings to impose royal rule over client kingdoms and provinces and to broaden his influence on the vassal states, which now were more dependent on him.

In the 40s AD, when there were struggles between the Parthian kings Vardanes I and Gotarzes II, the Roman Emperor Tiberius (14 AD to 37 AD) took the opportunity to strengthen his influence in Armenia by putting Mithradates on the Armenian throne. Mithradates was a Parthian prince, a grandson of Phraates IV, who grew up in Rome. Although he was a Parthian prince, the political goal was of course to strengthen Rome's influence in Armenia. L. Vitellius, governor of Syria, supported Tiberius militarily. From this time, at the latest, Rome tried to expand its spheres of interest beyond the Euphrates to the east.

TABLE 3.2 Unnatural and natural deaths of Parthian kings between 70 BC and 51 AD.

Phraates III	c. 70–57 BC	Killed by his sons
Mithradates III	c. 57–54 BC	Conflict/revolt with his brother Orodes II, killed in fight
Orodes II	c. 57–38 BC	Killed by his son Phrates IV
Pacorus I	c. 39 BC	Died during an attack on a Roman camp in Syria
Phraates IV	c. 38–2 BC	Killed by his wife Musa
Queen Musa and Phraataces	c. 2 BC–4 AD	Phraataces fled to Syria, presumably killed by Parthian nobles
Tiridates I	c. 29–26 BC	Fled to the Romans, no information on his death
Orodes III	c. 6 AD	Probably murdered by Parthian nobles
Vonones I	c. 8–12 AD	Killed in 19 AD in an escape attempt in Cilicia
Artabanus II	c. 10–38 AD	Natural death
Tiridates II	c. 35–36 AD	Tiridates II disappeared, after having reigned a short period
Vardanes I	c. 40–45 AD	Vardanes I died during a hunt, most likely following an assassination attempt by parts of the Parthian nobility
Gotarzes II	c. 40–51 AD	Natural death, died due to an illness as Tacitus states, but according to Josephus by assassination*
Vonones II	c. 51 AD	Natural death

* Tacitus, *Ann.* 2.14; Josephus, *Jüdische Altertümer* 12.3.4.

Domestically, however, considerable power struggles had emerged in this period in Parthia. Many of the Parthian kings were murdered by their own relatives or political groups, as Table 3.2 shows. More information can be found in the history of the individual kings. It remains to be noted, however, that despite this accumulation of unnatural deaths among Parthian kings, almost always sons or brothers from the Arsacid lineage were able to establish themselves as successors.[86]

3.3.1 Phraates III (c. 70–57 BC)

According to Sellwood, Phraates III reigned from c. 70 to 57 BC;[87] he was a son of Sinatruces and succeeded his father on the throne. Babylonian cuneiform writings reveal that he wore the title 'king of kings'. Phraates III was involved in the turmoil caused by the wars in Asia Minor during the war between the kingdom of Pontus and Rome. The Armenian king Tigranes II (The Great, 140–55 BC), who allied with the Pontian king Mithridates, tried to persuade the Parthians to fight Rome, but the Parthians remained neutral. The conflict that had broken out between Tigranes the Great and his son Tigranes the Younger made matters worse during this period. Tigranes the Younger had risen against his father and, when the uprising failed, fled to the Parthians and even married a daughter of Phraates III. Thus, the Parthians had become part of a political game. An attempt by Phraates III to conquer Gordyene and Armenia by sending Tigranes the Younger with Parthian troops failed.

Pompey, the Roman military and political leader, who in turn intended to invade Armenia, succeeded in ending this turmoil and made Armenia a vassal state. Gordyene was occupied by Tigranes the Younger. Phraates III tried to recapture Gordyene, but then lost this area to Tigranes, nonetheless retaining Adiabene. In 64 BC Phraates III waged another war against Armenia. He was able to expel Tigranes II, who fled to Pompey. An arbitration commission headed by Pompey and which was accepted by Phraates III finally brought the desired peace. Owing to the military and diplomatic successes, Rome had been able to significantly strengthen its influence in the east: Syria, Commagene, Osrhoene and Sophene became Roman vassal states and formed a buffer zone against the Parthians. With these successes, Pompey had also created economic advantage, as trade could be expanded to the east.

Thanks to a cuneiform inscription, we know that Phraates III's mother was called 'Mistress/Queen' Ištar, while his wife was called 'Wife/Mistress/Queen' Piriwuštanā. On the S 37 and S 38 tetradrachms the inscription 'ΦΙΛΟΠΑΤΟ ΡΟΣ' ('who loves his father') is given by Phraates III to show his love for and to honour his recently deceased father.[88] In the year 58/57 BC, Phraates III was murdered by his sons Orodes II and Mithradates III.

3.3.2 Mithradates III (c. 57–54 BC)

According to Roman reports, Mithradates III (c. 57–54 BC) and his brother Orodes II murdered their father Phraates III. But peace between the brothers did not last long. Orodes II soon tried to gain power over his brother Mithradates III, as overstrikes on all tetradrachms with the portrait of Orodes II (S 41.1) indicate.[89] As Assar attributes the S 31 coins (attributed by Sellwood to Orodes I) to a king that he names Mithradates III (July/August 87 – August/September 80 BC), he names this king Mithradates IV (58–55 BC).[90] For this, see comparison coin attributions by Sellwood and Assar in Table 8.1.

Orodes II finally managed to expel his brother from Media. Mithradates III fled and sought, though in vain, the protection of Gabinus, the Roman proconsul of Syria.[91] There he succeeded in starting a civil war in the cities of Seleucia and Babylon. Orodes II recognised the imminent danger and immediately sent his general Surena, a member of one of Parthia's leading families – the Sūrēns – with an army to Seleucia. In 54 BC, the revolt was suppressed and Mithradates III was killed in the fighting. The same Surena was sent into combat by king Orodes II against the Romans one year later, winning a glorious victory for the Parthians in the Battle of Carrhae (53 BC).

3.3.3 Orodes II (c. 57–38 BC)

After having killed his brother Mithradates III, Orodes II expanded the territories of Parthia. Armenia was made a vassal state, and he even captured the regions of present-day Israel. As the Romans made Syria a Roman province and wanted to expand further east, the conflicts between Rome and the Parthian Empire

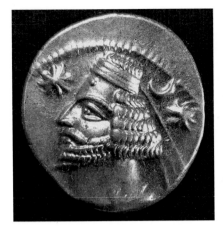 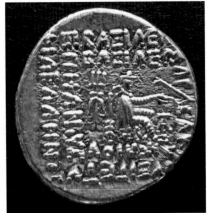

FIG. 3.3 A + B Orodes II, drachm, S 48.9. Obverse: bearded bust facing to the left, hair in five waves, wearing a diadem (three lines) and three lines for the ties. Royal wart on his forehead. Torque ends in a seahorse, star (could it be the sun?) in front and crescent and star behind the head, circular border of pellets. Reverse: beardless archer seated right on throne with a long back, holding an asymmetrical reflex bow in his right hand. He wears a bashlyk, around which a diadem is tied, and a kandys. Under the bow is the monogram A for Ecbatana. Behind the archer is an anchor (type iv), seven-line Greek inscription: ΒΑΣΙΛΕΩΣ ΒΑΣΙΛΕΩΝ ΑΡΣΑΚΟΥ ΕΥΕΡΓΕΤΟΥ ΔΙΚΑΙΟΥ ΕΠΙΦΑΝΟΥΣ ΦΙΛΕΛΛΗΝΟΣ, [Coin of] the king of kings, Arsaces, the benefactor, the just, the manifest, the friend of the Greek. Original size: 18 mm, weight: 4.08 g.

were pre-programmed. The Roman commander, Crassus (c. 114–53 BC), began preparations for war. These were not concealed from the Parthians. Orodes II sent an embassy to Crassus to prevent the imminent war. Crassus' answer to the question of why he was striving for this war read: 'In Seleucia I will give you the answer.'[92]

Crassus moved against the Parthians with an army of approximately 40,000 soldiers, including 4000 horsemen. The decisive battle between the two great empires took place in June 53 BC in the area south of the city of Carrhae (in the area of today's Harran, south-east Turkey). Surena, the Parthian general of Orodes II, lured the Romans into the desolate steppe landscape and attacked them with over 40,000 horsemen, of whom 10,000 were heavily armed riders (cataphracts). With the Parthian light cavalry delivering a massive hail of arrows, many Romans were wounded or killed during the first Parthian attack. With the cataphracts, the Parthians then separated parts of the Roman army, which could thus be easily attacked by the light cavalry. The Parthians used a technique that later became known in history as the 'Parthian shot': the Parthian riders faked a retreat after an attack, let themselves be attacked by the Romans, and then suddenly turned around on horseback, and fired masses of arrows against the pursuing enemies.

It is reported, that about 1000 camels transported an almost endless supply of arrows. On the first day of the battle 10,000 Roman soldiers were killed. Out of

fear of being captured by the Parthians, Publius Crassus, a son of Crassus, seriously wounded, was killed by his own servant. The Roman commanders – Crassus no longer being capable of acting – retreated to Carrhae in the night but lost further soldiers during continued Parthian attacks. In this hopeless situation, part of the Roman army emerged. Crassus was killed during the negotiations with the Parthians, but it is not quite clear how this happened. In this battle at Carrhae, about 20,000 Romans were killed, while many others were seriously injured. Ten thousand Romans were captured and taken to Merv – near the city of Mary in today's Turkmenistan – where they had to continue construction of Merv's huge defensive wall, which can still be seen today (Fig. 7.13).[93]

Crassus' wars against the Parthians ended in the greatest defeat in the history of Rome. It was 33 years later that peace negotiations were held with Emperor Augustus (Fig. 3.4). After their victory in Carrhae, the Parthians attempted to extend their influence over the small states lying between the two great empires in Asia Minor. Thus, the marriage of Orodes II to Laodice, the daughter of Antiochus I Theos (69–36 BC), king of Commagene, may have had political motivation, as the Parthians wanted to secure their western flank. On his coins Orodes II presents himself as a well-groomed ruler with a short beard, his hair arranged in five waves. He mastered the Greek language and was familiar with Greek literature.[94]

3.3.4 Pacorus I (c. 39 BC)

Pacorus I was the eldest son of Orodes II. Sellwood dates his reign to c. 39. BC, and assigns the coin S 49 to this king. After the glorious victory against the Romans at the Battle of Carrhae (53 BC), Orodes II decided to attack the province of Syria. His young son, Pacorus I, was the official leader, but actual leadership of this campaign was transferred to the commander, Osakes. After the Parthians' initial success, Cassius, the Roman quaestor of Crassus, was able to crush this attack in 51 BC. Osakes died in this battle.[95] Pacorus I died in 38 BC during an attack on a Roman camp in Syria.[96] It is unclear whether Pacorus I ruled in parallel to his father, Orodes II, or ruled as sole king in c. 39 BC.

3.3.5 Phraates IV (c. 38–2 BC)

With his various wives and co-wives, Orodes II had a total of 30 children from whom the successor to the throne had to be chosen after the death of Pacorus I. Justin tells us that Orodes II, who must have been very old at the time, felt deeply saddened by the death of his son Pacorus I.[97] In principle, the sons who came from Orodes II's marriage to Laodice, the daughter of Antiochus I, the king of Commagene, would have had the privilege of the throne. Instead, Orodes II chose his son Phraates IV, a fatal decision. Phraates IV immediately gave the order to murder all 30 of his father's sons. The highlight of the family clash was the murder of his father. Parthian noblemen, who could have been dangerous to him, now feared for their lives and went into exile. Artavasdes, also a Parthian noble,

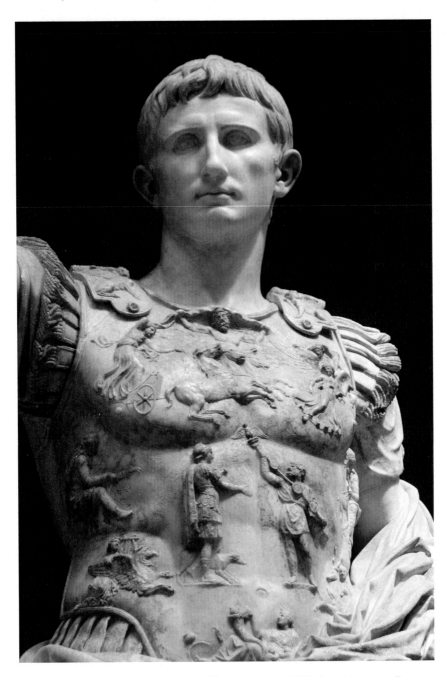

FIG. 3.4 Emperor Augustus, white marble, 1st century AD. Vatican Museums, Rome. The handing over of the Roman standards is shown on the breastplate.

even enlisted the support of the Roman commander, Mark Antony (Latin: Marcus Antonius, c. 83–30 BC), probably in the hope of being established as a rival king to Phraates IV.

With Mark Antony's May 36 BC campaign against the Parthians, another war broke out between the two great empires. Mark Antony moved into battle with approximately 80,000 warriors (16 legions). Among them were 10,000 Spanish and Celtic riders. Artavasdes, the king of Armenia, had made 13,000 warriors available to Mark Antony. But this time too, the Parthians would be superior to the Romans. Mark Antony led his troops to the Euphrates, accompanied by his beloved Ptolemy queen Cleopatra VII (who also had been the lover of Julius Caesar) who wanted to conduct negotiations with the Jewish king Herod in Judea. Antony's campaign ended in disaster, as more than 12,000 Roman soldiers were killed in battle, and more than 10,000 Romans died of disease. This defeat of the Romans strengthened the Parthians' pre-eminence in the Middle East.

Only Emperor Augustus' diplomatic negotiations with the Parthians in 20 BC brought the desired peace, defining the Euphrates once more as the border between the two realms. Captive Romans were released by the Parthians; the conquered Roman standards were returned. Politically skilled, Emperor Augustus sold these peace negotiations to the people as a victory. This is clearly shown on Augustus' breastplate (Fig. 3.4), where the standards are handed over to the Romans. Here, the Parthian shown is portrayed as a barbarian, not as an equal negotiating partner. The establishment of the Euphrates as a frontier between the empires was to last for the next two centuries. It was only with the conquest of Mesopotamia by Lucius Septimius Severus in 198 AD that this changed.

During the peace negotiations between the Parthians and Emperor Augustus it was also laid down that a son of Phraates IV be returned to the ruler. In his suite was a slave named Musa, who later became Parthian queen for a brief time. The story of this slave girl sounds like a fairy tale. Phraates IV took Musa as his lover and she bore him a son, Phraataces. Musa was able to disperse the other women and became the wife of Phraates IV. She is the only queen whose portrait is minted on coins. She then convinced Phraates IV to send his four sons – Seraspadanes, Vonones, Phraates, Rhodaspes (all from Phraates' marriage to Laodice, the daughter of the king Antiochus I Theos from Commagene) to Rome for education. The sons were handed over to the Syrian legate Marcus Titius in the year 10 or 9 BC on the border, and from there were brought to Rome. Formerly it was presumed that this would constitute exile, but according to recent investigations, such a 'stay abroad' was not uncommon in Roman client states.[98] Even the word 'slave' is not appropriate in this context, as Wolski shows.[99] The other sons having been sent to Rome, their son Phraataces would be able to succeed the throne. If the reports of Roman sources to be are believed, only a few years passed before Musa poisoned her husband Phraates IV to make way for her son Phraataces to be made king at a later date. Thus, she became the first queen of the Parthian Empire.

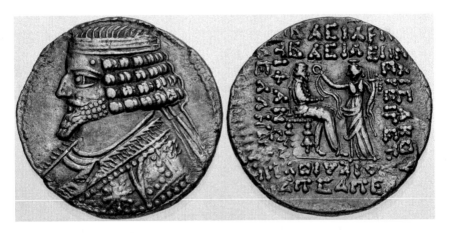

FIG. 3.5 Phraates IV, AR tetradrachm, S 50.8, variant. Obverse: bearded bust facing to the left, hair in four waves, wearing a diadem (four lines) with three lines for the ties. Royal wart on his forehead. Torque with no end, typical V-shaped Parthian tunic with embroidery, star on the tunic, circular border of pellets. Reverse: king sits on a throne facing to the right, his appearance resembling the king's portrait on the obverse. Tyche standing before him, wearing a polos, dressed in a long dress, a shawl tied around her hip. With her right hand she offers a diadem to the king, in her left hand she holds a cornucopia. Circular border of pellets. Inscription: S 50 i, in exergue: ZΠC*
(year 287 SE (Seleucid era) = 26 BC); AΠE (= AΠEΛΛIOY) = November. Original size: 28 mm, weight: 13.2 g.

Note:
* The Greek Σ is also written on coins as 'C'.

Source: Frank L. Kovacs Collection.

3.3.6 Queen Musa and Phraataces, c. 2 BC–4 AD

In 1 AD, Augustus sent Gaius Caesar, his grandson, with an army against the Parthians. The conflict was again about the Armenian throne and the question of predominance in the area. Phraataces (also named Phraates V)[100] met Gaius Caesar for negotiations on an island in the Euphrates. As part of the previously negotiated protocol, it had been determined that Phraataces would first be a guest on the Roman side and then Gaius would be invited to a banquet on the Parthian side.

It must have been a peculiar situation, as on one side of the river the Roman army was stationed and on the other side was the Parthian army. As a result, Phraataces was accepted as Parthian king, but he agreed not to interfere in Armenia. A war had been avoided. This encounter shows that Rome considered the Parthian Empire an equal.

Since her son's power alone was insufficient, in 2 AD Musa married her own son, hoping for more political influence. On the coins (Fig. 3.6) in which Musa is presented together with Phraataces, she is described as 'ΘΕΑΣ ΟΥΡΑΝΙΑΣ

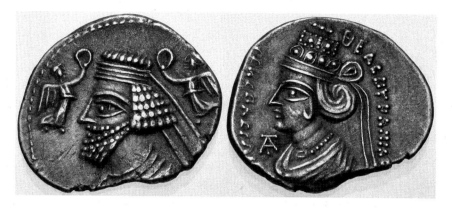

FIG. 3.6 Queen Musa and Phraataces, AR drachm, S 58.9. Obverse: bearded bust facing to the left, curly hair in five waves, wearing a diadem (four lines) with three lines for the ties. No royal wart on his forehead. Torque without end, circular border of dots. Nike flying in front of and behind the head, presenting a diadem to the king. Reverse: queen's portrait facing to the left, wearing a three-stepped crown with jewels, a broad diadem tied to it with two bows and two lines for the diadem, hair in one wave beneath the crown, no earring, necklace with jewels and medallion. She wears a blouse with transverse applications, A in front of the bust. Inscription behind the bust: ΘΕΑΣ ΟΥΡΑΝΙΑΣ ΜΟΥΣΗΣ ΒΑΣΙΛΙΣΣΗΣ, [Coin of] the divine Urania Musa, the goddess.*

Note:
* Keller, D., 2010: p. 630.

Source: By courtesy of: Parviz Ahghari, Pars Coins.

ΜΟΥΣΗΣ ΒΑΣΙΛΕΙΣ' ([Coin of] the divine Urania Musa, the goddess),[101] and receives a diadem from a Nike, as do Parthian kings. It is understandable that such political developments aroused strong antagonism, and it is not surprising that Phraataces and Musa disappeared from the political stage in the year 4 AD. Phraataces fled to Syria; nothing more is reported of them and presumably they were killed.

3.3.7 Tiridates I (c. 29–26 BC)

Sellwood named this king only Tiridates (S 55), not Tiridates I, as is proposed by Chris Hopkins (www.parthia.com).[102] This is done by the latter to distinguish him better from: Tiridates (who did not reign), the brother of Arsaces I; from Tiridates II (c. 35–36 AD), who is not mentioned by Sellwood; and from Tiridates III, who recently was identified by Sellwood (see 3.4.16).[103] Decisive for the proper assignment of the coins of Tiridates I is the work of F. De Callataÿ, who calls him Tiridate II (as Tiridate I is for him the brother of Arsaces I).[104] In this book, however, I accept the name of Tiridates I, as proposed by Chris Hopkins.

Tiridates I was a rival king to Phraates IV and was supported by parts of the Parthian aristocracy, who disagreed with the despotic leadership of Phraates IV. Tiridates was able to banish Phraates IV from Parthia for some time (between c. 29 and 26 BC). In the end, Phraates IV won this clash and Tiridates I fled to the Romans, taking with him as hostage a son of Phraates IV, whom he had been able to capture. This son was handed over to Emperor Augustus as a hostage. Tiridates I might have come to power once more with Roman support, as suggested by a coin dated May/June 26 BC,[105] which carries the inscription: 'ΦΙΛΟΡΩΜΑΙΟΥ' (Friend of the Romans).[106] The last known date we have for Tiridates I is 23 BC.[107] At this time Emperor Augustus received a delegation from Phraates IV, who demanded the surrender of Tiridates I. Augustus acted politically: Tiridates I was not surrendered but received asylum in Rome; however, it was agreed that the captured son of Phraates IV would be released, accompanied by the slave Musa, already mentioned, who later became Parthian queen. Furthermore, it was decided during these peace negotiations, that the Parthians would return the Roman standards lost at the Battle of Carrhae.[108] No more is known of Tiridates I.

The difficulty of assigning Parthian coins to a king is also found in those coins that Sellwood assigns to Tiridates I. On the basis of the already mentioned scientific study by F. De Callataÿ, the coins S 55.1–55.6 (tetradrachms) and S 55.10–55.14 (tetradrachms), attributed by Sellwood to Tiridates I, are now to be regarded as coin editions of Phraates IV.[109]

3.3.8 Orodes III (c. 6 AD)

After the deposition of Phraataces, a new king, Orodes III (c. 6 AD), sat on the Parthian throne for a few months. Like all Parthian rulers, he may have had an Arsacid ancestry, but nothing more is known about him. It is thought that he was installed on the throne by the Parthian nobles, who murdered him shortly afterwards. Coins of this Parthian king are rare. According to Sellwood, only tetradrachms are known (S 59).

3.3.9 Vonones I (c. 8–12 AD)

Phraates IV sent his son Vonones I (c. 8–12 AD) to Rome with three other brothers in 10 or 9 BC (see 3.3.5). According to recent investigations, such a 'stay abroad' was not uncommon among Roman clientele states,[110] though formerly this was thought to be an exile. After Orodes III had presumably been murdered, the Parthian throne being vacant, the search started for a successor. Some members of the Parthian nobility had therefore asked Emperor Augustus to return Vonones I to Parthia and there to enthrone him as king. Augustus accepted this request, hoping for strengthened Roman influence. Thus, Vonones I was made Parthian king in 8/9 AD. However, an element among the Parthian aristocratic families who did not like Vonones' Roman-influenced way of life – he was not

interested in hunting, for example – preferred Artabanus II as a new king.[111] They enthroned Artabanus II as a rival king, the ceremony taking place in Ctesiphon about 10/11 AD.

A confrontation between the two was unavoidable. A coin of Vonones I (S 60.5) proclaims his successful victory over his opponent: 'ΒΑΣΙΛΕΥΣ ΟΝΩΝΗΣ ΝΕΙΚΗΣΑΣ ΑΡΤΑΒΑΝΟΝ' ([coin of] king Vonones, who defeated Artabanus).[112] However, Vonones I lost further clashes with Artabanus II in 11 AD, fled to Armenia and there took over the throne. This did not please Artabanus II and he intervened with the Roman Emperor Tiberius. As a result, Vonones I was forced to retreat from the Armenian throne, and the Romans sent him to Cilicia, where he was killed in 19 AD in an escape attempt. Artabanus had accepted in return that the Romans could raise Zeno, the son of the king of Pontus, to the throne and Roman influence thus survived in Armenia. This compromise brought peace to both empires for one and a half decades.

3.3.10 Artabanus II (c. 10–38 AD)

Artabanus II's lineage was long considered uncertain. According to Olbrycht, his father was a prince of the Dahae, being from a line of the Arsacids, his mother was the daughter of Phraates IV.[113] Artabanus II grew up among the Dahae and then came to power as king of the Media Atropatene. The data on his reign, given by various experts, differ slightly. According to Sellwood he reigned from c. 10 to 38 AD, according to Olbrycht from 8/9 to 39/40 AD. Gregoratti believes that he reigned from 12 to 38/40 AD.[114] In the dispute between Artabanus II and Vonones I, the conflict was fuelled by two groups who supported them: one was the Arsacid branch, based on Phraates IV, the father of Vonones I, who was more Hellenised. Opposed to them were the supporters of Artabanus II, who came from the eastern regions of Parthia and were more oriental.

It was not until 12 AD that Artabanus II was victorious over Vonones I. An important testimony from the reign of Artabanus II is an archaeological find (see Fig. 3.7) that provides one of the few more complete inscriptions about the Parthians in the Greek language. It is a letter, carved in stone, from the Parthian king Artabanus II to the archons of Susa, and includes the problematic re-election of a treasurer of the city. The letter gives as the date 268 (Parthian era), Audnaeus 17 (= 17 December 20 AD). This letter was probably first written on leather, then copied by stonemasons onto a marble stone.

Artabanus apparently managed to stabilise power between the years 12 and 22/23 AD and to consolidate it in the future. This is what coin analysis might reveal. On coins dating until the year 11 AD, the king still calls himself 'ΦΙΛΕΛΛΗΝΟΣ' (the friend of the Greek). For a period of 11 years there are no dated coins, and only from the year 22 AD onwards do the tetradrachms again bear dates (in years), but the title 'ΦΙΛΕΛΛΗΝΟΣ' is missing. Gregoratti suspects conscious action on the part of the king in omitting this epithet, as this would ensure no distinction between Greeks and Parthians would be made any longer. Through the economic

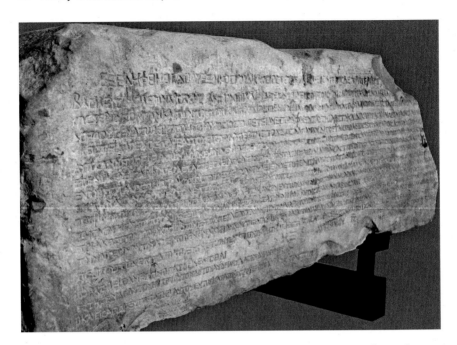

FIG. 3.7 Letter from Artabanus II to the town of Susa, marble stone with Greek inscription. Inv. Nr.: Fouilles R. de Mecquenem 1922, Sb 2780, Louvre, Paris.

boom and flourishing trade that the country experienced, Greek traders in Seleucia had become part of the Parthian people and would have felt themselves so.[115]

The invocation of the Parthian king in a dispute, as can be seen in Artabanus' letter to Susa, shows that Artabanus succeeded in strengthening his power.[116] Media Atropatene, Persis and Elymais, which had formerly probably been more autonomous, were more firmly integrated into the Parthian Empire. Artabanus II attempted to strengthen his influence in Armenia, enthroning his son Orodes there, but failed when his son was forced to retreat (see historical information on Vonones I).[117] With the emergence of the Indo-Parthian kingdom in the east, Artabanus II probably lost some provinces there.

Note: Since some historians and coin dealers now follow the genealogy that Assar has created, and which is partially disputed, there is some confusion in the assignment of kings with the name Artabanus. For more details, see Table 8.1.

3.3.11 Tiridates II (c. 35–36 AD)

Sellwood does not list Tiridates II, as no coins of him are known, and therefore no Sellwood (S) number is given to him. Artabanus II, who had brought the Armenian throne under his control, was opposed by some of the Parthian nobility, fearing that the king would get too much power. They therefore sent a delegation to the Emperor Tiberius at Rome, with a request to send the last son of Phraates IV,

Phraates, back to Parthia to take over the throne. Tiberius agreed, but Phraates died on his way east.[118] In his stead, the young prince Tiridates II, who had grown up in Rome, was sent to Ctesiphon. In the meantime, Artabanus II had been defeated by Vitellius, the Roman governor in Syria. Thus, Tiridates II was crowned king of kings in Ctesiphon in about 35/36 AD.[119]

He did not, however, stay on the throne for long, as another part of the Parthian aristocracy re-installed Artabanus II on the throne. Tiridates II disappeared and nothing else is known of him. Analysing the political scene of this time, it is interesting to realise that the influence of the nobility on a royal election could be quite considerable (see 4.2).[120]

3.3.12 Vardanes I (c. 40–45 AD) and Gotarzes II (c. 40–51 AD)

The two sons of Artabanus II, Vardanes I and Gotarzes II (according to Olbrycht, an adoptive son)[121] engaged in a dispute over the throne after the death of their father.[122] Vardanes I (c. 40–45 AD) had initially taken succession of the throne and had then been ousted by Gotarzes II. Two different political groups, who supported the two kings, can be distinguished. Vardanes, who found refuge in Atropatene, was supported by the Parthian noble family Kārin – also written 'Kāren' –, presumably being pro-Roman, while Gotarzes II found support from nomadic tribes living in the area of Hyrcania.

Vardanes I must soon have succeeded in expelling his brother Gotarzes II from Mesopotamia. However, an attempt to conquer the city of Seleucia on the Tigris, which had declared itself independent in the power struggles between Artabanus II and the pro-Roman Tiridates II, failed.[123] Vardanes I pursued his brother as far as Hyrcania (on the south-east side of the Caspian Sea), where his brother received support from the Dahae and Hyrcanians, and also from a tribe of Saka (dynasty of Sapadbizea).

The battles between the two kings extended into the region of west Bactria, which also testifies to the expansion of the Parthian Empire in the east at that time. The conflict between the brothers was then ended, presumably by a 'third political force in the kingdom', a 'legitimistic party' – as Olbrycht suspects –, which opposed Gotarzes II as well as Vardanes I. In the end, a compromise was found: Vardanes I became king of Parthia, while Gotarzes II became ruler in Hyrcania, being supported there by the 'Daho-Hyrcanian group'.[124] At this stage, the threatened division of the empire was finally prevented by the political power and skill of Vologases I (c. 51–79 AD).

The city of Seleucia, which became independent after an insurrection in 35/36 AD, or still during the reign of Artabanus II, probably surrendered in 41 AD, as tetradrachms of Vardanes I from October 41 AD show.[125] However, in c. 44/45 AD coins of Gotarzes II were also minted in Seleucia, which might indicate adoption of the compromise of double rule previously mentioned. The peace between the two kings did not last long. Vardanes I died during a hunt, according to Tacitus most likely following an assassination attempt. His last coins were minted in July 45 AD.[126]

3.3.13 Gotarzes II (c. 40–51 AD)

After the death of Vardanes I in 45 AD, Gotarzes II finally succeeded in taking over the throne. But parts of the Parthian aristocracy (the pro-Roman faction as well as the 'legitimistic party', see 3.3.12) were still dissatisfied with Gotarzes II's rule. They therefore sent a Parthian delegation, the Legati Parthorum, to the Romans to seek their assistance.

The Romans thus established Meherdates, a son of Vonones I, as a counter-king. He had grown up in Rome as an exile and was supported by the governor of the province of Syria, Cassius Longinus. As could be foreseen, a battle with Meherdates ensued. Gotarzes II was the victor. The captured Meherdates was kept alive by Gotarzes II, but his ears were cut off to prevent him from becoming king again, also to humiliate the Romans.[127] Given the cruelties described and the political opposition to him, it is not surprising that Gotarzes II died, probably as the result of a conspiracy, in AD 51.[128] Some of Gotarzes II's coins (type S 66) bear the personal name of the ruler: on tetradrachms inscriptions read: 'ΓΩΤΑΡΖΟΥ' (Gotarzes, nominative), on drachms 'ΓΩΤΑΡΖΗΣ' (genitive).

3.3.14 Vonones II (c. 51 AD)

Gotarzes II's successor was Vonones II (c. 51 AD), who only held power for a brief period. He came from Media Atropatene. The most striking feature of his coins is that the king is shown in a frontal view. Tetradrachms were not issued by him, therefore his power in Seleucia/Mesopotamia must have been weak. He might have controlled the northern part of Parthia, but only for a brief time, as the coinage of Sanabares (type S 93) indicates. This superseded the coinage of Vonones II in Aria and Margiana.[129]

3.4 Phase 4: Phases of stability – inner turmoil – decline of the Parthian Empire: from Vologases I (c. 51–79 AD) to Artabanus IV (c. 216–224 AD)

The peace that followed the diplomatic negotiations between Augustus and the Parthians ultimately turned out to be fragile. Artabanus II (c. 10–38 AD) had brought stability to the Parthian Empire, but the following 20 years saw internal power struggles, in which Rome was also involved in decisions to occupy the Parthian throne (see 3.3 and 3.3.11–13).

The struggles between Gotarzes II and Vardanes II in the 40s AD show how difficult it was to maintain peace in the empire. A new challenge came from the Romans. Rome's policy changed at the latest from 40 AD, when the Romans exercised their influence in Armenia through the establishment of King Mithradates (see 3.3). Rome also tried to extend its influence to Osrhoene and Adiabene in addition to Armenia. Rome's influence also grew stronger in the Parthian-dominated cities of Hatra and Dura-Europos.[130]

It was Vologases I (c. 50/51–78 AD) who consolidated the internal political situation of the Parthian Empire. He achieved this by giving his brother Tiridates control of Armenia and placing his other brother Pacorus on the throne of Media Atropatene. Vologases I also strengthened his influence in Characene and Elymais by installing Arsacid princes as local rulers there. These measures also succeeded in improving the economic situation and subsequently led to economic growth in Parthia through trade with countries to both east and west.

But even during Vologases I's reign, small clashes broke out between Rome and Parthia, and here too the focus was the question of who exercised sovereignty in Armenia. With the establishment of the Arsacid king Tiridates, who, however, had to submit to Rome in 66 AD, a compromise was reached in Armenia under Vologases I (see 3.4.1). This would bring extensive peace for over 50 years. From the beginning of the reign of Vologases I (c. 50/51 AD) to the end of the reign of Pacorus II (c. 110 AD), a number of uncertainties prevail regarding the question of which Parthian king was in power. These ambiguities exist due to a lack of Roman reports as well as the difficulty in assigning coins to Parthian kings.

Ultimately, the investigations by F. Sinisi (see p. 56) brought more clarity regarding this phase of the Parthian Empire. Through an intensive study of the coins, he was able to discover more about the reigns of the Parthian kings or rebel rulers (e.g. the son of Vardanes, see 3.4.2). He also found that king Vologases II, who – due to coin attributions – was postulated as a reigning king by Sellwood and other authors, did not exist (see Table 3.3).

The peace between the two empires during the reign of Vologases I, described above, did not mean, however, that Rome completely abandoned its expansion policy. About 72 AD Commagene was made a Roman vassal state and Roman troops were stationed in Samosata, capital of Commagene, an important place for crossing the Euphrates.[131] Such transfer of troops to the border ultimately confirms that Rome on the one hand wanted to protect itself against further attacks by the Parthians, and on the other had never lost sight of its expansion policy.

These measures laid the foundations for a Roman war against the Parthian Empire, which took place under Trajan in the years 114–117 AD. In addition to Rome's general desire to expand to the east, there had to be an opportunity and a reason to attack. One of the triggers for Trajan's war may have been the appointment of Parthamasiris (son of Pacorus II) as king of Armenia by Osroes I. Another possible reason for this war could have been that Rome was concerned with securing trade routes through Mesopotamia.[132] From c. 105 AD on, a politically unstable situation in Parthia also prevailed, when Vologases III (c. 105–147 AD) was in power in addition to the Parthian king Osroes I (c. 109–129 AD).[133] In the eyes of the Romans, Osroes I was accepted as a Parthian king, as is made evident by the fact that in AD 113 Osroes I's representatives undertook negotiations to try to convince Emperor Trajan not to fight the Parthians. But the opportunity seemed favourable for the Romans and so Trajan waged a war against the Parthians, which started in spring 114 AD. His troops first conquered Armenia, occupied Adiabene and then moved on to northern Mesopotamia, passing Dura-Europos and following

TABLE 3.3 Timetable for Vologases I, Pacorus II and Artabanus III according to Sinisi (2012).

Period	King	Sellwood Types
SE 362–365 (50/51–53/54 AD)	Vologases I, Tetradrachms, Period 1	Tetradrachms, S 68
SE 373–380 (59/60–68/69 AD)	Vologases I, Tetradrachms, Period 2	Tetradrachms, S 70
SE 366–369 (54/55–57/58 AD)	Son of Vardanes	Tetradrachms, S 69
SE 380 (68–69 AD)	City Issue	
SE 383–385 (71/72–73/74 AD)	Vologases I, Phase 1	Chalkoi, S 70.17–18
c. SE 386–c. 388 (c. 74/75–76/77 AD)	Vologases I, Phase 2	Drachms, Type S 71
c. SE 386–c. 388 (c. 74/75–76/77 AD)	also: Pacorus II, Phase 1	Drachms, S 73.11–14
SE 388–390 (76/77–78/79 AD)	Vologases I, Phase 3	Tetradrachms, S 72 (attributed by Sellwood to Vologases II)
SE 388–c. 390/1 (76/77–c. 78/79/79/80 AD) SE 391–393 (79/80–81/82 AD)	also: Pacorus II, Phase 2	Tetradrachms Type S 73: coins containing the letters A + B in the obverse were minted in the year SE 389 (77/78 AD), whereas tetradrachms with the signs Γ and Δ were minted in the year SE 390 (78/79 AD) and those with Δ and E are from the year SE 391 (79/80 AD), minted by Artabanus III (month Gorpiaios)[1]
SE 391–393 (79/80–81/82 AD)	also: Artabanus III	Tetradrachms, Type S 74
SE 393 (81/82 AD)	Pacorus II, Phase 2	Tetradrachms, Type S 75
SE 401–404	Pacorus II, Phase 3	Tetradrachms, Type S 76
from SE 404 (= 92/93 AD)	Pacorus II, Phase 4	Tetradrachm, Type S 77

Source: Sinisi, F., 2012: p. 201 ff. and plates 72 and 73.

1 Sinisi, F., 2012: p. 85 and p. 170.

the Euphrates to Babylon. In 116 AD he defeated the Parthian capital Ctesiphon. Trajan then moved on to the Persian Gulf and also conquered Characene. Trajan's attacks resulted in the Parthians' loss of both Mesopotamia and Babylon within a short period, and the Roman province of Assyria emerged.

But luck was not on Trajan's side. The Parthians, with a significant effort under Osroes I, were able to recapture the occupied territories, inflicting severe defeat on

the Romans, even though Armenia, the province of Nisibis and Adiabene remained as vassal states under Roman influence. However, a document found in Dura-Europos, dated and signed by a Parthian official in 121 AD, reveals that the Parthians continued to exercise their power there (see 7.3.3). Following the successful warding-off of Trajan's attack, peace prevailed between the two empires over the next three decades (c. 118–134 AD). However, during the reign of Vologases III in 134–136 AD, the Alans invaded in the east, which the Parthians were able to successfully hold off.

Vologases IV, who followed Vologases III on the throne, reigned from c. 147 to 191 AD – that is, over 44 years. No other Parthian king can boast such a long reign, an indication of the king's excellent leadership skills. The early years of his reign brought peace and economic stability, a prerequisite for fighting the Romans and their expansionist policies.

As has been emphasised, we learn most about the Parthians from Roman sources, when wars between the two empires took place. However, information from this period is much sparser, so we learn little about the internal political situation of the Parthian Empire. In 161 AD the Parthian king Vologases IV declared war on the Romans under Emperor Marcus Aurelius. This was probably the first time during the period of conflict between the two great powers that a Parthian ruler formally declared war on the Romans. The background for the war is not clear. It was perhaps once again about supremacy in Armenia. The Parthians succeeded in conquering Armenia and advancing as far as Syria. Osrhoene, Adiabene and Nisibis were subjugated by the Parthians. This inevitably challenged the Romans to strike back.

From 162 to 166 AD, Lucius Verus, who had been sent to the east by Emperor Marcus Aurelius, fought against the Parthian Empire, successfully expelling the Parthians from Syria and Armenia in 164 AD. In 165 AD he conquered the cities of Seleucia and Ctesiphon. Only a plague – smallpox has been mentioned, but it could also have been an infection of *Yersinia pestis*, which causes the plague – forced the Romans to retreat. The plague spread to Rome with the soldiers, causing up to 2000 deaths every day. The disease raged for over 24 years before disappearing relatively quickly. It is estimated that up to 25 per cent of the population died from it.

Peace negotiations took place between Marcus Aurelius and Parthian emissaries in 173 AD, which would bring a longer period of stability to the Parthian Empire. As a result of this war, Dura-Europos, Edessa and Carrhae returned to the Roman sphere of power, and Armenia remained under Roman control. Peace was to last little more than 20 years before the Parthians made another advance westward and conquered Osrhoene. Unsurprisingly the Romans could not tolerate this and prepared a counterattack. In 194 AD, Lucius Septimius Severus fought against the Parthians, subjugated Babylonia and conquered the Parthian capital Ctesiphon. Owing to unrest in Gaul, Septimius Severus soon withdrew from Parthia, but continued his attack against the Parthian Empire in a second war (197–199 AD). Seleucia and Ctesiphon were again conquered by the Romans and Ctesiphon was

opened for looting. It was not long before Septimius Severus had to withdraw from the occupied territories; presumably a lack of food supplies was the problem. Mesopotamia, however, remained under Roman control.

Through this war, the Romans managed to create two new provinces – Osrhoene and Mesopotamia – and to push back the Parthians significantly. Hatra could not be conquered, and a second attack in the spring of 199 AD failed. A final Roman attack against the Parthian Empire was carried out by Caracalla in 216 AD (his official name was Marcus Aurelius Severus Antoninus, in memory of the revered Marcus Aurelius, who had been emperor from 161 to 180 AD). Having brought Armenia under Roman rule two years earlier, Caracalla probably wanted to finally conquer the Parthian capital Ctesiphon and thus decisively defeat the Parthian Empire. On his campaign, he first conquered Adiabene with its capital Arbela. According to Cassius Dio, he destroyed the graves of the Parthian kings buried there. From recent investigations we know that the graves belonged to a local dynasty (see 5.4). Caracalla and his troops reached the area of Carrhae, but he was murdered there in 217 AD by his successor, Emperor Macrinus. However, Macrinus was unsuccessful in continuing the Parthian war. Thus, the Parthians were able to defeat the Roman army in the Battle of Nisibis (217 AD, today in the region of the province Mardin, south-east Turkey) and obliged the Romans to make high tribute payments. Armenia was again made a Roman vassal state.

At the end of the Parthian Empire inner turmoil arose between the two brothers, Artabanus IV and Vologases VI. The fraternal fight ended in favour of Artabanus IV (c. 216–224 AD), but his power was weakened. In this situation a power vacuum arose. Ardashir, a local king in Persis, took the opportunity to riot and defeated Artabanus IV. This victory gave birth to the new Sasanid Empire (see 3.5).

Vologases I to Pacorus II (50/51–81/82 AD): general information

Through the intensive analysis that F. Sinisi made in his seventh volume of the *Sylloge Nummorum Parthicorum*[134] for the period of Vologases I to Pacorus II (c. 50 – 110 AD), it has become clear that the data from Sellwood are not always consistent. Similarly, statements or assignments by Assar and other authors are also open to criticism.[135] But even Sinisi cannot explain everything. Analysis of the coins of this period is difficult because the coins were minted in parallel or have no details of months. Formerly this led to the idea that a rival king was in power. This applies to Vologases II, who did not exist at all. Sinisi has placed the coins he examined into his own chronological order (Table 3.3) and analysed various coin types. In this book, however, it is not possible to deal with his type differentiation more extensively.

3.4.1 *Vologases I (c. 50/51–79 AD)*

Vologases I (c. 51–79 AD)[136] was the successor of Gotarzes II. He must be regarded as one of the most successful Parthian kings and was an opponent equal to the emperor of Rome. Under his rule, there was a longer period of stability, during

which the Parthian Empire flourished economically. According to Tacitus, Vologases I was the son of Vonones II from his marriage to a Greek concubine.[137] As Flavius Josephus states, his brother was Gotarzes II.[138] In 54 or 55 AD, he apparently had a conflict with the son of Vardanes (see 3.4.2). This is explained by the dates of coinage of the son of Vardanes, which began in June/July 55 AD and ended in June/July 58 AD (see Table 3.3). Vardanes' son's influence seems to have been limited to Seleucia. After the revolt in Seleucia had ended, Vologases I brought peace to the country and the division of Hyrcania as a country under the rule of Gotarzes, with the rest of the kingdom being under Vardanes I, was abolished.[139] Hyrcania was restored to the importance that it had enjoyed since the rise of the Parthian Empire, for it was from here that the Parthian Empire had always been reinforced with troops. It had also always served as a retreat, when attacks in the west made this necessary.

Vologases I proved his political skill by giving Armenia to his brother Tiridates and the throne of Media Atropatene to his other brother Pacorus.[140] His brother Tiridates, who became Tiridates I of Armenia, thereby founded the lineage of the Arsacids ruling in Armenia, a line that survived the end of the Parthian Empire and lasted until 423 AD, when the Sasanids defeated them. Tiridates I of Armenia is not to be confused with the Parthian ruler of the same name, Tiridates I (c. 29–26 BC), a counter-king to Phraates IV.

The decision of Vologases I to hand over Armenia to his brother was met with resistance in Rome, and war ensued. Corbulo, governor of the province of Asia, was sent to the east by Emperor Nero to strengthen Roman influence in Armenia. In the ensuing psychological war with Vologases I, the Parthian king proved himself politically as skilled as the Roman general. Gregoratti describes it as 'A Game of Chess for Armenia'.[141] In the end a compromise was found: Tiridates I was accepted as king of Armenia by Rome but had to be crowned in Rome. The Roman Emperor Nero (54–68 AD) had insisted on this, to preserve the influence of Rome. Nero had to pay for this compromise by meeting the travelling costs of Tiridates I, who rode to Rome with a band of 3000 horsemen.[142]

Cassius Dio has impressively described the encounter that took place in 66 AD:[143]

> Nero, wearing the triumphal garb and accompanied by the senate and the Praetorians, entered the Forum. He ascended the rostra and seated himself upon a chair of state. Next Tiridates and his suite passed between lines of heavy-armed troops drawn up on either side, took their stand close to the rostra, and did obeisance to the emperor as they had done before. At this a great roar went up, which so alarmed Tiridates that for some moments he stood speechless, in terror of his life. Then, silence having been proclaimed, he recovered courage and quelling his pride made himself subservient to the occasion and to his need, caring little how humbly he spoke, in view of the prize he hoped to obtain. These were his words: 'Master, I am the descendant of Arsaces, brother of the kings Vologaesus and Pacorus, and thy slave. And I have come to thee, my god, to worship thee as I do Mithra. The

destiny thou spinnest for me shall be mine; for thou art my Fortune and my Fate.' Nero replied to him as follows: 'Well hast thou done to come hither in person, that meeting me face to face thou mightest enjoy my grace. For what neither thy father left thee nor thy brothers gave and preserved for thee, this do I grant thee. King of Armenia I now declare thee, that both thou and they may understand that I have power to take away kingdoms and to bestow them.'

However, this concession seemed worthwhile because it brought peace between the Parthians and Romans for a period of about 50 years, bringing likewise inner stability to the empire. New cities were built, such as Vologesocerta and Vologesias.[144] At this stage, Vologases strengthened Iranian traditions. This is recognised by the fact, that his name minted on his coins not only appears in Greek (= ΟΛΑΓΑΣΟΥ, genitive), but also in Parthian, where the inscription 'wl', the abbreviation for 'wlgš' (Valgaš, Vologases) is to be found (Fig. 9.1).[145]

3.4.2 Son of Vardanes (c. 55–58 AD) = Vardanes II (Sellwood)

The attribution of coins of type S 69 has been the subject of numerous discussions.[146] According to Sinisi, this rebel was probably a son of Vardanes I (c. 55–58 AD).[147] Sellwood calls him Vardanes II. His influence seems to have been restricted to Seleucia.[148] The absence of tetradrachms of Vologases I in the years c. 55–58 AD seems to affirm the influence of the son of Vardanes in the Parthian capital Seleucia. This is confirmed by the fact that Vologases I minted tetradrachms in a first phase from February/March 54 to June/July 55 AD, then in a second phase from 58/ 59 AD onwards (see Table 3.3). The earliest dated coins of Vardanes II date from June 55 AD (according to Sellwood the earliest date is the month of November 55 AD = S 69.1). On his coins the son of Vardanes bears the 'royal wart'.

3.4.3 Vologases II (listed by Sellwood, but did not exist)

Coins of the type S 72, which Sellwood, due to iconographic aspects, assigned to a separate ruler Vologases II (c. 77 – 80 AD), are now attributed to the coinage of Vologases I, who died in 79 AD.[149] Sinisi's studies now show that no Vologases II existed.[150]

3.4.4 Pacorus II (c. 75–110 AD)

Pacorus II (c. 75–110 AD), the son of Vologases I,[151] was raised by his father as co-regent on the throne, when he was still a child. This was done most likely between the years 75 to 77 AD. From 78 AD, the first tetradrachms of Pacorus II were minted. His youthfulness is also indicated by the fact that the early coins of Pacorus II show him beardless (Fig. 4.13 A + B). Vologases I rightly hoped that such a step would strengthen the monarchy. Sellwood and others[152] believed that Pacorus – still

at a young age – had to fight against Artabanus III, who probably contested his throne. According to Sinisi's research, Artabanus III took over the throne for two years (c. 80–82 AD) since Pacorus was too young (see 3.4.5: Artabanus III).

Under the reign of Pacorus II, economic stability seems to have prevailed. One indication of this is the sending of a delegation to China with the aim of promoting trade relations between the two countries. According to the Greek writer Arrian (born around 85/90 AD), Pacorus II sold Osrhoene to Abgar VII in 109/110 AD.[153] The city of Ctesiphon was fortified during his reign. More detailed information on Pacorus II, Vologases I and Artabanus III can be found in Sinisi's extensive coin analyses. His studies show that it is essential to carry out an exact coin analysis, but they also show that a few questions must remain open.

3.4.5 Artabanus III (c. 80–80/81 AD)

Since some historians now follow the genealogy that Assar has created (see 8.1.1, Sunrise collection), there is some confusion in the assignment of kings with the name Artabanus. Table 3.4 shows the different attributions Sellwood and/or Assar give. The genealogy of Artabanus III is unclear. Sellwood postulates the reign from c. 80–90 AD. According to Olbrycht, he was probably not a Parthian king but a governor of Parthian territories in northern Mesopotamia.[154] The coinage of Artabanus III (S 74) starts in August (Gorpiaios) 391 SÄ (Seleucid Era) and ends in 392 SÄ (= 80/81 AD). The appearance of coins of Artabanus III, according to Olbrycht, can be explained by the fact that Artabanus III had tried to take the crown but had failed and had been eliminated by Pacorus II.[155] While Sellwood assumed that Artabanus III should be regarded as an opponent of Pacorus II, Sinisi

TABLE 3.4 Parthian kings named Artabanus: different attributions by Sellwood and Assar.

S Number	Sellwood	Sellwood	Assar	Assar	Assar*
S 6	Arsaces II	c. 211–191 BC	Artabanus I	= Arsaces II	211–185 BC
S 7	Arsaces II	c. 211–191 BC	Artabanus I	= Arsaces II	211–185 BC
S 18	Inter-Regnal Issue	c. 127 BC	Artabanus II*	= Arsaces VIII	127–126 BC
S 19 – S 22	Artabanus I	c. 127–124 BC	Artabanus III	= Arsaces IX	126–122 BC
S 61 – S 63	Artabanus II	c. 10–38 AD	Artabanus IV	= Arsaces IX	10–38 AD
S 74	Artabanus III	c. 80–90 AD	Artabanus V		79/80–c. 85 AD
S 89	Artabanus IV	c. 216–224 AD	Artabanus VI		212–224/7 AD

* Formerly identified by Assar as BAGASIS. All dates are circa dates.

(2012) comes to a different conclusion on the basis of his coin analysis: Artabanus III took the throne for two years (c. 80–82 AD),[156] as Pacorus was too young, when his father died in the summer of 79 AD. Sinisi considers it possible that Artabanus III was an uncle of Pacorus II – that is, a brother of Vologases I – who took over government business until Pacorus II was able to become king at the age of 18.[157] Olbrycht sees this differently – in his opinion, it is more likely that Artabanus III was a son of Vologases I and a brother of Pacorus II.[158]

3.4.6 Vologases III (c. 105–147 AD)

Vologases III reigned from c. 105 to 147 AD. During this time, he had to deal with three opponent kings: Osroes I (c. 109–129 AD), Mithradates IV (c. 129–140 AD) and the unknown King III (c. 140 AD). It is not clear in which part of the Parthian Empire Vologases III ruled. The Romans accepted Osroes I as the Parthian king, as in 113 AD his deputies tried to persuade Emperor Trajan not to fight the Parthians. The coinage of Osroes ends in the year 127/28 AD in Seleucia, which is probably at the time of Vologases III's supremacy.

Between 134 and 136 AD the Alans (an Iranian people) penetrated from the north-east into Armenia. It is believed that Vologases III ransomed himself from the Alans,[159] as one can assume that at this time the Parthian Empire was well situated economically, since many coins were minted under his reign.

3.4.7 Osroes I (c. 109–129 AD)

Osroes I was a son of Pacorus II.[160] Osroes I (and not Vologases III) was – in the eyes of the Romans – regarded as the Parthian king, for in 113 AD, deputies of Osroes tried to persuade the Roman Emperor Trajan to stop the planned war against the Parthians. Nevertheless, Trajan waged war against the Parthians from 114 to 117 AD. One of the triggers for Trajan's war may have been the appointment of Parthamasiris (son of Pacorus II) as king of Armenia by Osroes I. In these three years, Trajan's troops first conquered Armenia, then moved to Mesopotamia. In 116 AD Trajan occupied the areas of Adiabene, conquered Dura-Europos and shortly afterwards defeated the Parthian capital Ctesiphon. Here Trajan is said to have captured a golden throne of the Parthian king. Osroes I was able to flee, but one of his daughters was taken prisoner.[161] As a sign of his victories, Trajan had given himself the nickname 'Parthicus', later receiving confirmation of this from the Roman senate. Trajan's triumph continued as he reached the Persian Gulf, his troops taking advantage of the more relaxed navigation on the Euphrates. Characene (see 5.5), under its king Athambelos VI, surrendered.

With his victory Trajan created for a short time the Roman provinces of Armenia, Assyria and Mesopotamia, but his successes did not last long. Revolts, especially in Osrhoene, shook the conquered lands. The health of the emperor was also so affected that he died on the return journey in August 117 AD in Cilicia. Before leaving Ctesiphon, Trajan crowned Parthamaspates, who had grown up in Rome

(see 3.4.8), as Parthian king, hoping that he would continue to represent Roman interests. But Parthamaspates proved to be too weak, and his father, Osroes I, soon succeeded in ousting his son and taking power again. In the end, Mesopotamia remained under Parthian control, whereas Armenia and Adiabene stayed under the influence of Rome. At last in the year 127/28 AD, Vologases III assumed the throne of the Parthian Empire as king of kings, Osroes I having been ousted.

3.4.8 Parthamaspates (c. 116 AD)

Parthamaspates was Osroes' son. He grew up in exile in Rome and enjoyed a Roman upbringing. As an adult, he supported Trajan in his campaign against the Parthians (114–117 AD). After the conquest of Ctesiphon by the Romans, Parthamaspates received his investiture there as Parthian king in 116 AD. However, he was unable to stay on the throne for long. After the Romans left, his father Osroes I expelled him from Ctesiphon. Parthamaspates fled back to Rome and was later appointed by Hadrian as ruler of the Rome-dependent kingdom of Osrhoene.[162] It is known that from there he cultivated trade relations with the Kushans in the east, goods being transported by sea via the river Indus.

3.4.9 Mithradates IV (c. 129–140 AD)

From Roman sources we have unsatisfactory information about this king. He was an antagonist of Vologases III. On the drachms attributed to this ruler, his name is written in the Parthian language (top line): 'mtrdt MLK' (king Mithradates). The remaining characters on his coins are not legible; they only look somewhat like Greek (Fig. 8.6).[163]

3.4.10 Unknown King III (c. 140 AD)

The unknown King III (c.140 AD) is likely to have been a counter-king to Vologases III.[164] No valid data exist.

3.4.11 Vologases IV (c. 147–191 AD)

Vologases IV reigned for about 44 years (c. 147–191 AD). Thanks to an inscription discovered in 1984 on a bronze statue of Heracles found in Seleucia, it is known that Vologases IV was the son of Mithradates IV. The text, which is written in Parthian, but also in a Greek version, informs us that in the year 462 according to the Seleucid calendar (= 151 AD) Vologases IV, son of Miradates (Mithradates), banished Miradates (Meredat), Son of Pacorus (= Pacorus II) from Mesene (= Characene).[165] Although the inscription gives only Miradates (Mithradates) as his name, one can now – thanks to the inscription on a bronze coin – conclude that he was the son of Mithradates IV.[166] During the many years of his reign, the Parthian Empire evidently experienced a series of peaceful phases. But in 161 AD

the Parthians declared war on the Romans for the first time in their history.[167] This remained a singular event, no war on the Romans being declared by Parthian kings after that. The background for this declaration of war is not clear. Perhaps it was once again about supremacy in Armenia.[168] The Parthians had just installed Pacorus as king in Armenia, and perhaps they intended to capture Syria as well.

Rome responded in 162 AD with the deployment of troops under Lucius Verus, co-emperor and adoptive brother of the Emperor Marcus Aurelius. The Romans managed to push the Parthians back, with the Roman troops reaching the cities of Ctesiphon and Seleucia in the winter of 165/166 AD and conquering them. However, a plague, the so-called Antonine plague, forced the Romans to withdraw. Despite this retreat, Dura-Europos, Edessa and Carrhae remained under Roman control, as did Armenia. Parthia was weakened by this war, which affected its long-distance trade considerably. Until the death of Vologases IV, Parthia remained quiet, so that the country was able to recover.

3.4.12 Osroes II (c. 190 AD)

Osroes II ruled only for a brief period; the data is weak. He is known only by his coins. Sellwood suspects that Osroes II ruled in Parthia for several years while Vologases V controlled Mesopotamia.

3.4.13 Vologases V (c. 191–208 AD)

During Vologases V's reign (c. 191–208 AD) the Romans again started to wage war against the Parthian Empire. Vologases V (see Fig. 3.8) had supported rebellions in

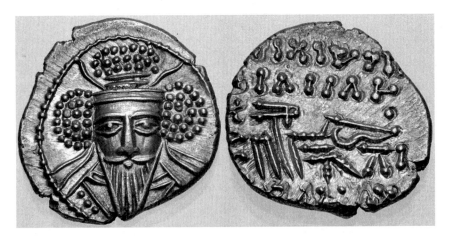

FIG. 3.8 Vologases V, silver drachm, S 86.3. Obverse: frontal view. Reverse: stylised archer, under the bow is the sign of Ecbatana. Inscription above: name of the king in Parthian script; inscription underneath: botched Greek legend. Original size: 21 mm, weight: 4.12 g.

Osrhoene and Adiabene, which caused the displeasure among the Romans. They responded with war. In 195 AD Septimius Severus, the Roman Emperor, moved with his troops against Osrhoene and subjugated it to Rome. Vologases V reacted with a counterattack on Nisibis (today's south-eastern Turkey), but without success. This encouraged Septimius Severus to move his troops along the Euphrates deep into the Parthian Empire and conquer Seleucia and Ctesiphon at the end of 198 AD. The inhabitants of the cities were killed or enslaved. With this Roman success, two new Roman provinces, Osrhoene and Mesopotamia, were created, and the supremacy of the Parthians in Mesopotamia broken. Septimius Severus failed to conquer only Hatra, which at that time was under Parthian influence.[169] After the withdrawal of the Roman troops, a peace treaty probably ensued in 199 AD. This enabled the Parthian Empire to recover. The loss of Mesopotamia, however, meant the loss of fertile lands for the Parthians. It is quite possible that this was one of the reasons why the Parthian Empire was weakened and eventually destroyed by civil uprising (see 3.6, reasons for the downfall). Vologases V died around 208 AD. His son Vologases VI became his successor.

3.4.14 Vologases VI (c. 208–228 AD)

We also have only a little information about Vologases VI. It is believed that he was involved in wars with his younger brother, Artabanus IV, who ruled in Media, as his coins minted there indicate. The fraternal conflict ended in favour of Artabanus IV, and Vologases VI seems to have lost most of the empire by 216 AD. He might still have been in power in some parts of Parthia, as some of his coins are dated as late as 228 AD.

3.4.15 Artabanus IV (c. 216–224 AD)

Artabanus IV (c. 216–224 AD), the last Parthian king, went to war with his brother Vologases VI, and by 216 AD (at the latest) was able to defeat him. In 216 AD the Roman Emperor Caracalla offered Artabanus IV his daughter's hand in marriage. This was rejected by the Parthian king. It is believed that Caracalla had made this only as a sham offer, simply seeking a reason to invade Adiabene.[170] Thus, Caracalla had found a reason to penetrate Adiabene and reached Arbela. In the winter of 216/217, the Parthian troops prepared for a counterattack. After Caracalla's assassination by a soldier, Emperor Macrinus continued the war, but lost the Battle of Nisibis in 217 AD. In the subsequent peace negotiations, it was determined that north-west Mesopotamia would remain a Roman province. The Parthians also accepted Roman supremacy over Armenia. However, the Parthians received the enormous sum of 50 million denarii (small silver coins) for this compromise.

An archaeological discovery in Susa, a stele, mentions king Artabanus IV. The stele shows the investiture of a local prince named Xwāsak by the king on 14 September 215 AD.[171] Artabanus IV apparently lost power in the following years.

Ardashir, the son of the local king Pāpak, who ruled in Fars, seems to have extended his sphere of influence from 220 AD onwards, and there may have been several battles between Artabanus IV and Ardashir.

The year 224 AD saw a final clash between the two, in which Ardashir defeated the Parthian king.[172] This marked the end of the Parthian Empire and the birth of the new Sasanid Empire, founded by Ardashir. The well-known relief in Naqsh-e-Rostam (also: Naqsh-e-Rustam) depicts this victory, with the new ruler receiving his investiture by the god Ahura Mazda, while his opponent Artabanus IV lies dead under the hooves of a horse (Fig. 4.10).

3.4.16 Tiridates III (c. 216–224 AD?)

Whether a ruler named Tiridates III existed after the death of Artabanus IV has not been definitively clarified. On a coin of Artabanus, Sellwood found a second row with a Parthian inscription showing the name of Tiridates.[173] However, this reading is dubious.[174]

3.5 Ardashir I and the newly founded Sasanian Empire

Ardashir I, who had defeated the last Parthian king Artabanus IV, became the founder of the Sasanian Empire. In 205/206 AD his father Pabag was crowned king of Istakhr (near Persepolis),[175] a city that would later become one of the summer residences of the Sasanian Empire. The name of this empire probably goes back to his grandfather Sasan, who was supposed to have been a high priest in the sanctuary in Istakhr. T. Daryaee writes regarding that history: 'There are so many different stories and legends in regard to the origins of Ardaxšīr and his family lineage that it makes one hesitant to readily accept any of the versions.'[176] After the death of his father, Ardashir I was crowned king.

By defeating local uprisings, Ardashir I was able to subjugate the area of today's Kerman (today's western Iran) and parts of Mesopotamia. In 221 AD Ardashir invaded Elymais and took its capital Susa. With these conquests he became a serious threat to the Parthian king Artabanus IV, who decided to fight against him. But fate, as already mentioned, turned against the king of the kings of the Parthians – in 224 AD Artabanus IV died at the Battle of Hormuzdagan. This was the beginning of the end of the Parthian Empire. In 226 AD (Fig. 4.10) Ardashir I was crowned king of the new Sasanian Empire, but it took another two years until the last Parthian king, Vologases VI, could be defeated. This can be deduced from the discovery of a coin of Vologases VI, which was minted in 228 AD.

The Parthian capital Ctesiphon, conquered by Ardashir I, was magnificently expanded by him in the following years and made the main residence of the Sasanian kings. Even today, the remains of the palace in Ctesiphon, with the huge iwan ('Taq-e Kisra', Fig. 7.14), reveal to us the magnificence of Sasanian architecture, based on Parthian knowledge (see 7.1.2). The Sasanian Empire existed until the 7th century AD and ended due to Islamic expansion. A branch of the Arsacid

family, which had ruled in Armenia at that time, was able to rule there for another 200 years, until in 428 AD the Sasanids took power.

The Sasanian Empire lasted from 224 to 651 AD. After the death of the Prophet Mohammad (632 AD) Muslim Arabs conquered large areas in Mesopotamia and invaded the Sasanian Empire. The Sasanian army was defeated at the Battle of Qâdisiya (638 AD); the final defeat taking place at the Battle of Nehâvand (642 AD). The last Sasanian king, Yazdegerd III, fled with some of his troops to the east, but was murdered near Merv (today's Turkmenistan). This was the end of the Sasanian Empire.

3.6 The end of the Parthian Empire – reasons for the downfall

What was the reason for the downfall of the Parthian Empire? Numerous discussions have been conducted on this. There is certainly not just one reason; numerous factors may have played a role. On the one hand, economic reasons have been discussed. The loss of the Mesopotamian territory to the Romans after their victory there in 198 AD may have been significant. Mesopotamia with its fertile soils along the rivers Euphrates and Tigris had been the breadbasket of Parthia and it is likely that trade partly came to a halt after this loss.

Another cause could be the war of almost 20 years later. The year 216 AD brought the Roman Emperor Caracalla's attack on the Parthian Empire; the Roman troops were able to take Edessa and Arbela, the capital of Adiabene, without a fight. In the winter of 216/217, the Roman troops camped in Edessa. Caracalla fell victim to an attack. His successor was the Roman Emperor Marcus Opellius Macrinus, who lost the fight against the Parthians at Nisibis in 217 AD. It was a last great victory by the Parthians against Rome, but without doubt it had involved significant effort and suffering. In 218 AD peace negotiations took place in which the Romans committed themselves to a payment of about 200 million sesterces (= 50 million denarii). The Romans regarded the Parthians as equals at this time, no indication of weakness being identifiable.[177] However, this view from the outside need not have corresponded to the internal situation. It is not clear what the reality was in the east of the Parthian Empire, and the wars there probably contributed to weakening internal stability.

Another reason for the decline of the Parthian Empire is seen in the domestic political debate. Especially in a situation in which the Parthian Empire was weakened internally through clashes between Vologases VI and Artabanus IV, local rulers could become strong. This is true of Ardashir's father, Pabag, who belonged to the Sasan clan living in the Fars region. In 205/206 AD, Pabag had successfully defeated the king of Gozihr of Istakhr (approximately 40 km from today's Shiraz) and wanted to install his son Ardashir I as king. The Parthian king of kings, Artabanus IV, could not tolerate this, perceiving his power to be in danger. Thus, conflict was inevitable. Behind this struggle there also lies a dispute between two groups: first, the Arsacids, who derived from the nomads having founded the Parthian Empire, and second,

the 'Iranians', to which the family Sasan belonged, living in Fars, the region formerly belonging to the Elamites.

However, Ardashir I, managed to capture areas of Mesopotamia – except Hatra – in around 220 AD, receiving support from the local rulers of Media Atropatene and Adiabene.[178] His uprising and victory against the last Parthian king, Artabanus IV, meant the end of the Parthian Empire. The era of the Sasanids begins with Ardashir I (Fig. 4.10). It remains to be noted, however, that various significant Parthian families, such as the Sūrēn, Kārēn and Mirhan families, still had great influence in the Sasanian Empire.

Notes

1 Strootman, R., 2018 (1): p. 142 ff. Strootman convincingly points out in his article that in the first phase one can not speak of a Parthian Empire.
2 Strootman, R., 2018 (1): p. 142.
3 Gregoratti, L., 2012 (1).
4 Assar, G.R.F., 2011.
5 Sinisi, F., 2012; e.g. De Callataÿ, Dąbrowa, Sinisi, Olbrycht, Wolski Overtoom; see also information on each separate king.
6 www.oeaw.ac.at/antike/forschung/documenta-antiqua/numismatik/sylloge-nummorum-parthicorum/.
7 See some of their works in the Bibliography.
8 I am thankful to Chris Hopkins, who allowed me to use his list (published on www.parthia.com), which I have revised in some details on the basis of new research (for more detail, see 8.1).
9 Justin 41.1.10–11.
10 Strootman, R., 2018 (2): p. 131.
11 Jacobs, B.: 2010: p. 39.
12 Overtoom, N.L., 2016: p. 988 ff.; 2020: p. 76 ff.
13 See: www.princeton.edu/~slaughtr/Articles/722_IntlRelPrincipalTheories_Slaughter_20110509zG.pdf.
14 Overtoom. N.L., 2016: p. 990. Jacobs, B., 2010: p. 31 ff. provides an extensive overview on different ancient writers, who describe the situation of the Parni.
15 Gregoratti, L., 2017: p. 117. Jacobs, B., 2010: p. 38 discusses the possibility that Andragoras was loyal to Antiochus II.
16 Olbrycht, M., 2003: p. 72 ff.
17 Justin 41.5.7–8.
18 Jacobs, B., 2010: p. 35. Polybios 10.28.7–29.1.
19 Jacobs, B., 2010: p. 41.
20 Assar, G.R.F., 2004: p. 77, gives 201 BC as the end of his reign.
21 Assar, G.F., 2005: p. 33.
22 The conquest of Parthia by the Parni may have taken place in 239/238 BC. The extent to which the founding date corresponds to the coronation date must remain open; see Jacobs, B., 2010: p. 39. See also: Lerner, J.D., 1999: p. 13 ff.
23 Note: even today Zoroastrians maintain a constantly burning fire in their houses of worship, which is regarded as sacred by them and can be supplied only by priests.
24 Assar, G.R.F., 2011: p. 114, gives the date 235 BC.
25 Justin 41.5.5–6.

26 Curtis, V.S., 2007 (2): p. 8.

27 Justin 41.5.6–8.

28 Assar, G.R.F. 2011: p. 116.

29 Justin 41.5.1; Thommen, L., 2010: p. 259; English translation at: www.forumromanum.org/literature/justin/english/trans41.html#4.

30 Assar, G.R.F., 2011: p. 174.

31 Assar, G.R.F., 2011: p. 116.

32 Assar, G.R.F., 2011: p. 116. Also: Overtoom, N.L.: 2019: p. 122.

33 Justin 41.5.9; Isidore of Charax (Jacoby, F., 1940).

34 Assar, G.R.F., 2005: p. 40 ff.

35 Assar, G.R.F., 2005: p. 36 ff.; also: Dąbrowa, E., 2014: p. 156, who gives the same dates for the reign.

36 Overtoom, N.L., 2019: p. 131 ff.

37 Overtoom, N.L., 2019: p. 133 f.

38 Strootman, R., Versheys, J., 2017: p. 192.

39 Jacobs, B., 2010: p. 54 f.

40 Jacobs, B., 2010: p. 48 f.

41 Strabo, Geographie 11.14.15. Jacobs, B., 2010: p. 49.

42 Plutarch, Sulla 5.8–11.

43 Livius, Periochae 70; Schippmann, K., 1980: p. 47.

44 Hackl, U.: 2010: p. 57.

45 Schippmann, K., 1980: p. 31.

46 Assar, G.R.F., 2011: p. 117: Assar dates the reign of Mithradates I (= Arsaces VI.) on the basis of the analysis of Babylonian cuneiform texts from 164–132 BC; Overtoom, N.L, 2019: p. 121 supports this. Dąbrowa, E., 2012: p. 28 gives 171–132 BC.

47 Overtoom, N.L, 2019: p. 133.

48 Gregoratti, L, 2018 (2).

49 van der Spek, R.J., 1998: pp. 207 ff.

50 Assar, G.R.F., 2005: p. 2 (online version).

51 Jacobs, B., 2010: p. 54, with further annotations: Mithradates I – and not, as is often stated, Mithradates II – already used the title 'King of Kings'.

52 According to Sellwood. Assar, G.R.F, 2006 (1): p. 88; 2011: p. 118 dates the reign of Phraates II (= Arsaces VII) from c. 132 to 127 BC; Dąbrowa, E., 2012: p. 28 give the dates as c. 132–126 BC.

53 Also written: Rīnnu.

54 Justin 38.10.2.

55 Schippmann, K., 1980: p. 27.

56 Justin 42.1.5; Olbrycht, M.J., 1998 (2): p. 87.

57 Sellwood, D., 1980: p. 54.

58 S 18, according to Sellwood, c. 127 BC; Assar, G.R.F., 2011: p. 176 calls him Artabanus II; Assar formerly identified this king as Bagasis.

59 Assar, G.R.F., 2011: p. 119. For this ruler, again different genealogies are given. Sellwood writes that Artabanus I is a son of Phriapatius, and thus a brother of Phraates I and Mithradates I. According to Assar, it is Artabanus III (= Arsaces IX) – period of reign: c. September/October 126 BC–October/November 122 BC). Assar postulates that he may have been a brother of Mithradates I, as on his coins the epithet 'ΦΙΛΑΔΕΛΦΟΥ' – 'Who loves his brother' – is found.

60 Justin 42.2.2.

61 Assar, G.R.F., 2011: p. 120.

62 Schuol, M., 2000: p. 299.

63 Sellwood, D., 1980: p. 63; Justin 42.2.3–6 and 42.4.1–4.

64 Assar, G.R.F., 2005: p. 36 ff.; also: Dąbrowa, E., 2014: p. 156, who gives the same dates for the reign.

65 Huber, I., Hartmann, U., 2006: p. 485 ff.

66 Hackl, U., 2010: p. 57 points out that 'It may have been a precautionary action to secure their spheres of interest'.

67 Hackl, U., 2010: p. 56 ff.

68 Jacobs, B., 2010: p. 55.

69 Strootman, R, 2014: pp. 38–61.

70 www.parthia.com/gotarzes1.htm.

71 Assar, G.R.F., 2011: p. 121. See also: Hauser, S.R., 2016: p. 444.

72 Assar, G.R.F., 2006 (2): p. 68.

73 Assar, G.R.F., 2006 (2): p. 59.

74 Sellwood, D., 1980: p. 89.

75 Assar, G.R.F., 2005: p. 29; 2006 (2): p. 59.

76 Assar, G.R.F., 2005: p. 52 ff.; also Dąbrowa, E., 2012: p. 30, who does not rule out that Sinatruces was a son of Mithradates I.

77 Assar, G.R.F., 2005: p. 53.

78 Assar, G.R.F., 2006 (2): p. 90.

79 Schippmann, K., 1980: p. 37.

80 Overtoom, N.L., 2017 (2): pp. 20–21.

81 Sheldon, R., 2010: p. 1 ff.

82 Schippmann, K., 1980: p. 41.

83 Schippmann, K., 1980: p. 43; Mark Antony was in Greece at the time; he had sent his subordinate Ventidius Bassus.

84 Cassius Dio 54.8.2–3.

85 Schippmann, K., 1980: p. 50 f.

86 Hauser, S.R., 2016: p. 448 f.

87 According to Assar, Phraates III (= Arsaces XVII) reigned from c. 70/69 BC in Parthia, and from c. 67/66 to 58/57 BC in Babylon.

88 Assar, G.R.F., 2006 (2): p. 87 ff,; 2006 (2): p. 90 f.

89 Sellwood, D., 1980: p. 127.

90 Assar, G.R.F., 2006 (2): p. 96.

91 Schippmann, K., 1980: p. 36.

92 Cassius Dio, *Historiae Romanae* 40.16.1–3.

93 Pliny, *Naturalis historia* 6.47.

94 Plutarch, *Crassus* 33.2.

95 Schippmann, K., 1980: p. 40.

96 Schippmann, K., 1980: p. 43: Mark Antony was in Greece at the time; he had sent Ventidius Bassus.

97 Marcus Iunianus Iustinus, *Epitoma Historiarum Philippicarum* 42.4.16–42.5.1.

98 Hackl, U., 2010: p. 66; also: Strothmann, M., 2012: p. 91 f. See also: Nabel, J., 2017.

99 Wolski, J., 1989: pp. 221–227.

100 Hackl, U., 2010: p. 68.

101 Urania is the (Greek) goddess of the stars.

102 www.parthia.com.

103 Sellwood, D., 1990: p. 157.

104 De Callataÿ, F., 1994: p. 42.

105 Sellwood wrongly gives the year as 27 BC (www.parthia.com/tiridates1.htm).
106 Keller, D., 2010: p. 628 f.
107 De Callataÿ, F., 1994: p. 57.
108 Hackl, U., 2010: p. 67.
109 De Callataÿ, F., 1994.
110 Hackl, U., 2010: p. 66; also: Strothmann, M., 2012: p. 91 f.
111 Schippmann, K., 1980: p. 49. According to Tacitus, Vonones turned away from the Parthian traditions, which aroused the resistance of the Parthian nobility. Tacitus, *Ann.* 2.2.2–3.
112 Keller, U., 2010: p. 632.
113 Olbrycht, M.J., 2014 (2): p. 92 ff.
114 Gregoratti, L., 2012 (1): p. 129.
115 Gregoratti, L., 2012 (1): p. 129 ff.
116 Gregoratti, L., 2015.
117 Hackl, U., 2010: p. 69. His son was probably installed there as a governor; it is doubtful, if he received a coronation.
118 Hackl, U., 2010: p. 70.
119 Schippmann, K., 1980: p. 51 f.
120 Ehrhardt, N., 1998: p. 298 f.
121 Olbrycht, M.J., 1997: p. 91.
122 Gregoratti, L., 2013: p. 48.
123 Olbrycht, M.J., 1997: p. 84.
124 Olbrycht, M.J., 1998 (2): p. 161.
125 Olbrycht, M. J., 1997: p. 83.
126 Tacitus, *Ann.* 11.10.3.
127 Hackl, U., 2010: p. 71; Tacitus, *Ann.* 12.10.1–14.4.
128 Olbrycht, M.J., 1997: p. 95.
129 Sellwood, D., 1980: p. 220.
130 Sommer, M., 2005: 306 ff.
131 Hackl, U., 2010: p. 73.
132 Schippmann, K., 1980: p. 60.
133 Olbrycht, M.J., 1998 (3): p. 144.
134 Sinisi, F., 2012.
135 Sinisi, F., 2012: p. 11, Annotation 2.
136 Sinisi, F., 2012: p. 15 dates the reign from 51 to 79 AD.
137 Tacitus, *Ann.* 12.44; Plutarch, *Crassus* 32.1.6; see Olbrycht, J.M., 2014: p. 132.
138 Tacitus, *Ann.* 11.10; see Sinisi, F., 2012: p. 137.
139 Olbrycht, M. J., 1997: p. 81 ff.
140 Tacitus, *Ann.* 15.2.1.
141 Gregoratti, L., 2017.
142 Gregoratti, L., 2016 (1): p. 85.
143 Cassius Dio 63.4–5. English Translation: http://penelope.uchicago.edu/Thayer/E/ Roman/Texts/Cassius_Dio/62*.html.
144 Pliny, *Naturalis historia* 6.122.
145 Olbrycht, M.J., 1999: p. 73.
146 Sinisi, F. 2012. The earliest dated coins of Vardanes II date from June 55 AD (according to Sellwood the earliest date is November 55 AD = S 69.1).
147 Sinisi, F. 2012: p. 16. Attributed by Sellwood to Vardanes II.
148 Sinisi, F. 2012: p. 150.

149 Olbrycht, M.J., 1999: p. 69 ff.; also Sinisi, F., 2012: pp. 11 and 165 ff.

150 Olbrycht, M.J., 1999: p. 69 ff.; also Sinisi, F., 2012: pp. 11 and 165 ff.

151 Sinisi, F., 2012: p. 15 indicates that Pacorus II already ruled from 75 AD, as well: Olbrycht, M.J. 1999: p. 91.

152 Olbrycht, M.J., 1999: p. 90.

153 Thommen, L., 2010: p. 46.

154 Olbrycht, M.J., 1999: p. 90.

155 Olbrycht, M.J., 1999: p. 90.

156 According to Assar, G.R.F., Artabanus III should be called Artabanus V (Assar 2011: p. 147 f.); Sinisi, F., 2012 still calls him Artabanus III (p. 11, p. 175 ff, plate 73). Sellwood, 1980, gives his reign as c. 80–90 AD.

157 Sinisi, F., 2012: p. 178.

158 Olbrycht, M.J., 2015: pp. 215 ff.

159 Schippmann, K., 1980: p. 65.

160 Sinisi, F., 2012: p. 199.

161 Schippmann, K., 1980: p. 61.

162 Thommen, L., 2010: p. 123.

163 Assar, G.R.F., 2006 (2): p. 59. According to Assar, the coins S 82 are assigned to Mithradates V, because the numbering has changed due to the insertion of another ruler of this name (Mithradates III = Arsaces XIV, see Table 8.1).

164 Sellwood does not give a numbering for the unknown kings; the numbering is based on the parthia.com site.

165 Thommen, L., 2010: p. 461.

166 See: www.parthia.com, under Vologases IV.

167 Schippmann, K., 1980: p. 65.

168 Schippmann, K., 1980: p. 65.

169 Hackl, U., 2010: p. 75.

170 Hackl, U., 2010: p 76.

171 Jacobs, B., 2010: pp. 168–173.

172 Schippmann, K., 1980: p. 73. The battle probably took place in the area between present-day Isfahan and Nihavand.

173 Sellwood, D., 1990: p. 157.

174 Weber, D., 2010: p. 638 f.

175 Wiesehöfer, J., 1998 (1): p. 205. For more about the lineage of Ardashir, see: Daryaee, T., 2010: p. 243 ff.

176 Daryaee, T., 2010: p. 241.

177 Schippmann, K., 1980: p. 74.

178 Dąbrowa, E., 2012: p. 38.

4

THE STRUCTURE OF THE PARTHIAN EMPIRE

In trying to get closer to the structure of the Parthian Empire, perhaps better named the 'Parthian Commonwealth' (see below), we again face the lack of sufficiently secure knowledge. When the Parthian Empire flourished it consisted of many small kingdoms that had to be integrated into the state. This was a major challenge for the Parthian central power, as the population in the various parts of the kingdom was ethnically, linguistically and confessionally very heterogeneous.

Only in recent decades have historians increasingly focused on the Parthians. In the 19th and early 20th centuries information about the Parthian Empire was mainly dominated by the view created by Roman and Greek writers. As shown in 1.3 – 'Ancient sources – historical truths or distorted images?' – these sources did not always provide a true historical picture. Over recent decades, the view has changed. L. Gregoratti, an Italian historian, states that 'The Parthian Empire, a state lasting for five long centuries, has in recent years slowly emerged from the shadow of history to regain its cultural and historical identity'.[1] It became clear that the term 'empire', for an aggregate of nations or people ruled over by an emperor, does not exactly match the structure of the Parthian state. Historians therefore now speak of the 'Parthian Commonwealth'. Similarly, Gregoratti also uses the epithet 'Parthian confederation' or 'network empire' to achieve a more differentiated approach to the structure of the Parthian Empire.[2] For reasons of simplification, the term 'Parthian Empire' is mostly used throughout in this book.

To successfully dominate such a great empire, the central authority needed to be prepared to grant its kingdoms or vassal states a greater or lesser degree of autonomy, for instance in questions of religion, culture or administration. In the initial phase of the empire, the defeated local kings continued to rule under the supervision of the Parthian king. Later they were replaced by relatives of the royal house. Likewise, after the conquest of an area, it was necessary to take over its

administrative organisation.[3] It was crucial that the local kings were tributary to the king of kings. In the event of war, they also had to provide soldiers for the army of the Parthian king of kings.

On the one hand, as Parthian history shows, this central government was fragile, with numerous counter-kings or uprisings among local rulers, for instance, from Characene or Elymais. If necessary, the balance of power was restored through the active intervention of the Parthian army. On the other hand, the fact that the Parthian Empire lasted for almost 500 years shows that this challenging task was dealt with amazingly well by the Parthian kings.

4.1 The king

The founder of the Parthian Empire, Arsaces I, refers to himself on coins as 'ΑΥΤΟΚΡΑΤΟΡΟΣ', an 'autocrat', while Mithradates I uses the epitaph 'ΒΑΣΙΛΕΩΣ ΜΕΓΑΛΟΥ', meaning 'great king'. Use of 'ΒΑΣΙΛΕΩΣ ΒΑΣΙΛΕΩΝ' on their coins, meaning 'king of kings', an epitaph starting from Mithradates I onwards,[4] involved a clear political statement: the Parthians claimed the succession of the Achaemenids, but also of the Seleucids, and embodied them in their claim to power.

The Parthians had a dynastic order of succession: with a few exceptions the kingship was passed on solely within the family of the Arsacids. Coronation rights were exercised by the heads of certain Parthian clans, such as the Kārēn family and the Sūrēn family, from which Surena was born, the later Parthian general, who won the Battle of Carrhae against the Romans in 53 BC. However, this right to a coronation cannot be regarded as an actual suffrage; as a rule, it was a formal confirmation of acceptance.

In times of crisis, the royal council (synhedrion) mentioned by Strabo, which consisted of the relatives (syngeneis) of the king as well as of wise men (sophoi) and priests (magoi, see 11.1.2), could select or confirm the new king.[5] How much influence the nobility possessed was dependent on the power and personality of the king and/or the nobility. It remains to be noted, however, that the rule of the Arsacid family was never affected, however great the influence of the nobility might have been. This was the case during the reign of the Parthian king Artabanus II (c. 10–38 AD), when an intervention by part of the nobility, who feared that the king would achieve too much power, took place.[6] These nobles were not afraid to send legations to Rome and to promote support there. The Romans with the help of this Parthian faction succeeded in establishing Tiridates II (c. 35–36 AD) as king.[7] Ultimately, however, Artabanus II returned to power and Rome proved unable to gain lasting influence on Parthian politics.

In later times, there were clear rules regarding the distribution of dominions. First and foremost came the Parthian king of kings, who reigned over his crown lands, one of his headquarters being in Ctesiphon. As long as Armenia was under Parthian influence, its territory was handed over to relatives from the king of kings' own lineage.[8] In third place came the kingdoms of vassals, which were dependent

on the Parthian Empire, but had their own local kings. In addition, there was a fourth power, the large Parthian noble houses, which usually possessed land wherever their tribesmen settled. The power of the king of kings is considered minor in some earlier investigations, and the freedom granted to the regional kings was often interpreted as a weakness of the Parthian Empire. But the fact that the empire existed for almost 500 years suggests that this form of government was successful for a long period.

4.1.1 The ruler's image as an agent of propaganda

The way the Parthian kings displayed themselves on coins reflects how they wanted to be seen. Every Parthian citizen or merchant viewed this image of power every day when he or she handled these coins. It is therefore important to look at what messages the Parthian kings chose to send in terms of their image, clothes or weapons. Coins spreading the king's ideology can therefore be regarded as extremely effective propaganda in ancient times. Of further importance is what changes are to be noticed over time in the images of the kings. The next section therefore focuses on some of the iconographic aspects of Parthian coins. These permit conclusions to be drawn regarding political or religious changes over time.

4.1.2 The king's image – iconography on Parthian coins

4.1.2.1 Headgear

The Parthian rulers present themselves in different types of headgear: a bashlyk, a diadem or a tiara. The bashlyk (Fig. 4.1 A) is a cap made of leather or felt, which has two long laces, hanging open to the front on both sides of the neck. At the back, the bashlyk ends in a neck guard. A diadem is always tied to the bashlyk, the two ties hanging down the back.[9] The first rulers – from Arsaces I to Mithradates I – present themselves wearing a bashlyk, thus referring to their nomadic origin.

FIG. 4.1 A + B Arsaces II, AR drachm, S 6.1. He wears a bashlyk.
Inscription: ΑΡΣΑΚΟΥ, Arsaces. Original size: 16 mm, weight 4.01 g.

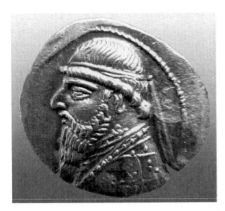
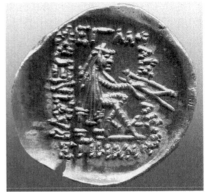

FIG. 4.2 A + B Mithradates II, AR drachm, S 26.1. He wears a diadem worn around the hair. Inscription: right: ΑΡΣΑΚΟΥ, above: ΜΕΓΑΛΟΥ, left: ΒΑΣΙΛΕΩΣ below: ΕΠΙΦΑΝΟΥΣ, [Coin of] the great king, Arsaces, the manifest. Original size: 21 mm, weight: 4.16 g.

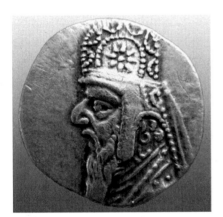
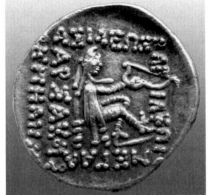

FIG. 4.3 A + B Mithradates II, AR drachm, S 28.1 variant. The king wears a tiara. Inscription: right: ΒΑΣΙΛΕΩΝ, above: ΒΑΣΙΛΕΩΣ, left: ΑΡΣΑΚΟΥ ΕΠΙΦΑΝΟΥΣ, below: ΜΕΓΑΛΟΥ, [Coin of] the great king of kings, Arsaces, the manifest. Original size: 20 mm, weight: 4.04 g.

4.1.2.2 Diadem – Greek and Iranian tradition

On the coin shown in Fig. 4.2, the Parthian king Mithradates II presents himself on the obverse with a diadem, the royal bandage, which was worn around the hair, ending in two diadem ties. Such a diadem is either worn alone, but also always worn in addition to the tiara (Fig. 4.3 A and Fig. 4.12 A) or the bashlyk (Fig. 4.4 A). J7The diadem is related to the Macedonian monarchy, where it was a sign of royal dignity. Thus, the diadem, with which the Parthians present themselves to the Greek population they now rule, refers to the Parthian succession of Alexander the Great. On the other hand, the diadem also has a long Iranian tradition. Not only

the kings of the Achaemenids, but also the kings of the Medes, wore a diadem.[10] Thus the diadem was regarded as a royal emblem not only by the Greek population, but also by the Parthians. Furthermore, it also was an emblem of the power that the Parthians now possessed. Please note, that on the reverse, the archer is still shown with a bashlyk, denoting nomad heritage.

4.1.2.3 Tiara – the headgear of rulers in Eurasia

Mithradates II (c. 121–91 BC) was the first Parthian king to present himself on his coins either with a diadem (S 23 – S 27) or with a tiara (S 28, S 29). A diadem is also always tied around the tiara (Fig. 4.3 A + B) as it is around a bashlyk. The rulers of nomadic peoples of Eurasia wore such tiaras, which were often decorated with embroidery and pearls. One can imagine that Mithradates II deliberately presented himself with a diadem, and on other coins with a tiara, as it is a clear confession of his nomadic origin, but also a recognition of the Greek side. From Mithradates II onwards, a tiara was also worn by his successors Gotarzes I, Orodes I, Unknown King I, Siatruces, Darius and Phraates III (c. 70–57 BC). From then on, the Parthian kings present themselves for the next 100 years only with a diadem. The tiara was then reintroduced by Vonones II (c. 51 AD) and sometimes worn by his successors.

4.1.2.4 Clothing: kandy, cloak of the Medes and Persians – chlamys, a Greek cloak – Parthian clothing, tunic and trousers

Political changes in the Parthian Empire can also be discerned from the clothing in which the kings present themselves on their coins. On the obverse of one of Mithradates I's coins (Fig. 4.4 A + B), the king is shown beardless, wearing a bashlyk with a diadem tied around it. On the reverse, a beardless archer sits right on an omphalos, holding an asymmetrical reflex bow in his right hand. He too is wearing a bashlyk, around which a diadem is tied. Thrown over his shoulders is a kandys, a long cloak – the sleeves are empty and hang down loosely, the cloak ending at the top of the omphalos. As the Medes wore such a cloak, this image suggests that the Parthians employed it to demonstrate their relationship with the Medes and the Persians.

Having established their empire for nearly 100 years, the Parthians adopted parts of Greek culture. Mithradates I (c. 165/4–132 BC) presents himself in Greek clothing: he wears a chlamys, a Greek cloak, the free ends fixed on the shoulder with a brooch (Fig. 4.5 A + B). A political motivation can be assumed to be behind this deliberate choice. The new rulers had subjected a Greek population and tried to assure it of their support by wearing Greek clothing and calling themselves 'ΦΙΛΕΛΛΗΝΟΣ', friends of the Greeks, an epitaph used on many Parthian coins.

Later, Parthian kings present themselves in Parthian clothing, thus demonstrating that Greek influence has subsided and that they self-confidently consider themselves an independent empire. Typical of this style is a combination of

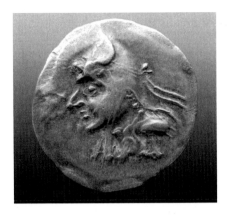
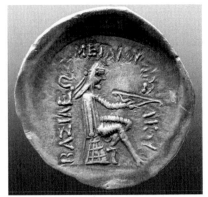

FIG. 4.4 A + B Mithradates I, AR drachm, S 10.1. He wears a bashlyk, around which a diadem is tied. Inscription: ΒΑΣΙΛΕΩΣ ΜΕΓΑΛΟΥ ΑΡΣΑΚΟΥ, [Coin of] the great king, Arsaces. Original size: 20 mm, weight: 4.25 g.

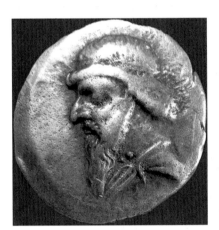
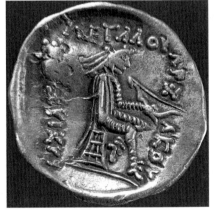

FIG. 4.5 A + B Mithradates I, AR drachm, S 11.1. He wears a chlamys, a Greek cloak, the free ends fixed on the shoulder with a brooch. Inscription: ΒΑΣΙΛΕΩΣ ΜΕΓΑΛΟΥ ΑΡΣΑΚΟΥ, [Coin of] the great king, Arsaces. Original size: 19 mm, weight 3.88 g.

a long-sleeved tunic with baggy trousers, somewhat comparable to trouser suits worn nowadays. The two front panels of the tunic, forming a V, overlap and are closed by a belt (Fig. 4.6 A + B).[11] See also the bronze sculpture of the 'Prince of Shami' (Fig. 9.12).

The Parthian trousers were a garment typical of this equestrian people. The trouser legs were pushed into the shoes and retained by the shoelaces, as can be seen on Parthian coins (Fig. 4.7). These trousers were not a Parthian invention, but originated from the nomad tradition, as well-preserved wool trousers from around 1100 BC indicate.[12] The shoes of the Parthians were made of soft leather, without heels, sometimes embroidered with jewellery (Fig. 9.14).

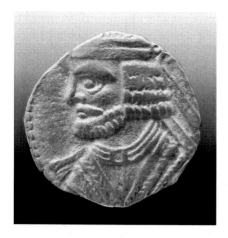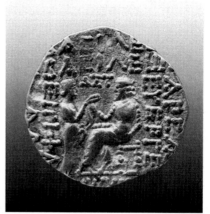

FIG. 4.6 A + B Vologases I (c. 51–79 AD), AR tetradrachm, S 68.9. Obverse: the front panels of the tunic form a V. Reverse: the king is dressed in Parthian clothing, a combination of a long-sleeved tunic with baggy trousers. Inscription: between the heads: $\Delta\ \Xi\ T$ ($\Delta = 4; \Xi = 80; T = 300 \rightarrow 384$ Seleucid era (minus 312 = year zero Seleucid era) \rightarrow 72/73 AD). No month given on this coin. (October 72 AD beginning of the reign, which ends in September 73 AD). Original size: 28 mm, weight: 14.46 g.

FIG. 4.7 Detail of a coin of Phraates II, S 16.11. Parthian trousers. The shoelaces, especially clearly seen here on the left foot, fix the trouser legs in the shoes.

4.1.2.5 About the royal wart

From the time of King Orodes II (c. 57 BC) onwards, over a period of roughly 100 years, the Parthian kings present themselves with a 'royal wart' on the forehead. The last king shown with such a royal wart on his coins is Vardanes II (c. 58 AD). The wart probably served as an outward sign of belonging to the royal family. Two probable causes for the presence of such warts have been debated.[13] First, the wart could

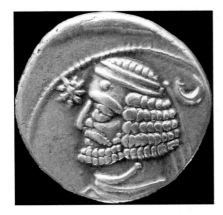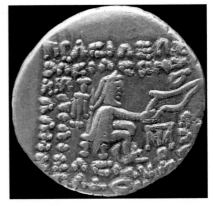

FIG. 4.8 A + B Orodes II (c. 57–38 BC), AR drachm, S 47.31. Obverse: bust facing to the left, royal wart on the forehead. Reverse: archer facing to the right, behind the archer an anchor. Inscription: S 47 iii. Mint: Mithradatkart. Original size: 20 mm, weight: 3.97 g.

be a special variety of an autosomal dominant hereditary form of neurofibromatosis, a non-cancerous disease. On the other hand, a dominantly recessive inherited trichoepithelioma, which is a benign tumour, has also been suggested. The royal wart is not always visible. Gotarzes II (c. 40–51 AD) is presented without a royal wart, but under the tiara appears a lock of hair, which, it is assumed, is intended to mask the wart (Fig. 9.22 A).

4.1.2.6 Omphalos

On coins of Mithradates I and his successors, Phraates I, Artabanus I and Mithradates II (S 23 – S 25), the archer, who is supposed to represent the founder of Arsaces I, sits on an omphalos, the navel of the world (Fig. 4.9). Among the Greeks, the omphalos was a sacred stone, erected in the Temple of Apollo in Delphi, being the cultic link between heaven, the world and Hades.[14] There is a similarly cultic site in Rome, the Umbilicus Orbis, the navel of the world, located in the centre of the Forum Romanum. It is interesting that the Parthian king himself is sitting on an omphalos, and not the god Apollo, as is familiar in the coin images of the Seleucids. In this regard we see that the Parthians are turning away from Greek religion (more information on this is provided in Chapter 11).

4.1.3 Investiture of the kings

Illustrations on coins (Figs. 4.12 and 4.13) or reliefs (Fig. 4.10) show that the Parthian kings were installed in their office by gods who presented to them a ring, a diadem or a wreath. These so-called investiture scenes are not to be interpreted as one-time events in the sense of a coronation scene, for the king already carries the diadem as a sign of worldly power. Rather, the iconography refers to a permanent

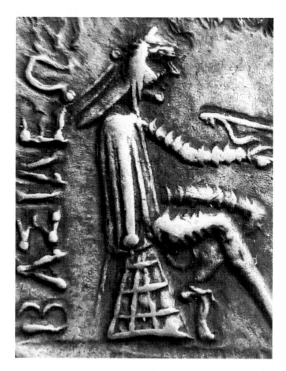

FIG. 4.9 Detail of a coin of Mithradates I, S 10.1. Archer sitting on an omphalos.

contract between the gods and the legitimate ruler, which must not be broken.[15] In this regard Iranian kingship, based on a Zoroastrian background, provides the likely context because the ring is a symbol of such contracts there. With the ring or the wreath, 'divine glory' and 'royal splendour' (*khvarenah*, see 11.1.10) are handed over by the *yazatas* (divine beings) to the legitimate rulers of the Parthians.[16] Such an investiture or inauguration legitimises the rule of the kings, confirmed by the gods, in the eyes of the people.

According to the Avesta, a collection of Zoroastrian religious texts, the Zoroastrian god Mithra is responsible for the observance of the treaties (see 11.1.5).[17] Investitures are made by the 'Parthian Tyche' or a Nike, symbolically also by an eagle (Fig. 4.11 A + B) or astral symbols, as shown in coins. The first indication of a divine investiture by a goddess, the 'Parthian Tyche', is found on coins of Phraates III (c. 70–57 BC), on which the goddess stands behind the king and holds a diadem over the head of the ruler (Fig. 4.12 A + B).

A new pictorial programme of investitures is shown on tetradrachms of Pacorus II, who sits on a horse and receives the diadem from the goddess Tyche standing before him (Fig. 4.13 B). Behind the goddess stands a man armed with a short sword who holds a kind of string with pearls in his hand. Sellwood calls this an 'untied diadem'. The possibility that this is a belt, which may also be a symbol of power, has also been discussed. It is most likely, as Sinisi suggests, that the untied

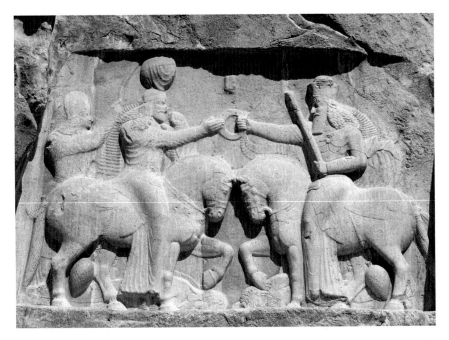

FIG. 4.10 Investiture of Ardashir I by Ahura Mazda (sitting on a horse to the right), rock relief, Naqsh-e-Rostam, Iran, dating from 28 April 224 AD. Beneath the horse-hoofs of the god Ahura Mazda lies his adversary Ahriman; under the horse of the victorious Sasanian king Ardashir I (left) lies the dead Parthian king, Artabanus IV.

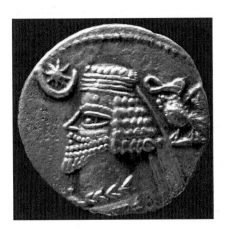
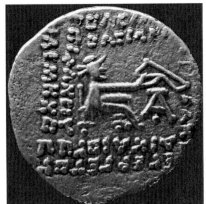

FIG. 4.11 A + B Phraates IV, AR drachm, S 54.7. Eagle invests the king with a diadem. Inscription: ΒΑΣΙΛΕΩΣ ΒΑΣΙΛΕΩΝ ΑΡΣΑΚΟΥ ΕΥΕΡΓΕΤΟΥ ΔΙΚΑΙΟΥ ΕΠΙΦΑΝΟΥΣ ΦΙΛΕΛΛΗΝΟΣ, [Coin of] the king of kings, Arsaces, the benefactor, the just, the manifest, the friend of the Greek. Original size: 19 mm, weight: 3.84 g.

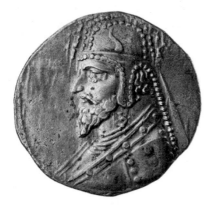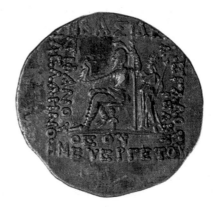

FIG. 4.12 A + B Phraates III, AR tetradrachm, S 39.1. Reverse: 'Parthian Tyche'. Inscription: ΒΑΣΙΛΕΩΣ ΜΕΓΑΛΟΥ ΑΡΣΑΚΟΥ ΘΕΟΥ ΕΥΕΡΓΕΤΟΥ ΕΠΙΦΑΝΟΥΣ ΦΙΛΕΛΛΗΝΟΣ, [Coin of] the great king, Arsaces, god (divine), the benefactor, the manifest, the friend of the Greek.

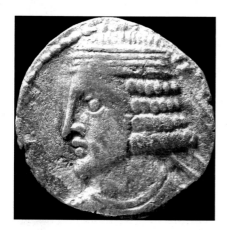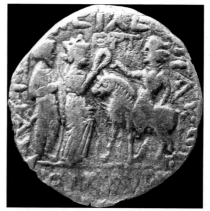

FIG. 4.13 A + B Pacorus II (c. 75–110 AD), AR tetradrachm, S 75.4. Investiture of the king. Inscription: parts of the inscriptions cannot be seen on this coin; the full inscription would be: ΒΑΣΙΛΕΩΣ ΒΑΣΙΛΕΩΝ ΑΡΣΑΚΟΥ ΠΑΚΟΡΟΥ ΔΙΚΑΙΟΥ ΕΠΙΦΑΝΟΥΣ ΦΙΛΕΛΛΗΝΟΣ, [Coin of the] king of kings, Arsaces, Pacorus, the just, the manifest, the friend of the Greek. Between the king and Tyche is the mint year: ΕΦΤ = 395 Seleucid era, which corresponds to 83–84 AD. Original size: 24 mm, weight: 12.52 g.

diadem indicates that the young king has not yet been given full power because he was still too young when he took office.[18] Sinisi also refers to the coinage of Artabanus III, who also receives such a diadem from the goddess Tyche. If one endorses Sinisi's theory, then it is quite conceivable that the man who stands behind Tyche is Artabanus III.

A similar scene is found on a relief in which the founder of the Sasanian Empire, Ardashir I, receives his investiture (Fig. 4.10). Instead of the goddess Tyche, an investiture may also be performed by an eagle, which presents a diadem in its beak to the king. This too is a reference to the Zoroastrian belief that the eagle is equated with the god Verethragna.[19]

4.1.4 Ancestral cult of the Parthian kings – were kings deified as gods?

Old Nisa is now 'generally interpreted as a great ceremonial centre dedicated to the glorification and celebration of the first Arsacids, the Parthian rulers',[20] and it is believed that Mithradates I had a place of worship built here for his father Phriapatius and his ancestors (Fig. 10.8).[21] However, when asked whether the kings were worshipped there as gods, the experts have no simple answer. One reason for this lies in the lack of Parthian sources, but another in the researcher's standpoint and on whether their assessments are based on a more Greek-Hellenistic or more Iranian, eastern perspective.[22]

Two important types of evidence play a role in the discussion: the first is the archaeological findings of larger-than-life figures in Old Nisa in the so-called 'Round Hall' (Figs. 7.7 and 7.11; see 7.2.1). These findings have led both the Russian and Italian excavators to assume a ruler cult.[23] The second source of evidence is the inscriptions on Parthian coins with a religious context, which also need to be considered. The latter involves interpreting the terms appearing on Parthian coins, such as 'ΘΕΟΥ' ('God'), 'ΕΠΙΦΑΝΟΥΣ' ('the appearance of God' or 'the epiphany') and 'ΘΕΟΠΑΤΟΡΟΣ' ('of divine descent/whose father is a god').

Dąbrowa, in his publication 'The Arsacids – Gods or Godlike Creatures?', asks whether these terms are to be interpreted from the Iranian perspective of the Parthians or from the Greeks' Hellenistic viewpoint. In the Hellenistic-influenced west, so he feels, these terms could have been understood quite differently and thus could have resulted in equation with a ruler cult in which the king is deified.[24]

In the religious system of Zoroastrianism, in which the Parthians believed, the deification of kings would have been excluded. As explained further in Chapter 11, on Parthian religion, the *khvarenah* – God-given glory or fortune – was given to the king by the *yazatas* (divine beings) at the time of the king's investiture (11.1.10). This would contradict deification. As explained in section 11.2, at the time of Mithradates I's conquests of Mesopotamia, the representation of Greek deities on Parthian tetradrachms is detectable for a period of only about 20 years (c. 141–120 BC), after which no Greek deities were minted on tetradrachms for the next 50 years. Thus, it is unlikely that Mithradates I, who built the complex at Old Nisa, had turned to the Greek faith or even accepted it. Thus, the presence of larger-than-life statues could probably be explained through an Iranian perspective, which would imply that in Old Nisa only a glorification and celebration, but no deification, of the first Arsacids took place. Further investigations might enable us to obtain a clearer picture.

4.2 The nobility

Parthia had several distinguished noble families. In Roman writings, for example by Justin,[25] the word 'nobles' is used as a collective term, without it being apparent which rank or which group membership is meant. The best-known are the family Sūrēn, which ruled in the Seistan area (south-east region of today's Iran/south-west Afghanistan), the family Kārēn, which was based in Media (in the area of the Zagros-Mountains/Iran), and the family Mihran, whose properties were in the Ray region (near today's Tehran). From the early days of the Parthian Empire, the influence of the noble family Sūrēn is tangible, as in the coronation rights described above (4.1).

Evidence of the existence of nobility can also be found in the army, which included 400 *liberi*, who were free knights and probably belonged to the lower nobility.[26] The question of what influence nobles had on the election of the successor to the throne has been already discussed in 4.1, above. These noble families received large portions of land as fiefs from the king. But they also had an obligation to provide the king with military support if necessary. In the third phase of the Parthian Empire (c. 70 BC–51 AD), there was a considerable accumulation of succession conflicts, which often ended in a political murder (see the list of murders at the beginning of 3.3). At least three murders are likely to have been due to the direct influence of the nobility. This is the case with Phraataces, Orodes III and Vardanes I.[27] According to literary sources the Parthian kings Phraates III, Orodes II, Phraates IV and possibly Vonones I were murdered by their sons or brothers. However, that the political influence of the nobility played a part cannot be ruled out.

From Vologases I (c. 50/51–79 AD) onwards, the influence of the nobility on the royal house diminished. The Arsacid royal family increasingly succeeded in putting provinces under its direct influence, placing its own family members in the most important positions. Thus, Vologases I proved his political skill by giving Armenia to his brother Tiridates and the throne of Media Atropatene to his other brother Pacorus. Owing to lack of sources, the question of which powers remained accessible to the nobility, despite this power shift, cannot be conclusively answered.

4.3 The Parthian army – standing army – Parthian shot

The wars between the Romans and the Parthians are legendary. But what are the reasons for the Parthians' success in the 1st century BC? Why was Rome unable to defeat the Parthian Empire? How did so many battles end in favour of the Parthians? But then why in the 2nd century did the Romans initially succeed in reaching the capital Ctesiphon, without any problems and encountering relatively little resistance from the Parthian army? What had changed?

Already in their battles against the Seleucids, it transpired that the Parthians had a better fighting technique, without which the emergence and development of the Parthian Empire would not have been possible. One of the main reasons for their success against the Romans is that the Parthian army was a cavalry army superior

to the Roman army in its tactics and armaments. Cassius Dio's[28] descriptions of the Battle of Carrhae in 53 BC show that Crassus entered the war with an army of approximately 40,000 soldiers, including 4000 riders. The Parthians, however, fought with about 40,000 horsemen – the light cavalry – and about 10,000 heavily armed riders (cataphracts). By confining their force almost only to horsemen, the Parthians were faster and more mobile than the Roman army.

The Parthians' first tactic in this battle was to attack the Romans with a massive hail of arrows from the light cavalry; many Romans were wounded or killed. The second tactic was the use of cataphracts: the Parthians separated parts of the Roman army that could then be attacked by the light cavalry. The third tactic was a technique later referred to by historians as the 'Parthian shot': the Parthian riders would simulate a retreat after an attack, let themselves be assaulted by the Romans, and then suddenly turn around, on horseback, and fire masses of deadly arrows at the pursuing enemies.

Another reason for the superiority of the Parthians was the tactical ability to provide sophisticated supplies for the troops and in particular to ensure the supply of weapons. It is reported that about 1000 camels transported an almost endless supply of arrows. By the end of the first day of the battle, 10,000 Roman soldiers had already been killed. Afraid of being captured by the Parthians, Publius Crassus, a son of Crassus, who was wounded seriously, was killed by his own servant. With Crassus no longer capable of leading them, the Roman commanders retreated to Carrhae in the night but lost further soldiers as the Parthians continued to pursue them. In this hopeless situation, part of the Roman army retreated. Crassus was killed during the negotiations with the Parthians, but it is not quite clear how this happened. In this battle at Carrhae, 20,000 Romans were killed and many others seriously injured. Ten thousand Romans were captured and taken to Merv (also called Merw, in today's Turkmenistan, near the city of Mary), where they had to perform the construction of a huge defensive wall that may still be seen today.[29]

Scientists have long discussed the question of how, in the 2nd century AD, the Romans managed to reach the capital Ctesiphon in a relatively short time and without much resistance. Many saw this as a weakness of the Parthian king.[30] It has even been proposed that the influence of the regional kings and the nobility, who had huge estates, had grown over time and thus weakened the king's central power.

In the meantime, a different perspective has taken hold.[31] Over time, the Parthian king of kings had succeeded in increasingly transferring control of the vassal states to their own Arsacid relatives, thereby strengthening their own influence. However, the large number of kingdoms that were subordinate to the Parthian king of kings only had local armies. There was no standing army for the Parthian Empire as a whole.

In the event of a major war, when there was an attack on the entire empire, soldiers had to be called to the army from their agricultural work, which of course took time. The individual Parthian kingdoms were primarily responsible for their own defence, because especially in the western border areas close to the Roman Empire there would certainly have been more minor armed conflicts than we learn

from Roman reports. The same would also apply to the eastern regions, but due to the lack of information we are dependent on even more speculation. Only when it became evident that not only a local war had broken out, but that the entire Parthian Empire was under attack (Trajan from 114 to 117 AD; L. Verus from 162 to 166; Septimius Severus from 195 to 198 AD; Caracalla from 216 to 217 AD), did the king of kings intervene.

It must also be recognised that in the Parthian Empire long distances had to be covered in order to convey relevant militarily messages. This cost time, which was lacking when larger troops were needed for defence. Thus, although sources reveal that the power of the Parthian king of kings was sufficient to persuade local kings and the nobility to form a common army, the course of history shows that the Parthians were initially overrun by the Roman army, but after a short period and the formation of an army they were able to repel the attacks.

4.3.1 War tactics – light cavalry – cataphracts – elephants

Information about the Parthians' weapons technology and the weapons they used is derived from the reports of Roman writers, on the one hand, and from illustrations on rock reliefs, statues, frescoes and coins, on the other. Armoured riders are known about especially from the Sarmatians, but also from the Scythians, the Saka and the Kushans.[32] The weapons the Parthians used traditionally derived from the nomadic peoples of Eurasia.

The Parthian army consisted of larger and smaller units: about 10,000 soldiers were commanded by a *spadpat* or *spāhbed*. The next smaller unit (*drafš*) consisted of 1000 soldiers each, which in turn consisted of ten units of 100 soldiers each (*wašt*).[33] Accounting for about 75 to 90 per cent of the total, the light cavalry constituted the main component of the army. The riders were armed with composite bows, with which they could shoot arrows up to 150 metres, which even then still achieved effective penetration. A large number of reserve horses were available for exchange, so that the Parthian attacks could always be carried out with fresh horses. The horses were specially bred and thanks to their endurance and speed were superior to others and key to Parthia's military superiority. Because of their military successes, the Parthians stuck to their war tactics until the fall of their empire. Thus, the wars were waged with armed horsemen, and Roman military tactics were not adopted.[34]

The cataphracts, armoured riders, were a special unit in the Parthian army. The horses were protected by armoured blankets and the riders wore metal scale armour (Figs. 4.14 and 4.15). Their weapons were on the one hand extra-long lances, but they also carried long swords, with which they fought from the back of their horses. With this heavy cavalry, the Parthians tried to break through opposing lines and separate out individual sections of the army that could then be attacked more easily with the light cavalry.

Equipped with significantly fewer riders, the somewhat immobile Roman army could do nothing against such a tactic. The Roman army quickly realised that

FIG. 4.14 Cataphract, graffito from Dura-Europos. M. Rostovtzeff, L'Art gréco-iranien, Revue des Arts Asiatiques 7, 1931–32, panel. LXIV.

FIG. 4.15 Sarmatian cataphracts, detail of Trajan's column, Rome, completed 113 AD.

FIG. 4.16 Riding Parthian with lance, Gotarzes relief, Bisotun, Iran. An inscription refers to Gotarzes, the son of Gew.

Note: Merkelbach, R., Stauber, J., 2005: p. 66 ff.

cataphracts played a key role in the war. At the latest from the 2nd century, Oriental mercenaries, trained as cataphracts, were therefore added to their own army.[35]

Only a minor part of the Parthian army consisted of foot soldiers. These were used to initiate the attack on the opposing army with a hail of arrows. Later, the number of infantry would have increased proportionately. It is reported that Vologases II (c. 135/136 AD) used 20,000 foot soldiers in the battle against the Sarmatians. This seems incredible.[36]

The riders in the Battle of Carrhae were supplied with an enormous number of arrows, which were transported by about 1000 camels. Lost arrows were collected after the battle and could be re-used. A unique feature of the Parthian army were the musicians who accompanied the soldiers on their military campaigns. They used large kettle drums that were tirelessly thumped. The sound from these drums was intended to wear down the opposing armies, a clever tactic of psychological warfare (see 9.6).

There are a few references to the use of elephants in the Parthians' wars. According to a report by Cassius Dio, the Parthian king Vologases I even rode into battle on an elephant.[37] However, such military use may have been rare. Hints are also provided by Parthian coins. Thus, an elephant is depicted on a Mithradates I coin (S 12.18), possibly a reference to the Parthian king's victory over Bactria.[38]

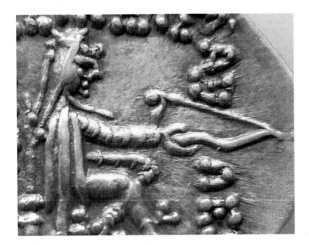

FIG. 4.17 Scythian asymmetrical composite bow, detail of a coin of Mithradates II, S 27.1.

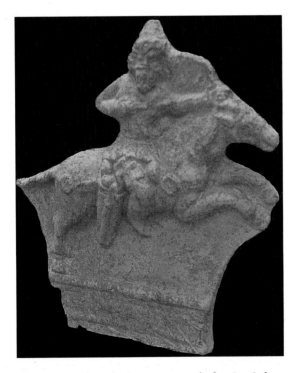

FIG. 4.18 Parthian archer on horseback, terracotta relief, c. 1st–3rd century. Inv. Nr. 1972,0229.1, British Museum, London. The archer is ready to fire his bow, a goryth hangs from the saddle and a four-lobed dagger is fixed to the right hip.

Even coins of later kings show elephants (Phraates II, Orodes II and Mithradates III). Why might Parthia have not used more elephants in their army? One of the main reasons might be that Parthia, separated from India by Graeco-Bactria, Tocharians, Indo-Scythians, Indo-Parthians and later the Kushans, had no direct access to trade for these animals.

4.3.2 Weapons – depictions of weapons – finds of real weapons

4.3.2.1 Bows and goryths (quiver and bow case)

One of the Parthians' most important weapons was the bow. Parthians used composite bows, made of a laminate of varied materials such as horn, wood and animal tendons. The tension of the bow was increased in this way, and their metal-tipped arrows could be fired 150 metres or more. Even at that distance, the arrows still had high penetrative force. Early on, a smaller bow, originating from the Scythians, was used by the Parthians (Fig. 4.17). Later, in the course of time, these bows were replaced by double-bent composite bows with strongly arched limbs.[39]

The Parthians used special cases (goryths) for carrying their bow and arrows while riding. Illustrations of such quivers can be found on some Parthian coins, on terracotta plates (Fig. 4.19) from Nisa, and on some of the terracotta cavalry figures (Fig. 4.18).

4.3.2.2 Four-lobed dagger

The Parthians wore four-lobed daggers, which were tied to the thigh by leather straps. Pictures of such daggers are to be found on coins (Fig. 4.20), belt buckles and reliefs. The 'Prince of Shami', the only over-life-size bronze sculpture so far found, also carries such a four-lobed dagger on both sides (Fig. 4.22). One of the most beautiful pictures of a four-lobed dagger from Parthian times can be seen on a stone relief of Antiochus I Theos (69–36 BC), the ruler of Commagene, who is shown with the God Heracles (located in Arsameia on the Nymphaios, today's south-east Turkey, Fig. 4.21).

Antiochus I, whose kingdom lay in the buffer zone between the Romans and the Parthians, acted astutely in his interactions with the two great powers, for instance, marrying his daughter Laodice to the Parthian king Phraates IV, who had defeated the Romans in the Battle of Carrhae (53 BC).

4.3.2.3 Short sword

Parthian rulers presented themselves wearing a short sword, thus demonstrating not only their power, but also the use of a more modern and effective weapon than a dagger. This change of depicting the king with a short sword began in the first half of the 1st century AD, starting with Vologases I (c. 50/51–79 AD) and succeeded

FIG. 4.19 Metope, terracotta, c. 2nd–1st century BC, find spot: palace of Nisa, Turkmenistan. National Museum of History, Ashgabat. This architectural element shows a goryth.

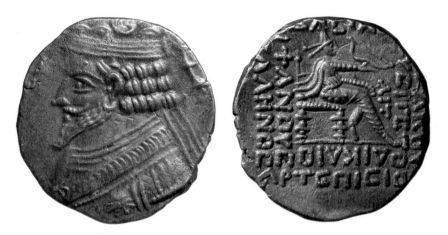

FIG. 4.20 A + B Phraataces, AR tetradrachm, S 57.4. Obverse: portrait of the king, the royal wart on his forehead. Reverse: the four knobs of the four-lobed dagger can be seen on the archer's right hip. Inscription: lower line: ΑΡΤΕΜΙΣΙΟΥ, 'April'; in front of the knees: ΑΙΤ (311 Seleucid era, corresponding to April in 1 AD).

Note: Since the year of reign was from October 1 BC to September 1 AD (the year zero does not exist) and the coin was minted in April, the coin dates from April 1 AD.

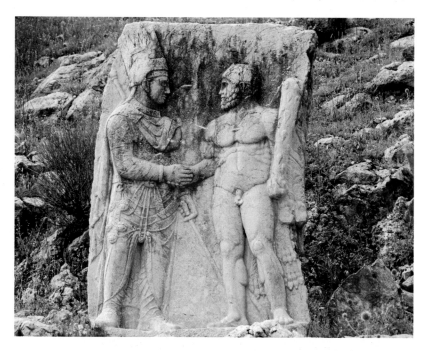

FIG. 4.21 Stone relief of Antiochus I Theos (69–36 BC) with Heracles, Arsameia on the Nymphaios, today's south-east Turkey. The king wears a four-lobed dragger on his right thigh.

FIG. 4.22 'Prince of Shami', with a four-lobed dragger at the right hip. National Museum of Iran, Tehran.

FIG. 4.23 Pacorus II (c. 75–110 AD), AR tetradrachm, S 73.2. Reverse: king seated, facing to the left, holding the handle of a short sword fixed to his belt.

FIG. 4.24 Remnants of the decorations of a shield, found during excavations in Nisa. National Museum of History, Ashgabat.

by Pacorus II, Vologases III, Vologases IV, Vologases V and Vologases VI. (Fig. 4.23). Images of long swords are not to be found on Parthian coins, but on numerous sculptures from Hatra (today's Iraq).

4.3.2.4 Shields

Only a few remnants of the decorations of shields used by the Parthians were found in Nisa (Fig. 4.24). Shields like the ones used by the Romans to protect them from arrows or sword blows were not used by the Parthians – their soldiers fought from the backs of their horses, so a shield would have been a hindrance for them.

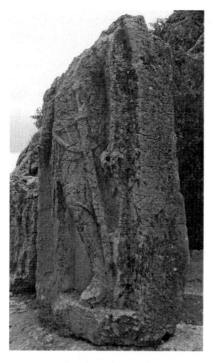

FIG. 4.25 King Mithradates I Kallinikos of Commagene with a long sword, relief stele from Arsameia on Nymphaios, today's south-east Turkey.

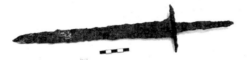

FIG. 4.26 Parthian long sword, find spot: Iran. Exhibition: National Museum of Iran, Teheran.

4.3.2.5 Long swords

Long swords were carried by the Parthian riders who fought from the backs of their horses. Being about one metre long, these were carried on the left hip and fixed with a carrying strap. Long swords are depicted on some reliefs and statues, dating from the 1st or 2nd century AD, but they were probably depicted only as insignia, not as real weapons. Thus, King Mithradates I Kallinikos of Commagene presents himself with a long sword on a relief stele (find spot: Arsameia on Nymphaios, Fig. 4.25). Further statues from Hatra, representing gods, kings or high representatives, show them wearing long swords (Fig. 7.21). Finds of Parthian weapons are extremely rare – so far only five long swords have been found in Iran (Fig. 4.26), their length varying between 74 and 92 cm.[40]

4.3.3 Parthian legionnaires in the service of Rome – Parthian soldiers on the Rhine?

Following devastating defeats at the hands of the Parthians in the 1st century BC, the Roman army would probably have felt compelled to deal with Parthian weapon technology and attack tactics. Thus it is not surprising that in the early imperial period the Roman army recruited experienced soldiers from the Oriental east, so that they could instruct the Roman soldiers.[41] Cassius Dio even relates that among the troops of the Roman general Quintus Labienus, fighting against the Second Triumvirate in 40 BC, were 20,000 Parthian legionnaires, who in support had been offered to him by the Parthian king Orodes.[42]

From the turn of the century several units in the Roman army bore the epithet 'Parthorum' or 'Parthica' in their name, thus referring to the Parthians. However, this did not necessarily mean that these troops consisted of Parthians. Rather, by using these epithets, the idea was to point out that these troops would be fighting against the Parthians. Nevertheless, there are a few indications that even soldiers belonging to the sphere of the Parthian Empire were present in these units and made their way to the Rhine, covering about 4000 km.

We know that the following units were stationed on the Rhine:

1 Ala Parthorum (c. 20 BC).[43]
2 Ala Parthorum Veterana, in Novaesium (today's Neuss, Germany), Beginning to middle of 1st century AD.[44]
3 Ala Parthorum et Araborum, in Mogontiacum (today's Mainz, Germany),[45] (c. 13 BC (?) – 68 AD).[46]
4 Equites singulares Augusti[47] (from 98 AD) in Mogontiacum (today's Mainz, Germany).

These four troops were equestrian units, as the names 'Ala' or 'Equites' show. They were one section of the auxiliary troops that represented a substantial proportion of the Roman cavalry at that time.[48] In the early imperial era, soldiers for the auxiliary troops were mostly recruited in their home countries. These equestrian soldiers brought with them experiences of war, in particular fighting on horseback, that the Romans lacked. Presumably, the Romans had drawn the relevant conclusions from the Battle of Carrhae that they lost against the Parthians. According to Alföldy,[49] the Ala Parthorum consisted of Parthian refugees. An important archaeological reference to a Parthian, Gaius Iulius, who served in the Ala Parthorum as decurion, can be found in an inscription from Dalmatia.[50] It was thought that he could be a son of the Parthian King Tiridates I (29–26 BC), but he is more likely to have been an exiled Parthian nobleman.[51]

Following attacks by the Germanic tribes and Rome's defeat in the Battle of the Teutoburg Forest (Varian Disaster, 9 AD), the aforementioned Ala Parthorum was probably moved to Novaesium in Lower Germany (today's Neuss, Germany). The only archaeological evidence found there was a signet ring dedicated to the

decurion of an Ala Parthorum Veterana.[52] Like Alföldy,[53] Rüger[54] assumes that the Ala Parthorum Veterana cavalry regiment was manned by Parthian refugees.

Another auxiliary force in Germania, which refers to the Parthians by name, is the Ala Parthorum et Araborum,[55] attested by two tombstones found in Mainz, Germany. It is believed that the Ala Parthorum et Araborum originated from the aforementioned Ala Parthorum Veterana.[56] The tombstones date from the middle of the 1st century AD. These are the gravestone of Antiochus, an officer in the Ala Parthorum et Araborum,[57] and the tombstone of Maris, a rider in the same Ala.[58] The name of this cavalry troop is explained by the fact that in addition to Parthian soldiers who may have emerged from parts of the Ala Parthorum Veterana – some of whose soldiers may have died in fighting – newly arrived 'Arab' soldiers, who came from the eastern Roman provinces or from the Mesopotamia area, served in the troop.[59]

Another possible indication of an Oriental presence on the Rhine is the relief found in Koblenz, Germany, which shows a servant dressed in Parthian-style clothes (Fig. 8.9). It is made of local limestone, evidence that it was not imported from elsewhere. However, we do not know exactly what this man holds in his hands or why this relief was erected. Another interesting find, which suggests the presence of people from the Parthian Empire on the Rhine, are the potsherds, which were found in today's Krefeld, Germany, in the Roman fort Gelduba.[60] On these potsherds graffiti in Old Assyrian script, which confines the origin of the scribes to the area of Osrhoene, were found. One potsherd is dated to 70–90 AD, a time when Osrhoene was a kingdom under Parthian influence. We do not know how they came to be in Gelduba; possibly they belonged to a Roman unit.

These few literary as well as archaeological traces seem to prove that soldiers from Parthia and/or Parthian-influenced Mesopotamia, reached as far as the Rhine. They presumably belonged to Roman equestrian units, some of them probably conscripted to fight against the Germanic tribes. The number of soldiers from these far-off areas, however, may have been low.

4.4 Administrative structure of the empire

Only a few Parthian sources give indications of the administrative structure in the empire. During the period of its greatest expansion at the time of Mithradates II (c. 121–91 BC), the Parthian Empire impressed outsiders as a great empire, but in fact it was divided into numerous kingdoms, vassal states or provinces. It can therefore also be assumed that the same structures did not initially prevail everywhere. It is known that after the conquest of various territories, the Parthians at least initially left the local dynasties in position, provided they recognised only Parthian sovereignty and paid their tribute. In other words, the Parthians relied on existing administrative structures and took over local staff. Not infrequently, promulgation of local mint law was associated with this. It was not until the reign of Mithradates II that members of the royal family acted as local kings, thus creating a system of family rule that was probably easier to control.

Owing to the lack of Parthian sources, it is difficult to get an idea of the administrative structure of the Parthian Empire. Conclusions on the Parthian administration could, however, be reached by comparison with familiar Persian and Sasanid structures. On the assumption that most of the Achaemenid administrative structures continued in Parthian times, and were found again in the Sasanian period, it is possible to draw cautious conclusions about the basic structure of an administration in the Parthian Empire.

Some conclusions about the Parthian administrative system have also mainly been made possible by linguistic comparisons. One example is the term *marzpān*, which is used on ostraca and on other written testimonies of the Parthians – a term that is found again as a relic among the Sasanids. It is presumably the name of a special group of nobles. The *marzpān* apparently had a very high dual military and civilian administrative function ('protector/guard of border areas'). In the ranking they were higher than the satraps and the *dizpat*, the fortress commanders. The Parthian satraps presumably held only administrative authority over a small district, whereas satraps appointed by the Achaemenids and the Seleucids administered large provinces. Parthian satraps are especially mentioned in connection with vineyards, but they also governed small provinces and districts bordering on big cities – in district administrations. The inscription on a stele found in Elymais tells us the name of the satrap Khawasak, who dedicated this stele to the Parthian king Artabanus, son of Vologases. The stele is dated 215 AD. There was also the office of leader or chief of the army. This office is often associated with the name *spāhbed*.[61] This title derives from the ancient Iranian language (*spāda-pati*/*spāda* = army, *pati* = master, chief), but then also became the surname of the noble family Spāhbed.

4.4.1 The Parthian language and the unification of administrative structures in the empire

The Parthian Empire was not a unified entity, but in its heyday covered a huge area with a highly heterogeneous population. Three main languages were important: Aramaic, Greek and Parthian. Aramaic was the universal language, the lingua franca, which was already established under the Achaemenids as an administrative and written language in the territory of Iran.[62] After the conquest of Greek-speaking areas of the Seleucid Empire, the Parthians were dependent on the regional administrative structures, and Greek remained their administrative language. This is revealed by Parthian coins on which Greek inscriptions appeared until the middle of the 1st century AD. More than 100 cuneiform tablets have survived from the Mesopotamian area, where Neo-Babylonian cuneiform writing was used. This dated back to the beginning of the 1st century BC.[63]

Parthian script was probably used in the eastern parts of the Parthian Empire from the time it was founded – see the inscriptions on the coins of Arsaces I and the ostraca of Nisa. During the 2nd century BC a change from the western to the eastern Aramaic language took place in the administration of the Parthian Empire. It remains unclear whether this was decided by a Parthian central administration or whether a gradual change took place in various sub-areas. Later, the Parthian

script and language prevailed. But only a few documents written in Parthian, such as the Avroman Parchment III, have survived.[64] In Parthyene, the region in which the Parthian Empire first developed, Parthian was the mother tongue. In that area it was also used in the administration alongside the Greek language.

With the expansion of the Parthian Empire, and thus the empire's encounter with the many languages of the conquered territories, however, a supervisory administrative structure had to be created in all parts of the empire, which in turn required a unified language. In the course of Parthian history, the Greek language and script were therefore replaced by Parthian. That the Parthians succeeded in establishing the Parthian language can be seen from the fact that Parthian scribes displayed a pronounced unity in grammar, spelling and expression in their texts, even if they worked in different areas of the empire.[65] This is deduced from stylistic and lexical similarities between the inscriptions of the Achaemenids and those from the early days of the Sasanids.

The Greek inscription on the stele of Artabanus II in Susa was possibly first written on parchment in Parthian, translated into Greek, and then carved in stone. The inscription is dated December 21 AD (Fig. 3.7).[66] There are a few direct references to Parthian scribes, who bear the Parthian name *dipīr*. Only one gem with a Parthian inscription and assignment to a scribe is known. It is now in a collection in the Bibliothèque Nationale in Paris. The Parthian scribes used the same administrative system as Achaemenid secretaries, who kept their writings in archives.

4.5 Parthian queens and marriage policy

Based on the study of Parthian sources, our knowledge of the political and the social status of women in the Parthian court is extremely tenuous. The documents from Avroman already mentioned, which are written in Greek on parchment, show us that, according to Zoroastrian law, the king was able to marry several women, as was the case with the Achaemenids, and later the Sasanids.

Marriage among relatives and even siblings was possible and permitted at the royal court: Mithradates II married his half-sisters Siake and Azate, who were begotten by the same father.[67] In the documents they are called 'Queen'. Orodes I married his sister Ispubarzā, who is called 'his sister, mistress/queen' in the cuneiform texts. Another cuneiform text informs us about Phraates III's mother Ištar, who is called 'mistress/queen' and about Piriwuštanā, who is called his 'wife/mistress/queen'. The extent of the queens' influence in the royal court can hardly be deduced from the few testimonies available. However, we at least know from a document written in 132 BC that Phraates II gave his mother Rīnu an important position at the court. The only queen depicted on Arsacid coins is Musa (c. 2 BC–4 AD), a Roman slave, who first married Phraates IV, but then murdered him and even married her own son Phraataces. Both are depicted on coins together (Fig. 3.6). Such a marriage was certainly an exception.

The harem was the central living room for the Queen Mother, the wives, sisters and daughters of the king, as well as for the female members of the court. To date, however, there is no archaeological evidence of separate rooms in Parthian

palaces, thus one has to be cautious with this term as our idea of a harem might be influenced by later knowledge of the Orient.[68] Even the concubines lived there. Concubines even had the opportunity of becoming the king's favourite wife, alongside the queen. Sons of relations with concubines could even become king, as is attested by Vologases I, who arose from Vonones II's relationship with a Greek concubine.[69] The decisive factor was that the father was of Parthian descent.

Parthian kings often had many children. Orodes II, for example, fathered a total of 30 children with various wives. It is understandable that in resolving the decision as to who should succeed the king, a considerable amount of wrangling must have occurred among the mothers of such a number of possible candidates. This could also mean that some children were killed. Fearing disputes over succession, Phraates IV – according to Roman writers – had killed all sons from his father's (Orodes II) marriage to Laodice, the daughter of King Antiochus I Theos from Commagene. Otherwise, these sons would have had a greater claim to the throne than his own son Phraataces from his marriage with Queen Musa.

In the 1st century BC several political marriages were made between the Parthians and the Hellenistic kingdoms of the Middle East, so that a dense network of relationships developed between the various kingdoms. This was the case with vassal states such as Commagene or Armenia, where the Parthian Empire wanted to broaden its political influence. Thus, Mithradates II married Automa, a daughter of Tigranes the Great of Armenia., who received the Parthian name Aryazate. The marriage in 93 BC between Tigranes and Cleopatra, a daughter of Mithridates IV Eupator of Pontus, created an alliance between Parthia, Armenia and Pontus, but one that was not to last long. Another example is Orodes II, who betrothed his son Pacorus with a princess from Armenia; he himself married Princess Laodice from Commagene.[70]

The earliest dynastic marriage of the Arsacids with the Seleucids was between Phraates II (c. 132–127 BC) and Laodice, the daughter of Demetrius II, who was captured by Phraates II in the conflict with the Seleucids. Although it cannot be ruled out that Phraates had also succumbed to the beauty of Laodice, it would equally have been based on a political calculation. Through the marriage, Phraates II hoped to increase his influence in Syria, arguing that it was defending his wife's rights.[71]

4.5.1 Clothing of women/of goddesses shown on coins

4.5.1.1 Chiton/himation/peplos

On the basis of sculptures from the Parthian period (especially from Hatra), the rhyta found in Nisa (Figs. 10.1–10.7) and in comparison with Parthian coins, which show only goddesses (Queen Musa being the only exception), one can draw conclusions about the clothes worn by the queens and women of the upper class.[72] As a general statement, it may be said that women's clothing shows a Hellenistic influence. We have no information about how normal Parthian women were dressed.

The goddess shown on coins of Mithradates II, the 'Hellenistic Tyche' (for further details, see 11.2.7) wears a chiton;[73] wrapped around the hips is a himation, a sort of shawl, one end being fixed to the shoulder (Fig. 4.27). In her right arm she holds a cornucopia, a horn of plenty, a symbol of abundance and nourishment.

FIG. 4.27 Mithradates II, AR tetradrachm, S 23.2. The goddess wears a chiton.

FIG. 4.28 Detail of a tetradrachm of Gotarzes II, S 65. "Parhian Tyche", wearing a chiton, presents a diadem to the king.

A chiton is assembled from two rectangular cloths, sewn as a sack on three sides, leaving open a section for the head. Below the breasts, the dress is laced with a ribbon. On statues from Hatra, women sometimes wear a peplos. A peplos is a body-length garment and differs from a chiton in that the upper portion of the dress embodies additional pleating of the cloth.

The most important goddess of the Parthians, the 'Parthian Tyche', is depicted during the investiture of the respective kings on tetradrachm coins (Fig. 4.28). She wears a floor-length garment (chiton), laced under the breasts, and a himation (Greek mantle cloth) is wrapped around the hips, one end of which is placed around the left arm, the other end hanging over her shoulder. In her left arm she holds a cornucopia as a symbol of fertility and wealth.

Notes

1 Different authors now use the term 'Commonwealth', e.g. Dirven, De Jong, Gregoratti, in: Dirven, L., 2013 (1); Gregoratti, L., 2018 (1): pp. 52–72.
2 *Webster's Encyclopedic Unabridged Dictionary of the English Language*, Portland House, New York, 1989, p. 468.
3 Jacobs, B., 2010: p. 97.
4 However, in a cuneiform text Mithradates I is also referred to as the 'king of kings', a title otherwise found only on the coins of Mithradates II. (Dąbrowa, E., 2008: p. 30, footnote 34). For the title 'king of kings' and its origins, see: Engels, D., 2014.
5 Strabo 11.9.3; Jacobs, B., 2010: p. 78, who concludes that 'the nobility had at least an affirmative function'.
6 Ehrhardt, N., 1998: p. 298 f.
7 Schippmann, K., 1980: p. 51 f.
8 Kettenhofen, E., 1998: p. 340.
9 Dąbrowa, E., 2008: p. 25.
10 Sinisi, F., 2012: p. 29 f.
11 Compare Pacorus II, Fig. 9.11. For this: Sinisi, F., 2012: p. 31.
12 www.sciencedirect.com/science/article/pii/S1040618214002808.
13 Don, T., 2008; Hart, G.D., 1973.
14 Pausanias 10.16.3.
15 Curtis, V.S., 2007 (3): p. 422 ff.
16 Curtis, V.S., 2012.
17 Curtis, V.S., 2007 (3): p. 422 ff.
18 Sinisi, F., 2012: p. 97.
19 Curtis, V.S., 2012: p. 71 f.
20 Lipollis, C., Davit, P., Turco, F., 2017: p. 2.
21 Phriapatius is also called Phrapatius.
22 Dąbrowa, E., 2014. This recently published article contains a wealth of information and many references to this topic.
23 Invernizzi, A., 2005; Lippolis, C.A., 2011 (1), p. 21 f.; Dąbrowa, E., 2009.
24 Dąbrowa, E., 2014.
25 Justin 41.2.1–2; for this Thommen, L., 2010: p. 253 f., states that the reading is controversial.
26 Hauser, S.R., 2005: p. 192 f.

27 Hauser, S.R., 2016: p. 447 ff.

28 Cassius Dio 40.22 ff.

29 Pliny, *Naturalis historia* 6.47.

30 Wolski, J., 1965.

31 Hauser, S.R., 2006: p. 306 ff.

32 Tang-e Sarvak, Fels III and Firuzabad. See: Vanden Berghe, L., 1984: Catalogue No. 32, Fig. 8.

33 Winkelmann, S., Ellerbrock, U., 2015: p. 153.

34 Overtoom, N.L., 2017 (1): p. 95.

35 Trajan received cataphracts from King Abgar VII, who reigned in Edessa, the capital of the kingdom of Osrhoene. In the 2nd and 3rd century AD, cataphracts from Osrhoene regularly served in the Roman army: see Winkelmann, S., 2009: p. 317.

36 Hackl, U., 2010: p. 73.

37 Cassius Dio 62.21.4; Jacobs, B., 2010: p. 110.

38 Daryaee, T., 2016: p. 40.

39 Winkelmann, S., Ellerbrock, U., 2015: p. 160 f.

40 Karamian, G., Farrokh, K., 2019.

41 Junkelmann, M., 1991: p. 102; Cassius Dio (48.24.5 and Appian 5.7.65) informs us that the Roman general Quintus Labienus received about 20,000 Parthian mercenaries from Orodes II.

42 Cassius Dio 48.24.5 and Appian 5.7.65.

43 Alföldy, G., 1968, p. 28.

44 Rüger, C.B., 1984: p. 45 f.

45 Maxfield, V., 1981: p. 173.

46 Chantraine, H. et al., 1984: p. 46 believes the Ala Parthorum et Araborum was stationed there before the middle of the 1st century.

47 Speidel, M.-P., 1965: p. 47 ff.

48 Junkelmann, M., 1991: p. 102.

49 Alföldy, G., 1968: p. 28 f.

50 CIL III 8746; translation and commentary: Thommen, L., 2010: p. 437; Kennedy, D.L., 1977: p. 522.

51 Kennedy, D.L., 1977: p. 523.

52 Chantraine, H. et al., 1984: p. 45.

53 Alföldy, G., 1968: p. 29.

54 Rüger, C.B., 1984: p. 45 f.

55 Herz, P., 1982.

56 Kennedy, D.L., 1977: p. 521 ff.

57 Tombstone of Antiochus, find spot: Mainz-Weisenau, Steinbruch, first half of the 1st century AD, Inv. No. 70/61, Landesmuseum Mainz.

58 Translation: Selzer, W., 1988: p. 158; FO Mainz, Kreuzschanze, first half of the 1st century AD., Inv. No. S 634, Kalksandstein aus Flonheim.

59 This supports the idea that the Ala Parthorum Veterana preceded the Ala Parthorum et Araborum.

60 Luther, A., 2009.

61 www.klassalt2.uni-kiel.de/Raxs_general.pdf.

62 Gzella, H., 2016: pp. 6–7.

63 See Böck, B., 2010: p. 1 ff.

64 Weber, D., 2010: p. 566.

65 Khurshudian, E., 1998: p. 169.

66 Thommen, L., 2010: p. 467 ff.; Weber, D., 2010: p. 569 ff.

67 A good overview to this theme is provided in: Madreiter, I., Hartmann, U., forthcoming.

68 Madreiter, I., Hartmann, U., forthcoming.

69 Huber, I., Hartmann, U., 2006: p. 496.

70 Dąbrowa, E., 2018: p. 80.

71 Dąbrowa, E., 2018: p. 74 ff.

72 Winkelmann, S., Ellerbrock, U., 2015: p. 197 ff.

73 For the distinction between the 'Hellenistic Tyche' and the 'Parthian Tyche', see: Ellerbrock, U., 2013 (1): p. 288 ff.

5

VASSAL STATES AND KINGDOMS UNDER PARTHIAN INFLUENCE

Parthian victories resulted in the development of vassal states or autonomous cities and areas on the fringes of the Parthian heartland. In the course of history, these became more or less directly dependent on the Parthian Empire or were subject to significant Parthian influence. The Roman historian Pliny the Elder (23/24–79 AD) reports that there were 18 kingdoms (*regna*) in the Parthian Empire.[1] Eleven of these empires were located in the northern part of the empire, from Armenia as far as the Scythians. The seven other kingdoms were in the south of the empire. Current knowledge suggests that these kingdoms or areas were dependent on the Parthian Empire: Osrhoene, Adiabene, Media Atropatene, Elymais, Mesene (Characene), Persis and Hatra. Hyrcania is considered another.[2]

The vassal states, which will be considered in more detail below, include Osrhoene, Gordyene, Adiabene and Media Atropatene (Fig. 5.1). Commagene (today's south-eastern Turkey), which was never a Parthian vassal state, is included here, as multiple cultural and religious Parthian influences are discernible there. Further south, in Mesopotamia we find the cities of Dura-Europos and Hatra, the capital of a small Arab kingdom, and in the south-west of the empire, the areas of Characene (Lower Mesopotamia) and Elymais. These areas on the periphery of the empire are of particular importance for research, since they provide most of the cultural evidence of Parthian influence, whereas testimonies in the central areas of the Parthian Empire are sparse.

5.1 The kingdom of Osrhoene

The kingdom of Osrhoene, with its capital Edessa, located in today's south-east Turkey and northern Syria, was one of the many small kingdoms that had arisen after the decline of the Seleucid kingdom. Most of the information about Osrhoene is derived from Roman authors, e.g. Tacitus or Cassius Dio. Edessa was expanded

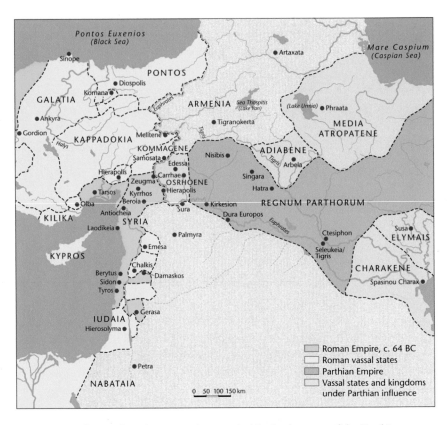

FIG. 5.1 Vassal states, kingdoms, provinces and cities in the west of the Parthian Empire, c. 64 BC.

into a military colony around 303 BC by Seleucus I Nicator (312–281 BC). The area around Edessa is historically significant: near this city lies the excavation area of Göbekli Tepe with cult sites that are about 11,000 years old. These sites have recently caused a stir, as they are home to some of the oldest religious cultural monuments in the world.

Owing to its geographical location, Osrhoene was a buffer zone between the states of Asia Minor, Armenia, Iran and Syria. It has always been an embattled region since it gave the rulers of Mesopotamia access to the mountainous areas of Armenia and Asia Minor via the most important crossing road in Seleucia at Zeugma on the bank of the Euphrates. It was similarly a well-known target for the Roman army when penetrating the Parthian territory.

By conquering the Seleucid king Antiochus VII Sidetes in 130/129 BC, Mithradates II (c. 121–91 BC) subjugated Adiabene, Gordyene and Osrhoene and made the Euphrates the western border of the Parthian Empire. Direct conflict with the Romans therefore became inevitable. Depending on their political situation, the kings of Osrhoene, the Abgarids, subsequently formed alliances with Parthians

or Romans and participated in the long-distance trade that extended across the Silk Road to China and north-west India and brought nomadic influences from Central Asia to the Near East. At the time of Mithradates II, Osrhoene was more or less a vassal state of the Parthians. About 100 years later Osrhoene, supported by the Parthians, was converted into a kingdom in 34/33 BC.[3]

The Parthians exercised no central power in Osrhoene, but tolerated a certain independence, whereby they were assured of both loyalty and probably the payment of appropriate tribute by the rulers they appointed. Parthian influence essentially survived until the 1st century AD. In the 2nd century AD, Parthian and Roman influences alternated. Following the wars between Septimius Severus (195– 198 AD) and the Parthians, Osrhoene became a Roman province.

5.2 The kingdom of Commagene

The kingdom of Commagene, with its capital Samosata (Samsat), lay in today's south-east Turkey on the upper course of the Euphrates. It never came under Parthian rule but reflects clear Parthian influence. The history of Commagene is characterised by its dependency on the Assyrians, the Babylonians, the Achaemenids and the Seleucids. Secluded from the usual theatres of war between the Romans and the Parthians, Commagene formed a sort of buffer region between the two great empires. It is a small, geographically favoured region known for its abundance of water, fertile valleys and rich mineral and ore resources, such as coal, iron, gypsum, silver and gold. In addition to these raw materials, it was above all its situation at the crossroads of numerous trade routes that established the wealth of Commagene. Thus, Commagene was connected by land and water with Edessa, Palmyra and Dura-Europos and, in turn, with the Silk Road.

Although Commagene was never the site of battle between the Romans and the Parthians, the country was an inevitable thoroughfare for the Roman troops on their way to the battlefields in Osrhoene and further on to Mesopotamia, as the area afforded good crossings over the Euphrates. Antiochus I Theos (69–36 BC) can be considered the most important king of Commagene, since he mainly governed his empire independently of Rome (Fig. 5.3). When he was besieged by the Romans under Pompey, he bought his freedom with cash derived from his country's ample customs revenues. Through negotiations with Rome in winter 65/64 BC, the city of Seleucia on the Euphrates (Zeugma) came under the rule of Commagene.[4] This extended the dominion of the small empire southwards.

The kingdom of Commagene reached its peak during the reign of Antiochus I. Construction activities and art reached their highest level in this period. Archaeologically and art-historically significant, the magnificent tombs for the members of the royal family (*hierothesia*) also date from the time of Antiochus I. These embody figures of gods and Dexiosis reliefs – Dexiosis: to give someone the right hand. The most famous tomb is that of Antiochus I on the mountain of Nemrud Dagh (Figs. 5.2 and 5.3). Significantly, in a first phase, the gods depicted here received only their Greek names: Zeus, Apollo and Artemis. In a second phase,

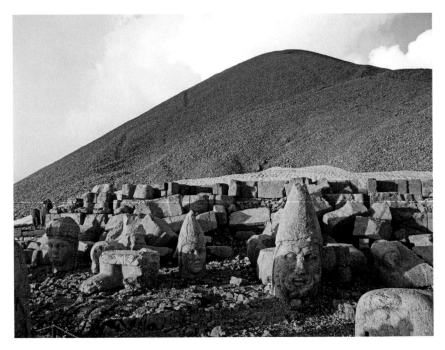

FIG. 5.2 Nemrud Dagh, Commagene (today's south-east Turkey, c. 2000 m altitude), view from the west terrace.

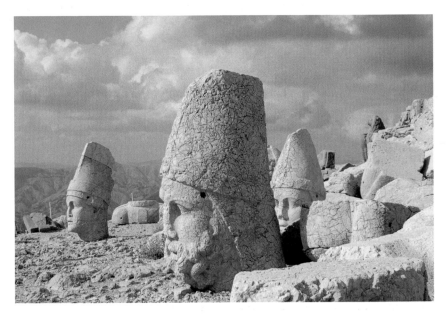

FIG. 5.3 Nemrud Dagh, Commagene (today's south-east Turkey), oversized heads fallen from their bases: left: Antiochus I; middle: Zeus-Oromasdes; right: Apollon-Mithra-Helios-Hermes, limestone, 1st century BC.

from c. 65/64 BC, the god figures then received Graeco-Iranian double names. Thus, Zeus is equated with Ahura Mazda – Oromasdes (also written Oromazdes). Heracles received his Iranian counterpart – Verethragna. Mithra found its Greek equivalent in the sun god Helios as well as in Apollo and in the god Hermes. In inscriptions, all four names are set in parallel: Mithra-Apollo-Helios-Hermes.[5] With the introduction of Ahura Mazda, Mithra and Verethragna, the influence of the Zoroastrian faith emerges.

On the reliefs, King Antiochus I is depicted in Parthian-influenced clothing, while the gods wear different garments: Heracles-Artagnes is naked, Mithra-Apollo-Helios-Hermes, however, is dressed in oriental clothing. The archaeological finds from Commagene thus provide a picture of the fusion of Hellenistic, Oriental and Iranian-Eurasian ideas. From 72 AD, Commagene became an integral part of the Roman province of Syria, with which Rome's eastern border was secured against the Parthian Empire.

5.3 Gordyene

Gordyene, a small area in northern Mesopotamia (north of Adiabene) on the border of today's Turkey, Iran, Iraq and Syria, was from 189 to 90 BC an independent area. Owing to conquests in the west by Mithradates II (c. 121–91 BC), Gordyene, as well as Adiabene and Osrhoene, came under Parthian influence. The Euphrates thus became the western border of the Parthian Empire. Around 95 BC, the Parthians made Tigranes II king of Armenia and in return received from him 70 Armenian valleys. This is mentioned by Strabo.[6] In later years, clashes between Tigranes II and Rome followed, and even the Parthian king Phraates III (c. 70–57 BC) was involved in these conflicts. Tigranes II eventually succeeded in making Gordyene independent from both the Romans and the Parthians. From the middle of the 1st century AD, Gordyene then came under Roman influence again, becoming a Roman vassal state and remaining within the Roman sphere of influence for the next three centuries. No significant archaeological finds from Parthian times have yet been recorded in this area.

5.4 Adiabene and Media Atropatene

Adiabene, located in the northern area of Assyria and east of the Tigris, was another *regnum* of the Parthian Empire. Throughout history it came under the influence of Armenia, Parthia and the Roman Empire. The most important city of Adiabene was Arbela, a city already populated by the Sumerians. According to ancient authors, Arbela was for a time the place where Parthian kings were buried – but recent investigations show that the graves found there belonged to a local dynasty.[7] Other important cities of Adiabene were Niniveh and Assur.

Our knowledge about Adiabene is scant.[8] Under Mithradates II (c. 121–91 BC), Adiabene, Gordyene and Osrhoene came under Parthian rule, remaining subordinate with brief interruptions until the end of the 2nd century AD. Little is known

about the rulers of Adiabene.[9] Izates I, king of Adiabene, reigned in the second half of the 1st century BC, and probably died in the first decades after this era. His son, Monobazos I was made king in c. 33/34 AD. Noteworthy is Queen Helena, wife of King Monobazos I, who converted to Judaism, as did the later kings Izates II and Monobazos II.[10] This is related to us by Flavius Josephus, a Roman-Jewish historian.[11]

Close relations with the Parthians can be assumed, because the Parthian king Artabanus II (c. 11/12–40 AD)[12] fled due to a revolt by the nobility in Adiabene, and sought protection there. Following successful mediation by Izates, Artabanus II returned to power in Parthia. In gratitude, Izates was awarded the city of Nisibis, thus extending the power of Adiabene. The Parthian king even granted him the right to sleep in a golden bed and to wear the upright tiara – which was probably the Parthian tiara – as a symbol of royal dignity.[13]

When the Romans under Trajan fought the Parthians from 114 AD onwards, Adiabene became a Roman province for a brief time, but in the aftermath of Vologases IV it again came under Parthian influence.[14] The wars of Lucius Verus against Parthia in 166 AD might have had an influence in Adiabene, since Roman troops were stationed in Nisibis. Through the wars under Septimius Severus (195 AD) and under Caracalla (216 AD), Adiabene finally became a Roman dependency.

Archaeological studies in Adiabene reveal different influences, which are of Greek Hellenistic, Assyrian and Iranian-Parthian origin. Overall, however, the studies indicate distinct Parthian influence, which existed in the period from the 1st century BC to the 3rd century AD.

As the modern city covers the ancient layers, hardly anything has been found in Arbela. Investigations in Kilizu, not far from Arbela, however, have revealed finds from the Parthian period, such as ceramic sarcophagi with typical blue-green glaze (see Fig. 10.60). In Nineveh, archaeological excavations brought many artefacts to light, displaying significant Greek, but also Parthian, influence. Greek influence is also proven by a Greek-style municipal organisation. These distinct Greek influences are not easy to explain since the city was under Parthian influence for more than 300 years. One explanation could be the existence of a Greek enclave in a mainly Oriental-Parthian city.[15] In any case, in the course of time, acculturation occurred among the religions, as can be seen in a sculpture that depicts Hermes, but presented in a typically Parthian manner.[16]

Assur was already settled in the first millennium. With the conquest by the Arsacids, the city became influenced by Parthian architecture, which can be seen in the temple of Assur, dating to the 1st century AD, and which was built on the site of a former Neo-Assyrian temple. This temple displays typically Parthian design, embodying three iwans. Parthian influences are noticeable in the temple of Heracles, where typically Parthian architectural elements such as attached stucco were found. Also noteworthy is a drawing on a large pithos, which depicts a male on a throne and a female deity on a couch. An inscription names them Bel and Nanaia (see 11.1.7); both are dressed in typical Parthian clothing. Presumably, the

Semitic population saw in them their own Babylonian gods, while the Parthians saw their Parthian counterparts.

Another important document mentioning Adiabene is the Chronical of Edessa, written in c. 540–550 AD. It gives an historical overview starting with the story of a flood that destroyed a Christian church building in Edessa in 201 AD, when Abgar VIII reigned in Adiabene. This demonstrates the early expansion of Christianity in Adiabene. This work also lists 20 names of bishops who worked there, an indicator of the Christian hierarchical structure that had arisen there at that early stage.[17]

Little is known about the history of Media Atropatene, which was located south-west of the Caspian see (see Fig. 1.1). The exact extent of this small state is not known. Its capital was Phraata (also named Praaspa or Phraaspa),[18] the exact location of which is still unknown. Most reports are from Greek or Roman writers, who describe the difficult circumstance of the small empire, which had to assert itself against both Rome and the Parthians. Around 120 BC, Atropatene became a Parthian vassal state. One branch of the dynasty, which on the maternal side was descended from the Arsacids, succeeded in taking over the crown there in the 1st century AD.[19] In 36 BC a war took place in Media Atropatene between Mark Antony and the Parthians. We know from Roman reports that the city of Phraata was besieged but could not be conquered by Mark Antony (see 3.3.5).

5.5 Characene

Characene was another *regnum* of the Parthian Empire. In ancient times it was synonymous with Mesene and encompassed the territory of southern Mesopotamia from Apamea to Shatt-el-Arab at the confluence of the Euphrates and Tigris. The capital of Characene was Charax-Spasinu, which controlled long-distance maritime trade relations between Mesopotamia and India. An archaeological survey has succeeded in locating Charax-Spasinu near the Persian Gulf. Earth walls still show the considerable extent of this ancient city, which covered an area of about 2.8 × 1.3 km.[20] Isidore of Charax, who was born in this city and lived during the reign of Emperor Augustus, wrote the only partially preserved contemporary travelogues about the Parthian Empire.

Around 140 BC Characene was ruled by Hyspaosines, who had been made satrap by the Seleucid King Antiochus IV. In 130 BC Characene was defeated by Mithradates II.[21] The Parthians knew the importance of the economic power of the country. The connection of the Euphrates and the Tigris with the Persian Gulf made it an important trading point, facilitating Parthian long-distance trade by sea with India and the Far East. An important stopover for trade between Characene and India was the island of Bahrain, which also belonged to the domain of Characene, as coin finds and a building inscription of King Hyspaosines testify.[22] Trade relations also existed with Palmyra, where King Meredates had installed the Palmyrian merchant Yarhai as a satrap.

Coins are among the most important primary testimonies regarding Characene. Their analyses combined with Roman reports have mainly been used to clarify

the question of what influence the Parthian Empire had on Characene and how much independence this kingdom retained.[23] Even if differences of opinion exist regarding details, relative independence and direct military intervention by the Parthians seem to have constantly alternated. Although the Parthians accepted local rulers on the Characenian throne and allowed them their own mint in times of peace, they did not renounce control of the trade routes and a certain degree of influence from Parthian central power prevailed. After the conquest of Characene by Parthian troops in 130 BC, the right to mint coins was withdrawn. Only from 110/109 BC did Characene start to mint coins again. It can therefore be assumed that peace prevailed in Characene from that time on. However, shortly afterwards Characenian coins bear Parthian overstrikes, revealing that to preserve their influence the Parthians had had to intervene militarily.

With no discoveries of Characenian coinage for the period between 74/75 and 101/102 AD, we may assume Parthian subjugation of Characene under King Vologases I. The resumption of coinage after 101/102 AD suggests partial autonomy for Characene, which was accepted by the Parthians.[24] After brief Roman occupation following Trajan's campaign in c. 116 AD, the Parthians again exercised their influence in the kingdom. Overall, details of the political situation in the following years is unclear. Vologases IV conquered Characene in c. 150 AD. At the same time, the minting of Characenian coins resumed, suggesting that the country became partly autonomous.[25] Until around 200 AD, coin finds still bear the name of Characenian kings. After the decline of the Parthian Empire, the Sasanids assumed rule in Characene.

5.6 Elymais

Elymais – the Greek name for Elam – is located north-east of Mesopotamian Characene in today's south-west Iran (Khuzestan) and corresponds to the heartland of the Elamite empires (see 2.1). Its capital, Susa, is one of the oldest populated places in the world. The settlement dates back to the 5th millennium BC. The Achaemenids also used Susa as one of their capitals. Alexander the Great conquered Susa and celebrated a mass wedding between Greeks and Persians there. After the conquest of the city by the Parthian king of kings Phraates II (c. 138–127 BC), Susa was made a Parthian capital. Owing to the Seleucids prior supremacy, the town had a particularly large Greek population and Greek remained the dominant language there until the 1st century BC.[26] Many works of art and buildings in Elymais therefore display Greek influence. Although the histories of the Parthian Empire and Elymais are closely related, ambiguities persist that lead to different scientific assumptions about what this dependency might have looked like. The most important testimonies for the history of Elymais come from coins, from which we know, at least in broad outline, the rulers' names from the period between c. 150 BC and 228 AD.

Around 147 BC the local king Kamnaskires I Soter made Elymais independent of the Seleucids, who had until then exercised dominion over this area. In around

140 BC, the Parthian king Mithradates I initiated attempts to conquer Elymais. After his death, Phraates II continued the attacks. In the period between 127 and 82 BC, no coins were minted by the local rulers of Elymais. It is therefore assumed today that the Parthians ruled directly in Elymais. From c. 82 to 32 BC a late dynasty of the Kamnaskirids then ruled as, it is assumed, a kind of dependency of the Parthian Empire. A third dynasty, that of the Elymaean Arsacids, then reigned from c. 25 BC. Until the end of the kingdom in 224 AD, Elymais continued to be a vassal state, ruled by the Parthian king of kings.[27] The sequence of the Elymaean kings was created by means of analysis of the coins minted there. Yet some unresolved details remain.[28] Tetradrachms of Elymais of the period mostly show the Elymaean-Parthian rulers' names on the obverse, while on drachms the king's name is usually found on the reverse of the coins.

The use of the Greek script ends in the 2nd century AD. From then on, royal names are written on coins using Aramaic legends.[29] This reveals a break with the Hellenistic tradition and coincides with the developments observed in the rest of Parthia. The capital Susa became known through the discovery of significant Mesopotamian antiquities, which had been removed by the Elamite kings. Today these can be found in the Louvre. These include the victory stele of King Sargon of Akkad and the famous stele with the Code of Hammurabi.

Susa is also mentioned in the book of Daniel and in the book of Esther in the Bible. According to tradition, the tomb of the prophet Daniel is presumed to be located near the archaeological site of Susa, located near today's Shush, Iran, and now a major pilgrimage destination. Research into the Seleucid and Parthian strata in Susa has revealed that a mixed population consisting of Greeks, Semites and Persians lived there. One significant find is a letter of Artabanus II, dating from 268 of the Parthian era – corresponding to 21/22 AD – and carved in stone (Fig. 3.7).[30] This find supplies convincing evidence that Susa still had a city constitution at that time, modelled on the Greek *polis*, and that Greek was a common language in the town. In addition to Susa, Shami is one of the most well-known Parthian sites in Elymais. A sanctuary excavated there was found to contain a larger-than-life statue of the 'Prince of Shami', now exhibited in the National Museum of Iran, Tehran (Figs. 4.22 and 9.12).

5.7 Persis

Persis is in south-west Iran and corresponds to the area of today's Fars. This area is known for excavations of the palace complex of the Achaemenid kings Darius I and his son Xerxes I in Persepolis. The famous portrayals of dignitaries and delegations from various countries along the sides of the Apadana (audience hall) bear eloquent testimony to the culture of the Persian Empire at that time (Fig. 2.2). Alexander the Great conquered and destroyed Persepolis in 331 BC. He built the nearby city of Istakhr from the remaining stone blocks. After Alexander's death, Persis became part of the Seleucid Empire, which was ruled by his general, Seleucus I. Source material for Persis during the Seleucid period is problematical.[31] Sparse

clues and numismatic testimonies suggest that in c. 280 BC, possibly even in the time of Seleucus I, Persis was probably dominated by local kings, the Frataraka.[32] The word 'Frataraka' can have different meanings; most likely it means 'head, commander, governor'.[33] Coins minted in the period of the Frataraka, which bear the images of the rulers, have iconographic parallels to the coins of the Achaemenids, but also exhibit Hellenistic symbols. Thus, in addition to the winged symbol of the Achaemenids, the *khvarenah* (also written Faravahar) and the Hellenistic goddess Nike are depicted (Fig. 11.9). The names of the first Frataraka, who reigned in the 3rd century BC, are known only from coins. Not much is known from the first half of the 2nd century BC.

With the victories of the Parthian king Mithradates I in Mesopotamia in around 141 BC, Persis and Elymais came under Parthian influence. Vadfradat II was probably the first regional king of Persis who had to recognise Parthian sovereignty. His coins, the main source of our knowledge about that time, were probably minted in around 100 BC. Pictorial religious symbols, and inscriptions on coins, of Persis show that the ruling kings received their legitimacy from deities. This indicates direct parallels with the Parthian coins and their religious references. It is therefore not unlikely that in Persis, too, the Iranian-Zoroastrian religion exercised decisive influence.[34] Literary testimonies of Parthian military intervention in Persis are known only from Vologases V. The lack of countermarks on coins of Persis might be an indication that the kings of Persis were loyal to the Parthian rulers. They had presumably been granted privileges and certain autonomies by the Parthians. Thus, Persis is another example of Parthian policy to grant vassal states a high degree of autonomy in administration and religious freedom, provided that Parthian economic interests were preserved.

5.8 The kingdom of Hatra

The kingdom of Hatra, with its eponymous capital Hatra, is in the north of today's Iraq in the steppe area between the Euphrates and the Tigris, about 90 km southwest of Mosul. Hatra's origins are unknown and the earliest written evidence dates from the end of the 1st century AD. It is certain that Hatra formed one of the 18 Parthian *regna* in the 2nd and at the beginning of the 3rd century. Situated in the region that bordered the Roman sphere of influence, Hatra became a decisive military strategic location for the Parthians, which, unlike Dura-Europos, the Romans were unable to conquer.

Hatra was also an important trading hub for caravan traffic between Iran and Syria and between Syria and Babylonia, from which the inhabitants of Hatra drew considerable wealth. The city was also the residential and administrative seat of the local Arab tribal leaders and a regional cult centre for the nomadic Arab tribes. This combination of nomadic and sedentary, tribal structure and urban organisation gave Hatra a unique dimorphic status.[35] Owing to an abundance of architectural monuments and evidence of Parthian art found during excavations, including

numerous sculptures and reliefs of gods and persons in Parthian clothing, Hatra is one of the most significant sites of the late Parthian period.

In 117 AD, Trajan, returning from his war against the Parthians, besieged the city without success. Archaeological excavations show that major construction works began after this date. The elevation of Hatra to become a kingdom probably occurred in connection with the Parthian war of Lucius Verus (162–166 AD). It is believed that the Parthian king, in response to the changes in Hatra's political situation – it had previously been an autonomous territory under Parthian influence – raised Hatra to the rank of kingdom.[36] Hatra's rulers now called themselves 'King of the Arabs'. A chronology of their rulers is not easy to create due to the limited data available. The dates for Nasru (c. 128–138 AD), Abdsamya (c. 180–201 AD), Sanatruq I (c. 138–176/177 AD) and Sanatruq II (c. 205–240 AD) are fairly secure. There is much to suggest that Hatra experienced a significant boom in the period between the wars of Trajan (114–117 AD) and Septimius Severus (195–198 AD), that is, for a period of about 80 years.[37]

During this time, the city gained its final form: a more than 120-hectare walled circular city with a central cult district, in which numerous temples and palaces were located. The holy district is still dominated by a group of iwans, formerly considered to be a palace, but, according to recent research, a building with cultic purpose (Fig. 7.17).[38] A huge courtyard served as night storage for caravans. It is estimated that approximately 30,000–55,000 people lived in Hatra. Water was brought from afar and channelled into an urban water system. After the fall of the Parthian Empire, the city came under Roman influence, but it is unclear to what extent. Hatra was then besieged for months by a large army of the Sasanian king Shapur I, finally being conquered and destroyed in 239/240 AD. For further information on the city, its inhabitants and the Parthians' influence, see 7.3.4.

The destruction of many cultural relics in Hatra and Palmyra initiated by the so-called 'Islamic State' from 2014 onwards has been deplorable; many buildings and statues have been irretrievably destroyed.

Notes

1 Pliny, *Naturalis historia* 6.112–113.
2 Wiesehöfer, J., 2005: p. 198; see also: Jacobs, B., 2010: p. 95.
3 Sommer, M., 2005: p. 232: From the year 34/33 BC, the rulers, previously acting as city lords, elevated themselves to kings.
4 Merkelbach, R., 1994: p. 57.
5 Wagner, J., 2012: p. 47.
6 Strabo 11.14.15; see also: Thommen, L., 2010: p. 378.
7 Hauser, S.R., 2016: p. 437 f.
8 A good and very detailed overview of Adiabene, the literary sources – mainly from Roman writers – the archaeological finds and the names found in inscriptions, is given by Marciak, M., 2014 and 2015.
9 Luther, A., 2015: pp. 275–300 provides a good overview.
10 For details, see: Luther, A., 2015: p. 282.

11 *Anitquitates Judaicae, Bellum Judaicum*, 20: 17–96.
12 The time of his reign is discussed in 3.3.10: Artabanus II.
13 For details, see: Luther, A., 2015: p. 283.
14 Hackl, U., 2010: p. 74.
15 Marciak, M., 2014: p. 122 with further explanation.
16 Marciak, M., 2014: p. 120, fig. 1.
17 Frenschkowski, M., 2015: p. 457 ff.
18 Schippmann, K., 1980: p. 44.
19 Schottky, M., 1998: p. 469.
20 Hansman, J., Stronach, D., 1974: p. 8 ff.
21 Schuol, M., 2000: p. 453.
22 Schuol, M., 2000: p. 352 f.
23 Schuol, M., 2000: p. 215.
24 Schuol, M., 2000: p. 342 speaks of partial autonomy under Attambelos VI; Jacobs, B. 2010: p. 91, on the other hand, notes that the permitted minting of coins does not signal an increasing independence from the Parthian Empire, but indicates a settlement voluntarily granted by the Parthians, but without putting the general central power in question.
25 Schuol, M., 2000: p. 356, like Jacobs, interprets that this gave more freedom to the local dynasties, but also bound them more closely to the Arsacid dynasty.
26 Van't Haaff, P.A., 2007: p. 2 f.
27 On the problem of dependency, see: Olbrycht, M.J., 1996: p. 127 ff.
28 Van't Haaff, P.A., 2007: p. 17 ff.
29 Van't Haaff, P.A., 2007: p. 135. It can be assumed, however, that the inscriptions on the copper drachms, as well as those on Parthian coins, are a stylised Parthian script (see: Weber, D., 2010: p. 634). See also: Olbrycht, M.J., 1996: p. 128, who speaks of a Parthian inscription.
30 Thommen, L., 2010: p. 486 ff.
31 Wiesehöfer, J., 1998 (2): p. 425 ff.
32 Curtis, V.S., 2005: p. 379 ff; see also: Klose, D., Müseler, W.: p. 15 ff.
33 Klose, D., Müseler, W., 2008: p. 18.
34 Klose, D., Müseler, W., 2008: p. 15 ff.
35 Sommer, M., 2003: p. 11.
36 Hauser, S.R., 1998: p. 515 f.
37 Sommer, M., 2005: p. 370.
38 Gawlikowski, M., 2013: p. 78.

6

THE PARTHIAN EMPIRE AND
THE PEOPLES OF EURASIA

Before the Parthian Empire expanded and finally reached the border region of the Roman Empire, the Parthians originated from the Eurasian region. In addition to new contacts with the Romans, the relations of the Parthian Empire with the peoples of Eurasia in the north and in the east remained of immense importance. Thus, a vital cultural exchange took place in the borderlands between Parthia and the Eurasian peoples. The trade in raw materials such as gold, ores and agricultural goods is evidence of this. Also of importance were the long-distance trade routes that led through the Eurasian region to China.[1] On the other hand, wars erupted again and again in the east. This caused the Parthians to adopt war technology and weapons from the Eurasian nomads.

Among the people and kingdoms described in more detail below are the Sarmatian, Saka, Graeco-Bactrian, Indo-Scythian, Indo-Parthian and Kushan empires. The kinship of the Parthians with the nomad peoples south-east of the Caspian Sea – that is, the Parthians' country of origin – was of importance in times of war. Parthian kings fled there several times. Without the support they received from this region, their return to the throne would not have been possible. Our knowledge of these realms is limited compared with our knowledge of the Roman Empire. These kingdoms emerged due to migration by the peoples that shifted westwards from the eastern regions of Central Asia. Before discussing the several kingdoms, the following section provides a brief overview about the movement of people from China to the west.

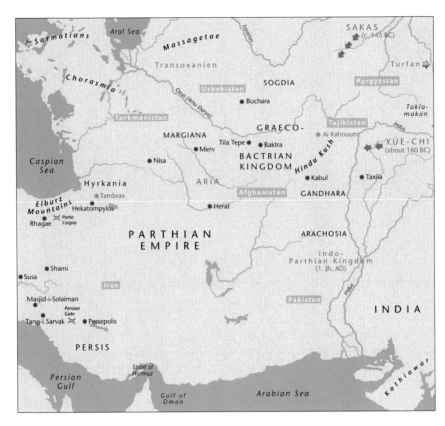

FIG. 6.1 Parthia and the empires in the east during the reign of Mithradates I (c. 165/164–132 BC).

6.1 Migration of peoples from China to the eastern border of Parthia – the construction of the Great Wall and its influence as far as the Parthian Empire

The migration of peoples triggered by clashes between the Chinese and the Xiongnu, a nomadic tribe in Central Asia, also affected the newly formed Parthian Empire. The Xiongnu were eventually ousted westwards by the Chinese. They in turn put pressure on the nomads of the Yüe-chi (also written Yuezhi), who lived on prime pastureland on the Yellow River. Through the pressure exerted on them, these people migrated further west and in turn displaced the Saka. From 160 BC, the Yüe-chi conquered the territories of Sogdia (also named Sogdiana – today's southern Kazakhstan, eastern Uzbekistan, Kyrgyzstan and Tajikistan) and Bactria.[2] They ruled this area until about the turn of the century. The city of Ai Khanoum, a large Greek-Bactrian city, was destroyed by the Yüe-chi invasion of around 145 BC. Greek inhabitants were expelled.[3] Today, Ai Khanoum is a highly significant

archaeological site in north-eastern Afghanistan, where the remains but also the structure of a Greek-Bactrian city can still be seen.

The tangible result of these tremendous changes caused by the migration of peoples can still be admired in China today: the Great Wall of China. Construction of the long wall, stretching thousands of kilometres, began under Emperor Qín Shǐhuángdìs in 220 BC. It served on the one hand to ward off attacks by the Xiongnu. On the other hand, further attacks on the Xiongnu were made, thus pushing them further westwards.[4] This displacement of people ultimately led to the destruction of the Graeco-Bactrian Empire and the emergence of the Indo-Scythian kingdom. As a result, the Indo-Greek kingdom emerged to the south, but it did not exist long and was soon replaced by the Indo-Parthian kingdom. This also did not last long, as the Kushans took over rule of the entire territory of the former Graeco-Bactrian kingdom.

6.2 Saka

The Saka people (also written Saca) lived on the steppes of Central Asia from the 1st millennium onwards, in an area extending from present-day Uzbekistan to western China. They are related to the Scythians, as archaeological finds show. The Saka were a nomadic people but their cultural centres and settlements date back to the 9th century BC. Tombs of the Saka rulers were found in the area of Siberia and the Altai Mountains. Their rulers were buried in a kurgan, which is a tumulus or burial mound. One of the most famous graves, discovered east of Almaty (the former capital of Kazakhstan), is the kurgan of the 'Golden Man of Issyk'. It measured 60 metres in diameter and is one of the largest and most richly decorated graves containing gold and other grave items. The 'Golden Man' wears clothes adorned with gold, and possesses a long sword.

Owing to pressure from the Yüe-chi, who themselves were forced by the Chinese to leave their realms, the Saka moved westwards. In around 130 BC, war broke out between the Saka and the Parthians. The Parthian king Phraates II probably also employed Greek prisoners in his army. According to Greek historians, brutal methods were used in persuading them to fight.[5] These Greeks fled in battle in 128/127 BC, thus weakening the Parthian army. The Saka won, and Phraates II was killed.[6] His successor, King Artabanus I (c. 127–124 BC), who was also involved in fighting against a Saka tribe based in Bactria, may have been killed in combat there by a poisoned weapon in 124 BC.[7]

Under Mithradates II (c. 121–91 BC), the Saka were finally beaten and made tributary. The Parthians adopted their clothing and weapons as role models for the Parthian court dress seen on coins.[8] They also took over architectural elements of the Saka. Evidence of this is seen in the dome-graves of Balandy, which were built by a Saka tribe that lived on the river Syr-Darya, which flows into the Aral Sea (see 7.1.3: Dome).[9]

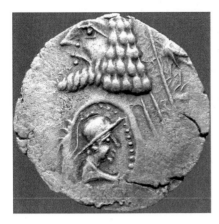

FIG. 6.2 A + B Phraates IV, silver drachm, S 91.13. Local imitation from Sakaraukae. Obverse: behind the king's head, an eagle offers a tiara to the king. The embossed bust shows the typical headgear of Graeco-Bactrian kings. Reverse: stylised sitting archer. Original size: 19 mm, weight: 3.65 g.

6.2.1 The area of the Sakaraukae

The Sakaraukae (also written Sacaraukae), a Saka tribe, which lived in the western area of the realms of the Saka, were conquered by the Parthians under Mithradates I (c. 165/164–132 BC).[10] Parthian coins with a countermark are witness to the occupation of this area by the Parthian Empire (Fig. 6.2 A + B). Tombs, believed to be associated with the Saka or Sakaraukae, were found in Tillya Tepe, today's northern Afghanistan.[11] A hill, known as the 'Necropolis of the Nomads', contained a temple fortress and six tombs with a rich deposit of gold.[12] The death of the prince, who was found in one of the graves, can perhaps be dated to the AD 40s or early 50s and suggests that Parthia no longer had influence in this region and that the nomadic people had again taken power.

6.3 Sarmatians

The Sarmatians were an equestrian people made up of different tribes. They spoke Scythian, an Indo-European language. From the 6th century BC onwards, they lived in the Urals in southern Russia. In the course of time, they moved westwards, settling in the area of the Volga river and the Black Sea in the 4th century BC, displacing the Scythian people there. In the 3rd century BC they reached the area of the Danube. With the strengthening of the Parthian Empire, wars with the Sarmatians were inevitable and occurred during the reign of the Parthian king Phraates IV in 35 AD.

The Sarmatians used cataphracts, heavily armed riders, as well as long swords, as early as the 2nd century BC.[13] This war technique was adopted by the Parthians and successfully used at the Battle of Carrhae (53 BC) against the Romans. A picture

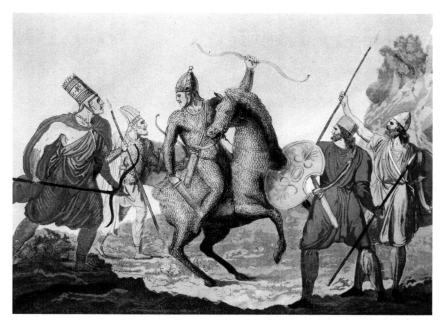

FIG. 6.3 Sarmatian cataphract, aquatint (coloured picture), from a book by Robert Spalart, c. 1799.

by Robert Spalart from c. 1799 (Fig. 6.3; compare Fig 4.15) provides an 18th-century impression of how people imagined cataphracts. But as coin finds indicate, many relationships and trade existed between the Sarmatians and Parthians. The Sarmatians were excellent artisans, as proved by a find of their eminent daggers, which were decorated with precious stones.[14]

6.4 Graeco-Bactrian kingdom

Bactria was an ancient settlement with its capital Bactria (now Balch/Afghanistan). After the conquest of Bactria by Alexander the Great, the Seleucids ruled this area and established garrisons of Greek and Macedonian soldiers there. In around 250 BC, the region was promoted by the Bactrian satrap Diodotus I Soter – the epithet Soter means 'the Saviour' – to become an independent Graeco–Bactrian kingdom, and split off from the Seleucids. Initially, he reigned in the areas around the Oxus valley, and later the kingdom extended to the southern Hindu Kush.[15] In the beginning, the young state was unstable.

In c. 221 BC, Euthydemus, possibly from Sogdiana, overthrew the then-ruling king Diodotus II and became king of Bactria. With the rise of Parthia, the Parthians became a threat to the Bactrians, but the threat was quashed after some decades, when Antiochus III defeated the Parthians in 210 BC and invaded Bactria. After four years of conflict an agreement was reached between Antiochus III and

Euthydemus: Euthydemus was accepted as Bactrian king, but Bactria officially became an ally of the Seleucid Empire.

The emergence and expansion of the Parthian Empire into Iranian territory in 160 BC led to a separation from the western Seleucid-dominated areas, and the Graeco-Bactrian kingdom thus increasingly became a Hellenistic enclave. This meant that, starting in the late 1st century BC, the Roman Empire had limited access to and contact with this kingdom.[16]

Excavations in Tajikistan and in Afghanistan in 1959 provided archaeological evidence that the area of Sogdia and areas south of the Hindu Kush belonged to this Graeco-Bactrian kingdom.[17] Data on this kingdom is scarce, although much information was revealed by coin finds providing indications of the ruling kings. Ai Khanoum, situated on the Oxus river (today's Amu-Darya, north-east Afghanistan), is the most important archaeological site of the Graeco-Bactrian kingdom. Founded in the late 4th or early 3rd century and surrounded by ramparts, the city had a citadel with 10-metre-high towers, a theatre for approximately 4000 people and a gymnasium. Greek was the language spoken and only Greek inscriptions have been found there. Investigations reveal that in the course of time Greeks and Macedonians intermarried with the local population.[18] Temples found in the area reveal that different religions were practised there and that the temple buildings were different to Greek ones. An important find in Tajikistan was the Oxus Temple, where different cult forms were also followed.

From coin analysis we learn that the Graeco-Bactrian kingdom suffered a division around 185–170 BC. North of the Hindu Kush only Greek-inscribed coins were minted,[19] while in the southern, Gandhara area – the Indo-Greek part – bilingual coins were in circulation.[20] The tensions between north and south were briefly ended under King Eucratides I (c. 171–145 BC) when he expelled King Menander I (c. 165/155–130 BC), who reigned in the south and called himself 'King of India'. The Graeco-Bactrian Empire thus extended to India.[21]

While Eucratides reigned in Bactria, Mithradates I (c. 165/164–132 BC) came to power in Parthia. Wars with the Graeco-Bactrian Empire soon ensued. The Graeco-Bactrian city of Herat – in today's Afghanistan – was conquered by the Parthians in 167 BC and became the starting point for further conquests in the east of the empire.[22] After the successful conquest of Mesopotamia in 141 BC, Mithradates I again fought against the Bactrians and defeated their king Heliocles.[23] The Graeco-Bactrian Empire experienced its protracted demise between 150 and 120 BC, following invasions by nomads, who had been displaced westwards by the migration of the peoples coming from China.[24]

6.5 Indo-Greek kingdom

After the destruction of the Bactrian Empire by the Yüe-chi, an Indo-Greek kingdom that was to exist as a Hellenistic outpost for about 100 years emerged in the Gandhara area of the southern part of the Graeco-Bactrian Empire. Even though coin analyses have succeeded in capturing the kings' data in more detail,

little is known of this kingdom. The Indo-Greek coins are bilingual: the obverses contain Greek inscriptions, whereas the reverses have a translation into Prakrit, a north-west Indian language written in Kharosthi script.[25]

After the fall of the northern part of the Graeco-Bactrian kingdom, the Indian governor Menander I (c.155–130 BC), who had been appointed there as local ruler by the Graeco-Bactrian king Eucratides, assumed control and ruled the Indo-Greek part of the country. His successor, Hermaeus, reigned in parts of Gandhara and the Indus valley in c. 90–70 BC.[26] After his death, the kingdom lost its power when nomads from the north, belonging to the Saka, conquered part of the region. The last king of the surviving Indo-Greek kingdom was Straton II (c. 25–10 BC).

6.6 Indo-Scythian kingdom of the Saka

Our knowledge of the Indo-Scythian kingdom is also fragmentary. The Indo-Scythians descended from the Saka, who came from the Eurasian steppes. Under the pressure of the Yüe-chi, the Saka had moved westwards and had been split in two groups. One of these had settled in the east of the Parthian Empire and was defeated under Mithradates II (c. 121–91 BC, see 6.2). Following the collapse of the Graeco-Bactrian kingdom, the regional ruler Maues (c. 85–60 BC) capitalised on a weakness of the Parthian kingdom and founded the Indo-Scythian Empire (part of which is today's Punjab in India), which was to last for almost 100 years. Much of the information available to us about the newly formed Indo-Scythian kingdom again comes from coin analysis.

Maues was succeeded by Vonones, a ruler with a Parthian name, who bore the title 'King of Kings'.[27] In approximately 57 BC, Azes I became his successor. His coins still betray Graeco-Bactrian influence with representations of Zeus, Athena, Demeter, Tyche, Hermes and Heracles.[28] The last Indo-Scythian ruler was Azes II, who reigned c. 35–12 BC.[29] The inscription 'Rajarajasa mahatasa' on his coins suggests the title of an Indian ruler that is still in use: Maharaja.

6.7 Indo-Parthian kingdom

The history of the Indo-Parthian kingdom, in which Arsacids ruled over northern parts of India, is also obscure, and essentially known only from coin finds. The provinces Arachosia and Gandhara formed the core of the Indo-Parthian Empire. The capital of this kingdom was Taxila in today's north-east Pakistan. At the beginning of the 1st century AD, the Indo-Parthian king Gondophares (c. 20–46 AD) took possession of these territories, where the Parthian king Artabanus II (c. 10–38 AD) had formerly exercised influence.[30] Gondophares underlined his position of power with the title ΒΑΣΙΛΕΩΣ ΒΑΣΙΛΕΩΝ ΜΕΓΑΣ, 'Great Basileos Basileon' (The great king of kings). His tiara is also similar to that of the Parthian kings Sinatruces and Phraates III.[31] However, due to a lack of evidence, it remains unclear what relationship existed between the Parthian Empire and the Indo-Parthian Empire.

King Gondophares is known to us through accounts in the Bible. He played a significant role in the spread of Christianity to India. According to the Apocrypha (Acts of St Thomas), missionary work in India was entrusted to the apostle Thomas. Thomas lived at the court of the king 'Gunduphar' (Gondophares) and is said to have converted many people to Christianity. Contemporary experts believe that early Christians had a close relationship to the Indian king Gondophares.[32] Abdagases, Orthagnes, Pacores and Gondophares II were other Indo-Parthian kings. Coin analyses indicate political stability in the Indo-Parthian kingdom until c. 80 AD. The Indo-Parthians, however, were unable to remain in power for long, being conquered by the Kushans under Kadphises.[33]

6.8 Kushan Empire

The nomad tribes of the Yüe-chi, who invaded Bactria from 150 BC onwards, consisted of five groups, among them the Kushans, who in subsequent years subjugated their neighbouring tribes and founded the kingdom of the Kushans.[34] Coins dating from the beginning of the 1st century AD name the clan chief Heraios, who refers to himself as ruler of the Kushans. In around 50 AD, the first tangible Kushan king Kujula Kadphises, who called himself 'King of Kings' in the style of Parthian rulers, expelled the Indo-Parthian kings inhabiting the Gandhara area.[35] Although the data on his reign cannot be determined with certainty, he probably ruled between 30 and 80 AD.[36] Kanishka I (c. 101–110 AD), whose grandfather was probably Kujula Kadphises, was the most important Kushan ruler.[37] Under his reign, the Kushan Empire was in its prime.

Taxila became the capital of the Kushan Empire, situated near today's Kabul in Afghanistan. The Gandhara region, east of today's Kabul, which lay between tributaries of the Indus, was one of the major regions of the Kushan Empire. Today it is one of the most important ancient sites for the Gandhara style, in which syncretism between Buddhist and Greek art is found. The Kushans took over the Greek alphabet they had encountered in Bactria and adopted the native language of the Bactrians, still using the Greek alphabet as a basis.[38] They soon began to mint coins, on which the rulers are titled as Maharaja or Basileus (king).

There was pronounced trade between the Kushans with the Romans. The transfer of money to the Kushans was considerable, as can be seen from Pliny's plea. He writes: 'There is no year in which India draws less than 50 million sesterces.'[39] It can be assumed that the Kushans melted down the Roman aurei (gold coins) and minted their own gold coins, for Roman gold coins have very rarely been found in India. A coin of the ruler Kanishka II (between 200 and 222 AD, possibly even 20 years later), calling himself 'Maharajasa Rajatirajasa Devaputra', bears an additional inscription 'Kaisara Kanishka', which is a direct reference to the Roman emperors![40] Trade with Rome took place by merchant ships, bypassing the Parthian Empire, where customs duties would have had to be paid. Thus, the Kushan Empire aimed to achieve supremacy at sea.

The Kushans were the Parthians' most important eastern and south-eastern neighbours in the 1st century AD. Certainly, this relationship was not always peaceful. It should be emphasised that the Hellenistic traditions, which were founded in the Graeco-Bactrian Empire, were preserved through the aforementioned intermediate realms. This is impressively demonstrated by coins, ceramics and small finds of the Kushan period.[41] The Kushan kingdom also played an essential role in the dissemination of various religions, such as Zoroastrianism, Buddhism and Christianity. Religious references and reciprocal influences are discussed in more detail in Chapter 11.

Notes

1 Gregoratti, L., 2013: p. 43 f.
2 Jacobs, B., 2010: p. 55.
3 Bernhard, P., 2010: p. 45.
4 Also written as 'Qin Shihuangdi' (which means: first sovereign emperor of the kingdom of Qin).
5 Olbrycht, M.J., 1998 (2): p. 105.
6 www.parthia.com.
7 Jacobs, B., 2010: p. 54.
8 Winkelmann, S., Ellerbrock, U., 2015, p. 133.
9 Brentjes, B., 1990 (2): p. 31 f.
10 Sayles, W.G., 1998: p. 63.
11 Schiltz, V., 2001: p. 63, exhibition catalogue containing many illustrations.
12 Posch, W., 1995: p. 140, affirms the assumption that it was from the Saka.
13 Winkelmann, S., 2015: p. 197 f.
14 Olbrycht, M.J., 1998 (1): p. 28.
15 Bernhard, P., 2010: p. 45.
16 Leriche, P., 2010: p. 158.
17 Tellenbach, M., 2010: p. 19.
18 Mairs, R., 2015.
19 Alram, M., 2009: p. 185.
20 Alram, M., 2009: p. 185. The inscription on the obverse is written in Greek, on the reverse, the Greek legend in Brahmi script is translated into Indian Prakrit.
21 Posch, W., 1995: p. 89. The data for Eucratides I's reign can only vaguely be determined.
22 Rawlinson, 1976: p. 75. Strabo calls the two conquered territories Turiura and Aspasicae.
23 Shore, F.B., 1993: p. 70 ff.
24 Bernhard, P., 2010: p. 51. The dissolution process probably lasted two generations: Posch, W., 1995: p. 147.
25 Harmatta, J., 1999: p. 126.
26 Bopearachchi, O., 1998: p. 389 ff.
27 Alram, M., 2009: pp. 186–188.
28 Rosenfield, J.M., 1967: p. 127.
29 Bopearachchi, O., 1998: p. 389.
30 Bopearachchi, O., 1998: p. 399.
31 Olbrycht, M.J., 1998 (3), p. 135.
32 Bivar, A.D.H., 2007: p. 30 ff. Some experts believe that Gondophares II might be the one mentioned in the Bible.

33 Bopearachchi, O, 1998: p. 400.

34 Cribb, J., 1999: p. 177 ff.

35 Bopearachchi, O., 1998: p. 400.

36 Alram, M., 1999: p. 22.

37 Alram, M., 1999: p. 46.

38 Alram, M., 2009: p. 190: Kanishka introduced the Bactrian language as a state language, an east Iranian dialect written in Greek script, which he describes as 'ariao' (Aryan) in the Rabatak inscription.

39 Pliny, *Naturalis historia* 6.101.

40 Harmatta, J., 1999: p. 323: Kanishka II is the son of Kanishka I, who possibly reigned together with Vasishka.

41 Hansen, S., Wieczorek, A., Tellenbach, M., 2009: Ausstellungskatalog, p. 341.

7

CITIES AND ARCHITECTURE IN THE PARTHIAN EMPIRE

7.1 Structure and architecture of the cities

It is unclear which city could have served as the Parthian capital in the early days. Hecatompylos is definitely a candidate, but it could also have been Asaak in Astauene (the north-eastern part of today's Iran, by the Caspian Sea).[1] The first Parthian cities were located near the satrapy of Parthia. Nisa, near Ashgabat (Turkmenistan), formerly thought to be one of the first Parthian capitals, is now considered to be a large eastern sanctuary, built by Mithradates I.[2]

Other cities of the empire's early days include Herat in today's Afghanistan and Rhagae, near today's Tehran. But it was not until the conquest of other areas in the west by Mithradates I and the kings that followed that further cities were added. These were gradually developed by the Parthians and included Ecbatana – said to have been near today's Hamadan, 200 km west of Tehran – and Assur in Mesopotamia. The Parthians even built a new city, Ctesiphon, which was situated opposite the Mesopotamian city of Seleucia. Parthian influence can also be seen in the cities of Susa and Nineveh, where numerous buildings from the Parthian period have been found.

7.1.1 Circular cities

Typical of the architecture of most Parthian cities was that their outer shape was round and protected by a city wall (in German: 'Rundstadt').[3] This stands in contrast to the rectangular floor plans of Hellenistic cities. The earliest settlements with a circular plan date from the first half of the 1st millennium BC. Kosholenko and Gaibow, both famous Russian archaeologists, conclude their investigation published in 2014:

It should be borne in mind that, as was mentioned earlier, most of the monuments built on a round plan are to be found in Bactria. This fact may be linked to the early diffusion of Zoroastrianism in this region, as has been suggested by some scholars, who believe that Bactria was the birthplace of Zoroastrianism.[4]

Such urban layouts characterise the floor plans of Merv, Hatra, Ecbatana and Ctesiphon.[5] An exception to this is Nisa, where the citadel has a pentagonal floor plan, probably due to the landscape. Clay brick walls secured the cities from raids. The building materials used depended on those available in the area. Not always mud bricks were used, as revealed by the Parthian fortress in Merv. There, the outer walls were made of rubble and solidified with gypsum mortar, which became extremely strong. The defensive walls were also plastered with stucco.

7.1.2 Iwan

In Parthian architecture, new and independent elements were created on the basis of Greek and Mesopotamian methods of construction, which in their entirety should be called Parthian art. The iwan, a Parthian trademark, deserves primary consideration. It is especially well known from Hatra and Assur.[6] An iwan is a large, vaulted hall, walled on three sides and completely open at the front (Figs. 7.14, 7.17 and 7.20). In Hatra, two little iwans join on both sides to the main building. The ceiling vaulting is achieved by a mudbrick construction that works entirely without wood.[7] According to Michael Rostovtzeff, this Parthian architecture seems to have its basis in the east Iranian residential buildings from the region of origin of the Parthians.[8] In Mansur Depe, near Nisa, such iwans were found dating from the 2nd to the 1st century BC. In contrast, F. Hauser emphasises that the earliest iwans originated in Mesopotamia in the 1st century AD.[9] This type of construction is found at the Parthian Palace in Assur, but can also be found as a dominant element in Parthian buildings in such western cities as Hatra and Palmyra. Although the iwans of 'Taq-e Kisra' (Fig. 7.14) were built by Sasanian kings, they are nevertheless influenced by Parthian architecture.

7.1.3 Dome

The dome, which covers a room (Figs. 7.7 and 7.11), is another element in architecture newly introduced by the Parthians. In the citadel of Nisa archaeologists made an important discovery: a square building with a round dome with a diameter of 17 m, which 'disconnects the structure from Hellenistic architecture' and reveals 'Near Eastern taste'.[10] The semi-circular vaults were built on squinch arches to ensure the transition between the vaulted ceiling and the square space. An idea of what the dome might have looked like is shown in Fig. 7.7. According to Lippolis, the leading archaeologist in Nisa, his most recent excavations (2012–2015) indicate that the Round Hall was a *heroon*, a room used for the commemoration of

ancestors, probably to honour Mithradates I and his forefathers. Nisa was primarily a fortified residence and later, after the death of Mithradates I, was turned into a dynastic centre. The clay head (Fig. 10.8), which was found there, probably portrays Mithradates I.

In the second half of the Parthian period, iwans and domes together with stucco decorations seem to have been the defining features of Parthian palace and temple architecture.[11] One of the most beautiful examples of such construction, with an iwan and overcoupled rooms from Sasanid times and based on Parthian architecture, is the well-preserved palace of Firozabad in the province of Fars in today's Iran. The appearance of the overcoupled rooms, as well as the construction of the iwan, should be regarded as a contribution of east Iranian or Eurasian architecture to the architecture of Iran and the Near East.[12] Buildings with domes, dating back to the 8th century BC, are found in Central Asia in the tombs of the Tagisken and in Chirik-Rabat (5th century BC), both located in present-day Kazakhstan. In Chorasmia such architectural structures are found in Koy-Krylgan-Kala (4th–2nd century BC) and in Balandy (2nd century BC).[13] Although no such Parthian dome structures have been preserved in Mesopotamia, Parthian cities with buildings composed of iwans and domes are depicted on the triumphal arch in Rome, which the Roman Emperor Septimius Severus had erected in 203 AD.[14] He was celebrated as the conqueror of the Mesopotamian cities Nisibis, Edessa and Seleucia on the Tigris, and Ctesiphon. Assuming the cities depicted here show features typical of Parthian architecture, iwans and domed buildings were unequivocally part of it. This statement inevitably leads to the question of the extent to which Parthian architecture influenced the Romans. It is probably no coincidence that the arcade in Rome is typical of its time, since dome structures can be detected there in mausoleums and public buildings.[15]

7.1.4 Stucco technique and stucco decoration

New Parthian elements, stucco decorations, were added to Parthian buildings. The Parthians used a stucco technique that they adopted from Greek and Roman buildings. So-called 'metopes' (not comparable with Greek metopes) with motifs like a goryth (Fig. 4.19) or a lion (Fig. 7.2) were found in Nisa and enjoyed popularity among the Parthians.[16] They were made of terracotta and had no supporting static function.

Another important Parthian site, where a large amount of stucco decorations was found, is the Qal'eh-i Yazdigird complex, situated in the west of the Zagros Mountains. It was probably the residence of a Parthian noble as archaeological findings in the complex include elements of Graeco-Roman Dionysian iconography that were adopted by the Arsacids and reflect the pleasures of court life with hunts and banquets.[17]

The sculpture on the building in Hatra also betrays Parthian influence. This consisted of figurative façade decoration, usually reliefs and sculptures, often in the form of masks or plants.[18] Beautiful façade ornaments can also be found in Nisa,

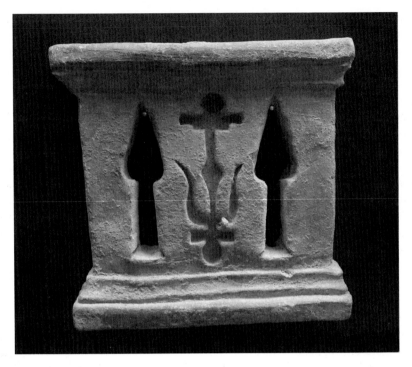

FIG. 7.1 Metope with a Seleucid anchor, terracotta, find spot: Nisa. National Museum of History, Ashgabat. Source: Invernizzi, A., 2007: p. 173.

depicting rosettes, plants, bows with quivers and arrows or the moon (Figs. 7.2 and 7.3).[19] Some of the terracotta work has Seleucid motives, such as the anchor symbol (Fig. 7.1). The building materials were mostly based on those already present on site. In Hatra, as well as in Palmyra, limestone was the predominant material.[20] In Mesopotamia, where there was little limestone, buildings were constructed of clay bricks.

The Parthian iwan was not only the basis for Sasanian buildings, but also ground-breaking for Persian mosque architecture in the subsequent period. Even today, the eminent Islamic mosques in Isfahan or Shiraz betray a basic structure that had its origins in Parthian architecture.

7.2 Cities in the homeland of the Parthians and in Iran

7.2.1 Nisa

Nisa, situated in today's Turkmenistan, near its capital Ashgabat, is one of the earliest and most important sites of testimony related to the Parthian Empire. Nisa consisted of 'Old Nisa', the site of the royal ceremonial citadel, and the nearby area called 'New Nisa', of which we know little, as no extensive excavations have so far been conducted.[21] In Parthian times New Nisa was the city proper. It was still an

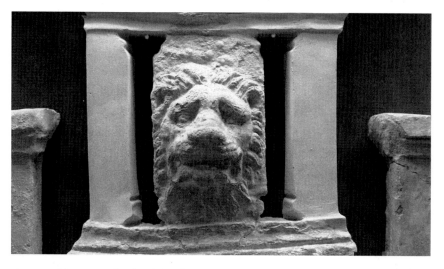

FIG. 7.2 Metope with a lion's head, terracotta, find spot: Nisa. National Museum of History, Ashgabat.

FIG. 7.3 Parthian stucco, find spot: Nisa. National Museum of History, Ashgabat.

important centre in Islamic times as shown by the layers found dating to this period. Both areas were surrounded by huge fortress walls with a thickness of 10 metres, built from clay bricks that were about 40–42 cm in length and 10–12 cm thick (Figs. 7.4 and 11.17).[22]

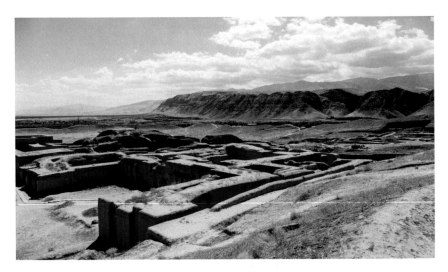

FIG. 7.4 Parthian Palace complex in Nisa. View from the east on the surrounding Parthian ramparts. In the background are the Kopet Dagh Mountains.

Old Nisa, with the Parthian castle complex – also called Mithradatkart, the castle of Mithradates – was initially explored by Russian archaeologists (V.M. Masson, 1929–2010) and later by Italian archaeologists (A. Invernizzi and C. Lippolis). Old Nisa plays an important role for understanding Parthian culture, art and architecture (see 8.1 and 10.1). Located on a hill at a height of about 50 metres, it was supplied by groundwater wells, but generally benefited from the waters of the nearby Kopet Dagh Mountains.

Several complexes of buildings spread over the inner area of the castle (Figs. 7.4–7.6), which are explained in detail below. They date between the 2nd century BC and the 1st–2nd century AD. Nisa was then abandoned, although an exact date is not known. As no traces of violent destruction were found, one suspects natural events such as water problems, earthquakes or climate change. It cannot have been a sudden event, as the archaeologists discovered that the main buildings were emptied of the furniture, which were then stored in the Square House.[23] Protected by metre-high clay deposits following an earthquake, the fortress remained largely intact for almost 2000 years.

7.2.1.1 Round Hall – Red Building

The castle complex had the shape of a pentagon, in the centre of which were several large, square buildings that enclosed an open area (Fig. 7.6). A unique feature of Parthian architecture, the Round Hall, which measures about 17 metres in diameter, was vaulted in Parthian times by an elliptical dome.[24] At first archaeologists thought the roof was created by a wooden construction, but new excavations revealed that only sun-dried clay bricks were used in the construction of the

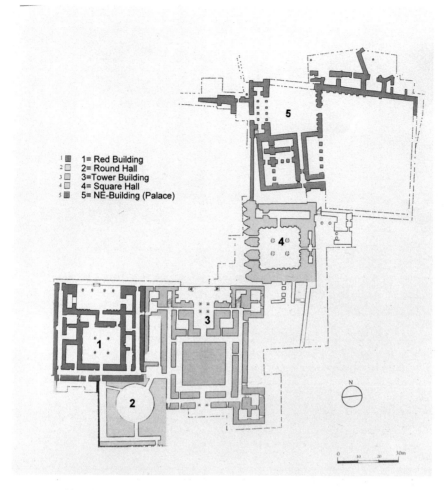

1= Red Building
2= Round Hall
3=Tower Building
4= Square Hall
5= NE-Building (Palace)

FIG. 7.5 Plan of Old Nisa. By courtesy of C. Lippolis. Drawing by C. Fossati, Archive of the Centro Scavi di Torino.

dome.[25] Archaeological findings support the thesis that the dome rested directly on the ground and that the top emerged from the outer square block. Such a construction was unique at that time but became common in the Sasanian and Islamic periods.

In this hall, the bases of larger-than-life statues were found, which led to the conclusion that the Round Hall was used for the commemoration of Mithradates I and his ancestors. It is believed that a fragment found there, and now exhibited in the National Museum of History, Ashgabat, shows Mithradates I (Fig. 10.8). With the discovery of the large statues, which were probably of ancestors of Parthian kings, the important question is if and to what extent the Parthians deified their ancestors. A possible answer to this question is given in 4.1.4.

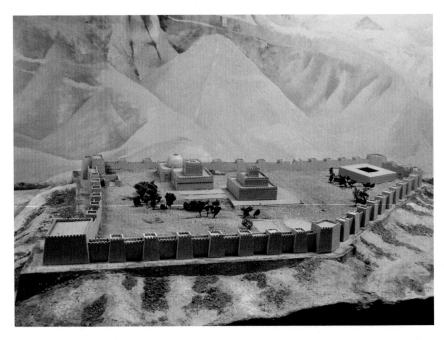

FIG. 7.6 Model of the Parthian castle in Nisa. National Museum of History, Ashgabat. Note: The model was a first attempt to show the castle, but due to the latest excavations the model is no longer up to date.

FIG. 7.7 Round Hall covered by a dome. Drawing, by courtesy of C. Lippolis, Archive of the Centro Scavi di Torino (compare Fig. 7.11).

Another important building that was excavated was the 'Red Building' that acquired its name from the red plaster that adorned the walls. It is older than the 'Round Hall'.[26] This building also opened on to a central courtyard. Its façade consisted of a 20-metre-wide portico with columns. It is not clear whether it was used for ceremonial purposes.

7.2.1.2 Treasury of Mithradatkart

Another important find in Nisa resulted from the excavation of a treasury, which had nine rooms and a total length of 60 metres. The building had only one entrance and was certainly well guarded at that time, as seals found by archaeologists indicate (Fig. 7.12). These seals bore several imprints, revealing that it was often opened and resealed. Unfortunately, in time, all rooms were looted, probably at the beginning of the 3rd century AD. The thieves must have entered the rooms via the roof, for the intervening doors were still sealed.

The finds show that the kings were certainly surrounded by considerable pomp. Among them were small, precious artefacts left behind by the thieves, including small female terracotta figurines coated with gold, but also glassware of Roman or Greek origin and Egyptian stone vessels. Among the most famous archaeological finds in Nisa are about 50 rhyta, ceremonial drinking vessels, made of ivory.[27] Their marginal figures mainly depict Greek motifs, but also scenes from nomadic life (Figs. 10.1–10.8).

The architectural forms of this fortress vary among the different buildings, but overall the building forms have their roots in both east Iranian and Central Asian traditions, as well as in the Achaemenid architecture that can be seen in the palace

FIG. 7.8 Coloured wall stucco, find spot: Parthian Palace, Nisa. National Museum of History, Ashgabat.

FIG. 7.9 Wall stucco, find spot: Parthian Palace, Nisa. National Museum of History, Ashgabat.

FIG. 7.10 Parthian vessels, find spot: Nisa. National Museum of History, Ashgabat.

FIG. 7.11 Round Hall, Nisa. The remains of the Parthian bricks used are still clearly visible here. The walls have now been secured by a clay layer. The Round Hall was once covered by a dome, which is no longer in existence.

FIG. 7.12 Seal found in the Treasury of Mithradatkart, find spot: Nisa. National Museum of History, Ashgabat.

of Persepolis.[28] Of great importance in the excavations in Nisa are more than 2500 clay tablets with Parthian inscriptions (ostraca), which are mainly concerned with the wine trade (see 8.4). These inscriptions provide numerous insights into Parthian life, even if they date from the 1st century BC and therefore relate only to a limited period and a small segment of daily life. It remains important to realise that the dates of months found on the ostraca are based on the Zoroastrian calendar, implying that the Parthians probably already adhered to Zoroastrian beliefs at the time.

7.2.2 Merv

Merv (near Mary in today's Turkmenistan, in the region of Margiana, also written Merw) was already settled in the Neolithic period. The Achaemenids also had a settlement here – their fortress Erk Kala, still preserved today, bears witness to this ancient culture. Greek Seleucids under Antiochus I reinforced this settlement, including by making the walls higher and thicker, now called Gyaur Kala. Under Alexander the Great, it was rebuilt into Alexandria Margiana, then destroyed by nomads, and again rebuilt under the Seleucid Antiochus Soter in a Greek style with a geometric layout. The strategic position of Merv was also known to the Parthians, who left the city intact after their conquest and promoted trade with the east from here. When the Romans lost their first major battle against the Parthians in 53 BC,

FIG. 7.13 Walls of Gyaur Kala, Merv. The large entrance gate show, that the Parthians reinforced and expanded the outer walls.

10,000 captured Roman soldiers were deported here and had to enforce the city walls.[29] Although they are almost two millennia old, the walls, an example of typical Central Asian mudbrick architecture, still rise to the considerable height of 30 metres. On closer inspection, one can still make out the individual sunburnt bricks used by the Parthians

The city was huge for the time, covering an area of 20 hectares. Dating back to Parthian days, about 72 settlements were found in the surrounding Merv Oasis, where the river Murghab, which originates from the Hindu Kush, was important for the supply of water. Despite the wall, archaeological finds in the city from Parthian times are scarce. Some Parthian coins were found, but the number of Sasanian coins found in the city was much higher. Merv must have been taken by the Sasanians during the final years of Ardashir I's reign (c. 220–240 AD). Canals and small aqueducts, which date to Parthian times, were cleaned and repaired by the Sasanids.[30] Under the reign of the Sasanids the region flourished; 162 settlements dating from this period were found by surveys, with most of the Parthian settlements still being used.

7.2.3 Herat

Located in the region of Khorasan, in present-day Afghanistan, Herat was founded by the Iranian tribe Aria in around 800 BC. This region is also known from Achaemenid times, as the Behistun inscription of Darius I (c. 520 BC) shows. People from this tribe are also portrayed at the royal Achaemenid tombs of Naqsh-e Rustam and Persepolis, where they are depicted wearing the typical Scythian dress of tunic plus trousers that were tucked into their boots.

Alexander the Great conquered the city in around 330 BC and built a citadel there. The city was an important military base for his expedition to the east. The citadel can still be admired today. As part of his expansion policy, the Parthian king Mithradates I conquered this fortress in around 167 BC, and it also served the strategic eastward expansion of the Parthian Empire.

7.2.4 Shahr-e Qumis (Hecatompylos)

This city of the 'hundred gates' (Greek: Hecatompylos) is located at Shahr-e Qumis, in the Qumis region in today's west Khorasan, Iran, about 32 km from the city of Damghan. At the time of the Seleucids, it was probably a smaller city. In the beginning of the 2nd century BC, the Parthians enlarged it and it became the capital of the Parthian province of Comisene, possibly even of the entire empire.[31] With the Parthian conquests in Mesopotamia and the building of the new town Ctesiphon, the town lost its importance, but it was still used by Parthian kings as a residence in autumn.

7.2.5 Rhagae

Like Hecatompylos, Rhagae was an old Parthian capital, located near today's Tehran. Rhagae was an important town and trading post on the Silk Route leading from Herat to Ecbatana. Here too, as in Hecatompylos, we have no significant archaeological findings from Parthian times, since Rhagae has been cleared and overbuilt through constant occupation, meaning that no recent research has been available.[32]

7.2.6 Ecbatana

The city of Ecbatana was already a large and important city in the empire of the Medes. In the 6th century BC the town was conquered by King Cyrus II, founder of the Achaemenid Empire, and made a royal residence. Regrettably, the city of Ecbatana has not yet been found. The city may be near Hamadan in today's Iran, but clear archaeological proof of this is not yet available. Hamadan itself has revealed only Parthian layers, but no Greek or older finds.

With the expansion of the Parthian Empire to the west and the conquest of Mesopotamia by Mithradates I (c. 165/4–132 BC), Ecbatana was conquered and made the Parthian provincial capital. Owing to its location at an altitude of 1800 metres and the concomitant pleasant temperatures, Ecbatana was chosen as the kings' summer residence, as reported by Greek historian Strabo. In approximately 148 BC, the Parthians conquered Ecbatana and the surrounding province of Media. Under the rule of Mithradates I, Ecbatana initially became the residence of the satraps of the province of Media. With the further expansion of the city, Ecbatana then became an important capital of the Parthian Empire, from which the affairs of state were conducted.

The city was strategically located. Part of the Silk Road, the Royal Road, which was specially built by the Achaemenids and which could be compared to modern-day highways, led from the city of Sardis in Lydia (today's Turkey) via Nineveh, the ancient capital of Assyria, to Babylon, where it divided into two roads: one to Susa and Persepolis and another to Ecbatana. From here the trade route continued to Bactria in the east of the empire. The importance of the city for the Parthian Empire is underlined by the fact that it was the site of a royal mint – almost all the coins dating from the late period of the Parthian Empire were minted here.[33]

7.2.7 Susa

Susa, situated in south-west Iran, has a long history as a city, its first settlements dating back to the 5th century BC, when it was the capital of Elymais (see 2.1) and the principal residence of the Achaemenids. The Seleucids, who ruled the city after the conquests of Alexander the Great, called it 'Seleucia on Eulaios', which flourished in the ensuing years, when many Greeks settled there.

The history of Elymais and of Susa during the Parthian period is described in more detail in 5.6. The wealth of the city was based on its location and flourishing agriculture. Excavations in Susa and its surroundings began in the late 19th century. These and later excavations brought to light numerous Greek inscriptions. These were translated and analysed by F. Cumont, a Belgian archaeologist and historian (1869–1947), and provide insights into the administration of the city at the time of the Seleucids and Parthians.[34] Roman Ghirshman, a well-known French archaeologist, made extensive excavations in Susa between 1946 and 1967, during which, as far as the Parthian era is concerned, several stone sculptures (Figs. 10.29–10.32 and 10.39–10.41) and a variety of Parthian terracotta were found.

An inscription from Parthian times dated 131 BC certifies the dedication of a slave to the goddess Nanaia of Susa (regarding slaves, see 9.5). Another engraving was made in honour of a bodyguard, this dating from the year 98 AD. Many of the inscriptions found in Susa are in honour of the merits of a well-known citizen, such as Zamaspes, who was *strategos* of Susa.[35] These credentials provide good insights into the city's administration. This includes supplying the city with water by improving the water flow of the Gondeisos river – which was important for the city of Susa – by using other source streams. This permitted the irrigation and cultivation of abandoned fields. The inscription also refers to guards, probably residents of Susa, whose duty was to protect the castle.

Another inscription dates to 21 AD and reproduces a letter from the Parthian king Artabanus II to the city of Susa (see 3.3.10; Fig. 3.7). The inscriptions in this document make reference to two different calendar systems: 'received in the year 268, as is the counting of the (Parthian) king, but of the year 333 used in former times'. The year 268 refers to the Parthian era, which equates to 21/22 AD. The year 333 dates to the Seleucid era (see 9.11).

Archaeological finds show that, in time, Seleucid buildings were replaced by Parthian edifices. In one of these houses was a bathhouse, its floors decorated with a mosaic bearing the Greek word Μοῦσα 'Muse'. Parthian houses had a central courtyard, which was surrounded by rooms, those south of the courtyard being larger. The houses also had an upper floor. However, the quality of the buildings declined during the 2nd century AD.[36]

Dating from Parthian times, numerous coins, or sometimes coin hoards, and a variety of pottery were found during the excavations. A female marble head was also found, which could be either a representation of Tyche or an image of Queen Musa (for more, see 10.5; Fig. 10.31). Archaeologists even found the remains of a gymnasium, proving the importance of education in Parthian times. The archaeological finds in Susa thus give an overall picture of a wealthy town that prospered under Parthian rule.

7.3 Cities in Syria and Mesopotamia

The conquests of the Parthian king Mithradates I brought many cities in Mesopotamia into the Parthian Empire's sphere. These include Seleucia on the

Tigris, Dura-Europos and Hatra, which will be considered in more detail below. Palmyra, a city that never belonged to the Parthian Empire, should also be considered here, as it betrays significant Parthian influence. The growing influence of the Parthians is noticeable through archaeological excavations, as the building structures and art reflect strong Parthian influence. This is particularly evident in the construction of Parthian iwans. Further indications are the reliefs and statues, found in these cities, of men and women wearing clothing that exhibit Parthian influence.

7.3.1 Seleucia on the Tigris

Seleucia on the Tigris, the capital of the Seleucid kingdom founded by Seleucus I Nicator in c. 305 BC, is located about 30 km south of today's Baghdad. The city flourished and soon became the Seleucid capital in the east. A main channel connecting the rivers Tigris and Euphrates was significant in that it enabled the city to take part in shipborne trade. As these rivers were directly connected to seaports in the Persian Gulf, Seleucia on the Tigris also participated in long-distance trade. The length of the city walls, and the size of the area that they enclosed, suggest that about 100,000 people lived in the city, and up to 500,000 in the surrounding region.

Initial investigations into the city were made in 1927–1936 by an American archaeological team under the leadership of the University of Michigan and the Museum of Toledo and Cleveland. From 1964 to 1989 work was continued by a team of the Centro di Ricerche Aecheologiche e Scavi di Torino per il Media Oriente e l'Asia. The archaeological finds essentially reveal urban architecture displaying Hellenistic influence. The city had a layout based on the 'Hippodamian Plan', so named after Hippodamus of Miletus (498–408 BC), who planned the town with streets intersecting at right angles. A channel bringing water from the Tigris divided the city in half. The archaeological excavations are significant and revealed 30,000 inscriptions originating from the state archives of the Seleucids and therefore providing eloquent testimony to their administrative structure.

Inhabitants came from different parts of the world, with Greeks, Babylonians and Hebrews living here together. Interactions between the different cultures resulted in a merging of deities. Thus, Apollo was equated with Nebu, Athena with Nanaia (see 10.1). One important find dates from Parthian times, namely a bronze statue of Heracles (Fig. 11.7 A + B). A Parthian inscription on his leg names him Verethragna, thus showing the Zoroastrian influence in Parthia (for more on this see 11.1.9).

Through the conquest of Mesopotamia by Mithradates I in 141 BC, the town soon became the Parthian capital, from which the conquered territory was governed. The city continued to boom and in the 1st century AD had a population of about 600,000.[37] It was an important city and a centre of trade connecting east and west.[38] With only a few exceptions, all Parthian tetradrachms were produced in Seleucia on the Tigris (see 8.1).

During Parthian rule riots repeatedly erupted in the city. One involved the conflict between Orodes II and Mithradates III, the latter being killed in 54 AD, thus supressing an uprising. A coin of Orodes II (S 45.1) shows his victory: Tyche as personification of the city kneeling in front of the king (more details are given in 3.3.2–3). It was only sometime later – in c. 55–58 AD – that the city supported Vardanes' son as Parthian king, while Vologases I lost his power there. These must have been troubled times because, as coins with dates reveal, from 58 AD Vologases I regained power.

Excavations reveal that in early Parthian times (1st century BC) some houses had a series of rectangular rooms opening on to a courtyard, while in the later Parthian era (1st–2nd century AD) two iwans were added to the rooms around a wide rectangular courtyard.[39] Excavations by the Italian archaeological team brought over 25,000 seals to light, which are extremely helpful for understanding Hellenistic influences in the Seleucid era. In addition, a variety of terracotta figures was found. The Italian archaeologists state that 'the terracotta figurines from Seleucia attest to the depth of the Greek cultural influence from every point of view (iconographic, technical, and stylistic) and, at the same time, to the strength and vitality of local traditions'.[40]

Another important excavation was undertaken in the city at the Tell'Omar, a small hill, 13 metres high and measuring 94 × 79 metres at its base. The remains of a theatre that was built in the Seleucid period but also used in Parthian times were found there.

Further excavations took place in the northern part of the city, where buildings dating back to Parthian times were found. Passages between the living quarters were probably used by bakers, as ovens for baking bread were discovered there. A variety of pottery, but also glassware and glazed terracotta tiles, was unearthed in the living rooms. Late in the Parthian era, unbaked brick walls were used as foundations for the walls of the rooms, while the façades were made from baked bricks. The Parthians embellished their homes with lively colours, decorating them with stucco. The motifs used here exhibit a distinct Parthian influence, based on Iranian culture. This is underlined by the findings of pottery, glazed ceramics and glassware (see 10.7). All this demonstrates the prosperity of Seleucia on the Tigris in Parthian times.[41]

During Rome's war against the Parthians, with Lucius Verus (161–166 AD) as leader, the cities of Seleucia on the Tigris and Ctesiphon were conquered, then looted in 165 AD under the command of Avidius Cassius. Following the Roman army's retreat, the Parthians rebuilt their capital Ctesiphon and thereafter the importance of Seleucia on the Tigris diminished.

7.3.2 Ctesiphon

Ctesiphon was built by Mithradates I and his successors as their new capital opposite Seleucia on the Tigris on the other side of the river. The major sources of

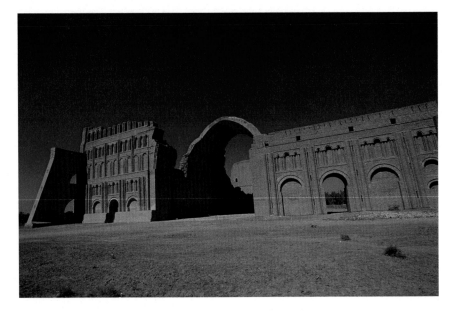

FIG. 7.14 Ruin of the Sasanian Palace, Ctesiphon. The large iwan in the middle, built in Parthian style, is called 'Taq-e Kisra' = 'arch of Khosrow' and was built by the Sasanian king Khosrow I (531–579 AD).

information about Ctesiphon during the Parthian period are provided by Greek and Roman historians, including Strabo, Pliny and Ammianus Marcellinus.

Unfortunately, there are hardly any archaeological finds from this Parthian capital. Supported by the Metropolitan Museum of Art in New York, excavations focused mainly on the remains of the Taq-e Kisra, meaning the Iwan of Khosrow, which was built under the Sasanian king Khosrow.[42] The lack of traces of the Parthian period is probably due to overbuilding of the city by the Sasanids, who established their capital here in around 228 AD. The final destruction of the city occurred under the Arabs under Caliph Omar. Today, only the remains of the Taq-e Kisra supply evidence of the ancient city of Ctesiphon (Fig. 7.14).

Its external form, like many Parthian urban towns, was circular. Around 129 AD it became the seat of government of the Parthian king. Life in the city was strongly influenced in those days by the presence of troops.[43] In time the city grew, soon attaining importance as the Parthian capital in the west. Parthian kings were crowned here, as we know from Artabanus II (in 10/11 AD) and Tiridates II (c. 35/36 AD). During the reign of Pacorus II (c. 75–110 AD) the city was fortified. The Roman war under Trajan against the Parthians shows the necessity for the fortifications. But in the end, this did not help, for the city was conquered in AD 116. Trajan invested Parthamaspates (see 3.4.8), the son of Osroes I, as Parthian king, hoping that he would be able to represent Roman interests. But Parthamaspates' influence was too weak and his father Osroes I regained power. In the end, Mesopotamia remained under Parthian control, whereas Roman influence persisted in Armenia and Adiabene.

Another attack against Parthia and Ctesiphon was undertaken by the Romans under Lucius Verus, who successfully took possession of the city in the winter of 165/166 AD. Their success did not last long, for they had to retreat, probably on account of a plague in Ctesiphon that enabled the Parthians to regain power there. The last, successful attack by the Romans took place under Lucius Septimius Severus at the end of 198 AD. The Roman troops destroyed the city and, as Cassius Dio related, 100,000 people were taken prisoner.

7.3.3 Dura-Europos

Dura-Europos, which was built by Seleucus I (312–280 BC) around 300 BC, is located on the Euphrates in today's Syria near the border with Iraq. The water wealth of the Euphrates was the basis for a fertile hinterland that played an important role in the development of this city. The Euphrates itself was less suitable than the Tigris for shipping, and the idea that Dura-Europos would have profited especially from long-distance trade has now been abandoned.

The importance of Dura-Europos and especially of Hatra (7.3.4) to our knowledge of the Parthian Empire arises from the fact that we here receive impressions of the art, the building activity and the structure of Parthian society, which are otherwise missing from what we have been able to gather from the heartland of the empire in Iran. The archaeological finds show that the artefacts 'combine elements of Classical and Oriental spheres of influence'.[44] For discussion regarding what is meant by 'Parthian art'[45] and the influence of the Parthians on the art found in Dura-Europos, but also in Hatra and Palmyra, see Chapter 10.

As the Parthian Empire spread under Mithradates II, Dura-Europos was conquered in 113 BC. The city remained under Parthian influence for more than 250 years. The location of the city in the west of the Parthian Empire thus became important in terms of both border protection and military presence. In the 1st and 2nd centuries AD, the city experienced an economic boom under Parthian influence. However, the city did suffer a brief setback after Trajan conquered it in 115 AD and subjugated it to Roman rule. Thereafter, the city prospered again for the next 50 years. The city's inhabitants comprised a mixture of Parthians, Greeks, Syrians, Jews and other ethnic groups. Numerous temples were built during this Parthian reign, showing the prosperity of its population. Different religions were practised here and a variety of gods worshipped. Temples dedicated to Zeus, Artemis, Adonis as well as the Palmyrene gods were built. The Zoroastrian god Mithra was also worshipped here. The Jews had their synagogue (Fig 7.15), and one of the first Christian churches was built in the city. In the aftermath of Trajan's Parthian war, but probably even before then, the Parthians had commissioned a local ruler, who belonged to the elite of the town, as a *stratēgos*, who controlled the civil and military administration. With the Parthian war of Lucius Verus (164/165 AD) the Arsacid influence ended, and the Romans finally gained control over Dura-Europos, which was incorporated into the province of Syria (Coele). In 256 or 257 AD, the city was destroyed by the Sasanids.

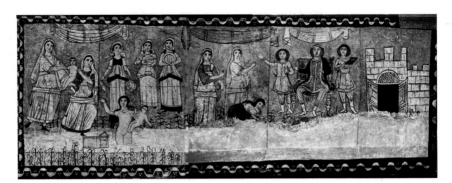

FIG. 7.15 Fresco from Dura-Europos synagogue, c. 245–256 AD. The picture shows Moses found in the river.

The first archaeological investigations into Dura-Europos were carried out by a team led by Ernst Herzfeld, a German archaeologist, Orientalist and historian, between 1898 and 1912. In 1920, British troops found the first frescoes there and alerted James Henry Breasted, an Orientalist from Chicago, who made more essential findings, such as the Konon fresco (Fig. 10.27) and the fresco of a hunting scene (Figs. 10.25 and 10.26). Franz Cumont, a Belgian archaeologist, made the first investigations.[46] He identified the site with Dura-Europos, which Isidore of Charax mentions in his book 'Parthian Stations' as 'Dura, City of Nicanor', a foundation of the Macedonians, called 'Europos' by the Greeks. Important discoveries of temples to Roman, Palmyrene and Greek gods were made by Cumont. Michael Rostovtzeff, a Russian archaeologist, continued the work until 1937. Investigations were then halted by the Second World War. From 1986, a Franco-Syrian team under the direction of Pierre Leriche re-started archaeological digging. This was followed by a British group.

The city was built on a Hellenistic-influenced city plan with a straight main road running from east to west to the Euphrates. Streets crossing at right angles complete the structure. These date from c. 150 BC.[47] A large city wall secured the city, with three city gates allowing access. The west-facing main gate was the Palmyra gate. The expansion of the Parthian Empire in Mesopotamia towards the west led to the conquest of Dura-Europos by the Parthians in c. 113 BC, the city becoming the Parthian administrative centre of this region. In the middle of the 1st century BC, in a first phase, the Parthians built an edifice on the citadel, similar to a palace in its structure, which included three iwans, thus demonstrating typical Parthian influence of a kind also known from Hatra.[48] The buildings following in a second phase no longer show any great Parthian influence, but continue with Hellenistic structures.

Dating to the last Parthian period is the Temple of the Gaddē named after the reliefs depicting two deities, the term 'gad' meaning the 'Lord'. One relief shows the Tyche of Palmyra, a Palmyrian tutelary deity. The other relief shows the gad

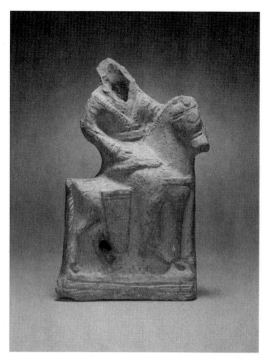

FIG. 7.16 Figurine of mounted Parthian horseman dressed in typical Parthian clothing, Dura-Europos, 15.2 × 8.35 × 3.35 × 3.35 cm, Yale-French Excavations at Dura-Europos, 1935.58. Yale University Art Gallery.

of Dura, a male deity responsible for the safety of Dura-Europos. Most likely it is Baalshamin, who was equated by the Romans to Zeus Megisthos. An inscription in Palmyrene language suggests the year 159 AD for the emergence of the reliefs.[49]

Dura-Europos residential houses studied by archaeologists are based on a Mesopotamian architectural style. The houses have a central courtyard, from which the rooms are accessible. The column elements (peristyles), as they are known from Greek or Hellenistic models, are missing. Even iwans, of the kind we know from Hatra, are missing here. However, the stucco elements in the houses reflect Iranian influences.

From the administration of the city we know that a 'stratēgos' stood at the head of the city administration. This office ran within a family and was passed on over 190 years. The names of various men who worked as a 'stratēgos' are known, such as Seleukos, Lysias and Lysania.[50] This indicates that they primarily belonged to the Macedonian ruling class. However, it can be assumed that after living for some decades in a Parthian city, they probably saw themselves as Parthians[51] and most likely received their legitimation from the ruling Parthian upper class in Ctesiphon.

The statues found in Dura-Europos display a mixture of Hellenistic but also Oriental-Parthian influence. Thus, frontality dominates in statues and reliefs, but also in frescoes (Fig. 10.27). Persons and gods are partially shown in Parthian-influenced clothing, and even the hairstyle looks Parthian. The paintings in the synagogue of Dura-Europos reflect Parthian influence (Fig. 7.15), even if these originated from the phase immediately after the fall of the empire.

In Dura, numerous Greek and Palmyrene writings were found. Four inscriptions found in Dura are written in Hatrean, a local Aramaic dialect (see 7.3.4). More than 60 inscriptions are in Palmyrene, and sometimes they are bilingual with a Greek inscription, indicating close connections between Dura-Europos and Palmyra. The oldest inscription dates from the year 32 AD and refers to the temple of the Mesopotamian god Bel.[52]

7.3.4 Hatra

Hatra, the capital of the kingdom of Hatra (for more information, see 5.8), is one of the most important cities in Mesopotamia – having long been part of the Parthian Empire, it provides much information about Parthian architecture and culture. Hatra's importance for understanding Parthian culture is partly due to the complete lack of archaeological findings from other Parthian cities such as Ecbatana or Ctesiphon. In assessing finds from Hatra in the Parthian era, however, we need to realise that specific factors must be taken into account, since the finds from there are not necessarily valid for the entire Parthian Empire.[53]

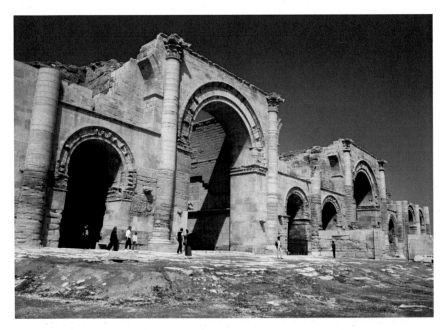

FIG. 7.17 The iwan complex in Hatra, 2nd century AD. General view from the north.

The location of the city on the western border of the Parthian Empire, approximately 300 km northwest of Baghdad in today's Iraq, placed it not far from the Roman Empire. Whereas it was formerly thought that Hatra had a strong Roman influence, it has now become clear, that 'the inhabitants of the city participated, in many ways, in Parthian culture'.[54] The city was secured by 6 kilometres of city wall, 10 metres high and 3 metres wide, and consisted of blocks of stone and mudbrick. Archaeologists found that embedded in the city wall were 11 forts, 28 major towers and 163 smaller ones.[55] We may conclude therefore that the city was often attacked and accordingly protected itself against such occurrences. Four main gates secured access to the city.

We do not know much about the beginnings of Hatra. Italian archaeologists found little evidence of settlement in the 1st century AD, and no evidence that Hatra had existed in Assyrian times. It is certain that Hatra formed one of the 18 Parthian *regna* at the end of the 1st and beginning of the 2nd century AD. The city was ruled by lords, who were under the control of the Parthian king of kings, as was the case with other vassal states of the Parthian Empire. The elevation of Hatra to the status of kingdom in c. 166 AD (see 5.8) changed its political situation – it had previously been an autonomous territory under Parthian influence. Hatra's rulers, who until then had styled themselves 'lord', now called themselves 'King of the Arabs'. Excavations show that the major construction works in the city began after 117 AD, when Trajan, who had returned from his war against the Parthians, besieged the city without success.

In the following 80 years, in the period between the wars of Trajan (114–117 AD) and Septimius Severus (195–198 AD), the city experienced a significant boom. Building activities were especially brisk between 117 and 150 AD. Roman attacks on the city under Septimius Severus in 197 and 199 failed, showing the importance and strength of Parthian Hatra. After the fall of the Parthian Empire, a Roman garrison was stationed there for a few years. In 240 AD the city was conquered and destroyed by the Sasanians.

It is difficult to answer the question of why Hatra developed into such a big city. Many factors have been discussed. Whereas Palmyra profited from the long-distance trade connecting China and Rome, there is not much evidence for any such trade in Hatra. Even the idea that Hatra became a religious centre over time, evidenced by the many temples or shrines, does not convince as the sole cause of the city's growth. However, one very convincing idea sees Hatra's hinterland as the reason for its growth. The production of food in smaller villages in Hatra's surroundings necessitated a central city for trading, which gradually prospered. This in turn promoted the further agricultural upswing of the villages. The influx of workers with different religious beliefs could explain the erection of various religious buildings in Hatra.[56]

The city, built in the circular shape typical of Parthian cities (see 7.1.1), is almost 2 km in diameter. Hatra's centre is dominated by a sacral complex, a *temenos*, which measures 320 × 435 metres and is surrounded by a wall. Besides the iwan complex (Fig. 7.17), it contains several temples, e.g. the temple of

Allat and the temple of the trinity (Māran, Mārtan and Barmārēn, see p. 149). Added to the *temenos* was building E (Temple of Maren), formerly misnamed a 'Hellenistic temple' as it was thought to have been built in the early days of Hatra. It actually dates from a later period.[57] Fourteen shrines were built around the sacred enclosure, probably used by a family or small groups.[58] These shrines were dedicated to more than one deity. Several gods are mentioned in scriptures in most of these shrines or are depicted by statues or reliefs. But it is still difficult to determine the name of a deity worshipped in a particular temple.[59] One of the most popular gods in the shrines is Heracles, who was also identified and worshipped as the Babylonian god Nergal, the god of the netherworld.[60] Heracles is often depicted together with the three-headed dog Cerberus. Inscriptions also refer to the assimilation of these two gods. It is noteworthy that the god Nergal is shown in a Parthian costume, pointing to the influence of Parthian culture on religious life in Hatra (Fig. 7.18).

In Hatra more than 400 inscriptions were found, written in a local Aramaic dialect known as Hatrean. These inscriptions reveal a picture of cultural diversity in which an assimilation of different deities occurs. Altogether 17 different gods are

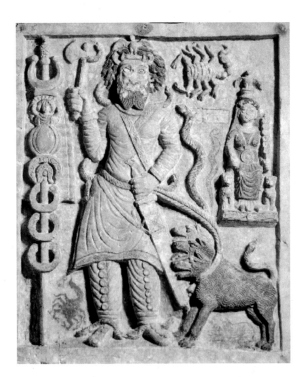

FIG. 7.18 Ancient Parthian relief carving of the god Nergal, find spot: Hatra, c. 1st or 2nd century AD. Nergal is depicted in typical Parthian costume with a tunic fastened by a belt and long trousers. The long sword is carried on the left hip and fixed with a carrying strap.

named, although the deities behind them could be various manifestations of the same god. Indeed, 80 per cent of the inscriptions refer to only four gods, namely a trinity of gods plus the god Nergal, who is equated with Heracles.[61] A trinity of gods were the highest ranking in Hatra: Māran, Mārtan and Barmārēn. Māran means 'our Lord', the supreme god of this trinity and identical to the main god of this region, the sun god Ŝamaŝ. Likewise, Māran was synonymous with the symbol of an eagle.

Considering the religious history of Mesopotamia, it is likely that Hatra's gods have their background in the ancient beliefs of this region. The ancient god Marduk, who commonly bore the name 'Bel' (the Lord), can thus be equated to Māran, who is also named in inscriptions as 'our Lord'. Mārtan, meaning 'our mistress', is the wife of Māran-Ŝamaŝ. Not much is known of her, for she is rarely mentioned in inscriptions and she likely did not have a temple of her own. She is also known as 'Allat' or 'Iŝŝarbel'.[62] Taking all this into account, Mārtan has to be equated with Marduk's wife.[63] Barmārēn, the son of Māran and Mārtan, is considered a youthful god, with responsibility for wine growing and architecture. In addition to a crown of rays, symbol of the sun, Barmārēn is also shown with a pair of horns, referring to the Mesopotamian moon gods Nabū and Sīn. In the overall view of all inscriptions and pictorial representations of the gods, however, even if it is difficult to obtain a clear picture of the character of these main gods in Hatra and to decide what assimilations of former deities to the trinity took place here, Assyrian but also Babylonian influences are likely.[64]

Roman historians equated Māran-Ŝamaŝ with the Roman sun god Helios.[65] That there was a close relationship to the Roman Empire is also suggested by the fact that Māran-Ŝamaŝ is sometimes depicted in Roman soldier's clothing. A parallel to Palmyra is unmistakable, because even there, Palmyrene deities wear Roman costumes (Fig. 7.26).

In terms of Parthian architecture, the iwan complex in Hatra is of enormous importance, as the buildings here feature typical Parthian architecture, with several iwans (Fig. 7.17) and their archivolts being adorned with human and animal heads (Fig. 7.19). They were built at the beginning of the 2nd century AD, while the temple of Allat, also erected in the grounds of the *temenos*, was constructed around 160 AD.[66] Formerly identified as a palace, excavations have now revealed that it is a religious monument. This original Parthian construction method of inserting iwans in their buildings was also adopted by their successors. It continued to be used in the mosque architecture of Islamic times, as may be seen in the edifices in Samarkand in Uzbekistan, where the iwan still plays a central role (Fig. 7.20).

Valuable insights into Parthian houses were facilitated by the excavations in Hatra. Archaeologists assume that the dwellings there were intended for larger families or clan-type communities – possibly they shared a room for the kitchen and provisions. All residential buildings had a central courtyard, extended by iwans with adjacent living spaces. This type of house is also found in Mesopotamia, especially in Assyria and Seleucia during the Arsacid period. Three building traditions flow

FIG. 7.19 Entrance to the iwan complex, Hatra. Standing figures in Parthian costume, camels and dromedaries.

FIG. 7.20 Ulugh Beg Madrasah (left), Registan Place, Samarkand, Uzbekistan, with an iwan hall based on Parthian architecture, built 1417/1420 AD.

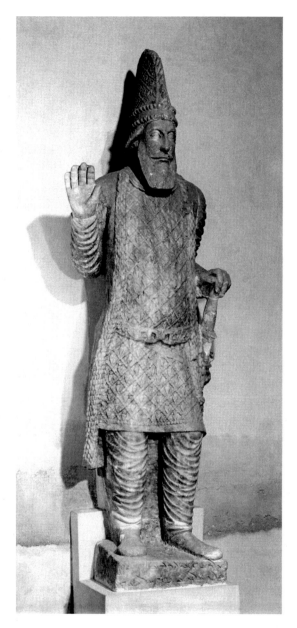

FIG. 7.21 Marble statue, temple III, Hatra, first half of 2nd century AD, 2.20 metres tall. The inscription refers to King Uthal, an early Arab king who ruled Hatra. The bearded ruler wears a tiara and a knee-length, elaborately embroidered upper garment in Parthian style and retained by a belt, while an open coat hangs over his shoulders. On the left side, he carries a long sword with a dragon-shaped handle, the right hand is raised in a typical Parthian gesture. In March 2015, this statue in the museum in Mosul was unfortunately destroyed by members of the so-called Islamic State. Photo: akg-images/Maurice Babey.

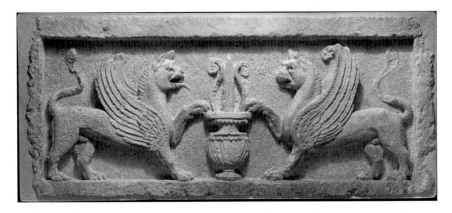

FIG. 7.22 Door lintel, once positioned as part of a decorated doorway in the north hall of the iwan complex in Hatra. Limestone. Each placing one leg on a vase in the middle, the beasts are a lion-griffin combination. This lion-griffin motif is characteristic of the Near East. Accession number: 32.145a, b. Metropolitan Museum of Art, New York, purchased 1932.

together here: the genuinely Mesopotamian court house type, which in Dura-Europos was the standard residential building, supplemented by the Parthian iwan and the Greek Hellenistic peristyl, a porch formed by a row of columns, which surrounds a courtyard.

These religious and architectural references to Parthian influence on the city of Hatra are supplemented by inscriptions attesting the use of Parthian words and loan words.[67] An entirely different indication of Parthian influence can be found by analysing the image of weapons shown on statues in Hatra. Here the dignitaries mainly wear long swords, which are worn on the left side (Fig. 7.21). Long swords were already used by the Scythians in the 6th–5th centuries BC. This weapon technology was then adopted by the Parthians. Representation of the Hatrean dignitaries with long swords is thus another indication of Parthian influence in Hatra.

Hatra, like Palmyra, was largely destroyed in 2015 by the so-called Islamic State, and many important testimonies from the Parthian period are therefore lost. This is also true of the marble statue shown in Fig. 7.21.

7.3.5 Palmyra

Palmyra, located in a desert in present-day Syria, never belonged to the Parthian Empire. However, trade flourished between the Parthian Empire and the west, which led to the considerable influence of Parthian culture, which is particularly evident in the Parthian clothing worn by citizens of Palmyra depicted in statues.

Palmyra, in ancient times called Tadmor, was already inhabited in the Neolithic period, as archaeological finds show. Several Assyrian kings mention the city in

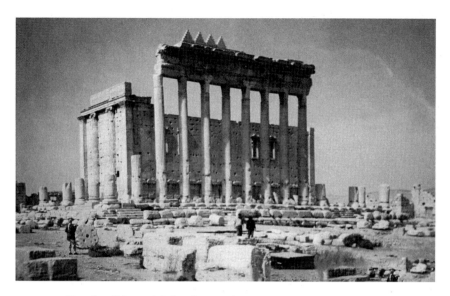

FIG. 7.23 Temple of the god Bel, Palmyra. Photo 1999.

their annals and the Bible, in the Old Testament, also tells us something about this town. Palmyra owed its importance and wealth to the water of an oasis that was an important stopover on the Silk Road, running through the middle of the Syrian desert and thus controlling trade between the Mediterranean and the Persian Gulf. Palmyra became part of the Seleucid Empire after the conquests of Alexander the Great.

With the expansion of the Roman Empire, Palmyra then came under Roman administration. Its heyday came in the 1st century AD. It is noteworthy that in the first three centuries there is no evidence of a kingship in Palmyra; the city was governed by the local nobility.[68]

Palmyra not only benefited from customs duties, but also generated additional revenues from the protection of merchant caravans by mounted archers.[69]

The city and its architecture are strongly influenced by a Graeco-Roman style. Especially imposing is the more than 1-km-long Great Colonnade, which extends from the Temple of Bel (Fig. 7.23), from east to west through the city. Hundreds of beautifully ornamented columns in Corinthian style lined this main street. The Temple of Bel was the largest building complex in the city, consecrated in 32 AD to the main Palmyrene god Bel, assimilated from the Babylonian god Bel-Marduk, the ruler of the universe. Bel was worshipped there in a trinity with the lunar god Aglibol and the sun god Yarhibol. When Christianity came to Syria, the Temple of Bel was converted into a Christian church.

It is noteworthy that in Palmyra there were two supreme gods: Bel and Baalshamin. The Temple of Baalshamin (Lord of Heaven) was situated not far from the Great Colonnade. There Baalshamin, of Phoenician origin, was worshipped as

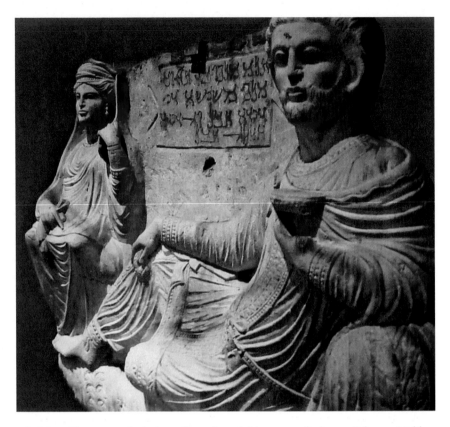

FIG. 7.24 Gravestone depicting a funeral meal. Limestone, find spot: Palmyra. Malike, dressed in Parthian trousers, and his wife Hadira. Inv. Nr. AO 2000, Paris, Louvre.

supreme god by part of the population. Like Bel, he is shown in a trinity together with the moon god Aglibol and the sun god Malakbel, as seen on a relief that presents the three gods clad in Roman-looking military dress (Fig. 7.26). Various other gods were worshipped in Palmyra, thus there was a temple of Nebu, also a temple of Allat. Nebu was a former Mesopotamian god of wisdom and writing but equated in Palmyra with the god Apollo.

Graeco-Roman culture influenced Palmyra, a city with a tribal social structure. In the period of Roman influence, Romans lived together with Amorites, Arabs and Arameans. They spoke Palmyrene, a dialect of Aramaic, but also Greek, the imperial language in the east, which was used for trade or by diplomats. All this confirms the cultural richness of the city, in which there was also a theatre near the agora.

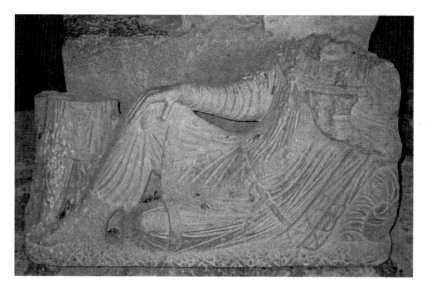

FIG. 7.25 Gravestone depicting a man with Parthian-influenced clothes, who lies on a kline, find spot: Palmyra.

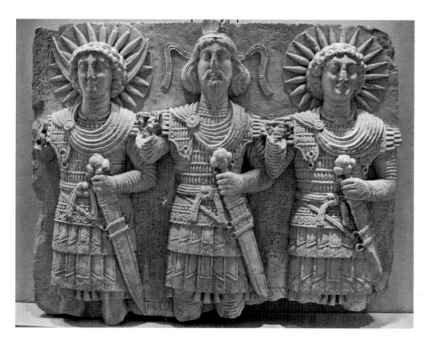

FIG. 7.26 Palmyrian deities: Aglibol, Baalshamin and Malakbel, limestone, middle of the 1st century AD, find spot: Bir Wereb, Wadi Miyah, near Palmyra, Syria. The bearded Baalshamin in the centre was master of the sky; to his left is the moon god Aglibol, with Malakbel the sun god to the right. Here the oriental gods are dressed in very Roman-looking military dress. AO 19801, Paris, Louvre.

With the strengthening of the Parthian Empire and its expansion to the west, trade with Rome became vibrant, and some of this was handled via Palmyra. How intense Parthian influences eventually became in Palmyra is revealed by the many reliefs and tombstones that were found there. Palmyrene inhabitants of the upper class present themselves on tombstones wearing Parthian-style costumes. An inscribed tombstone refers to Malike and his wife Hadira (Fig. 7.24) – Malike is lying on a kline, supporting a cup with his left hand and wearing Parthian clothing, the wide and pleated trouser legs being inserted into his soft leather shoes. The tunic, fixed by a leather belt, displays exquisitely crafted embroidery. A similar illustration depicts another grave stele (Fig. 7.25).

Notes

1 Jacobs, B., 2010: p. 41.
2 Lippolis, C., 2019: p. 76; Jacobs, B., 2010: p. 87: it is also possible that Hecatompylos was the first main town of the Parthians.
3 Winkelmann, S., Ellerbrock, U., 2015: 139.
4 Koshelenko, G.A., Gaibov, V.A., 2014: pp. 69–91.
5 Ghirshman, R., 1962 (2): p. 34.
6 Keall, E.J., 1973, 15 ff.; Schlumberger, 1969 (2): pp. 192–194.
7 Gall, H. von, 1998: p. 76.
8 Rostovtzeff, M.I., 1935: p. 219; Winkelmann, S., Ellerbrock, U., 2015: p. 130 ff.
9 Hauser, S.R., 2014: p. 134.
10 Invernizzi, A., 2016: p. 83.
11 Winkelmann, S., Ellerbrock, U., 2015: p. 138 ff.
12 For discussion, see: Schlumberger, D., 1969 (2): pp. 195–196.
13 For literature, see Winkelmann, S., Ellerbrock, U., 2015: p. 130 ff.
14 Brentjes, 1990 (2): see photo no. 18. The triumphal arch contains what is possibly a representation of the city of Ctesiphon, which was besieged by the Romans.
15 Cech, B., 2017: p. 63. The 'Temple of Mercury', built in the time of Augustus, is considered to be the earliest Roman dome; Winkelmann, S., Ellerbrock, U., 2015: p. 138.
16 Lippolis, C., 2019: p. 74 ff.; Winkelmann, S., Ellerbrock, U., 2015: p. 135.
17 Kaim, B., 2016, p. 92 ff.
18 Safar, F., Mustafa, M.A., 1974: figs. on pp. 267, 248 and 249, 140, 138, 118, 117, 95, 38.
19 E.g. www.parthia.com/nisa/images/nisa_2002-6.jpg.
20 Ghirshman, R., 1962 (1): p. 36.
21 Lippolis, C., 2019: p. 73.
22 Masson, V.M., 1987: p. 122.
23 Lippolis, C., Davit, P., Turco, F., 2017: p. 2, footnote 2.
24 Invernizzi, A., 2016: pp. 83–89; 2002, p. 234.
25 Lippolis, C., 2011 (2): p. 287 ff.
26 Lippolis, C., 2011 (2): p. 287 ff.
27 Masson, V.M., 1987: p. 129.
28 Invernizzi, A., 2002: p. 234 ff.; Jacobs, B., 2010: p. 133.
29 Ghirshman, R., 1962 (2): p. 34.
30 Simpson, S., 2014: pp. 1–21.
31 Jacobs, B., 2010: p. 88.
32 Gall, H. von, 1998: p. 75.

33 www.parthia.com: Coin analysis.

34 Cumont, F.: various articles at: www.persee.fr/authority/272960. See also: Thommen, L., 2010: p. 478 ff.

35 Thommen, L., 2010: p. 484.

36 Martinez-Sève, L., 2002: pp. 44–45.

37 Pliny, *Naturalis historia* 6.122.

38 Gregoratti, L., 2014.

39 Messina, V., 2011: pp. 157–168.

40 See, www.centroscavitorino.it/index.php/en/projects/iraq-eng/iraq-seleucia-on-the-tigris.

41 A list of the various literary sources on Seleucia can be found at: www.centroscavitorino.it/en/progetti/iraq/seleucia-biblio_generale.html.

42 Rakic, Y., 2010: p. 11.

43 Hackl, U., 2010: p. 127.

44 Kaizer, T., 2016, pp. 1–15.

45 Rostovtzeff, M., 1935: p. 157 ff.

46 Cumont, F.: many of his articles on his research and on Greek inscriptions found in Iran are to be found at: www.persee.fr/authority/272960.

47 Sommer, M., 2005: p. 272.

48 Sommer, M., 2005: p. 276.

49 Sommer, M., 2005: p. 286.

50 Sommer, M., 2005: p. 298.

51 Gregoratti, L., 2016 (2): p. 20 f.

52 Zehnder, M., 2010: p. 371.

53 Dirven, L., 2013 (1): p. 11.

54 De Jong, A., 2013: p. 144.

55 Sommer, M., 2003: p. 31.

56 Kaizer, T., 2013: pp. 58–71.

57 Hauser, S.R., 1998: p. 505.

58 Dirven, L., 2009: p. 52.

59 Jakubiak, K., 2013: p. 92.

60 al-Salehi, W., 1971: pp. 111–115.

61 Dirven, L., 2011, p. 157 ff.

62 Dirven, L., 2011: p. 165.

63 Tubach, J., 2013: p. 215.

64 Tubach, J., 2013: p. 206.

65 Tubach, J., 2013: p. 202.

66 Dirven, L., 2009: p. 48.

67 De Jong, A., 2013: 155 ff.

68 Yon, J.B., 2010: p. 229.

69 Sommer, M., 2005: p. 155.

8

TRADE AND BUSINESS IN THE PARTHIAN EMPIRE

At the height of its power the Parthian Empire engaged in extensive trade with its neighbours, a greater part of this being conducted by land, and a lesser part by river and by sea. The basis for goods handling by land was the existing Achaemenid trade route, which was based on the long-distance trade network that had existed for thousands of years, the Silk Road, which in the east stretched across Central Asia to China and in the west to the Mediterranean. The term 'Silk Road', however, was not coined until the 19th century.

Amazingly, there is little literary evidence of the exact course of the main trade routes. Presumably, the route went from Hierapolis (northern Mesopotamia) via Ecbatana to Hecatompylos and from there on to Merv and Turfan (China).[1] Isidore of Charax, who was born in Charax near the Persian Gulf and lived during the Augustean era at the end of the 1st century BC, was a geographer, who described the royal road in Parthia, which connected the royal centres of administration of the empire. This royal road is to be distinguished from the trade route, as it mainly served military purposes, such as the transfer of troops and of royal orders and dispatches.[2] It is not certain, but the royal road could also have been used for the transport of goods, as parts of the trade routes were largely congruent with the royal road.

The Euphrates, Tigris and Karun[3] rivers permitted maritime trade with India and even with China. During the reign of Mithradates II, state-controlled and -secured long-distance trade existed between Parthia and China. Parthian coins reveal evidence of such trade relations, as they were discovered, albeit in small quantities, in more distant cities in Eurasia and even in the Turfan region that is now part of western China.

Our knowledge of trade policy in Parthia is generally poor. Udo Hartmann, based on the few literary references, assumes that Parthian central power did not pursue an active trade policy and that traders enjoyed extensive freedoms.[4] There is

also little evidence of tariffs. Customs revenues from long-distance trade are therefore likely to have had little significance for the Parthian crown treasury. Trade policy might have changed in the 2nd to the 3rd century AD. Although the Parthians were frequently at war with Rome, trade between the two empires became enormously important. This is shown by the intense negotiations of the Roman Emperor Caracalla (211–217 AD) with the Parthian king Artabanus IV, on free trade in spices and garments. Caracalla offered Roman metals and handicrafts as a counterpart for Parthian goods.[5] For the transport of goods by river, the Euphrates played a significant role in Parthian times, as the few currents made it more navigable. Seleucia on the Tigris was the centre for the transport and exchange of heavy goods. Through a canal system, the city was directly connected to the Euphrates and thus also to the seaports on the Persian Gulf.

A major seaport on the Gulf was Charax-Spasinu, which controlled maritime long-distance trade relations between Mesopotamia, India and even China. The city port of Omana on the Persian Gulf (now United Arab Emirates) provided a stopover on the way to the east.[6] This city even boasted a shipyard.[7] The size of Parthian vessels is given as more than 26 gross registered tons.[8] Investigations today assume that this area of the Arab region, at least in the 1st century AD, was within the sphere of influence of the Parthian Empire. The Parthians also realised the strategic importance of the Strait of Hormuz, which separates the Persian Gulf from the Indian Ocean. The remains of a huge castle complex (Nakhl-e Ebrahim) have been found on today's Iranian side, and its harbour enabled the Parthians to control this important strait.[9]

The Parthians imported luxury goods from China, such as silk, jade or mineral resources, which were not sufficiently available in the heartland of Parthia.[10] These included silver used for the production of coins and jewellery, but also specially treated iron ore, the so-called 'Chinese iron', special steel that was of crucial importance for the production of weapons for the Parthian army.[11] The Parthians exported horses from Nisa, trees and exotic woods, slaves, pearls, pomegranates, vines, alfalfa (lucerne) and even ostriches to China. Lions were also exported to China, enjoying great popularity with the Chinese rulers. In the course of this trade, jugglers and acrobats joined the caravans and made their way to the east.

In addition to cotton and spices, Chinese silk was a particular focus of trade with China. The first silk fabrics are said to have been made by the wife of Emperor Hoang-Ti as early as 2700 BC. At the time of the Han Dynasty in China (206 BC–220 AD), the military expansion of China westward into the Turfan area was promoted in the 1st century BC. Soldiers and generals stationed in garrisons there were paid for with silk bales. This became the starting point for extensive trade involving Scythian and Parthian merchants, who continued to bring goods to markets in Syria and even to Rome. In the imperial era, the elegant Romans' interest in silk was great. Silk was expensive, so only wealthy Roman women could buy wholly silk robes. As a result, lower-priced dresses were highly sought after. These simply had silk trimmings. The Kushan kingdom, which had become a new great power from the 1st century AD onwards, started to control large sections of

the Silk Road and expanded sea trade with Rome – bypassing Parthian customs duties. The flow of goods was so great that the Romans at times ran out of the gold with which they had to pay the Kushans.[12]

8.1 Parthian coins and the genealogy of Parthian kings – basic information

While we have sufficient information about the rough sequence of Parthian kings, especially from Roman sources, but also from others, uncertainties persist regarding the details.

Information on Parthian coins – such as date stamps or the king's name – therefore have to be reconciled with the aforementioned sources. With his first book *An Introduction to the Coinage of Parthia*, published in 1971, David Sellwood laid the most important foundation for this work and it remains the primary basis for determining the order of Parthian kings.[13] However, one of the main problems with the coin analyses is that, especially for the early Arsacid period, the coins provide no direct indications who the king is, as all kings bear the name 'Arsaces' and personal names and dates are lacking. The data provided by Sellwood on the genealogy of the Parthians is therefore essentially based on the iconography of the coins, visible changes in their images or inscriptions, but also on the overstrikes that render simpler a better temporal classification of the coins. The details given by Sellwood in the first edition of his book were corrected by him in a second edition (1980) in a few regards. His later articles change again some of the attributions he made in 1980. One example is his assignment of the S 5 coins to Arsaces I instead of Arsaces II.[14] All this shows how difficult it remains to discover the exact sequence of the kings. In any case, his book today continues to be the basis for assigning coins to the Parthian kings.

Recent research attempts to fill these gaps. Thus G.F. Assar, a well-known researcher into Parthian history, gives a sequence of Parthian kings that differs in parts from Sellwood's.[15] The largest transnational scientific processing of Parthian coins, based on Sellwood's cataloguing, is the *Sylloge Nummorum Parthicorum* (SNP), which was started in 2011 under the leadership of Michael Alram (Austrian Academy of Sciences, Numismatic Commission) and Vesta Sarkhosh Curtis (British Museum, Department of Coins and Medals). The first completed volume, Volume VII, whose research has been taken into account here, was prepared by Fabrizio Sinisi and published in 2012.[16] Unfortunately Vol. 2 (Mithradates II), published in October 2020, could not be taken into account.

8.1.1 Cataloguing Parthian coins according to Sellwood and Assar

David Sellwood assigns a total of 93 main coin types to the various Parthian kings. For the identification of a Parthian coin, the name S (for Sellwood) followed by a type number has been established worldwide.[17] To the first ruler, Arsaces I, for example, types from S 1 to S 5 have been assigned.[18] This main type is followed by a further sub-division into sub-types. For example: type S 3.1 is a coin that contains

a monogram on the reverse (sign of the Mithradatkart mint), type S 3.2 differs from S 3.1 due to the lack of a monogram.

Some historians – and coin dealers in particular – now follow Assar's genealogy of Parthian kings,[19] sometimes without reference to Sellwood's coin types or even mentioning that Assar's attribution is used. This might result in confusion, e.g. as Mithradates III (Sellwood's attribution) is named Mithradates IV by Assar. Table 8.1 shows the differences between the two listings. The genealogy given by

TABLE 8.1 Comparison of the genealogy of Parthian kings provided by Sellwood[1] and Assar (Sunrise Collection, 2011).[2]

Sell-wood type	Period of reign	Kings listed by Sellwood	Kings listed by Assar[3]	Period of reign	Number – Assar (2011)
Type 1	c. 247–211 BC	Arsaces I	Arsakes I	c. 247–211 BC	234–236
2	c. 247–211 BC	Arsaces I	Arsakes I	c. 247–211 BC	237
3	c. 247–211 BC	Arsaces I	Arsakes I	c. 247–211 BC	238
4	c. 247–211 BC	Arsaces I	Arsakes I	c. 247–211 BC	239
5	c. 211–191 BC	Arsaces II	Arsakes I	c. 247–211 BC	240
6	c. 211–191 BC	Arsaces II	Artabanus I (Arsakes II)	c. 211–185 BC	241–244
	c. 191–176 BC	Phriapatius		c. 185–170 BC	248–250
		Not listed by Sellwood, as no coins are known			
	c. 176–171 BC	Phraates I			
		Not listed by Sellwood, as no coins are known			
7	c. 171–132 BC	Mithradates I	Artabanus I (Arsakes II)	c. 211–185 BC	245–247
8	c. 171–132 BC	Mithradates I	Phriapatios (Arsakes III)	c. 185–170 BC	248–250
9	c. 171–132 BC	Mithradates I	Phriapatios to Mithradates I (Arsakes IV)	c. 170–168 BC	251–254

(continued)

TABLE 8.1 Cont.

Sell-wood type	Period of reign	Kings listed by Sellwood	Kings listed by Assar³	Period of reign	Number – Assar (2011)
10	c. 171–132 BC	Mithradates I	Phraates I (Arsakes V) or Mithradates I	c. 168–164 BC	255–256
11	c. 171–132 BC	Mithradates I	Mithradates I (Arsakes VI)	c. 164–132 BC	265–266
12	c. 171–132 BC	Mithradates I	Mithradates I (Arsakes VI)	c. 164–132 BC	258–259
13	c. 171–132 BC	Mithradates I	Mithradates I (Arsakes VI)	c. 164–132 BC	260–266
14	c. 132–127 BC	Phraates II	Phraates II (Arsakes VII)	c. 132–127 BC	267–272
15	c. 132–127 BC	Phraates II	Phraates II (Arsakes VII)	c. 132–127 BC	267–272
16	c. 132–127 BC	Phraates II	Phraates II (Arsakes VII)	c. 132–127 BC	267–272
17	c. 132–127 BC	Phraates II	Phraates II (Arsakes VII)	c. 132–127 BC	267–272
18	c. 127–125 BC	Interregnal Issues	Artabanus II (Arsakes VIII)	c. 127 – 126 BC	273–274
19	c. 127–124 BC	Artabanus I	Artabanus III (Arsakes IX)	c. 126–122 BC	275–279
20	c. 127–124 BC	Artabanus I	Artabanus III (Arsakes IX)	c. 126–122 BC	275–279
21	c. 127–124 BC	Artabanus I	Artabanus III (Arsakes IX)	c. 126–122 BC	275–279
22	c. 127–124 BC	Artabanus I	Artabanus III (Arsakes IX)	c. 126–122 BC	275–279
23	c. 121–91 BC	Mithradates II	Arsakes X	c. 122–121 BC	280
24	c. 121–91 BC	Mithradates II	Mithradates II (Arsakes XI)	c. 121–91 BC	281–288
25	c. 121–91 BC	Mithradates II	Mithradates II (Arsakes XI)	c. 121–91 BC	281–301
26	c. 121–91 BC	Mithradates II	Mithradates II (Arsakes XI)	c. 121–91 BC	289–292
27	c. 121–91 BC	Mithradates II	Mithradates II (Arsakes XI)	c. 121–91 BC	293–295
28	c. 121–91 BC	Mithradates II	Mithradates II (Arsakes XI)	c. 121–91 BC	296–301
29	c. 121–91 BC	Mithradates II	Gotarzes I (Arsakes XIII)	c. 91–87 BC	305
30	c. 80–70 BC	Unknown King (II)	Arsaces XVI	c. 78/77–62/ 61 BC	311–316
31	c. 90–80 BC	Orodes I	Mithradates III (Arsakes XIV)	c. 87–80 BC	306–308

TABLE 8.1 Cont.

Sell-wood type	Period of reign	Kings listed by Sellwood	Kings listed by Assar[3]	Period of reign	Number – Assar (2011)
32	c. 80 BC	Unknown King (I)	Gotarzes I (Arsakes XIII)	c. 91–87 BC	304
33	c. 95–90 BC	Gotarzes I	Sinatrukes (Arsakes XII), (intermittently)	c. 93/92–70/ 69 BC	302–303
34	c. 93/92–69/ 68 BC	Sinatruces	Orodes I (Arsakes XV)	c. 80–75 BC	309–310
35	c. 70 BC	Darius (?)	Phraates III (Arsakes XVII)	c. 70/69–58/ 57 BC	326–334
36	c. 70 BC	Darius (?)	Phraates III (Arsakes XVII)	c. 70/69–58/ 57 BC	317–325
37	c. 70 BC	Darius (?)	Phraates III (Arsakes XVII)	c. 70/69–58/ 57 BC	
38	c. 70–57 BC	Phraates III	Phraates III (Arsakes XVII)	c. 70/69–58/ 57 BC	335–339
39	c. 70–57 BC	Phraates III	Phraates III (Arsakes XVII)	c. 70/69–58/ 57 BC	340–347
40	c. 57–54 BC	Mithradates III	Mithradates IV (Arsakes XVIII)	c. 58/57–55 BC	348–354
41	c. 57–54 BC	Mithradates III	Mithradates IV (Arsakes XVIII)	c. 58/57–55 BC	356–357
42	c. 57–38 BC	Orodes II	Orodes II	c. 57–38	360
43	c. 57–38 BC	Orodes II	Orodes II	c. 57–38	361–362
44	c. 57–38 BC	Orodes II	Mithradates IV (Arsakes XVIII)	c. 58/57–55 BC	355
45	c. 57–38 BC	Orodes II	Orodes II	c. 57–38	358–359, 363–366
46	c. 57–38 BC	Orodes II	Orodes II	c. 57–38	367–370
47	c. 57–38 BC	Orodes II	Orodes II	c. 57–38	371–374
48	c. 57–38 BC	Orodes II	Orodes II	c. 57–38	375–386
49	c. 39 BC	Pacorus I			
50	c. 38–2 BC	Phraates IV	Phraates IV	c. 38/37–2 BC	387, 390
51	c. 38–2 BC	Phraates IV	Phraates IV	c. 38/37–2 BC	388
52	c. 38–2 BC	Phraates IV	Phraates IV	c. 38/37–2 BC	391–395
53	c. 38–2 BC	Phraates IV	Phraates IV	c. 38/37–2 BC	
54	c. 38–2 BC	Phraates IV	Phraates IV	c. 38/37–2 BC	389, 396
55	c. 29–27 BC	Tiridates (I)	Uncertain Usurper, Tiridates?	Apr./May– Oct./Dec. 27 BC	397–398

(continued)

TABLE 8.1 Cont.

Sell-wood type	Period of reign	Kings listed by Sellwood	Kings listed by Assar³	Period of reign	Number – Assar (2011)
	c. 29–27 BC	Tiridates (I)	Usurper Mithradates in Mesopotamia (S 55.10)	c. 15–10 BC	399
56	c. 2 BC–4 AD	Phraataces	Phraatakes	c. 2 BC–4/5 AD	400
57	c. 2 BC–4 AD	Phraataces	Phraatakes	c. 2 BC–4/5 AD	401–402
58	c. 2 BC–4 AD	Phraataces & Musa	Phraataces & Musa	c. 2 BC–4/5 AD	403–404
59	c. 6 AD	Orodes III	Orodes III	c. 6–8 AD	405
60	c. 8–12 AD	Vonones I	Vonones I	c. 8–12 AD	406–408
61	c. 10–38 AD	Artabanus II	Vonones I	c. 8–12 AD	409
62	c. 10–38 AD	Artabanus II	Artabanus IV	c. 10–38 AD	410
63	c. 10–38 AD	Artabanus II	Artabanus IV	c. 10–38 AD	411–412
63	c. 10–38 AD	Artabanus II	Vardanes I (Sellwood: 63.13)	c. 38–46 AD	415
	c. 35–36 AD not mentioned by Sellwood, as no coins are known	(Tiridates II)			
64	c. 40–47 AD	Vardanes I	Vardanes I	c. 38–46 AD	413–414
65	c. 40–51 AD	Gotarzes II	Gotarzes II	c. 44–51 AD	416
66	c. 40–51 AD	Gotarzes II	Gotarzes II	c. 44–51 AD	
67	c. 51 AD	Vonones II	Usurper Meherdates	c. 49–50 AD	417–418
68	c. 50–79 AD	Vologases I	Vologases I (First reign)	c. 50–54/55 AD	419
69	c. 55–58 AD	Vardanes II = Son of Vardanes	Vardanes II	c. 55–58 AD	420–421
70	c. 50–79 AD	Vologases I	Vologases I (Second reign)	c. 58–77 AD	422, 424
	c. 50–79 AD	Vologases I	Vologases I (Second reign)	c. 58–77 AD	425
	c. 50–79 AD	Vologases I	Vologases I (Second reign)	c. 58–77 AD	426
71	c. 50–79 AD	Vologases I	Vologases I (Second reign)	c. 58–77 AD	423
72		Vologases II– did not exist, according to Sinisi	Vologases II	c. 76/77–79 AD	427–429
73	c. 75–110 AD	Pacorus II	Pakorus I	c. 78–120 AD	430–431

TABLE 8.1 Cont.

Sell-wood type	Period of reign	Kings listed by Sellwood	Kings listed by Assar[3]	Period of reign	Number – Assar (2011)
74	c. 80–82 AD	Artabanus III	Artabanus V	c. 79/80–c. 85 AD	440–442
75	c. 75–110 AD	Pacorus II	Pacorus I	c. 78–120 AD	432
76	c. 75–110 AD	Pacorus II	Pacorus I	c. 78–120 AD	433
77	c. 75–110 AD	Pacorus II	Pacorus I	c. 78–120 AD	434–438
78	c. 105–147 AD	Vologases III	Pacorus I (S 78.6)	c. 78–120 AD	439
79	c. 105–147 AD	Vologases III	Vologases III	c. 111–146 AD	445–448
80	c. 109–129 AD	Osroes I	Osroes I	c. 108/109–127/128 AD	443–444
81	c. 116 AD	Parthamaspates	Sanatrukes (?)	c. 116 AD	449
82	c. 129–140 AD	Mithradates IV	Mithradates V	c. 128–147 AD	450
83	c. 140 AD	Unknown King (III)			
84	c. 147–191 AD	Vologases IV	Vologases IV	c. 147–191 AD	451–452
85	c. 190 AD	Osroes II	Osroes II	c. 190–208 AD	453
86	c. 191–208 AD	Vologases V	Vologases V	c. 191–207/208 AD	454–456
87	c. 191–208 AD	Vologases V	Vologases V	c. 191–207/208 AD	457
88	c. 208–228 AD	Vologases VI	Vologases VI	c. 207/208–221/222AD	458–460
89	c. 216–224 AD	Artabanus IV	Artabanus VI	c. 212–224/227 AD	461
90	c. 216–224 AD	Artabanus IV	Artabanus VI	c. 212–224/227 AD	462

1 Sellwood's genealogy revised to include changes resulting from more recent investigations by Sinisi, Dąbrowa, Olbrycht and others. For details see sections on each king.
2 Assar, G.R.F., 2011.
3 Assar uses Greek names, while Sellwood gives the Latin versions.

Assar is partially doubted by other specialists, who also for good reasons still follow Sellwood's attribution. Thus, without being able to state what is right or wrong, Table 8.1 shows the different assignments of coins and names.[20]

8.1.2 Parthian denominations

The founders of the Parthian Empire, the Parni, had no coinage of their own when they conquered the Seleucid satrapy of Parthia. With this victory over the Greek satrapy, they inevitably took over the existing administrative structures. That the Parthians also took over the Seleucid coinage is therefore not surprising.[21] They made use of the experience of the die-cutters, who worked there in the mint.

The weights and the value of Parthian coins are based on the Greek-Hellenistic coin system of the Seleucids, which is based on the Greek-Attic coin system. Silver drachms there had a weight of 4.36 grams, silver tetradrachms had a fixed weight of 17.46 grams.[22] Only drachms and dichalkoi have been found for the first Parthian ruler, Arsaces I. At the time of Mithradates I and subsequent rulers, the following values were also issued: tetradrachms, hemidrachms, triobols, diobols, obols and hemiobols, octacholkoi, tetrachalkoi, dichalkoi, chalkoi (see Table 8.2 and Fig. 8.1 A + B).[23]

Tetradrachms were produced by Mithradates I only after the conquest of the city of Seleucia in the year 141 BC.[24] Here, too, the Parthians used the existing structures and continued to use the established mints. Thus, the first tetradrachms minted under Mithradates I were similar to the Seleucid model. The same applied

TABLE 8.2 Nominal values of Parthian coins.

Nominal value		Approximate weight*
Tetradrachm	= 4 Drachms	13.4–14.6 g
Drachm	= 2 Hemidrachms	3.7–4.1 g
Hemidrachm	= 1/2 Drachm	1.99 g
Triobol	= 3 Obols = 1/2 Drachm	1.95 g (S 9.5) (see: www.parthia.com)
Diobol	= 2 Obols = 1/3 Drachm	1.40 g
Obol	= 1/6 Drachm	0.57 g
Hemiobol	= 1/2 Obol	0.37 g
Chalkous	= 1/8 Obol	1.25 g
Octochalkous	= 8 Chalkoi	13.04 g
Tetrachalkous	= 4 Chalkoi	8.74 g
Dichalkous	= 2 Chalkoi	3.65 g
Hemichalkous	= 1/2 Chalkous	? (only one coin mentioned by Sellwood: S 27.28)

*Without written documentary evidence it is impossible to confirm the exact weights. The figures given are approximations based on average measurements of found coins.

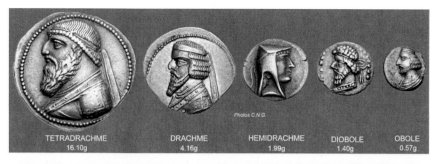

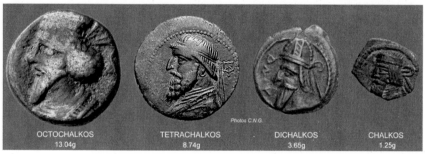

FIG. 8.1 A + B Nominal values of Parthian coins. See: www.cngcoins.com/

to the production of drachms. Nowadays it is assumed, with just a few exceptions, that Mesopotamia tetradrachms were produced only in Seleucia.[25]

A tetradrachm was worth four drachms (see Table 8.2),[26] a hemidrachm had half the value of a drachm. An obol, also of silver, corresponded to the value of one-sixth of a drachm. In addition to obols, diobols and hemiobols were also in circulation. A chalkous was equivalent to one-eighth of an obol. Coins whose value was double that of the chalkous (dichalkous) were also in circulation, as were those with quadruple value (tetrachalkous), and eight-fold value (octochalkous, Sellwood, S 80.3).

8.1.3 Value of Parthian money

We have very little information about the value of Parthian money. From three parchments found in Avroman, in the Iranian Kurdistan area, we have details about the purchase price for half a vineyard.[27] The first two contracts (almost identical in content) were written in Greek; the purchase price was 30 drachms in 88/87 BC. From cuneiform inscriptions and further calculations it is known that at this time about 2.8 tetradrachms per month were needed to feed a five-person family.[28] From this it can be calculated that this family would require more than a year's salary for the purchase of half a vineyard. The third of the contracts found in Avroman dates

to AD 53 and was written in Parthian. By that time, this vineyard already cost 65 drachms.

These contracts reveal not only that prices had risen, but, more importantly, that the official language by 88 BC was Greek, which was replaced 100 years later by Parthian. This coincides with the observation that initially Greek was readable on Parthian coins, but that Greek later disappeared from the coins, and only Greek-looking characters without meaning were used alongside a Parthian inscription (king's name, see 8.1.5).

8.1.4 Mints

On many Parthian coins one can find references to the mints, as is also the case today. Monograms on Parthian coins that signify the mint are more common than mint names or abbreviations of those names. These monograms can usually be

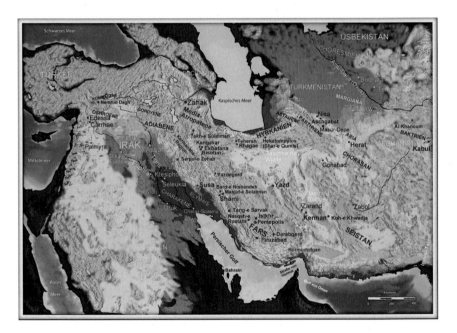

FIG. 8.2 Iran in the Parthian age, with archaeological sites and mint locations in relation to today's countries and cities.

Note: A helpful interactive map can be found at: www.parthia.com/parthia_mints. htm. Further maps to the mints are found in Sellwood, D., 1980, as well as in: Hackl, U. et al., 2010: vol. 1, p. 235, fig. 74. The map presented here was created by the author on the basis of: 'Partherreich', licensed under Creative Commons Attribution-Share Alike 3.0, Wikimedia Commons – http://commons.wikimedia.org/wiki/File:Parther_reich.jpg#mediaviewer/File:Parther_reich.jpg

found under the bow of the archer on the reverse. On the basis of monographs or letters, Sellwood names Ecbatana, Rhagae, Mithradatkart, Nisa, Margiana, Traxiane, Aria, Artemita, Kangavar (Konkobar), Laodicea and Susa.[29]

One of the earliest existing mints in the Parthian Empire was at Nisa, near Ashgabat in Turkmenistan, which is documented by coin inscriptions (Nicaia and/or NI). It is not clear whether another mint in the vicinity of Nisa, which Sellwood identifies with the citadel Mithradatkart (with the letter M-T or M-θ-T), actually existed. According to Michael Alram, an Austrian archaeologist and numismatist, the following mints existed: Ecbatana, probably near Hamadan in Iran (see 7.2.6); Rhagae, near today's Ray in the province of Tehran, Iran; Susa, in today's province of Khuzestan, Iran, near the Iraqi border; Margiana, in today's Merv region of Turkmenistan; and Seleucia on the Tigris, not far from today's Baghdad, Iraq.[30]

Other mints, whose existence is not clear or that have yet to be found by archaeologists, and where probably only a small quantity of coins were minted, include: Areia (near today's Herat), Traxiane, Hecatompylos, Syrinx, Tambrax, Saramana, Apameia, Epardus, Persepolis, Charax, Laodicea, Kangavar, Artemita, Edessa, Ctesiphon (near Baghdad) and Nineveh. In the period before the reign of Vologases I (c. 51–79 AD), drachms were produced in the mints listed, but from then onwards Ecbatana became Parthia's main mint, where most Parthian coins were produced.[31] A travelling court mint also existed, the coins bearing the words ΚΑΤΑΣΤΡΑΤΕΙΑ or ΚΑΤΑΣΤΡΑΤΕΙΑ. Apparently, the king minted coins while travelling around or during his wars. Although it is assumed today that almost all tetradrachms were minted in Seleucia, a few tetradrachms have survived that were minted in Susa (e.g. Phraates II, S 14.1 and S 14.2).[32]

8.1.5 Inscriptions on coins

On most Parthian coins, the inscriptions are usually written in Greek. A Parthian inscription is only found on the coins of Arsaces I at the beginning of the Parthian Empire. For a long time the Parthian kings who succeeded Arsaces I used only Greek inscriptions. Only after Vologases I (c. 51–79 AD) are Parthian inscriptions used again. With the turning away from Hellenism and the return to their roots and their own language, from the middle of the 1st century AD onwards, the Greek inscriptions slowly become illegible, inscriptions without meaning, only still recalling Greek letters in their outer shape.

The first ruler to use the epithet 'ΦΙΛΕΛΛΗΝΟΣ' (friend of the Greeks, who loves the Greek) was Mithradates I (c. 165/4–132 BC) – this inscription can easily be interpreted as propaganda. On a tetradrachm of Orodes II, a series of his positive qualities can be read: 'ΒΑΣΙΛΕΩΣ ΒΑΣΙΛΕΩΝ ΑΡΣΑΚΟΥ ΕΥΕΡΓΕΤΟΥ ΔΙΚΑΙΟΥ ΕΠΙΦΑΝΟΥΣ ΦΙΛΕΛΛΗΝΟΣ' ([Coin of] the king of kings, Arsaces, the benefactor, the just, the manifest, the friend of the Greek) (Fig. 8.3 A + B).

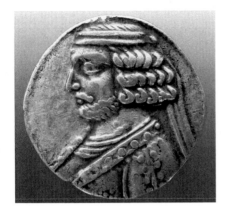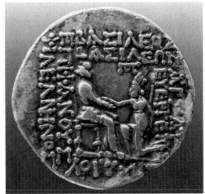

FIG. 8.3 A + B Orodes II, S 45.1, variant. Obverse: bearded bust facing to the left, wearing a diadem (two lines) with small bows and three broader lines for the ties, hair in three waves, the torque ending in a griffin, and wearing a typical Parthian tunic with dotted border and circular border of pellets. Reverse: the king sits on a throne facing to the right, his appearance resembling the king's portrait on the obverse; a four-lobed dagger can be seen attached to the right thigh; before the king kneels a woman, wearing a mural crown, her right hand outstretched to the arm of the king, her left hand holding a sceptre; thus, she can be identified as a personification of the city of Seleucia. Inscriptions: above: ΒΑΣΙΛΕΩΣ ΒΑΣΙΛΕΩΝ, right: ΑΡΣΑΚΟΥ ΕΥΕΡΓΕΤΟΥ, left: ΕΠΙΦΑΝΟΥΣ ΦΙΛΕΛΛΗΝΟΣ, below: ΔΙΚΑΙΟΥ, [Coin of] the king of kings, Arsaces, the benefactor, the just, the manifest, the friend of the Greek. Original size: 29.2 mm, weight: 14.43 g.

8.1.5.1 Greek inscriptions

Table 8.3 provides a short list of typical Greek inscriptions to be found on Parthian coins. The terms appear on the coins as a rule in the genitive, as for example in 'ΒΑΣΙΛΕΩΣ ΜΕΓΑΛΟΥ ΑΡΣΑΚΟΥ ΦΙΛΕΛΛΗΝΟΣ' ([Coin of] the great king, Arsaces, friend of the Greek/who loves the Greek). For linguistic reasons, the nominative is given in Table 8.3 as translation for the terms used in the genitive.[33] Other Greek inscriptions, such as year or monthly names, can be found in 9.11.4 and Tables 9.1 and 9.2, or in the explanation of the coins of each Parthian king.

8.1.5.2 Parthian inscriptions

The Parthian letters have evolved from Aramaic letters; Aramaic was the administrative language of the Achaemenids, the 'lingua franca'. The Parthian letters are written from right to left. Parthian inscriptions are first found on coins of

TABLE 8.3 Greek inscriptions on Parthian coins (for linguistic reasons, the nominative was chosen for the translation of terms used in the genitive).

ΑΡΣΑΚΟΥ	Arsaces (King)
ΑΡΤΑΒΑΝΟΥ	Artabanus (King)
ΑΥΤΟΚΡΑΤΟΡΟΣ	Autocrat
ΒΑΣΙΛΕΩΣ	King
ΒΑΣΙΛΕΩΣ ΒΑΣΙΛΕΩΝ	The king of kings
ΒΑΣΙΛΕΩΣ ΜΕΓΑΛΟΥ	The great king
ΔΙΚΑΙΟΥ	The just
ΕΠΙΦΑΝΟΥΣ	The manifest, epiphany of god,* illustrious
ΕΥΕΡΓΕΤΟΥ	The benefactor, beneficent
ΚΑΙ	and
ΚΤΙΣΤΟΥ	The founder
ΜΕΓΑΛΟΥ	The great
ΝΙΚΕΦΟΡΟΥ	The one who brings the victory
ΝΙΚΑΤΟΡΟΣ	The victorious, bearer of victory, conqueror
ΟΝΩΝΗΣ	Vonones (king)
ΦΙΛΟΡΩΜΑΙΟΥ	The friend of the Romans, who loves the Romans
ΦΙΛΑΔΕΛΦΟΥ	Who loves his brother
ΦΙΛΕΛΛΗΝΟΣ	The friend of the Greek, who loves the Greek
ΦΙΛΟΠΑΤΟΡΟΣ	Who loves his father
ΘΕΟΥ	The god
ΘΕΟΠΑΤΟΡΟΣ	Of divine descent (whose father is a god, son of a divine father)
ΣΩΤΗΡΟΣ	The saviour

* De Callataÿ, F., Corber, C., 2011: p. 450 ff., translates epiphanies as: 'visible, manifest'. Wick, P., 2008: p. 14: ΕΠΙΦΑΝΟΥΣ can be translated as: 'The epiphany of god'.

Arsaces I (Fig. 8.4), then start again on coins of Vologases I (c. 51–79 AD). The coins show, in addition to the Greek, a Parthian inscription with abbreviated royal names: 'wl' for 'wlgšy' (= Vologases). From Mithradates IV onwards, the whole title of the king is used, e.g. 'mtrdt' for Mithradates and 'MLK' for 'king' (Figs. 8.6 and 8.7).[34]

With the introduction of Parthian inscriptions, first on coins of Vologases I (c. 50/51–79 AD), Greek inscriptions became increasingly illegible, only the letters still resembling Greek (second upper line, Fig. 8.6).

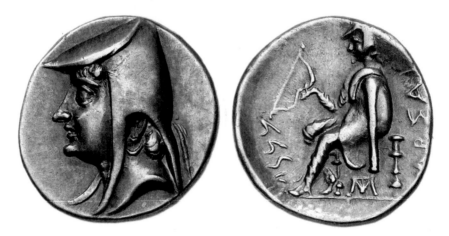

FIG. 8.4 Arsaces I, AR drachm, S 3.1. Obverse: beardless bust facing to the left, wearing a bashlyk, a diadem tied around it, earring. Reverse: beardless archer seated left on a chair, holding a bow in his right hand; he wears a bashlyk and a kandys with an empty sleeve hanging down; in his right hand he holds an asymmetrical reflex bow. Inscription: right: ΑΡΣΑΚΟΥ, [Coin of] Arsaces; below the bow: a Parthian inscription 'krny', probably meaning 'ΑΥΤΟΚΡΑΤΟΡΟΣ'.

Note: Weber, D., 2010: vol. 2, p. 634; Shayegan, M.R., 2016: p. 11 ff.

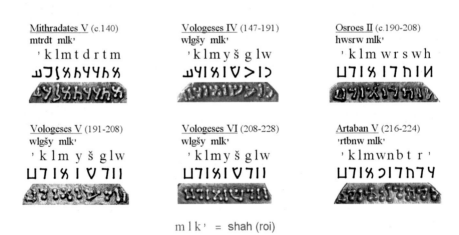

FIG. 8.5 Parthian inscriptions on coins of various Parthian kings. Courtesy of: www.parthika.fr (names of the kings in French). 'mlk' is usually written in capital letters.

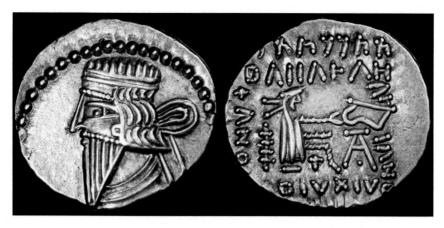

FIG. 8.6 Mithradates IV (c. 129–140 AD), AR drachm, S 82.1, variant. Inscription: first upper line: Parthian (from right to left), '[K]LM tdrtm' (= King Mithradates).

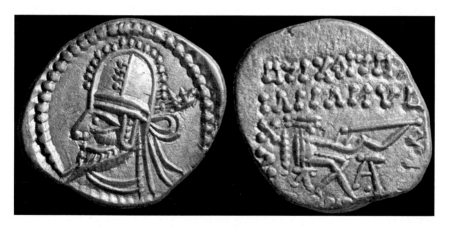

FIG. 8.7 Artabanus IV (c. 216–224 AD), AR drachm, S 89.1. Obverse: bust facing to the left, tiara, with Parthian inscription behind the head (abbreviation of the king's name Artabanus). Inscription: upper line: Parthian inscription – from right to left the letters read: 'KLM wnbtr' (that is, from left to right: 'rtbnw MLK' (Artabanus King)); the line below is illegible.

FIG. 8.8 A + B Vologases VI, AR drachm, S 88.19. Obverse: bust facing to the left, with a Parthian inscription behind the head (abbreviation of the king's name, Vologases). Inscription: upper line Parthian inscription: recast from left to right: [wl]gšyMLK' (King Vologases); below: illegible.

Note: Weber, D., 2010: p. 634.

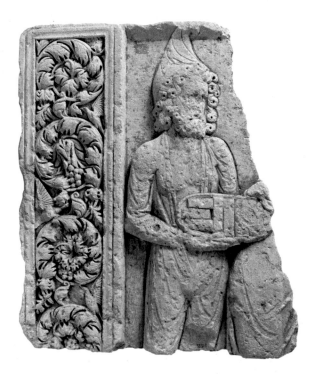

FIG. 8.9 Parthian servant (?), who may be presenting gold or silver bars on a tray, local limestone, find spot: Koblenz, second half of 2nd century AD. Inv.-No. G 37 c, Rheinisches Landesmuseum Trier.

8.2 Mineral resources – mining

The most important mineral resources – gold, silver, copper and iron – lie in the highlands of Iran, in the Zagros Mountains and in Afghanistan, where they have been mined since the Bronze Age.[35] At the same time, Iran also possessed extensive mountain forests, whose wood was a prerequisite for the production of charcoal for the smelting of ores. More than 80 old copper mines can still be found in Iran today. Iron ores were indispensable for the production of weapons and armour. Enormous quantities were needed just to produce Parthian arrowheads and swords. Other metals such as zinc, nickel, arsenic, cobalt, tungsten, lead and tin were also found in the ore deposits. The Roman writer Pliny the Elder was aware of the gold mines in Parthia.

Gold was obtained in two different ways: through direct gold mining from pure gold veins (13 locations are known in Iran) or as a by-product of copper mining. Copper, gold and silver mines were found in central Iran, in Kerman in south-eastern Iran, in eastern Iran and in north-west Iran. There were also significant gold deposits in Media in north-west Iran, but these had already been exploited early in the history of Iran.

Salt, another sought-after commodity in Parthia, was also mined. In the period between 1993 and 2006, a total of six mummified corpses were found in a salt mine in Chehrabad near Zanjan in north-western Iran, where workers had been killed by the collapse of the mine. Studies employing carbon dating have shown that these people had worked there in Parthian times, in the 2nd and 3rd centuries AD. One find revealed a blond man who was about 37 years old and 1.75 metres tall. A DNA sample showed that he had blood type B (in the United States and Europe about 10 per cent of people have this blood type). He was dressed in well-made leather boots (Fig. 9.14), wearing woollen trousers and carrying various tools: three iron knives and a grindstone.

8.3 Agriculture in Parthia

The Parthians dominated a large empire with highly varied geographical, geological, hydrographical and climatic conditions. In the Iranian heartland there are deserts that receive almost no precipitation, while in the border region of the Zagros Mountains there are fertile and humid areas. The area of Elymais was as fertile as the newly conquered areas of Mesopotamia, which received sufficient water through the Tigris and the Euphrates. Wheat, barley, oats and Einkorn wheat were grown on a large scale in the Parthian Empire, especially in Margiana, Hyrcania and Mesopotamia. Linen was grown to a greater extent for both the manufacture of cloth and for the production of common flax and linseed oil. The cultivation of lentils, peas, beans, onions, garlic, cucumbers, several types of cabbage, melons and pumpkin is also known to have been practised. In Mesopotamia and in climatically favourable areas of Iran, such as the Kerman area and the south, date palms were cultivated on a large scale. In upper Mesopotamia, in Syria and in northern Iran, olives were cultivated, the oil being used for baking, roasting and for body

care. Peaches, which had originally been imported from China, were cultivated in Parthia and sold to Rome.

Of particular importance was the cultivation of alfalfa (*Medicago sativa*, lucerne), which was already cultivated in Iran by the Achaemenids. Alfalfa was grown especially as horse feed and, with the arrival of horsemen in Iran, gained special significance. The Parthians, who, like all Iranians, bred horses on a large scale, had such large alfalfa crops that the plant was even exported.

Under the Parthians, a rich garden culture developed. Many kinds of fruit were cultivated in the gardens, such as pomegranates, apples, figs, cherries, quinces, plums and pears, but also nuts of all kinds, including pistachios and almonds. Gardens were also used for recreation. Extensive walled gardens – with bricked water channels, shady pavilions and open green areas alternating with flowerbeds and shrubs – were particularly likely to be found near palaces, a tradition that had already been established under the Achaemenids and presumably dates back even further to the Elamites, where sacred groves and ponds or pools belonged to the typical cult complexes. Interesting in this context is that the biblical term 'paradise' derives from the Persian term '*pairi daēza*', which was used as an analogy for the fencing off of the royal gardens and holy places.[36]

8.4 Wine and trade

Vines were grown on an exceptionally large scale throughout the Parthian Empire. The importance of wine, which was mostly drunk diluted, is particularly clear given wine was more durable than water, which was usually not free of germs. Wine had been made in Iran since the 5th millennium BC, as investigations of ceramic vessels has revealed. Wild vines were developed over time, especially in the areas of the Zagros Mountains and Seistan. This is illustrated by seals from Fars dating from the beginning of the 2nd millennium BC, on which Elamite kings and goddesses were represented in wine bowers.

Vine growing was one of the most important economic sectors in the Parthian Empire. The best evidence to date for the great extent of wine production and wine storage, as well as the administration of the wine, can be found in the Parthian residence in Nisa.[37] The Parthian palace in Nisa had a huge wine store. Its cellars could hold up to 500,000 litres of wine. The area from which the wine was delivered to Nisa was large and reached the banks of the Amu-Darya, the ancient Oxus. The wine was stored in large bulbous vessels, partially buried in the ground. These are known as *chume*, which is also the Russian name for a large vessel. A *chume* held about 200 litres of liquid. Labelled potsherds – the ostraca mentioned in an earlier chapter – on which information was written in Parthian, hung on the clay jars. On an ostracon dating from the time of Mithradates I or Mithradates II, the following inscription was found:

> In the fortress Mithridatkirt, in a vineyard called the 'new', are 160 wine and vinegar *chume*, empty: 8. In the wine store … in the mentioned, there are 316 wine and vinegar *chume*, empty 16. A total of 500 *chume*.[38]

Another ostracon reads:

> In this *chume* are 17 Mari of wine [1 Mari being approx. 11 litres] delivered from the taxable vineyard of the Friapatikan estate, which is in possession of the satrap, brought by Chumajak, supplier of wine, who is born in Artastavanak, this is documented for the year 188.[39]

Later in this document, it states that two Mari wines have gone sour. The documents from Nisa give us a good overview of the management of the trade of wine there.

Vineyards were taxed and some of the taxes were paid in the form of wine deliveries. Thus, on various ostraca payments were documented, on behalf of distinguished individuals, payments that are interpreted as rent. Among these persons were, for example, a winegrower, a horseman called Sasan, a treasurer and even the commander-in-chief of the Parthian cavalry. All documents show that there was a well-organised documentation system. Special office bearers carried out the monitoring of wine deliveries and wine trade. The delivered wine jugs were officially sealed. Checks in the form of breakage of the seals and subsequent re-sealing were marked with additional control seals, some of which bore the inscription 'board of scribe' or 'Satrap'.

Insight into the importance of owning vineyards is provided by the three parchments from Avroman already mentioned, which were found in a sealed clay jug. The first two documents were written in Greek and indicate the years 88/87 and 22/21 BC. The third dates from 53 AD and is written in the Parthian language.[40] These documents show the sale of a vineyard at various times to three different owners. In 88 BC half of the vineyard cost 30 silver drachms, the price rose to 55 drachms in 22/21 BC and, by 53 AD, the price had risen again to 65 silver drachms.

8.5 Water management – underground qanats in Parthia

The largest part of Iran is mainly rain-poor and unsuitable for agriculture. Surface irrigation by the few rivers, which flow from the mountains into the inland region, usually takes place only in spring when the mountain snow melts. After that, these rivers mostly dry up. To extend the naturally irrigated area, large-scale surface and underground irrigation systems or qanats have been in use since the 3rd millennium BC. Qanats use the large groundwater layers in the mountainous areas or water reservoirs beneath the deserts at depths of 20 to over 100 metres. The construction of such channels was costly, as about every 25 metres a deep borehole had to be made, the base of which had to be connected deep down so that the water could run through it without a great incline. Aerial photographs impressively document these chains of essential boreholes.[41]

The earliest written records of underground qanats are found in New Assyrian sources, dating from the 8th century BC, which deal with King Sargon II's campaign in Iran. According to these documents, qanats were in use in the Gorgon area. Under the Achaemenids, the use of such qanats spread through Mesopotamia to

Egypt and to the west. Over 40,000 qanats were in operation in Achaemenid times, as can be deduced from aerial reconnaissance.

The construction of large qanat systems flourished in Parthian times.[42] Settlements grouped around the course of these qanats. It can be shown that as these settlements expanded and the accompanying water management systems were built, they were accompanied by a separation of social classes. Larger residential buildings belonging to residents of higher social status were located upstream of a village, where access to the water was better than in the lower residential areas.[43] Better irrigation naturally resulted in bigger harvests and reinforced differences in social structure.

To a considerable extent, qanats were also widespread in the Seistan area of south-eastern Iranian in the Parthian period. Thanks to intensive irrigation, the land was very fertile at that time. The wealth of the noble family Sūrēn, which owned large estates in the Seistan area, was mainly based on this highly developed irrigated agriculture. In wartime, qanats became a tactical target for armies. Thus, ancient sources tell us that Artabanus I (c. 127–124 BC), fleeing with his army from the troops of Antiochus III, deliberately destroyed qanats to protect themselves from their pursuers.[44] Today, the arid and predominantly desert-like state of the Seistan area dates back to the deliberate destruction of the qanat systems during the Mongol invasion.

Until the 1960s, the city of Tehran was supplied solely by the water of a qanat system that brought water from the Elburz. Today, about 22,000 qanat systems with a total length of approximately 270,000 km are still in operation. These provide 75 per cent of the water needed for agriculture in Iran. Many of these qanats date back to ancient days.

8.6 Cattle breeding among the Parthians

Animal breeding played a significant role in the Parthian Empire. The plateaux and high mountain regions or desert steppes in Iran, which were not suitable for growing cereals, were always used by predominantly nomadic peoples for highly specialised cattle breeding. In the territory of the Parthian Empire, sheep, goats, cattle (zebu), donkeys and poultry were bred on a large scale. Camels were also bred – they were essential for crossing deserts, but were also employed in the Parthian army, where they were used as a means of transport for weapons and especially arrows.[45]

The most important livestock for the Parthians, however, were horses, which have been bred by the peoples of Iran since the 3rd millennium BC. Horses were an indispensable part of the nomadic equestrian armies: they facilitated quick attack and quick escape and gave the rider seated on the horse a much stronger attack position. Centres of horse breeding in the Parthian kingdom were Fars, the Hamadan plateau and the area east of the Caspian Sea. In the vicinity of Nisa, the well-watered Achal oasis was a special centre of horse breeding, and the source of what were known as 'Nisean horses'. These horses were considered

particularly valuable as they were fast and enduring and were a much sought-after commodity.

These horses were originally bred from horses that originated from the steppes of the Turan area in the Gorgan region, south-east of the Caspian Sea and extending to the Altai Mountains. Today's breed of Akhal-Teke horse is descended from these horses. It is a large, robust and enduring horse with a height of 140–150 centimetres, accustomed to extreme climatic fluctuations, as well as lack of food and water, and has a shiny golden-yellow coat. The horses also had a particularly firm gait, which was of particular importance in any cavalry horse used by the Parthians. Strong battle-horses were also a prerequisite for the heavily armoured riders (cataphracts) that made the Parthian army almost invincible.

Another centre for breeding these horses was in the Fergana valley in today's eastern Uzbekistan. Even the Chinese Emperor Han Wudis, who had sent a delegation to the Fergana valley, bought these horses, calling them 'The heavenly horses'.[46] As a result, a regular trade link flourished with the Chinese, horses being sold in large numbers to China. The number of horses bred in the Parthian kingdom must have run into millions. Alexander the Great, too, had equipped his army with thousands of Turkmen horses, and his famous stallion, Bucephalus, was a noble Nisean stallion.

8.7 Parthian markets

Parthian markets differed significantly from the Greek markets. A reference for the structure of a Parthian market can be found in Dura-Europos. After the city was conquered in 114 AD by the Parthians, a thriving commercial city developed. In contrast to the Greek rectangular agora, or open marketplace, under Parthian rule a typical winding Oriental bazaar (or sukh) gradually emerged – a development of a kind that probably took place in other cities.[47]

Notes

1 Hartmann, U., 2018: p. 455 ff.
2 Hartmann, U., 2018: p. 449; Thommen, L., 2010: p. 191.
3 The river of the Zagros Mountains, which flows into the Persian Gulf.
4 Hartmann, U., 2018: p. 464.
5 Wiesehöfer, J., 2005: p. 200.
6 Gregoratti, L., 2011: p. 209 ff.
7 Wiesehöfer, J., 1998 (1): p. 427; Gregoratti, L., 2018 (1): pp. 52–72.
8 Widengren, G., 1960: p. 15.
9 www.cais-soas.com/News/2008/February2008/27-02.htm.
10 Gregoratti, L., 2012 (2): p. 109 ff.
11 Wiesehöfer, J., 2005: p. 201.
12 Pliny, *Naturalis historia* 6.101.
13 Sellwood, D., 1980 (1st edition, 1971).
14 Assar, G.R.F., 2004: p. 78.

15 Assar, G.R.F.: various articles online: http://Parthian-Empire.com/.

16 Sinisi, F., 2012. In October 2020 a second volume of *Sylloge Nummorum Parthicorum* will be published. Its focus is Mithradates II; see https://verlag.oeaw.ac.at/mithradates-ii.

17 Sellwood, D., 1980; Assar, G.R.F.: 2004; 2006 (1); 2006 (2); and Assar's articles published online at: http://Parthian-Empire.com/.

18 S 5, this coin has now also been attributed by Sellwood to the coinage of Arsaces I. For more information, see Arsaces I (3.1.1).

19 Assar, G.R.F., 2011.

20 Sellwood, D.: 1980; Assar, G.R.F.: 2004; 2006 (1); 2006 (2); and Assar's articles published online at: http://Parthian-Empire.com/. The list provided in Table 8.1 does not include the correlations, which other authors (Shore, Sear, Mitchiner, Wroth, Gardner, Petrowicz, DeMorgan) give. For this information consult the internet page of Parthia.com: Attribution Correlation Chart for Parthian Coins at: http://parthia.com/parthia_corr.htm.

21 Dąbrowa, E., 2008: p. 26.

22 http://gdz.sub.uni-goettingen.de/dms/load/img/?PPN=PPN356973360&DMDID=DMDLOG_0082&LOGID=LOG_0082&PHYSID= PHYS_0287.

23 With the gracious assent of the Classical Numismatic Group. See also: www.parthika.fr/Denominations.html. However, it should be noted, that the coin attribution there is that given by Assar, without mentioning Sellwood's attribution.

24 Shore, F.B., 1993: p. 84.

25 Assar, G.F., 2005: p. 29 ff. (Tetradrachms of Phraates II were minted in Susa).

26 See also: Boillet, P.-Y., 2016: pp. 109–122.

27 Weber, D., 2010: p. 566 f.

28 Van der Spek, R.J., 1998: p. 246 ff.

29 Sellwood, D., 1980: p. 12 ff.

30 Alram, M., 1998: p. 366 ff.

31 Sinisi, F., 2012: p. 50.

32 Assar, G.R.F., 2006 (1): p. 134 f.

33 All Greek terms inscribed on the coins are in the genitive except ΔΙΚΑΙΟΥ, which is in the nominative.

34 Weber, D., 2010: vol. 2, p. 633 ff.

35 On the mineral resources: see: Stöllner, Th., Slotta, R., Vatandoust, A., 2004.

36 Heim, M., 2008: p. 317.

37 Masson, V.M., 1987: p. 124 ff.

38 Masson, V.M., 1987: p. 122.

39 Masson, V.M., 1987: p. 125.

40 Weber, D., 2010: p. 566 f. and Thommen, L., 2010: p. 467 ff. (Avroman I has two versions: in version A the price for the vineyard is 30 drachms; in version B it is 40 drachms.)

41 Stronach, D., Mousavi, A., 2009: p. 15 ff.

42 Stronach, D., Mousavi, A., 2009: p. 15 ff.

43 Stronach, D., Mousavi, A., 2009: p. 22.

44 Colledge, M.A.R., 1967: p. 77.

45 Heavily armed camel riders were also used in the army, as reported by Herodian (4.14.3).

46 Posch, W., 1998: p. 360.

47 Colledge, M.A.R., 1977: p. 37.

9

INSIGHTS INTO SOCIAL LIFE IN PARTHIA

9.1 The Parthian language

In the Parthian Empire, various writings and languages were used in the course of nearly 500 years. Greek was a primarily administrative language, recognisable also from Parthian coins with Greek inscriptions. It was introduced by Greek settlers in the Iranian area from the Achaemenid period onwards, and spread further among the Seleucids in Iran, as well as to the Bactrian and north-west Indian regions. Aramaic, which had already been used under the Achaemenids as an administrative and written language, was firmly established as a universal language or *lingua franca* in the territory of Iran. The third language was Parthian. This was initially spoken only in the core area of the Parthian kingdom, in Hyrcania, Khorasan and Gorgan, then gradually established as the court and administrative language of the Parthian Empire in all the territories it conquered.

During the 2nd century BC, a change from the Western Aramaic language to the Eastern Aramaic local language took place in the administration of Parthia. Later, the Parthian script and language prevailed in the whole of Parthia. But unfortunately, only a few documents in Parthian writing, such as Parchment III, have survived. This was found in Avroman, which is in the south-western Iranian area of Kurdistan. The writings document the sale of a vineyard and date to 53 BC.[1]

Parthian is a north-western Iranian language that belongs to the Indo-Iranian branch of the Indo-European language family. The Parthian script used to record the language had evolved from the Aramaic script, which had previously been used in Iran in addition to the cuneiform script.[2] From the Mesopotamian area more than 100 cuneiform tablets, partly written during the Parthian government, have survived. These date back to the beginning of the 1st century BC. They show Neo-Babylonian cuneiform writing, which was still used at that time.[3] With the transition to the use of papyrus and parchment in the Achaemenid period, cuneiform died out.

The Parthian script developed from the Aramaic alphabet. The characters were written from right to left in horizontal notation and were already used in the 2nd century BC, as shown by the inscriptions on the ostraca found in Nisa (Fig. 9.2). Deciphering the Parthian language has posed a significant problem for linguists, because writing and language were of completely different origin. The language was Indo-Iranian but was recorded in a Semitic script. Semitic scripts, however, are consonant alphabets, which do not use vowels. One and the same word can therefore have different pronunciations and thereby different meanings. For the reconstruction of Parthian, the study of Armenian was therefore of particular importance. The Armenian language absorbed strong Parthian influences through the centuries-long rule of the Arsacids and their descendants in Armenia. In contrast to the languages whose script was based on Aramaic, the Armenian script also contained the vowels. This made it possible to reconstruct the pronunciation of the words and thus also the sound of the Parthian language.

But the bulk of our knowledge of the Parthian language is based on the manuscripts found in the oasis of Turfan (Xinjiang Province, China) at the beginning of the 20th century. Part of these consisted simply of fragments. As they were discovered by German archaeologists Albert Grünwedel and Albert von Le Coq, most of these Turfan texts were brought to Germany and are now in safe keeping in Berlin. They remain the most important source for the study of the various Central Iranian languages. Most of the documents are texts written in the 8th to the 11th century AD. Their origins, however, could be traced back to the time of Manichaeism and therefore reflect the early phase of the Sasanian Empire, still influenced by Parthian heritage and belief. At the time of the discovery of the Turfan writings, only Middle Persian was known in the form of Pahlavi (the name derives from Parthian, Old Persian: Parθava),[4] the language of Zoroastrian books. Middle Persian was the spoken language, Pahlavi the written form, based on Aramaic. Various Middle Iranian languages, such as Middle Persian, Parthian, Sogdian and Bactrian, are represented in these texts, which consisted in part only of fragments.[5] Through the analysis of these texts, it was possible for the first time to clearly distinguish the languages Middle Persian and Parthian.

The Parthians, as stated above, wrote their important documents, perhaps also literary texts, on parchment pages which, with few exceptions, were unfortunately destroyed over the centuries by a process of natural decay. Parthian writing was later used also on Parthian coins. Vologases I (c. 51–79 AD) was the first Parthian ruler, who minted his name in Parthian, in an abbreviated form, on his coins: *wl* for *wlgšy* (Vologases). From King Mithradates IV (c. 129–140 AD) onwards, the king's name in full appears in Parthian (Fig. 9.1). The further turning away from Greek is clearly to be seen on the coins, as the Greek inscriptions are increasingly illegible and finally impressed only as botched Greek letters.

The Parthian language was still in use in early Sasanian times. This is evidenced by the inscriptions of Shapur I (241/242–271/272 AD) on the Ka'ba-ye Zartosht (Ka'ba of Zoroaster) in Naqsh-e Rostam, near Persepolis, where in addition to Middle Persian and Greek the Parthian language was also used.

It is interesting to note, that the word 'parchment' derives from the Latin 'Parthica pellis', which can be translated as 'Parthian leather'. Thus, if we admire painted parchments in medieval books, we can be reminded of the Parthians, who

k l m t d r t m	k l m y š g l w	k l m w r s w h
Mithradates IV	Vologases IV	Osroes II
c. 129–140 n. Chr.	c. 147–191 n. Chr.	c. 190 n. Chr.
mtrdt MLK	wlgšy MLK	hwsrw MLK

FIG. 9.1 Parthian inscriptions on coins of Parthian kings. The Parthian script is to be read from right to left. 'MLK' means king.

Note: Courtesy of: www.parthika.fr. Names of the kings in French.

FIG. 9.2 Ostracon, Parthian script, only partially deciphered, contains information on quantities of goods and names, find spot: Nisa, c. 1st century BC.

were known for making and using parchments and giving their name to this writing material.

9.2 Parthian literature – an epic with heroes

The existence of a Parthian literature can only be a tentative conclusion since we have an extremely limited quantity of Parthian writings. However, two stories preserved to this day testify to Parthian poetry: 'The Hymn of the Pearl' and the

love story of 'Vis and Ramin'. Both stories use Parthian names and contain Parthian place names.

9.2.1 The Hymn of the Pearl

This piece of literature appears in the apocryphal Acts of Thomas. Today it is generally assumed that it was written in Syria in the period around 110–120 AD. Oral sources could date it up to 50 years earlier. Different answers have been posited regarding the hymn's religious background. Christian, Manichaean and Gnostic backgrounds have all been suggested. Another consideration is that it comes from a Jewish-Christian community in Edessa. However, a careful examination of the text, the content and the geographical data show that this poetry undoubtedly comes from the Parthian area. One indication is that a number of Parthian loanwords are used in the text.[6] The content of this Hymn of the Pearl also clearly points to the Parthian era; it describes the long journey of a Parthian prince, who could possibly even have come from the Arsacid royal family.[7] The text lists a number of different travel stations on the way to Egypt, with the royal residence of Old Nisa possibly being the starting point. Amongst other geographical names the place Mēshan is mentioned. Mēshan is the seaport in Characene that was a starting point for Parthian trade to both west and east.[8] The text also reports that the prince carries agate (from India) and chalcedony (from Kushan) with him, which is seen as an indication of Parthian trade contacts with the west. A Zoroastrian background can be postulated by the fact that the prince at the end of his journey receives his 'ray dress' and is worthy to become king. Such a 'ray dress' is directly related to the *khvarenah*, the God-given glory or fortune given to the king by the *yazatas* (see 11.1.10; see also the sun ray with which Ahura Madzda is shown in Fig. 11.5).

The hymn is about a king's son from the eastern realm who is sent to Egypt by his parents to retrieve a pearl from a serpent in the sea near Egypt.[9] They provide him with gold, silver and diamonds, but deprive him of the splendid robe ('ray dress') that they had previously given to him as a mark of affection. The king's son is accompanied by two angoloi (angels). Their path leads via Mesene, or Characene, a Parthian vassal state in the south of Babylon, to Babylon and Egypt. Based on the travelogue, one can assume that the Kingdom of the East, of which the song speaks, is the Parthian Empire. In Egypt, the king's son is to seek the pearl, without which he would no longer be able to wear the 'ray dress'. When he arrives in Egypt, he forgets why he has left; he refrains from searching for the pearl. Instead, he dresses like the other Egyptians, eats like the others and lives in the present. He forgets his roots and his origins. His parents learn about his way of life and write him a letter and remind him to think about his task. This causes the king's son to remember his parents, retrieve the pearl and return to his homeland. There he is received with honours and obtains his 'ray dress'. Only now can he step in front of his father's throne, worthy of the succession.

The pearl hymn symbolically describes the way of the adolescent royal son. It is an inner journey to fathom his heart and soul. The pearl is a symbol of the

precious interior, of the roots of identity, which shines out like a ray of light. Only when he has found the pearl, and thus himself, is it possible for him to succeed to the throne.

9.2.2 The story of Vis and Ramin

The story of Vis and Ramin is a romantic novel written in the 11th century AD by the Persian writer Fakhraddin Asaad Gorgani and based on ancient stories. Whereas it was formerly thought that the origins were to be found in the Sasanian period, it is now believed that the novel had its origin in Parthian poetry and was probably written in the 1st century AD.[10] The background story is the confrontation between two Parthian kingships, one in the west and one in the east. One kingship is that of the noble family Kārēn, whose realm is based on the ancient Median capital Ecbatana, near today's Hamadan. Its opponent is Mubad Manikan, the king of Merv, an old Parthian city located in today's Turkmenistan. Mubad solicits a promise from the beautiful Queen Schahru of Mah (Media) that he can marry the next daughter born to her. Since Schahru is convinced that she will not have any children due to her age, she gives him that promise. But she becomes pregnant and gives birth to a daughter named Vis. Vis is taken to Khuzestan in the Elamite region, and raised there by a nurse. Her mother, Schahru, hopes that the king of Merv will not hear about this.

But fate takes its course, as Ramin, the younger brother of the king of Merv, is also raised by this nurse. When Vis and Ramin have grown up, they return to their respective homelands. However, King Mubad learns of Vis, and reminds Queen Schahru of her promise. When Vis declines to comply, King Mubad starts a war, supported by kings of the eastern territories in Sogdia – Bukhara in today's Uzbekistan, Dahistan in today's south-western Turkmenistan, and Chorezmien, south of the Sea of Aral. He even receives support from India, China and Tibet. Queen Shahru, for her part, has found allies in the kingdoms of the western region, or today's Azerbaijan, Khuzestan and Isfahan. During the war, Vis' father is killed, and Ramin sees Vis and falls in love with her. The war ends when Queen Schahru gives Vis to King Mubad.

In Merv, the king's residence, a big feast is to be held. Meanwhile, Ramin is consumed by his love for Vis. Fate takes a new turn when the wet-nurse, who has raised both children, brings about a meeting between Ramin and Vis, and the royal children embrace in insatiable love for each other. The love relationship between them reaches King Mubad's ears. Only with difficulty can he be soothed by Vis into not killing Ramin. However, the whole court now knows about this relationship, and when Ramin even sings outright of his love for Vis at a court banquet, King Mubad can hardly restrain himself from killing his younger brother. Ramin leaves the court and marries the Parthian princess Gol in the west of the empire. Ultimately, Ramin cannot forget Vis. An exchange of letters begins, until Ramin finally returns to Merv and the love between them is reignited. Ramin and Vis flee from Merv. Mubad pursues the pair, only to be attacked and killed by a boar during

the chase. Vis and Ramin return to Merv, and Ramin is crowned successor and king. The two live happily together, and Vis gives birth to two children. The love story of Tristan and Isolde, a romance dating to the 12th century, has many similarities with the tale of Vis and Ramin, so it is not surprising that some scholars suggest that Parthian poetry is the basis for the legend of Tristan and Isolde. Others believe that there are possible Irish antecedents for the Tristan legend.

9.2.3 Shāhnāme – heroic legends

The Persian national epic, *Shāhnāme*, the Book of Kings, contains Iran's most important collection of heroic legends. The epic poem was written between 977 and 1010 AD by the Persian poet Ferdowsi, also written 'Ferdausi', and relates the myths, legends and history of ancient Iran in more than 50,000 couplets.[11] Although the Sasanids attempted to destroy any memory of Parthian culture and history, the *Shāhnāme* contains a few, but important indications that there must have been such a collection of epics, myths and heroic legends in Parthian times. The battles waged by the mythical kings in the east describe the conquest of north-western India by Parthians, Indo-Parthians and Saka tribes and take place between Khorasan and Transoxiana.[12] The story of the heroes Rostam, Sām, Zāl and Farāmarz goes back to historical figures, to a Parthian dynasty in the Seistan area.[13] The main hero Rostam himself was most likely an Indo-Parthian or Indo-Scythian prince of the 1st century BC, and his mother, the beautiful Rudabeh, was probably the princess of a small kingdom in the area of today's Kabul, Afghanistan. If this interpretation is correct, then even very essential parts of the *Shāhnāme* look back to historical events in the Parthian period.

9.2.4 Parthian literature and Europe

Of further interest to the European reader is the theory that a legend from the *Shāhnāme*, the tragic duel between the hero Rostam and his son Sohrab, whom he did not know and therefore killed, became the model for the German song of Hildebrand, a heroic epic poem, which is one of the earliest literary works written in Old High German.

Likewise, it is not unlikely that the story of Rapunzel, a German fairy tale, who let her long hair hang down from a tower window so her lover could climb up to her, takes its origin in the *Shāhnāme*, where the beautiful Princess Rudabeh enables her lover Zāl to climb up.[14] Another story in the *Shāhnāme* is about Rostam's daughter Banugoschasp, who is as strong as a man and wants to marry only the one who defeats her in battle, so all her admirers are forced to fight with her. The similarities with Brünhild (also spelled Brynhildr) from the Songs of the Nibelungs, an epic poem written in Middle High German, are not to be overlooked. The main hero is Siegfried, who slayed a dragon, bathed in its blood and thus became nearly invulnerable. With Siegfried's help and by using an invisible cloak, King Gunther succeeds in defeating Brünhild, who – like Banugoschasp – has incredible power.

A theory even exists that the Holy Grail history and the knights of King Arthur derive from legends dating back to the Parthians.

These possible connections, already suspected in the story of Tristan and Isolde, are related to the spread of numerous Indian and Iranian tales, myths and legends to Europe. Meanwhile, linguists have proven that this has shaped our European literature more than is generally realised.

9.3 Equality between men and women – women and law – property

Only a few Parthian sources permit statements about social structures and Parthian life. Writings from the Parthian vassal states are therefore especially important. They give us insights into legal procedures, the legal status of women and the living conditions of slaves. In Dura-Europos, or in the area of the middle Euphrates, a series of parchments was found in Greek, originating in Edessa or in the territory of Osrhoene. These documents are about a lease (P Dura 18 Welles, 87 AD,[15] and P Dura 20 Welles, 121 AD) and the transfer of a bond.[16] One amazing item is that the contract, which is written only in Syrian and is about the sale of a slave (P Dura Welles 28, dating to 243 AD), was made by a woman who obviously enjoyed the right to sign the contract. Even if this testimony was signed after the decline of the Parthian Empire, it may be surmised that the social and political structures that can be deduced from the contract were already in existence in Parthian days. This is in accordance with the Mesopotamian legal tradition in the Neo-Babylonian era, in which the independence of women in business affairs was in no way inferior to that of men. Documented contracts of the wife also show that a woman could possess assets separately from those of her husband.

A Chinese source supplies confirmation of woman's equal place in Parthian society. The Shiji's reports state: 'It is customary among them (the Parthians) to esteem the women, and it is only when something is said by the women that the men find it right to do so.'[17] The relatively independent role of women may go back to Parthians' nomadic heritage. Many Eurasian peoples, especially the Sarmatians, are known to have accorded women a privileged position that was quite different from that of a Greek housewife. Parthian belt buckles may also provide another indication of the equality of men and women. The belt buckles found often show couples with their heads snuggled or hugging (Fig. 9.3). Such an openly displayed connection is typical of a nomadic society and was completely alien to the world view of the Greeks.

9.4 Education

No sources about education in Parthia are known that date from Parthian times. However, documents from the Sasanian period may allow conclusions to be drawn regarding the situation in Parthia, assuming that similar educational systems existed and that the Avesta was part of the curriculum. For upper-class children, Sasanians

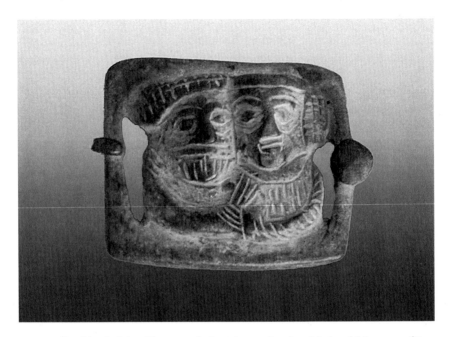

FIG. 9.3 Parthian belt buckle, a couple hugging each other. National Museum of Iran, Tehran.

started school between the ages of five and seven. The pupils remained in school until the age of 15. The children were taught to read and write, and they had to memorise religious texts from the Videvdat. The Videvdat (or Vendidad) is a part of the Avesta (see 11.1) and contains texts and instructions for healing and cleaning ceremonies, but also penalties.[18] Astrology was as much a subject as physical education. Riding, archery, hunting and military training were of importance in the lessons for the boys. A musical education, for instance playing an instrument, was also part of the syllabus. Dice games, such as a form of backgammon, were taught.[19] Evidence from the Sasanian period suggests that girls, in small numbers, attended school and received religious education. Most likely, they were trained in domestic work. Texts from Dura-Europos are witness to the Greek tradition of a gymnasium. The writings indicate that honours were conferred on the participants in archery, shield combat, endurance trials and javelin throwing.

In addition to their own myths and legends, the educated Parthian upper class loved Greek art. The Parthian elite knew the great Greek poets and promoted the construction and preservation of theatres. From the writings of Plutarch, we know that Orodes II mastered the Greek language[20] and, like his commander Surena, was familiar with Greek literature.[21]

In addition to artistic performances, the theatre also served the proclamation of publicly important news and thus had a political function. Theatres dating to Parthian times were found in Babylon, Dura-Europos and Seleucia on the Tigris.

9.5 Slaves and prisoners of war

It is difficult to say if there were slaves in the Parthian Empire and what the term 'slave' really meant, as we have only a few examples in written sources. A Parthian-based parchment from Dura-Europos, dated 121 AD (P Dura 20 Welles),[22] tells us about a farmer being dependent on the owner of the farm, Phraates, who was an influential government official. This government official owned a promissory note from a farmer called Barlaas from the village of Paliga. Phraates had lent him 400 silver drachms, the farmer's farmland and his entire property serving as security. In this promissory note, the farmer agreed to serve Phraates as a slave until repayment of this sum of money, whereby he was to carry out all the work required of him. The certificate gives even more detailed information about the farmer's dependency. He must not move away from the estate either by day or by night. Should he become ill and incapacitated for work, he would have to pay one drachm per day without work; should he seek refuge in the temple, he could be expelled from it by force. Such basic conditions suggest that something akin to slavery existed in Parthian times.

Such conditions are also found with the Sasanids. A Sasanian legal book known as the 'Collection of a Thousand Legal Decisions' indicates that slaves were sold together with land. It is probable that this book from Sasanian times also bears witness to the Parthian period. Even children were among the slaves, as we are informed by a parchment from Dura-Europos, dating to 180 AD, which tells us about the selling of a farm including a 12-year-old child.[23] In reports of the trade we are also told of slaves being transported in addition to gold, wine and dates from ports in the Parthian Empire to India and Arabia.

Another meaning for the term 'slave' derives from the information that slaves learned to ride and shoot in the army. Such people were probably dependent on their owner, but not in the sense of being 'slaves'.[24] Slaves could also be released, as an inscription from Susa dating 142/141 BC (SE 171 = Seleucid Era) testifies.[25] This documents the dedication in Susa of a 30-year-old woman slave to the great fertility goddess Nanaia. However, it is unclear whether this slave girl was supposed to do temple service (holy prostitution) or whether she was released according to Greek law and custom.[26]

A penalty of 3000 silver drachms was set if the rights granted to the woman were violated. As indicated in legal documents, a change in the position of workers took place in the 2nd to 3rd century AD.[27] Although many workers still had to work on the owner's land, they were granted a share of the proceeds of their labour. This share was between one-tenth and one-quarter of the total proceeds. Prisoners of war had to do compulsory work. One example: after about 10,000 Romans had been captured in the Battle of Carrhae in 53 BC, they were taken to Merv, where they were used in the construction of the defensive wall.[28]

9.6 Music of the Parthians

Music played a significant role in the Parthian Empire, as it did in all ancient cultures. Music was played during festivals, weddings, receptions and marching in war.

However, so far only a few representations of Parthian musical instruments have been found. Most of the finds are from either Hatra or Nisa. We have gained knowledge of the following musical instruments from pictorial representations: tambourines, panpipes (Pan flutes, Greek: *syrinx*), double reeds, a sort of hurdy-gurdy, drums, trumpets (about 50–60 cm long), oboes and harps.

Women and men alike played the instruments, as can be demonstrated by a relief depicting a pageant at the temple of the Allat in Hatra (South Iwan, Building B, Parthian era). The relief shows a bride sitting on a festively decorated dromedary. She wears a floor-length, slightly pleated robe. She is depicted sitting on a stretcher placed transversely to the direction of the dromedary. She is preceded by a tambourine player wearing a long robe. Another section of this relief portrays two wind instruments, one of these a panpipe consisting of 13 pipes, the other a wind instrument. Such instruments first appear in Mesopotamia during the Hellenistic period. It is an exuberant celebration, as you can conclude from the presentations of song and dance. The music is accompanied by clapping, while wine flows abundantly, and as other illustrations show, the cups are well filled.

Only wind and percussion instruments are shown at the wedding mentioned. Even at today's festivals in the Mesopotamian area, these two groups of instruments are the only ones used, mainly consisting of reed instruments accompanied by drums. The wedding relief also shows a player with a double reed, a wind instrument with two single reeds which are not connected to each other and are kept V-shaped while playing. A find from Bactria proves that the double reed was already in use in the 3rd to the 2nd century BC.[29] Excavated clay figures even reveal that the Parthians played the harp.

Other sources for details regarding Parthian music are the drinking vessels (*rhyta*) found during the Nisa excavations (Figs. 10.1–10.7). The panpipe depicted here is played by a satyr, a human–goat hybrid – an indication of the Hellenistic influence in Nisa. Such musical instruments are known in Central Asia only from a few finds. We also gain information about Parthian music from Greek authors. Plutarch describes the Battle of Carrhae (53 BC), including the Parthian general Surena's procession with a group of musicians accompanying the warriors. The group even included women playing the castanets. As Plutarch further reports, the Parthians used large kettle drums in the war against the Romans, causing unrest and confusion among the Roman soldiers and thus producing a significant psychological effect.[30] The kettle drums, similar to Indian ones, were probably made of clay and covered tautly with a membrane of animal skin by means of crossing thongs. In addition, they were hung with copper rattles or bells inside. When struck, they emitted a deep horrible roar resembling a mixture of beastly howls with peals of thunder (Plutarch, *Crassus* 23:7).[31] To produce such a deep sound, the kettle drums must have been large and heavy, and were probably transported by camels, which must have been accustomed to the noise. It is assumed that specially trained soldiers hit these kettle drums.

Another report mentions wandering singers (*gōsān*) in Parthian times who visited and sang in markets during times of peace. Part of the Avesta consists of

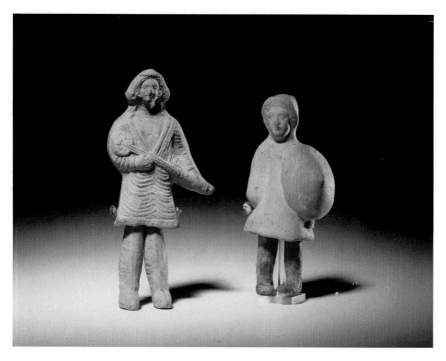

FIG. 9.4 Parthian musicians, terracotta, find spot: Iran. Inv. Nr.: B 1952/2.1, National Museum of Antiquities, Leiden.

Gathas, religious hymns. These were sung at gatherings of the Zoroastrians to proclaim the message of faith. Presumably, these texts were only transmitted orally. It is assumed that secular literature was also sung in verse and accompanied by music. The lyrics were performed by a singer, who had many functions:[32] he appeared at court before the king and the courtiers and was called to parties and funerals. As Plutarch reports, the *gōsān* sang the deeds of Parthian heroes, but also sang songs mocking the Romans.[33]

9.7 Medical knowledge in Parthian times

There are no reports on the medicine of the Parthians. However, our knowledge of the Sasanids' medicine enables us to draw conclusions about Parthian medical knowledge. It may be assumed that part of the traditional knowledge comes from the Avesta, which was already known in Parthian and Achaemenid times, and includes requirements for medical treatments. It may also be assumed that the warlike Parthians possessed sophisticated treatment for combat wounds.

In the Sasanian kingdom a sort of university was probably founded by King Shapur II (309–379 AD) in Gondischapur in the south-west of Iran, medicine and other natural sciences such as astronomy being taught there.[34] The teachers came from different countries, and the knowledge they imparted there was partly based

FIG. 9.5 Musician, terracotta, Parthian era, c. 1st–2nd century AD, height: 19.1 cm. Joint Expeditions – Iraq Excavations Fund 1933.173. Cleveland Museum of Art, Ohio.

on the Vendidad, part of the Avesta. The Vendidad describes numerous plants and their effects. Other chapters deal with the handling of the dead in winter (sections 10–14), how to deal with stillbirths (sections 45–62), fees for doctors or cutting nails and hair (section 9). Among the plants, 'Haoma' is mentioned by the Zoroastrians. This was probably the small yellow-flowered plant found in the highlands of Iran and bearing the scientific name *Ephedra vulgaris*. It has not yet been scientifically confirmed whether or not this contains the active substance ephedrine, used to treat circulatory and respiratory diseases. Whether a drink made of 'Haoma', which can cause intoxication and was used as a drug in Zoroastrian rituals, was made from this or another plant – some researchers also suspect hemp or fly agaric (*Amanita muscaria*). An extract of cannabis seeds (bangha, Avesta: bhangh) was also used. Its hallucinatory effect was known, especially when mixed with wine. This extract may have been used to relieve pain in operations such as in the treatment of fractured bones or wounds.

According to the Vendidad, there were regulations for the training of doctors. Incoming doctors had to examine three patients, diagnose their disease and treat it before they were admitted to the practice of their profession.[35] According to data in the Avesta there were different fields of specialisation for the doctors. A hygienist (*asho baeshazo*), who cared for the prevention of communicable diseases, was also responsible for women who had stillbirth. Such women had to live away from their family for a few days and regularly drink bull urine several times a day, thus purifying themselves as well. Only then were they allowed to return to their family. There was also a general practitioner (*urvaro baeshazo*) with knowledge in herbal medicine, a surgeon (*karato baeshazo*), a forensic scientist (*dato baeshazo*), who is likely to correspond to today's forensic physician, and a *manthra baeshazo*, who healed with holy words. This could correspond to a shaman, or in the modern sense, a psychologist.

Remuneration for the doctors was linked to the income of the patients they treated. In individual cases, this could mean that they were given a bull by a rich village owner, or even a four-horse carriage by a sovereign. Women paid less, e.g. the purchase price for a donkey, a cow, a horse or camel mare. The penalties for doctors who were guilty of maltreatment were significant. If a doctor performed a major operation on the eye with a bronze lancet, opening the eye socket and destroying the patient's eyesight, his hand was to be cut off (Law No. 218). Abortion was considered to constitute murder.

The report on the so-called Antonine plague at the time of Emperor Marcus Aurelius (121–180 AD) gives an indication of epidemics that may have plagued the Parthian kingdom. The cause of the Antonine plague is unclear. According to the description, it may have been an infection with *Yersinia pestis*, the pest irritant, but it could also have been a form of smallpox. The epidemic first appeared during the Parthian campaign of Lucius Verus in Nisibis in today's south-eastern Turkey in 165 AD and spread through Athens to the entire Roman Empire. The plague raged for more than 24 years. According to Cassius Dio, in 189 AD, at the height of the spread in Rome, up to 2000 people were dying each day. Thereafter, the wave of illness ebbed away.[36]

9.8 Living conditions – income – salary payments

Although some documents enable us to look at living conditions in the Parthian Empire, it is impossible to make a general judgement. Cuneiform tablets that are regarded to be administrative and documents from Parthian days were found in Babylon. Most of these tablets contain dates which refer to the years 94 or 93 BC.[37] They permit conclusions on the earning potential of employees in the temple area at that time. A man who worked in the cleaning service was paid 1.5 shekels, whereas a clerk who wrote certificates on leather received 2 shekels. One shekel corresponded to the value of a tetradrachm. The prices for grain are known from other written records. From this data, we can roughly calculate how much grain, whose calorific content per kilogram has been roughly calculated, is needed to feed a family of five. To simplify matters, it is assumed that nutrition is possible only with grain. Such calculations estimate that about 2.8 shekels per month were needed to feed a family of three children adequately.[38]

Based on various other documents, we can surmise that such families lived on the poverty line, as the wage of 1.5 to 2 shekels per month was insufficient to buy the amount of grain required for nutrition. Families may therefore have been dependent on further income. This is supported by a note in the archives, namely that a baker named Mardu-Suma-Iddin was responsible, in addition to his work as a baker, for the management of revenue in the temple and that he received money for this.

From the parchment documents found in Avroman, in south-western Iranian Kurdistan, in 88/87 BC half a vineyard could be bought for 30 silver drachms.[39] This corresponds to about 14 shekels or 14 tetradrachms. It was thus possible to acquire real estate on the annual salary of a simple employee. Analysis of almost 700 skeletons in a cemetery from Roman-Parthian times in Magdala in northern Mesopotamia, an area that had been under Parthian influence since Mithradates I, allows a different insight into the living conditions of the Parthian population.[40] The studies show that people enjoyed good living conditions and had a sufficient amount of animal protein. Child mortality is stated as 25.5 per cent. At birth, life expectancy was 33.5 years. Once the age of 20 had been reached, people on average were likely to live to 45.

9.9 The kitchen of the Parthians: recipe for chicken in Parthian style

References to Parthian cuisine can be found in the Roman special cookbook 'De re coquinaria' by Marcus Gravius Apicius, which describes a recipe for the preparation of a chicken in Parthian style.[41] By reading the recipe, we get an idea of the dish. Apicius writes:

> Open the chicken at the back end and dress it on a board. Pestle pepper, lovage and some cumin (careum), moisten it with Liquamen (fish sauce)

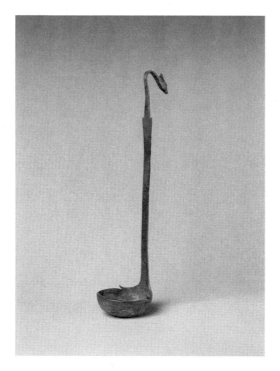

FIG. 9.6 Ladle, Parthian, c. 2nd century BC–3rd century AD, Mesopotamia, Nippur, bronze, length: 25.81 cm. Accession Number: 59.41.4, Metropolitan Museum of Art, New York.

and mix it with wine. Put the chicken in an earthen pot (*cumana*) and pour the sauce over it. Dissolve some fresh *laser*[42] (a kind of spice) in lukewarm water, pour this over the chicken and let it stew. Sprinkle with pepper and serve.

A ladle such as that shown in Fig. 9.6 could have been used to serve the soup before the main course.

From Roman reports as well as from representations on a Parthian terracotta (Fig. 11.3) and a silver plate (Fig. 9.7), we know that Parthian kings did not despise the pleasures of the table. They lay on a kline – a type of couch – and ate 'barbaric meals' (meaning very spicy) and enjoyed wine. The documents from Nisa also provide evidence of intensive wine consumption. Again and again the sentence 'left over from the cupbearer' appears on ostraca. It may be assumed, however, that the wine they enjoyed was diluted. Aristocratic Parthian families were wealthy and will not have lived badly, as revealed by the rhyton and bowls found by archaeologists (Figs. 9.7 and 9.8). If we can believe Roman reports, Parthian nobles attached importance to hunting and exclusive hunting rights. Game was also part of their diet.

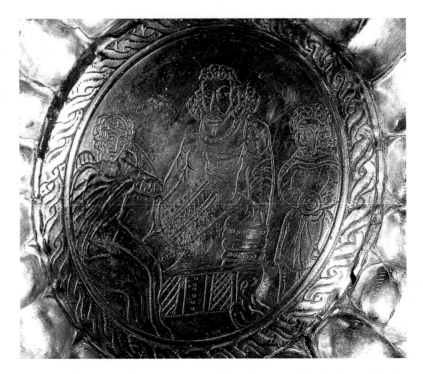

FIG. 9.7 Silver bowl, Parthian period. A Parthian with typical curly hair and Parthian clothing lies on a kline, holding a bowl in his left hand. At the foot of the couch sits a woman, behind the Parthian is another man (servant?). Registration Number: 1968, 0210.1, British Museum, London.

9.10 Clothing in Parthia: kandys – chlamys – tunic and trousers

9.10.1 Kandys

The analysis of Parthian coins with their realistic illustrations shows us the change in Parthian regal clothing over the centuries of the empire. Such different representations also involve political motivations. At the emergence of the Parthian Empire, the Parthians still appear in clothing that had its origins with the nomads. On the first coins the first Parthian ruler Arsaces I presents himself with a bashlyk – a nomad headgear – and a kandys – a long coat that hangs over the shoulders, its sleeves empty and hanging down loosely (Fig. 9.9). Such a coat was already worn by the Medes. This was an image that the Parthians certainly used to demonstrate their relation to the Medes and the Persians.

9.10.2 Chlamys

The Parthian Empire, which in the first 100 years of its power had conquered numerous areas that were also influenced by Greek culture, now had to adjust

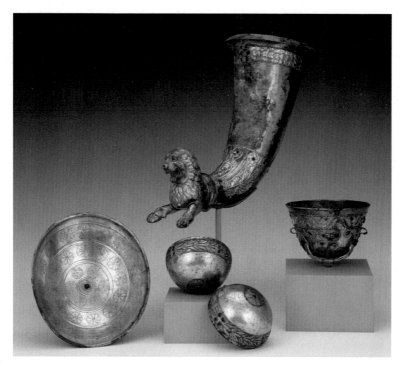

FIG. 9.8 A large rhyton and four bowls or cups form a group of silver vessels. The rhyton and bowls were made around the same time, but they come from different areas of the Near East. While most of the vessels are Parthian, the deep cup with relief decoration appears to have originated in Bactria. 1st century BC, gilt silver, garnet, inlaid glass, semi-precious stones. Getty Museum, Los Angeles. Object Number: 86.AM.754.

FIG. 9.9 Arsaces I (c. 247–211 BC), AR drachm, S 3.1. Obverse: head of the ruler, who wears a bashlyk, a nomad headgear, a diadem tied around it. Reverse: archer, sitting on a chair, who wears a kandys, a long coat, which hangs over the shoulders with its sleeves empty. Original size: 20 mm, weight 4.3 g.

 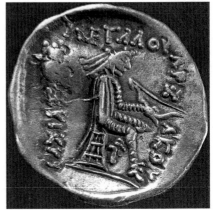

FIG. 9.10 A + B Mithradates I, AR drachm, S 11.1. Obverse: Bearded bust facing to the left, wearing a diadem, a chlamys fixed with a brooch over the left shoulder. Reverse: beardless archer seated right on an omphalos, holding an asymmetrical reflex bow in his right hand. He is wearing a bashlyk, around which a diadem is tied. The two ties of the diadem and the back neck-guard of the bashlyk are readily visible. A kandys is thrown over his shoulders. Original size: 19 mm, weight: 4.08 g.

politically to the new situation. This is recognisable by the Greek-style clothing with which Phraates II (c. 176–171 BC) and Mithradates I (c. 165/164–132 BC) present themselves. They wear the chlamys, a Greek cloak, the free ends fixed to the shoulder with a brooch. They also wear a diadem. With this consciously chosen representation, a political motivation can be assumed. The new rulers had subjected a Greek population and tried to ensure their support by wearing Greek clothing and calling themselves ΦΙΛΕΛΛΗΝΟΣ, the friends of the Greeks.

9.10.3 Parthian tunic and trousers

Later in Parthian history, from the time of Artabanus I (c. 127–124 BC), the Parthians can be seen to have stopped wearing Greek-style clothing, and now present themselves in typical Parthian dress with tunic and trousers. The Parthians clearly demonstrate their self-confidence and their own Parthian identity, in an empire with no need to fear enemies. The typical Parthian clothing of the men is the combination of a long-sleeved tunic with trousers, somewhat comparable to trouser suits worn today. The two front panels of the tunic form a V, overlap and are closed by a belt, as can be clearly seen on the coin of Pacorus II (Fig. 9.11). See also the bronze sculpture of the 'Prince of Shami' (Fig. 9.12). In the opinion of Fabrizio Sinisi, the assumption that the tunic shown on tetradrachms may be a cuirass – as several authors (Wroth, Petrowicz, De Callataÿ) suggest – is wrong.[43]

The discovery of the well-preserved body of a Parthian, who died in an accident in a salt mine 2000 years ago ('salt man'), shows us that the man wore soft sheepskin boots that were excellently worked (Fig. 9.14).

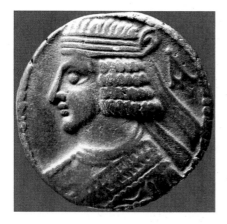
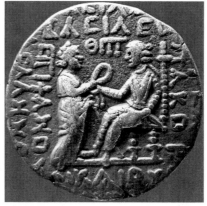

FIG. 9.11 A + B Pacorus II, AR tetradrachm, S 73.2. Obverse: the beardless ruler with a diadem. Reverse: king with tunic with V-shaped neckline, short sword on the left side; Tyche stands before him, presenting a tiara. Date between the heads: ΘΠΤ (year 389, corresponds to 77/78 AD). The tunic was worn on the skin,* a belt is fastened round the tunic. At his left a short sword is fixed to the belt, the king holding its handle with his left hand (Fig. 9.11 B). The king wears typical Parthian trousers, which are baggy in shape, reaching down to the ankles. The trousers are not an invention of the Parthians, but originate from the tradition of the nomads, as shown by the well-preserved wool trousers from c. 1100 BC.† The trouser legs were pushed into the shoes and held with the shoelaces, a typical feature shown on Parthian coins (Figs. 9.13 and 7.24).†† Original size: 28 mm, weight 13.35 g.

* Sinisi, F., 2012: p. 58.
† www.sciencedirect.com/science/article/pii/S1040618214002808.
†† Winkelmann, S., Ellerbrock, U., 2015: p. 197.

However, important finds that give us information about the clothing of the Parthians come from Hatra and Palmyra, where certainly no pure Parthian influence existed. Thus, the clothing presented on statues in these finds shows a mixture of local forms and Parthian heritage. A good example of this is the sculpture of a Parthian youth found in Hatra wearing a splendidly ornamented robe that is worn knee-high over the trousers (Fig. 9.15).

9.10.4 Women: beauty and clothing: chiton/himation/peplos

Undoubtedly, Parthian women also valued beauty. This is shown by earrings, belt buckles and pretty necklaces (for jewellery finds and illustrations thereof, see 10.6). A pallet for cosmetics also indicates that Parthian women were even using make-up to make an impression (Fig. 9.16). The question of what clothes Parthian woman wore is not easy to answer. Sculptures from the Parthian period, especially from Hatra, Dura-Europos and Palmyra, allow some conclusions to be made about the clothes worn by queens and women of the upper class who lived there.[44] It must be understood, however, that in these depictions of feminine clothing we are certainly

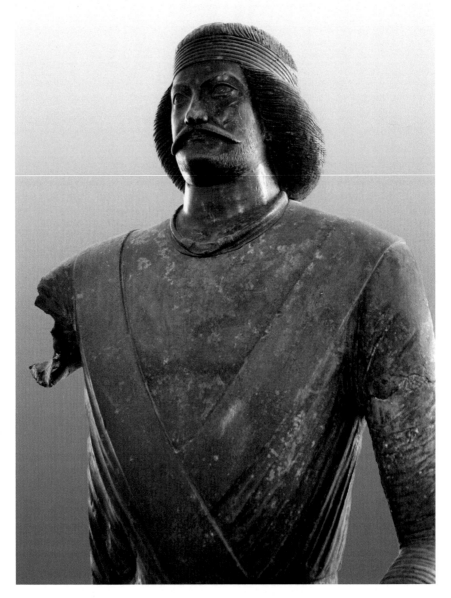

FIG. 9.12 'Prince of Shami', bronze statue. National Museum of Iran, Tehran. The prince is dressed in a tunic, which is fixed by a belt (see also Fig. 4.22 and 9.13).

seeing hybrid forms that involve Parthian influence as well as local developments, based on Greek influence. Unfortunately, we have only very scarce information about what sort of clothing Parthian women living in Ctesiphon or Nisa, the capitals, actually wore. The women shown on Parthian coins are goddesses, the only

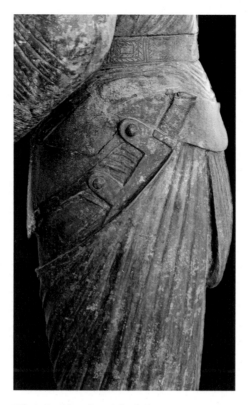

FIG. 9.13 'Prince of Shami' with a four-lobed dagger.

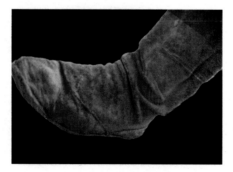

FIG. 9.14 Sheepskin boots, Parthian era. National Museum of Iran, Tehran.

exception being the Parthian Queen Musa. Nevertheless, they wear Hellenistic-style clothing.

A chiton comprises two rectangular cloths, sewn as a sack on three sides, leaving open a section for the head. Below the breast, the dress is laced with a ribbon. On

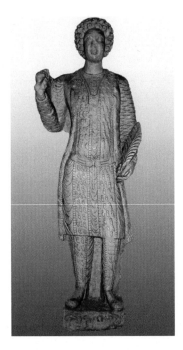

FIG. 9.15 Parthian youth, inscription: Aphrahat, cast, find spot: Hatra. Archaeological Museum, Amsterdam.

FIG. 9.16 Palette for cosmetics, stone, Parthian era, c. 1st century BC–1st century AD, approx. 5 × 11.9 cm. Accession Number: 56.81.56, Metropolitan Museum of Art, New York, purchased 1956.

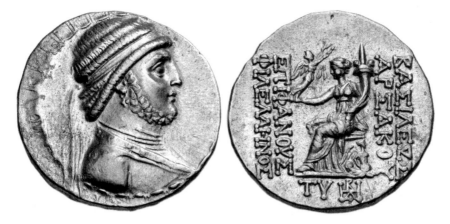

FIG. 9.17 Mithradates II, AR tetradrachms, S 23.2. The goddess shown on coins of Mithradates II, the 'Hellenistic Tyche',* wears a chiton, with a himation, a sort of shawl, wrapped around the hips, one end fixed to the shoulder. In her right arm she holds a cornucopia, a horn of plenty, a symbol of abundance and nourishment.

* For the distinction between the 'Hellenistic Tyche' and the 'Parthian Tyche', see: Ellerbrock, U., Winkelmann, S., 2015: p. 288 ff.; Ellerbrock, U., 2013 (1): 253 ff.

statues from Hatra women also wear a peplos. A peplos is a body-length garment and differs from a chiton in that an additional pleating of the cloth is made in the upper portion of the dress. The most important goddess of the Parthians, the 'Parthian Tyche', is depicted on tetradrachms during the investiture of the respective kings (Fig. 9.18). She wears a floor-length garment (chiton), laced under the chest, part of the himation (Greek mantle cloth) around the hips being visible, one end of which is placed around the left arm, the other end hanging over the shoulder. In her left arm she holds a cornucopia as a sign of fertility and wealth.

9.11 Astronomy – calendars

The Parthians used different calendar systems to date the years and months.

1 The Seleucid Era
2 The Parthian Era
3 Calculation according to the Zoroastrian calendar.

Before discussing the different calendar systems in detail, it is useful to get a picture of the methods used by the ancient peoples to determine the course of a year. Basically, one possibility is orientation based on the moon's orbits, another is by the course of the sun. In the countries of the Mediterranean and the neighbouring eastern countries, the luni-solar calendar was used. This calendar used the lunar cycle, which was easier to determine, and was supplemented by observations of the sun. The beginning

FIG. 9.18 Tyche. Detail of a tetradrachm of Gotarzes II, S 65. The goddess Tyche wears a chiton.

of a month was determined by the first appearance of the crescent moon. The year was divided into 12 months. Since a lunar month lasts only about 29.5 days, only 354 days (= 12 × 29.5) made a full lunar year, such that in a solar year with approximately 365 days – as we use today – 11 days are missing. In 19 years the miscalculation totals about 209 days (19 × 11 days). The choice of 19 years was the result of observations (Meton Cycle), since the sun and moon are seen from the earth before the same stars every 19 years, which corresponds to 235 lunar revolutions. The calculated 209 missing days are roughly equivalent to seven months of 30 days.

This problem of missing days was known to ancient peoples, and so time-equilibrations had to be carried out at regular intervals. Every three years, an additional switching month was inserted. The Achaemenids used the luni-solar calendar. In 19 years, this required the insertion of seven months of 30 days. This adaptation to the solar year was necessary to be able to accurately determine times for the sowing of seeds or for the determination of religious festivals, such as the beginning of spring. The Babylonians, as well as Alexander the Great and his successors, the Seleucids, used this calendar system.

Although we have a much more accurate year with 365 days per year, we too adapt to this problem by inserting a leap day in February every four years. Owing to the low volume of data, not all questions about the necessary calendar adaptations

FIG. 9.19 Abbu, wife of Sanatruk II, with a floor-length dress and a high head-dress. With her left hand, the pleated hem of the garment is lifted, with her right hand, which is raised in a typical Parthian style of greeting, she holds a veil that falls from the headgear over the shoulders. Hatra, 1st half of the 3rd century AD. Photo: akg-images/ François Guénet.

in the Parthian Empire have yet been clarified.[45] For the last two centuries of the Parthian Empire, especially, there is a lack of information on the undoubtedly essential adaptations of the calculated lunar years to the solar years.[46]

9.11.1 The Seleucid calendar

As mentioned above, the Seleucids continued to use the calendar calculations of the Babylonians. The years were counted on the basis of those of individual rulers. The Seleucids merely set the beginning of their calculations in the year 312 to 'zero', as shown by the numerous cuneiform inscriptions of the Seleucid Era (SE) or Parthian Era (PE) that were found in Mesopotamia.

9.11.2 The Parthian calendar

With their victory over the Seleucids, the Parthians continued to use the Seleucid calendar, which, as explained above, was based on the luni-solar calendar. Thanks

to available Babylonian cuneiform documents, which in one case used the dates of the Parthian as well as the Seleucid calendars, the beginning of the Parthian chronology can be traced back to the 14/15 April 247 BC – it begins with the reign of Arsaces I.[47] Just when this date was defined as the beginning of the Parthian Empire has not been clarified. Assar assumes that the establishment of the beginning of the Empire may only have taken place under Mithradates I or Phraates I.[48] The beginning of the Parthian year 'zero' thus corresponds to year 65 of the Seleucid Era.

A document from Dura-Europos[49] reads:

> Under the reign of the king of kings, Arsaces (meaning Osroes I, c. 109–129 AD), the benefactor, the just, the manifest,[50] and friend of the Greeks, in the year 368, as the king of the kings counts (in Arsacid time, as however in earlier times – Seleucid times) the year 432 was counted, on the 26th day of the month Daisios (May), in the village Paliga.

Converted to the Gregorian calendar this is May 121 AD (432–312 = 120). In today's counting, as the ruling year of the king started in October 120 AD and the month given is May, it is the year 121 AD. This document shows that at least in Dura-Europos in the first half of the 2nd century AD the two systems existed side by side.

According to Sellwood, the inscription 'EKP' on a coin of Artabanus I (Fig. 9.20) could mean the Parthian year 125 (P=1, K=20, E=5), corresponding to 123/122 BC (see 9.11.6). This reading is, however, controversial, according to Parthia.com.[51]

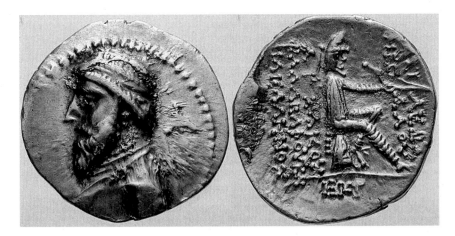

FIG. 9.20 Artabanus I, AR drachm, S 22.2. Reverse: in exergue: EKP. The letters could indicate the Parthian year 125 (P=1, K=20, E=5), corresponding to 123/122 BC, but this reading is controversial.

9.11.3 The Zoroastrian calendar

In addition to the Seleucid and Parthian calendars, the Zoroastrian calendrical system was used. This calendar is closely linked to Zoroastrian belief. The Zoroastrians (see 11.1), who it is presumed lived in the Bactrian area and spread their beliefs from there, calculated a calendar year based on a solar year of 360 days. Such a calculation was much more precise than one which used lunar years. It is shorter than today's 365-day year by only five days. Thus, in the Zoroastrian system, only five additional days (*epagomene*) had to be introduced; these days followed the twelfth month and were inserted annually to arrive at a correct solar year.

It is believed that this Zoroastrian calendar was introduced about 460 BC by the Achaemenids.[52] This calendar may have been used in the early days of the Parthian Empire, at least in the eastern regions. This is supported by ostraca bearing Zoroastrian names and found in Nisa. The earliest date on these inscriptions is c. 100 BC; the most recent ones are from 12 AD.[53] As successors of the Parthians, the Sasanians elevated the Zoroastrian belief system to the position of state religion, and also adopted the Zoroastrian calendar.

9.11.4 Year and month dates on Parthian coins

Following the conquest of Mesopotamia by Mithradates I, the minting of Parthian tetradrachms was introduced – the coins produced contained year dates based on the Seleucid calendar. The years were inscribed in Greek letters (Table 9.1). Year dates are rarely found on tetradrachms between Mithradates I and Orodes II, but they are more regularly found on the coins of later kings, starting with the coinage of Phraates IV (c. 38 BC). The lack of annual data on the coins also explains the difficulties described in creating the genealogy of the Parthian rulers prior to this period. The year dates are usually to be found on the reverses, normally in the area between the heads of the king and the goddess Tyche. The names of the months

TABLE 9.1 Year dates in Greek letters

Units		Tens		Hundreds	
A	1	I	10	P	100
B	2	K	20	Σ	200
Γ	3	Λ	30	T	300
Δ	4	M	40	Y	400
E	5	N	50	Φ	500
ς	6	Ξ	60		
Z	7	O	70		
H	8	Π	80		
Θ	9	Ϙ	90		

TABLE 9.2 Monthly names in various calendars used. According to the Babylonian calendar, April is the first month of the year, according to the Greek-Macedonian calendar, it is October. On the coins, Greek month names are given in the genitive.

Babylonian calendar		Greek-Macedonian calendar	
1st month	April	ΔΙΟΥ	October
2nd month	May	ΑΠΕΛΛΑΙΟΥ	November
3rd month	June	ΑΥΔΥΝΑΙΟΥ	December
4th month	July	ΠΕΡΙΤΙΟΥ	January
5th month	August	ΔΥΣΤΡΟΥ	February
6th month	September	ΞΑΝΔΙΚΟΥ	March
7th month	October	ΑΡΤΕΜΙΣΙΟΥ	April
8th month	November	ΔΑΙΣΙΟΥ	May
9th month	December	ΠΑΝΗΜΟΥ	June
10th month	January	ΟΛΩΟΥ	July
11th month	February	ΓΟΡΠΙΑΙΟΥ	August
12th month	March	ΥΠΕΡΒΕΡΕΤΑΙΟΥ	September
		ΕΜΒΟΛΙΜΟΥ	Intermediate time – month

(Table 9.2) on Parthian tetradrachms are usually in the exergue of the coin and thus rarely seen.

On many coins, the name of the month can hardly be recognised in the exergue or it is completely missing. It was not uncommon to mint either the month or the year, as is evidenced on tetradrachms of Mithradates I or Orodes II. The combination of annual and monthly data is usually found on coins of later kings, starting with Phraates IV.

9.11.5 Coins with intercalated years/months (ΕΜΒΟΛΙΜΟΥ)

As indicated above, intercalated months need to be used to adjust the calendar to the actual sun year. There are very few Parthian tetradrachms on which an intercalated period is recorded. Orodes II is the earliest ruler on whose tetradrachms an intercalated month is given, but unfortunately these coins do not carry a date. The specification of an intercalated time is also found on tetradrachms of Orodes II (S 45.1 and S 46.7; Fig. 9.21), Phraates IV (S 50.13) and Vologases I (S 72.7), formerly known as coins of Vologases II.[54] Assar's analyses show that, due to calendar adjustments between 48 BC and 67 AD, a shift in the usual start of the year – and thus the beginning of the government year – took place from the month of Dios (October) to the month ΥΠΕΡΒΕΡΕΤΑΙΟΥ (September).[55] The reason for this shift was probably adjustment to the calendar in Antioch. After this period, the beginning of a calendar year (and thus the beginning of a new year) was moved back to the month of October.[56]

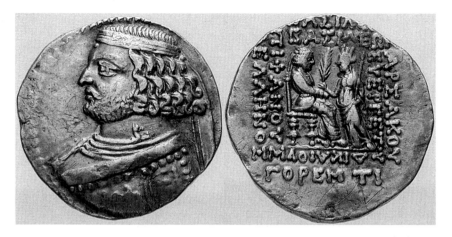

FIG. 9.21 Orodes II, tetradrachm, S 46.7. Inscription in exergue: ΓΟΡ[ΠΙΑΙΟΥ] = August, EM (=EM[BOΛIMOY] = intercalated month), 'TI' could signify the approval of the magistrate of the mint.

Note: Assar, G.R.F., 2003: p. 178.

9.11.6 Conversion of the Seleucid Era into the Dionysian or Common Era

Almost all Parthians coins bear dates, which are based on the Seleucid calendar. As explained above, the Seleucid Empire established its first year as beginning in October 312 BC. To convert a Seleucid Era date to today's widely used Dionysian (BC/AD) or Common Era (BCE/CE), the following formula applies: if the Seleucid year indicated on a coin is 312 or less, then this number must be subtracted from 313 to obtain the corresponding year BC (or BCE). If the Seleucid year is greater than 313, then 312 must be subtracted from this number to obtain the corresponding year AD (or CE).

The following example may illustrate this: a coin has the year B I T, where B=2, I=10, T=300 and thus the Seleucid year 312 results. To convert this, subtract 312 from 313, to make 1, which corresponds to the year 1 BC/1 AD, since there is no year zero. The government year thus spanned from 1 October BC to 1 October AD.

9.11.6.1 Example coin to illustrate the conversion of the year's date to the Dionysian or Common Era

Inscriptions on the coin presented in Fig. 9.22 may be used as an example to illustrate how a date given in the Seleucid Era system would be converted to today's widely used Dionysian or Common Era.

FIG. 9.22 A + B Gotarzes II, AR tetradrachm, S 65. Obverse: long bearded bust facing to the left, hair in four waves below the diadem, which has one bow and ties (three lines), torque with four rings, no end to be seen, circular border of pellets, lock of hair on forehead representing the royal wart. Reverse: king seated right on throne with a back, wearing a diadem and Parthian clothing with baggy trousers; Tyche, standing left before him, presents a diadem with her right hand and holds a cornucopia with her left arm. Inscription: ΒΑΣΙΛΕΩΣ ΒΑΣΙΛΕΩΝ ΑΡΣΑΚΟΥ ΕΠΙΦΑΝΟΥΣ ΦΙΛΕΛΛΗΝΟΣ ΔΙΚΑΙΟΥ ΕΥΕΡΓΕΤΟΥ, [Coin of] the king of kings, Arsaces, the manifest, the friend of the Greek, the just, the benefactor.* Between the heads: HNT, Greek numbers for the Seleucid year 358 (H=8, N=50, T=300). Conversion results in the year 46 AD (358 minus 312). Since no name of a month is visible on this coin, the conversion date must be the year 46/47 AD.

* Keller, D., 2010: p. 624; De Callataÿ, F., Corber, C.A., 2011: p. 450 ff.

9.11.7 Conversion of the Parthian Era into the Dionysian or Common Era

The beginning of the Seleucid Empire was in 313 BC. The Parthian Empire started 65 years later in 248 BC. If a Parthian date (starting with zero in 248 BC) on a coin is given as prior to 248, the number must be subtracted from 248. Example (Fig. 9.20): the Parthian Era date inscribed is year 125 (Parthian Era, P=1, K=20, E=5). To convert it to the Dionysian or Common Era: 248 minus 125 gives 123, the coin therefore dates from the year 123/122 BC (or BCE). (The reign began in October 123 and ended in September 122 BC). The reading as a Parthian Era date on this coin is controversial.[57]

Notes

1 Weber, D., 2010: vol. 2, p. 566 f. (Avroman III).
2 De Jong, A., 2012 (2): p. 23 ff.
3 Böck, B., 2010: p. 27 ff.

4 Paul, L., 2013: p. 286.
5 Extensive information is available at: http://turfan.bbaw.de/.
6 Zehnder, M., 2010: p. 239, with further references.
7 Hackl, U., 2010: p. 144.
8 Zehnder, M., 2010: p. 248: original text with translation into German.
9 Betz, O., 1985: p. 19 ff.; and: www.iranicaonline.org/articles/hymn-of-the-pearl.
10 Curtis, V.S., 2007 (1): p. 2 ff.
11 Ehlers, J., 2010: German translation. English edition: David, D., 2004.
12 Davis, D., 2004: p. xxi.
13 Davis, D., 2004: p. xviii ff.
14 Ehlers, J., 2010: p. 34 ff.
15 Thommen, L., 2010: p. 455 ff.
16 Sommer, M., 2005: p. 267 ff and 317 ff.
17 Posch, W., 1998: p. 359.
18 Skjærvæ, P.O., 2007: p. 105 ff.
19 www.iranicaonline.org/articles/board-games-in-pre-islamic-persia.
20 Plutarch, *Crassus* 33.2.
21 Jacobs. B., 2010: p. 134 provides information on the king's knowledge of Greek.
22 Thommen, L., 2010: p. 448 ff.
23 Thommen, L., 2010: p. 456 f. (P Dura 17 A/B Welles (=Inv.D. Pg.2).
24 Jacobs, B., 2010: p. 105.
25 Merkelbach, R., Stauber, J., 2005: p. 93; the inscription is thus from before the conquest of Susa by the Parthians, and speaks for slavery among the Greeks.
26 Thommen, L., 2010: p. 478 f.
27 Lukonin, W.G., 1967: p. 41.
28 Sonnabend, H., 1986: p. 173, *Ann.* 61.
29 Karomatov, F.M., Meškeris, V.A., Vyzgo, T.S., 1984: p. 5 ff.
30 Plutarch, *Crassus* 23.8–9.
31 Nikonorov, V.P., 1998, p. 72.
32 Curtis, V.S., 2007 (1): p. 2.
33 www.iranica.com/articles/music-history-i-pre-islamic-iran.
34 Azizi, M.-H., 2008: p. 116 ff.
35 Jahanian, D., n.d.: Medicine in Avesta and Ancient Iran.
36 Cassius Dio 73.14.3–4.
37 Van der Spek, R.J., 1998: p. 205 ff.
38 Van der Spek, R.J., 1998: p. 246 ff.
39 Thommen, L., 2010: p. 470, Version B mentions 40 drachms.
40 Hornig, H., 2008.
41 Apicus, 6.9.2; translation in: Klose, D., 2008: p. 288.
42 Laser: botanists suspect that the Romans used the spice plant 'laser' with the botanical name *Ferula tingitana* and the Parthians used to season their dishes with a similar plant, bearing the botanical name *Ferula asafetida*.
43 Sinisi, F., 2012: p. 31. Winkelmann, S., Ellerbrock, U., 2015: p. 197, write that men usually wore a sort of T-shirt under the tunic.
44 Winkelmann, S., Ellerbrock, U., 2015: p. 197 ff.
45 Korn, A., 2006: p. 153 ff.
46 Assar, G.R.F., 2000: p. 12.
47 Böck, B., 2010: p. 6 f.; Assar, G.R.F., 2004: p. 77.
48 Assar, G.R.F., 2004: p. 77 f.

49 Thommen, L, 2010.: p. 450 ff.

50 De Callataÿ, F., 2011: p. 426.

51 www.parthia.com does not mention the source; Sellwood defines it as Parthian time.

52 Rettelbach, G.: www.nabkal.de/impressum.html; this German source provides much information on different calendar systems.

53 Weber, D., 2010: vol. 2, p. 561.

54 Assar, G.R.F., 2000: p. 8; 2003: p. 178.

55 Assar, G.R.F., 2003: p. 171 f.; also: http://parthika.fr/Embo.html#haut.

56 Assar, G.R.F., 2003: p. 171 ff.

57 Information on www.parthia.com: the reading is controversial, and Parthia.com does not mention the source; Sellwood defines it as Parthian time.

10

PARTHIAN ART: ART IN THE ARSACID KINGDOM

The question of whether a specific Parthian art actually existed has long been a subject of controversy among the experts. Writing in 1935, the Russian archaeologist Michael Rostovtzeff was one of the first experts to stress that the Parthians had an art of their own. As Parthian elements, he cited the frontality with which people were depicted, but also the realistic details, of the kind that we find in sculptures and reliefs from the Parthian era.[1] Another well-known archaeologist, Frenchman Roman Ghirshman, who describes Parthian art in his book *Iran – Parther und Sasaniden*, points out that two separate phases existed in Parthian art. For the first phase ending with the kingdom of Artabanus I (c. 127–124 BC), Ghirshman states that one cannot speak of a Parthian art in the true sense.[2] But from the reign of Mithradates II, Parthian art developed. For this phase, Ghirshman likewise emphasises frontality as an essential feature, but also points out that Parthian art reflects not only a Hellenistic, but also an independent Iranian–Parthian influence.[3]

In contrast, however, Malcolm Colledge, a British archaeologist, points out that no art forms of their own are known for those Parthians that began as nomads to build the Parthian Empire.[4] This was changed in the course of Parthian rule by the fact that influences of the Graeco-Bactrian Empire in the east as well as intensive Hellenistic influences in Mesopotamia had a strong impact on the art of the Parthians. Colledge states in particular, that frontality, which is always emphasised as a feature of independent Parthian art, was already to be found in Roman times and therefore a Parthian art would not exist.[5] Stefan Hauser, a participant in the colloquium described below, confirms Colledge's opinion, as 'frontality is common in the representation of the deceased in Roman funerary art'.[6] Even though the question of whether frontality is a particular feature only to be found in the Parthian Empire has in recent times been corrected, it needs to be noted that a general consensus remains that frontality played an eminent role as a common stylistic feature in the later Arsacid Empire.[7]

In 2010, an international colloquium under the direction of Bruno Jacobs dealt with the question of whether there was any 'Parthian art' at all.[8] The general, difficult question is how art is defined. Jacobs emphasises that the term 'Parthian art' should not be understood as the summation of all art which developed in different parts of the Parthian Empire at different times, as it was defined by H.-E. Mathiesen.[9] As a result of this conference it was suggested that one should no longer speak of 'Parthian art', but instead use the terminology 'Art in the Arsacid kingdom'.[10] This expression essentially refers to representative arts, such as reliefs, sculptures and paintings, but also includes architecture with its various architectural elements.

Of course, the Parthian Empire did have its own developments in art, but these, depending on the region, were based on the local art styles that had previously existed, and were then further developed. In the east of the Parthian Empire, in the royal residence Old Nisa, the art objects found there display influences that were significantly determined by Graeco-Bactrian culture. It can be assumed that the sculptures found there were created locally by artists who either came from the Greek area itself, or by local artists who had at least learned from Greek-influenced artists.[11] Experts are largely in agreement about these influences. However, it is much more difficult to answer the question whether the Parthians, in spite of this recognisable Hellenistic-influenced art, associated their own 'Parthian ideology' with it. This question becomes clearest in the figure of a semi-nude goddess (Fig. 10.11): did the Parthians see in this figure Aphrodite, or perhaps the Zoroastrian goddess Anahita, the great goddess of the waters? As is explained in more detail in Chapter 11, the Parthians subscribed to Zoroastrian beliefs, and most probably saw in this figure the Zoroastrian goddess Anāhitā.

Many of the archaeological findings from the Parthian period discussed come from the peripheral areas of the Parthian Empire. In the west, from Mesopotamia to the outskirts of Syria, we have a mixed population whose local traditions were also subject to Hellenistic and Parthian influences. This is especially true for Hatra,[12] Palmyra and Dura-Europos.[13] According to current findings, the art in these cities must be regarded as a representative visual art of the regionally dominant elites and rulers, and not as a Parthian art that would be an expression of an elite (an ethnically dominant class – *éthno-classe dominante*)[14] extending over the whole Parthian Empire. This view also means that one should no longer speak of the 'Parthian Empire' but rather of the 'Parthian Commonwealth' (see introductions to Chapters 1 and 4).

Another important factor in the discussion of art in the Parthian Empire is the problem that we have far too few archaeological finds from the centre of the Parthian Empire. This applies in particular to the later capital of Ctesiphon, where we are ultimately ignorant about how art at the royal court may have looked. In general, there is another problem: the number of archaeological finds from the Parthian period, an empire with a history of almost 500 years, is alarmingly low. Unfortunately, some of these finds, which are now in major museums such as the Metropolitan Museum of Art in New York, the British Museum in London or the Louvre in Paris, did not originate from targeted excavations, but have been acquired

through the art trade. The occasional lack of any temporal, geographical or arch-aeological contexts for these finds bring additional problems in the assessment of such art objects.

Even if today one should better speak of the 'Art in the Arsacid kingdom', there is an architectural element that was of importance throughout the Parthian Empire and which should be characterised as Parthian art. This is the architecture of the iwan (see Chapter 7: Cities and architecture in the Parthian Empire). The iwan was later adopted by the Sasanids and led to the famous iwans in Iran and Uzbekistan, which can still be admired today (Figs. 7.14, 7.17 and 7.20).

10.1 Art finds in Nisa – rhyta – sculptures

The excavations carried out by Russian and, later, Italian archaeologists in Nisa show us the art that Parthian kings preferred at the time of the 1st century BC. Noteworthy are the approximately 55 rhyta, drinking horns carved from ivory, which were found in the Square House in the Royal Palace of Nisa. Their heights range from 30 to 60 cm. Normally they consisted of at least three pieces that were fixed by copper nails. The lower part of the rhyton (protome) shows mytho-logical creatures. The protome is connected to a shaft, on top of which a figural frieze is mounted. The upper part of the rhyton is the cornice, which is usu-ally adorned with figural heads (Fig. 10.4). Many rhyta friezes depict Olympian gods, the 'dodekatheoi' (meaning 12 gods): Zeus, Apollo, Hera, Athena, Aphrodite, Demeter, Ares, Haphaestus, Artemis, Poseidon, Hestia and Hermes. Other friezes depict Greek poets, and so-called 'Dionysian' themes, such as festivities with wine and joy. The protomes, the lower parts of the rhyta, show chimeric creatures like lion-gryphons (Fig. 10.1), centaurs (Fig. 10.3) or bull-men.[15] Research reveals that the rhyta were not brought to Nisa from elsewhere but must have been carved and produced there.

On the one hand, the Nisa rhytons are to be seen in the tradition of the Achaemenids, who loved drinking horns, which were equally decorated with hybrid creatures. On the other hand, the rhyta embody strong Hellenistic influences, which were recognised by archaeologists at an early stage. The earliest research dates the rhyta as being from the middle of the 2nd century to the 1st century BC. Recent studies of the rhyta show a still more differentiated picture. The archaeolo-gist Eleonora Pappalardo discovered that not only Greek, but also other motifs were used that have their origin in the Italic and Roman domain.[16] Pappalardo dates the rhyta as being from the middle of the 2nd century BC to the first decades AD. Jennifer Black compares the Nisa rhyta with a marble fountain in the shape of a rhyton, found in the Horti Maecenas and concludes that the Nisa rhyta were made at the end of the 1st century BC or the beginning of the 1st century AD.[17]

However, the question of the way in which Iranian ideas and beliefs were connected with the Hellenistic portrayal is one that remains open, although it was evident to the first researchers that the rhyta could be seen within both Hellenistic and Parthian religious contexts. Especially with regard to the question of the

worship, or even deification, of Parthian kings, an Iranian-influenced perspective plays a special role (see 4.1.4). The Italian archaeologist Antonio Invernizzi sums up his ideas on these questions:

> In conclusion, the choices the artists made in the vast repertory of Greek art for the sculptures and furnishings in Nisa were guided by purposes of celebration of the Arsacid kings, specifically on the occasion of funerary rituals, according to coherent programs which were created at the time of Mithradates I or his immediate successors, and were constantly followed and so to say progressively modernized with additions until the vulgar era.[18]

This means, that the rhyta could be 'read' within both Hellenistic and Parthian religious contexts. Although the gods shown here were of Hellenistic origin, the Parthians were able to recognise their own gods in them.[19] However, this view is not shared by all experts. Thus, Lucinda Dirven expresses doubts about these interpretations, which emphasise more the Iranian point of view.[20]

The rhyta depict not only gods but also new local motifs, such as scenes in which a woman is catching animals with a net, or women are guarding their goats. The statuettes of women, which are designed in a Hellenistic style but also contain local influences, are of considerable beauty (Figs. 10.11 and 10.12). During the excavations in Nisa, several other finds came to light, including sculptures of male heads and small sculptures (Figs. 10.8–10.10 and 10.14–10.19).

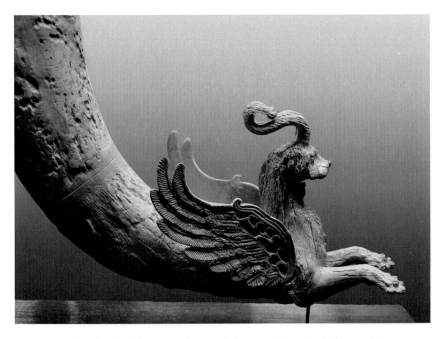

FIG. 10.1 Rhyton, detail, lion-gryphon with horns, Nisa, c. 2nd century BC. National Museum of History, Ashgabat.

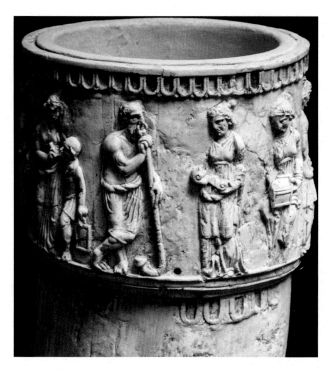

FIG. 10.2 Rhyton, detail, upper part of the rhyton, the lower part of which is shown in Fig. 10.1. The stick, which the man holds, is a 'pedum', a feature that is common in the representation of ancient philosophers in the Hellenistic and Roman west.*
National Museum of History, Ashgabat.

* Pappalardo, E., personal correspondence.

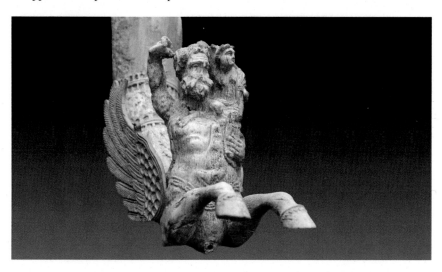

FIG. 10.3 Rhyton, detail, a centaur. On his shoulder, the centaur carries a woman in Greek dress. National Museum of History, Ashgabat.

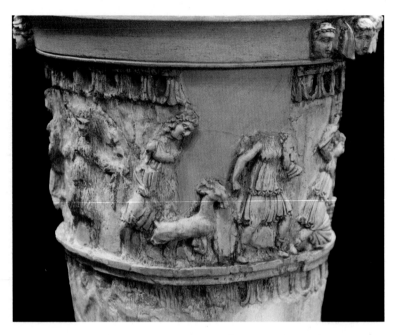

FIG. 10.4 Rhyton, detail, women with a goat. National Museum of History, Ashgabat.

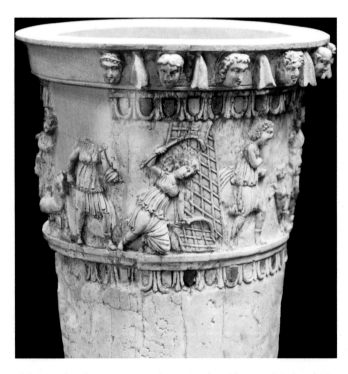

FIG. 10.5 Rhyton, detail, a woman catches animals with a net. National Museum of History, Ashgabat.

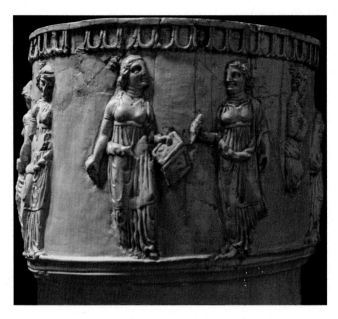

FIG. 10.6 Rhyton, detail, women representing muses – one is holding a stylus, a writing pen, the other a tablet. They represent the 'celebration of literature'. National Museum of History, Ashgabat.

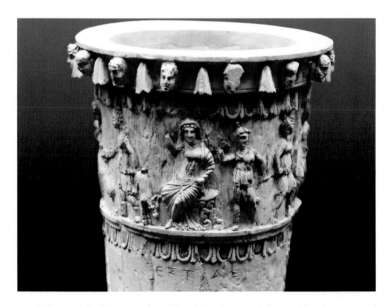

FIG. 10.7 Rhyton, detail, a seated goddess. The name of the goddess is engraved in the lower area: ΕΣΤΙΑΣ (Estias). The drinking horn is dedicated to the Greek goddess Hestia, goddess of the domestic hearth and sacrificial fire.[*] National Museum of History, Ashgabat.

[*] Merkelbach, R., Stauber, J., 2005: p. 64.

FIG. 10.8 Portrait of a bearded man, Nisa. This sculpture possibly represents the Parthian king Mithradates I, who had his royal castle in Nisa. National Museum of History, Ashgabat.

The image of the goddess Hestia (on the rhyton in Fig. 10.7), which is characterised as such in the Greek language, has raised the question of whether the Parthians believed in Greek gods. This problem is dealt with in more detail in Chapter 11. Based on the representation of the goddess Hestia, recent research discusses the extent to which not only a Greek but also an Iranian perspective has to be considered. Fire was a central element in the Zoroastrian faith of the Parthians, and so it is quite possible that the representation of a Greek goddess, the Greek goddess of hearth, who was responsible for the hearth fire, meant a Zoroastrian goddess, also guardian of the fire. Niccolò Manassero states in his latest work that a connection can also be established with the Scythian goddess Tabiti, whom Herodotus equates as 'Queen of Scythians' with the Greek goddess Hestia.[21] Of importance in this context is the fact that the Scythian goddess refers to the divine grace and the royal glory, the *khvarenah* (also *farnah*, *xvarenah* or *hvarnah*), which is given to the king by the *yazatas* (divine beings) at his investiture. The term *khvarenah* is discussed further in 11.1.[22]

10.1.1 The throne of the Parthian kings

The archer seen on the reverse of Parthian coins normally sits on a throne, sometimes with a backrest, sometimes without, and varied by the shape of ornaments.

From findings in Nisa, we know that a royal chair was skilfully carved from ivory (Fig. 10.13). The thrones depicted on the coins are thus shown in a realistic manner.

10.1.2 Small sculptures found in Nisa

Many of the small works of art found in Nisa display a clear Hellenistic style, such as portrayals of the winged sphinx, the goddess Athena, the winged Eros or other small items (see Figs. 10.14–10.21).

Closer investigations reveal that the hatchet in Fig. 10.20 was probably a trophy from a campaign of Mithradates II against nomadic people (Sakas/Tocharians/Yüechi).[23] It was a ceremonial hatchet and probably belonged to a defeated chieftain of the nomadic people. It is believed that the hatchet was produced in the area of Bactria.

10.2 Rock reliefs

Rock reliefs dating from the Parthian period, have mostly been found in the Elymais area, with a few reliefs being found in Bisotun (Iranian Kurdistan). In Bisotun, a rock relief known as the 'Vologases relief' (Fig. 10.22) was found near the eminent rock relief of the Persian king Darius I (the Great) with a trilingual inscription (Behistun inscription).[24] It shows the frontal figure of a king, sacrificing on an altar. Two noblemen, not visible in the photo, are depicted on the sides. Since the man shown wears two daggers, bracelets and a decorated belt as a symbol, he is a king and not a priest. An inscription that is today almost illegible reveals the king's name: Vologases. As we know of several Parthian kings with that name, this Parthian rock relief is difficult to date. Archaeologists put it in the 1st–2nd century AD.

Near this stone is another relief that possibly shows the Parthian king Gotarzes II (c. 40–51 AD). The king is shown with a long lance; above him hovers a Nike, indicating that she gives protection to the ruler (Fig. 4.16). In Hung-i-Nauruzi, in the area of the former Elymais (today's Iran), is another imposing rock relief (Fig. 10.23). A rider is visible on the left side – one suspects that it is Mithradates I because of similarities with the coin portraits. The larger figure wears a longsword; the other three figures are also shown frontally and carry medium-length swords. Possibly the larger figure is the local ruler of the Elymais, Kamnaskires-Orodes.[25] The relief has now been further investigated with laser technology,[26] revealing that the relief was sculpted at different times. This had been suspected earlier, because the riding king is not shown frontally like the other men.

10.3 Stone reliefs

The rock relief in Fig. 10.24 depicts a sacrificial scene: in the centre stands the king of kings, recognisable by the long sword and a diadem. The king draws his right hand over an altar. On the right side of the altar stands a local king of the Elymais, recognisable by the coat rolled up over his shoulder and his Elymean costume.[27] The men to the left of the king wear open coats, while typical Parthian trousers are

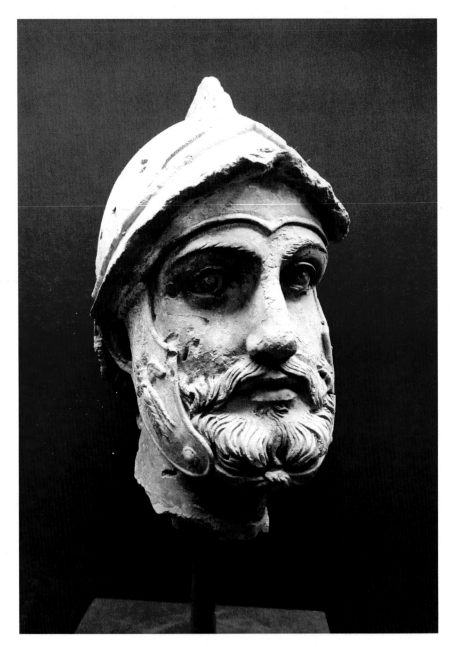

FIG. 10.9 Head of a warrior, sun-baked clay, found in the Square Hall at the Palace of Nisa. The warrior wears an Attic helmet, the cheek-pieces are decorated with a winged thunderbolt and an armed, snake-footed Triton. The work is done in a Hellenistic style. National Museum of History, Ashgabat.

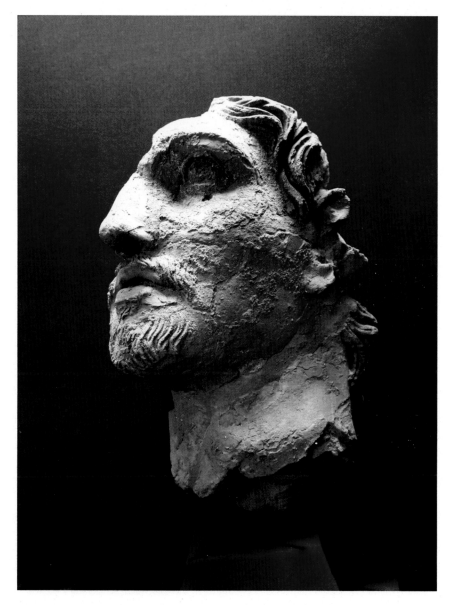

FIG. 10.10 Head of a Parthian. This head also betrays clear Hellenistic influence in its design.* National Museum of History, Ashgabat.

* Invernizzi, A., 2017: p. 277 ff.

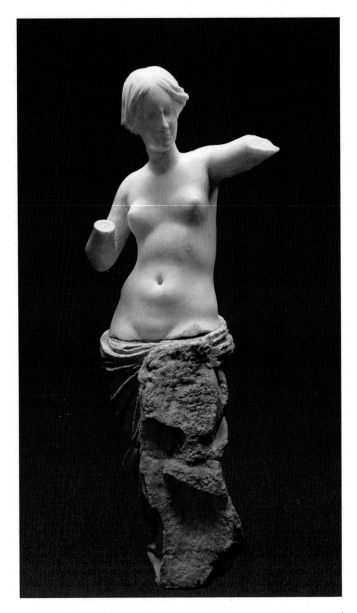

FIG. 10.11 Small figurine of semi-nude goddess (Aphrodite Anadyomene?),[*] marble, found in the Square House at the Palace of Nisa. The hair looks wet, as if the woman has just bathed. The torso is made more vivid by being placed on a separately worked dark-coloured stone, which is local stone, making it clear that the whole work was created in Nisa. Aside from the unusual presentation of the hair, the figure is in the Hellenistic style. The figure is therefore thought to represent the goddess Anahita, the great goddess of the waters.[†] Whether the woman could be Rhodogune, Mithradates' daughter, has also been debated. National Museum of History, Ashgabat.

[*] Ghirshman, R., 1962 (2): p. 38.
[†] Invernizzi, A., 2010: www.iranicaonline.org/articles/nisa.

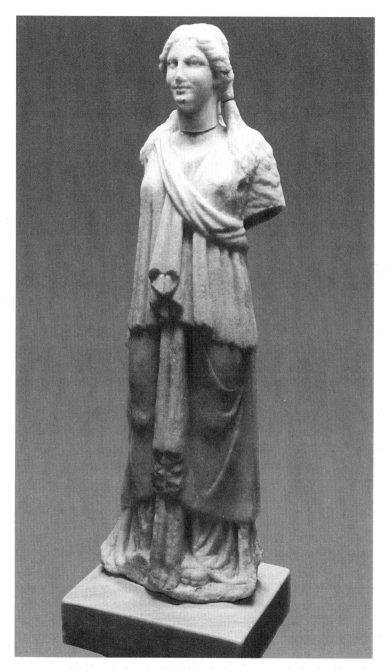

FIG. 10.12 Woman, find spot: Square House, Nisa. The woman, who is executed in an archaising style, is portrayed as Hekate/Artemis or Hestia.[*] It is thought that she could be the goddess Nana, if looked at from the Iranian–Parthian point of view.[†] National Museum of History, Ashgabat.

[*] Invernizzi, A., 2010: www.iranicaonline.org/articles/nisa.
[†] Invernizzi, A., 2010: www.iranicaonline.org/articles/nisa.

FIG. 10.13 Parthian chair leg made of ivory. National Museum of History, Ashgabat.

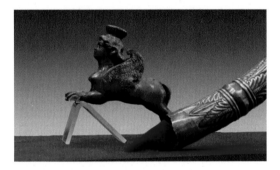

FIG. 10.14 Winged sphinx with the head of a woman. National Museum of History, Ashgabat.

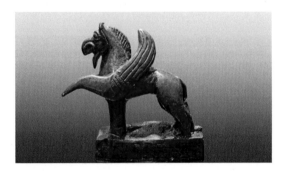

FIG. 10.15 Winged gryphon. National Museum of History, Ashgabat.

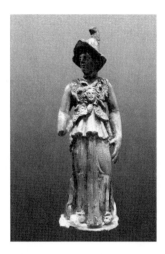

FIG. 10.16 Athena. Although Athena is portrayed in a distinctly Hellenistic style, the question remains whether Parthians may have seen in her a Parthian goddess. National Museum of History, Ashgabat.

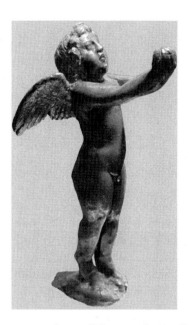

FIG. 10.17 Winged Eros. Even in this small figure a clear Hellenistic influence is visible. National Museum of History, Ashgabat.

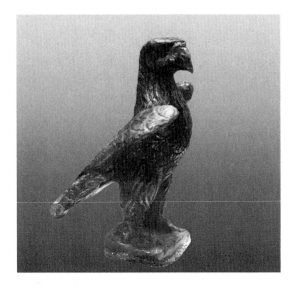

FIG. 10.18 Eagle. National Museum of History, Ashgabat.

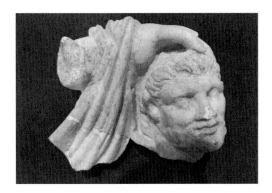

FIG. 10.19 Head of a satyr, Nisa. National Museum of History, Ashgabat.

FIG. 10.20 Ceremonial hatchet, Nisa. National Museum of History, Ashgabat.

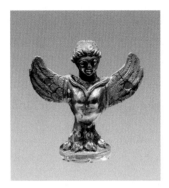

FIG. 10.21 Siren, silver, Nisa. National Museum of History, Ashgabat.

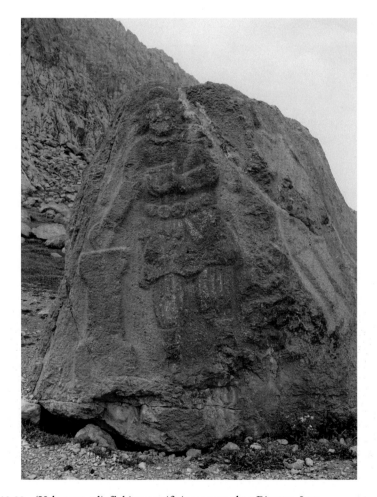

FIG. 10.22 'Vologases relief', king sacrificing on an altar, Bisotun, Iran.

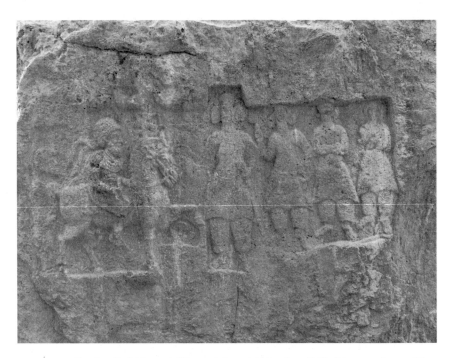

FIG. 10.23 Rock relief, Hung-i-Nauruzi, Iran. Mithradates I (?) rides on a horse. The larger figure with a long sword may represent the local ruler Kamnaskires-Orodes, the other three figures are shown frontally and carry medium-length swords.

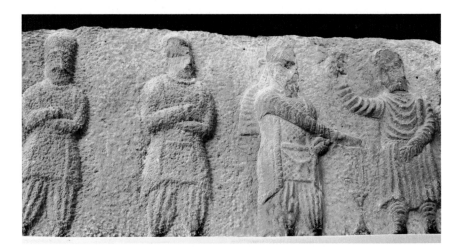

FIG. 10.24 Rock relief, find spot: Bard-e Nishandeh. Sacrifice scene. The Parthian king of kings stands on the left side of the altar, a local king of Elymais to the right. Only four of five persons, who are shown on the relief, are visible in this photo. Reg. Nr. 18835, National Museum of Iran, Tehran.

clearly visible on all the figures. On the right side – not visible in the photo – is a fifth person on this relief.

10.4 Mural painting – frescoes

Some frescoes from the Parthian period have survived (Figs. 10.25–10.28). Most of the paintings were found in Hatra, Dura-Europos, Palmyra and Assur. The fresco found in Dura-Europos depicts a hunting scene in which two wild donkeys are pursued by one rider. The primed Parthian composite bow is easily recognisable. Based on an inscription we learn that the picture was painted in 194 AD. We also learn the names of the painter and the hunter.

FIG. 10.25 Fresco, Dura-Europos, 194 AD. Inv. Nr.: AO 0173310, Louvre, Paris.

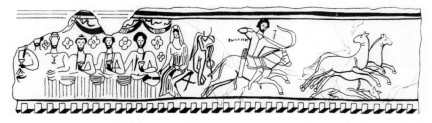

FIG. 10.26 Modern painting of the fresco shown in Fig. 10.25, Dura-Europos, 194 AD. Inv. Nr.: AO 0173310, Louvre, Paris.

FIG. 10.27 Fresco, found in the Temple of Baal at Dura–Europos. The fresco depicts a sacrifice performed by the priest Konon. He wears a long white robe and is pouring something into an oblong vessel standing on the ground from which it seems that steam is rising. It is believed that this fresco dates to 70 AD, when Dura–Europos was under Parthian influence. Based on Franz Cumont, Fouilles de Doura–Europos, Atlas, Table XXXII.

FIG. 10.28 Parthian tomb mosaic from Edessa, early 3rd century AD. The mosaic
depicts a banquet scene. The man resting on a kline – a piece of ancient furniture, a
sort of couch – is surrounded by his wife and his six children, one of them a girl. Like
his sons, he wears typical Parthian-style trousers over which a knee-length garment is
worn. The woman is wearing a local dress with a floor-length robe and a Syrian piece
of headgear, a tantour.*

* Winkelmann, S., Ellerbrock, U., 2015: p. 239.

10.5 Sculptures

The only surviving larger-than-life bronze sculpture from Parthian times is the
figure of the 'Prince of Shami'. It was found in the Temple of Shami in Elymais.
According to recent research, the statue is said to have originated between 50 BC
and 50 AD. The realistic presentation of the clothes worn, as well as of the two
daggers worn on each side, is noteworthy (Figs. 4.22 and 9.12). Another important
bronze sculpture, the bronze statue of Heracles, was found in Seleucia in 1984
(Fig. 11.7 A + B). As this statue is an important testimony to the Parthian religion,
more information is given in 11.1. Also found in Elymais and its capital Susa are
two superbly preserved male heads. The sculptures show a well-groomed haircut
and a carefully tended beard.

FIG. 10.29 Head of a man from Susa, stone, Parthian era (dating is difficult – the range given is between the 1st century BC and the 3rd century AD*), find spot: Royal City of Susa. Fouilles R. de Mecquenem, Inv. No.: Sb 790, Louvre, Paris.

* More details are provided by Mathiesen, H.E., 1992: p. 169.

10.6 Jewellery: torque, earrings, belt buckles and other art

As Parthian coins show, Parthian kings always wore torques (necklaces). They consisted of gold with several spirals (Fig. 10.44). These spirals could end in the depiction of an animal, for example a gryphon, a winged sea monster or a sea horse. Torques have their origin in the nomadic art of the Eurasian steppe.[28] Some kings also wear a segmented necklace with a medallion (Fig. 10.43).

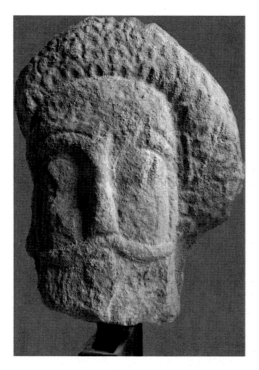

FIG. 10.30 Head of a man, Parthian, find spot: Bard-e Nishandeh, approx. 100 km east of Susa, Iran. Inv. Nr.: Sb 6760, Louvre, Paris.

Parthian rulers wore an earring, which was either simply circular (Figs. 8.4, 4.2 A + B and 9.9), or could also be very elaborate, as in the earring on a coin of Artabanus I (Fig. 10.45). It is astonishing that an earring exhibited in the Metropolitan Museum of Art in New York (Fig. 10.46) is similar to Artabanus I's earring. However, not all the kings show earrings in their coin portraits (Figs. 9.11, 10.43 and 10.44), since hair often covers the ears: e.g. in coins of Orodes II, Unknown King II, Mithradates III and Phraates IV.

Belt buckles (e.g. Fig. 10.48) were found in larger quantities in archaeological excavations, but also bought from art traders, who sold their finds, from illegal excavations, to museums. Thus, we have no knowledge of the find spots. Another belt buckle is shown in Fig. 9.3.

10.7 Parthian vessels – bowls – glass

Like the Achaemenids and the Sasanids, the Parthians also possessed eminent precious metal vessels or glassware for the royal table, of which only very few are preserved (e.g. Fig. 10.54). Terracotta vessels show zoomorphic figures (Figs. 10.56–10.58).

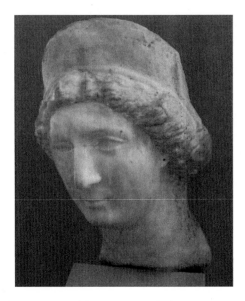

FIG. 10.31 Head of a woman, marble, size: 35 cm, find spot: Susa. It is unclear who this figure portrays. Malcolm Colledge, a British archaeologist, suggested that the marble head depicts the goddess Tyche, as she wears a mural crown. K. Palasca, on the other hand, considers that the crown is different to those with which Tyche is normally adorned, as it has battlements, and therefore attributes this head to a noble woman, which could then be Queen Musa, as had earlier been proposed by Franz Cumont, a Belgian archaeologist and historian (1868–1947).* A Greek inscription was found on the crown: 'Antiochos, the son of Tryas, produced (this sculpture)'. National Museum of Iran, Tehran.

* Cumont, F., 1939: pp. 330–339; Colledge, M.A.R., 1977: fig. 9 a; Palasca, K., 2002: pp. 407–414.

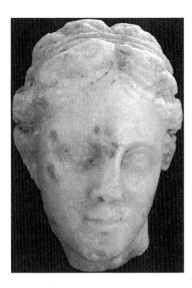

FIG. 10.32 Head of a woman, marble, Parthian era, Susa. National Museum of Iran, Tehran.

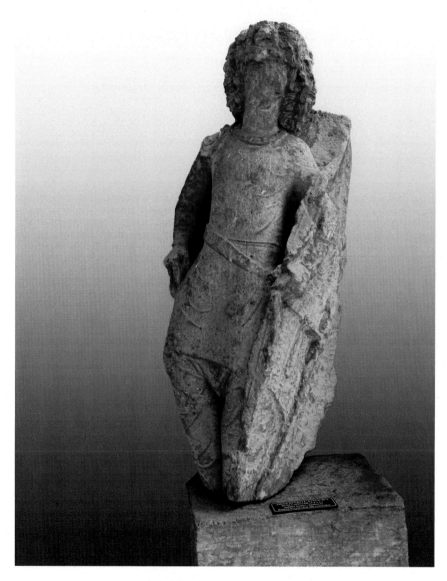

FIG. 10.33 Young noble warrior, Parthian, early 3rd century BC. Parthian sculpture of a young noble warrior with girded tunic, trousers and typical Parthian curly hair, wearing a coat, with a dagger on one side and a longsword on the other. Museum Sanliurfa (antique name: Edessa), Turkey.

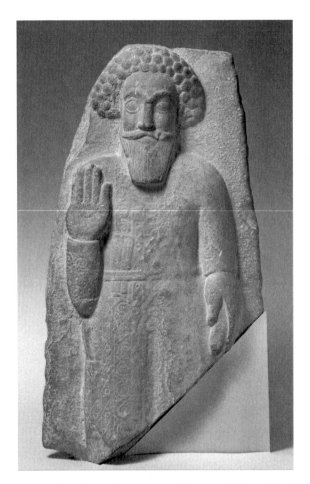

FIG. 10.34 Parthian noble, shown in strict frontality, basalt, dimensions: 76.8 cm × 40.1 cm. Thick spirals form his hair, and he wears a moustache and a broad, square-cut beard. His right hand is raised in a typical gesture; he could be a worshipper. He wears a belted tunic, two items are tucked under his belt, and in his left hand he holds an object. Its significance is not clear. This object was purchased, find spot unknown, but similar images of worshippers are found in Bard-e Nishandeh and Masjid-e-Suleiman, both in the Iranian province of Khuzestan. Metropolitan Museum of Art, New York, Accession Number: 51.72.1.

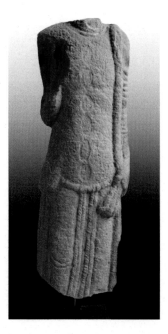

FIG. 10.35 Statue, without head, Masjid–e Suleiman, Elymais, Iran. Inv. Nr.: Sb 7297, Louvre, Paris.

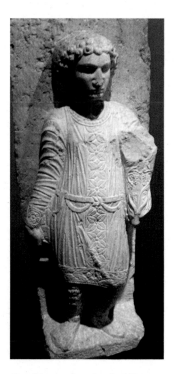

FIG. 10.36 Young man in a Parthian-style robe, holding a cornucopia in his left hand. Sarcophagus lid, find spot: Palmyra. Inv. No. AO 4084, Louvre, Paris.

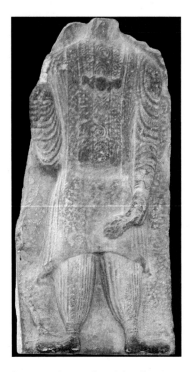

FIG. 10.37 Relief, stone, from Bard-e-Nishandeh, Elymais, Iran. The man is dressed in a tunic and wears typical Parthian trousers; the right hand is lifted, in the left hand he holds an object, which may be a pinecone.* National Museum of Iran, Tehran.

* Compare Mathiesen, H.E., 1992: fig. 27.

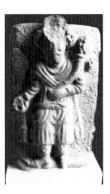

FIG. 10.38 Parthian, sacrificing, Masjid-e Suleiman, Temple of Heracles, Elymais, Iran. In his left hand he holds a cornucopia, a horn of plenty, a symbol of abundance and nourishment. Inv. No.: Sb 7297, Louvre, Paris.

FIG. 10.39 Terracotta relief, Parthian, Susa, 2nd–1st century BC.* This relief depicts a sacrifice scene, which is being performed by a naked woman. National Museum of Iran, Tehran.

* Compare Ghirshman, R., 1962 (2): p. 103, fig. 116.

FIG. 10.40 Terracotta relief, Parthian, Susa, 2nd–1st century BC.* This relief depicts a woman undressing. National Museum of Iran, Tehran.

* Compare Ghirshman, R., 1962 (2): p. 103, fig. 116.

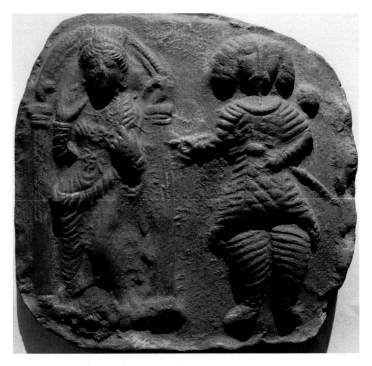

FIG. 10.41 Terracotta cast from a mould, the original dated first half of the 1st century AD, H. 13 cm, W. 12 cm. Tyche (?) with a 'mural crown', her right hand raised in the typical Parthian manner. To her side is a Parthian man in frontal position with typical Parthian trousers, holding a sword in his left hand. Iranian Museum, Hamburg.*

* More details are provided by Mathiesen, H.E., 1992: p. 219.

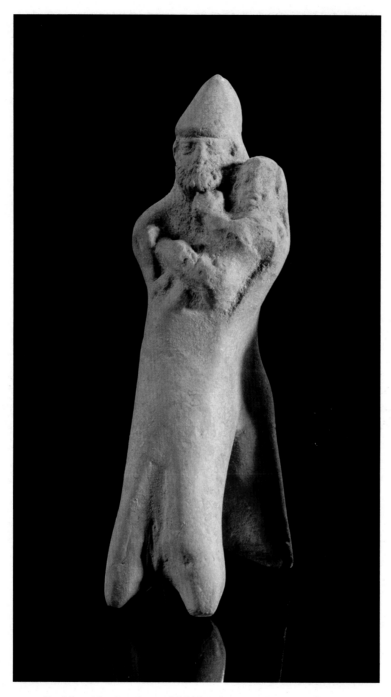

FIG. 10.42 Parthian rider, bearing a child (?) in his arms. Private collection.

FIG. 10.43 Mithradates III, S 40.2. He wears a segmented necklace with a medallion.

FIG. 10.44 Orodes II, S. 48.10, variant. The king wears a necklace, which ends in a seahorse.

FIG. 10.45 Artabanus I (c. 127–124 BC), S 20.1, detail. The king wears an earring.

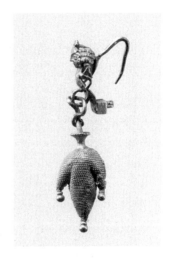

FIG. 10.46 Earring in the form of a three-lobed wineskin, find spot: Mesopotamia, said to be from Nineveh, 2nd–1st century BC. Purchase. The upper part of the earring depicts an Eros-like, winged male youth with long curly hair. Accession No.: 1995.366, Metropolitan Museum of Art, New York.

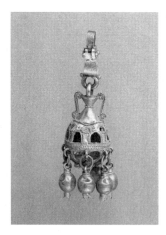

FIG. 10.47 Earring, gold, 1st–2nd century AD. Five pomegranates hang from rings attached to the pendant vase (two are missing). Accession No.: X.94, Metropolitan Museum of Art, New York.

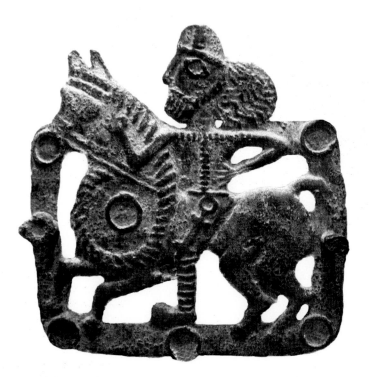

FIG. 10.48 Belt buckle depicting a Parthian riding and wearing a four-lobed dagger on his left thigh. Inv. Nr. 1992,0125.1, British Museum, London.

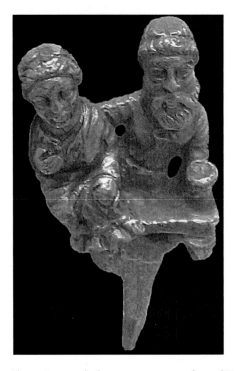

FIG. 10.49 Parthian silver pin, couple, banquet scene at a funeral(?). Inv. Nr. 1990,0625.1, British Museum, London.

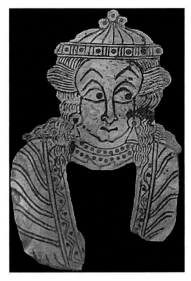

FIG. 10.50 A + B Fragments of an ivory box decoration, find spot: Shami, west Iran. National Museum of Iran, Tehran.

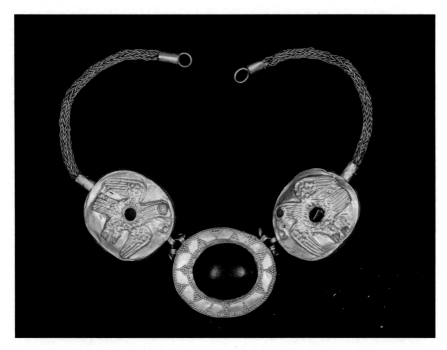

FIG. 10.51 Golden necklace with three oval plaques, Dailaman (?), 1st–3rd century AD. Embedded in the central disc is a dark brown glass stone, the outer discs show an eagle decorated with stones. Inv. Nr. 1965,0215.1, British Museum, London.

FIG. 10.52 Necklace with different gemstones, Parthian era. National Museum of History, Ashgabat.

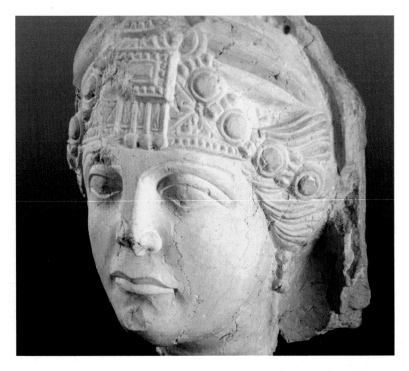

FIG. 10.53 Woman's head, limestone, find spot: Palmyra, Parthian era: mid–2nd–early 3rd century AD. The woman wears typical jewellery familiar from other excavation finds at Palmyra. The resemblance to the jewellery and even the clothing of women from Tillya Tepe (Afghanistan), who were found in tombs there which date back to the Parthian era (1st century AD), is striking. Viktor Sarianidi, a famous Russian archaeologist, has no doubt that there was a cultural connection between Hatra and Tillya Tepe.* Inv. No. 26432, Paris, Louvre.

* Sarianidi, V., 1998: p. 20 ff.

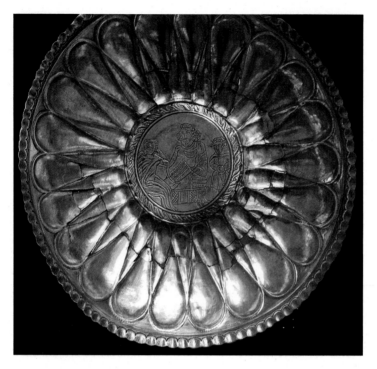

FIG. 10.54 Silver bowl, Parthian. Inv. Nr.: 1968,0210.1, British Museum, London. Compare Fig. 9.7, which shows more detail.

FIG. 10.55 Glass bowl, Parthian era. National Museum of Iran, Tehran.

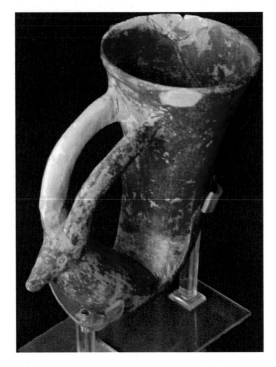

FIG. 10.56 Rhyton, terracotta, Parthian era. National Museum of Iran, Tehran.

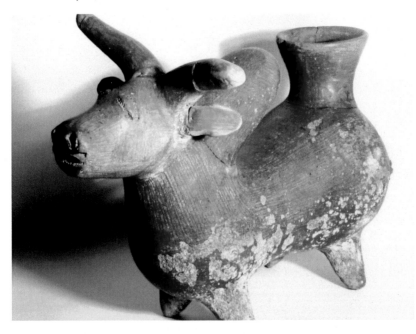

FIG. 10.57 Zoomorphic vessel, Parthian, 1st century BC–2nd century AD, find spot: Region d'Ardebil (Azerbaijan/or Iran). Louvre, Paris, Inv. No.: from Rabenau 1680.

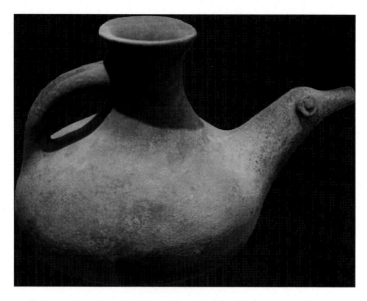

FIG. 10.58 Zoomorphic vessel, shaped like a bird, Parthian, Iran, 2nd century BC–2nd century AD. National Museum of Iran, Tehran.

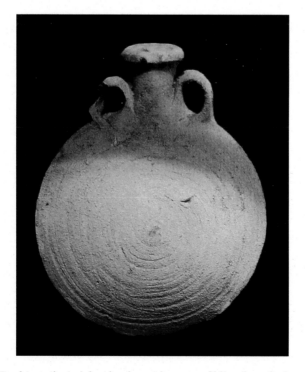

FIG. 10.59 Parthian pilgrim's bottle, clay with traces of blue glaze, find spot: Tella Meaïn (Mesopotamia), end of 2nd century BC–beginning of 3rd century AD. Inv. No.: AO 30115, Louvre, Paris.

FIG. 10.60 Jug with typical blue-green glaze, Parthian era, Iran. National Museum of Iran, Tehran.

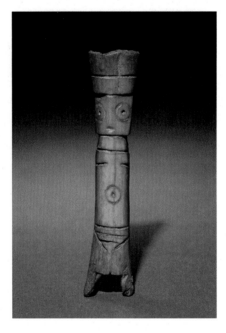

FIG. 10.61 Amulet (?), naked woman, carved bone, height: 10.2 cm, Parthian, c. 1st–2nd century AD. Joint Expeditions-Iraq Excavations Fund 1933.176. Cleveland Museum, Ohio.

Notes

1 Rostovtzeff, M.I., 1935.
2 Ghirshman, R., 1962 (2): p. 17.
3 Ghirshman, R., 1962 (2).
4 Colledge, M.A.R., 1977: p. 139.
5 Hauser, S.R., 2014: 127 ff.; Colledge, M.A.R., 1977: p. 144.
6 Hauser, S.R., 2014: p. 156.
7 Hauser, S.R., 2014: p. 131.
8 Jacobs, B., 2014: p. 129 ff.
9 Jacobs, B., 2014: p. 4.
10 Hauser, S.R., 2014: p. 127.
11 Jacobs, B., 2014: p. 97.
12 Dirven, L., 2009: p. 46 ff.
13 Hauser, S.R., 2014: p. 130 f.
14 Jacobs, B., 2014: p. 95.
15 Black, J., 2018: p. 14 ff.
16 Pappalardo, E., 2010: p. 303 ff.
17 Black, J., 2018: p. 21 ff.
18 Invernizzi, A., 2013: p. 99.
19 Black, J., 2018: p. 24.
20 Dirven, L., 2013 (2): p. 632 ff.
21 Manassero, N., 2016: p. 5 ff.
22 Curtis, V.S., 2007 (3): p. 422 ff.
23 Nikonorov, V.P., 2013: p. 179 ff.
24 Vanden Berghe, L., 1984, pp. 118–125; Mathiesen, H.E., 1992, figs. 1–26.
25 Dąbrowa, E., 1998: p. 420 f.; Jacobs, B., 2010: p. 44 f.
26 www.parthia.com/khuzistan/khuzistan2008.htm.
27 Winkelmann, S., Ellerbrock, U., 2015: p. 242.
28 Winkelmann, S., Ellerbrock, U., 2015: p. 266.

11

THE PARTHIAN EMPIRE AND ITS RELIGIONS

As for other fields of Parthian culture, we lack significant sources of information regarding Parthian religions and religious practices.[1] The few statements that we have from the later period of the Sasanids should be interpreted with caution. This applies equally to reports from Greek, Roman or other sources. According to the current state of research, our knowledge of Parthian religion is extremely incomplete, and the sources available for it give rise in part to different evaluations.[2] It is therefore scarcely possible to make definitive statements about the beliefs shared by the Parthian kings or the normal population, or what any distribution of religious affiliations might have looked like. Nevertheless, various hints reinforce the assumption that the Parthians adhered to the Zoroastrian faith.

Before we go into the question of what evidence there is to assume the Zoroastrian faith was practised by the Parthians, we first provide an overview of the origin and development of Zoroastrianism.

11.1 An overview of Zoroastrianism and the Avesta

The religious founder of Zoroastrianism was Zarathustra (Greek: Zoroaster), who received a revelation from the supreme god Ahura Mazda. The exact dates of his life are unknown. It is believed he lived between 1800 and 600 BC, but many experts consider that he was born in the mid-2nd millennium BC[3] and probably lived in southern Central Asia, in Bactria.[4] Initially, the contents of the faith were passed on orally. It was only in the Achaemenid era that they were fixed in writing. Unfortunately, these texts were lost (see p. 256). The earliest written collection of Zoroastrian religious texts that we have are found in the Avesta, written in the 13th–14th century AD.[5] The Avesta consists of two different groups of texts, known as the Old and Young Avestan, clearly to be distinguished by linguistic research. The Old Avestan predates the Young Avestan considerably. The scriptures of the Avesta

contain the teachings of Zarathustra, with Ahura Mazda, the founder of the world, at the centre.

The Avesta is written in the language of the early Zoroastrians, Avestan. It is thus the earliest document of any Iranian language.[6] The Avestan is closely related to the Vedic language, which is found in the Vedic texts, an important source for the Hindu tradition. From the birth of the faith its rituals were transmitted orally, so by the time it was written down almost 2000 years had passed, during which changes inevitably occurred. These changes concerned not only the transmission of the ritual texts but also the rituals themselves. Understanding the rituals became increasingly difficult, even for the priests who had learned Avestan. It therefore became necessary to make the texts understandable for the priests. Thus, the texts of the Avesta were translated into Middle Persian or Pahlavi. This is how the so-called Pahlavi books came into being. Written in various Middle Iranian languages (such as Middle Persian, Parthian, Sogdian and Bactrian; see 9.1), they contain not only translations of the Avesta but also supplementary texts, which are significant for an exegesis. These are known as the *Zand*, meaning knowledge. The texts can be attributed to the 9th century AD. They were thought to derive from commentaries based on the Avestan scripture, but in its existing form the *Zand* contains no Avestan passages.[7] Access to the books was restricted to priests only, whereas lay Zoroastrians continued to learn the Avestan texts by heart.[8]

The *Dēnkard*, also part of the Pahlavi books, is a compendium of Zarathustra's life and Zoroastrian beliefs and customs The texts can be attributed to the reign of Khosrow I. Unfortunately, they afford us no reliable view on the Zoroastrianism practised in Sasanid times. It is still difficult to ascertain at what time which changes occurred, as a lot of information is missing. Furthermore, the texts are difficult to understand and leave room for different interpretations.[9]

The *Gathas*, hymns belonging to the Old Avestan, contain ritual texts in a poetical form. The *Yasna* are a collection of hymns of the Young Avestan that are addressed to the principal deities. They contain myths that begin with the creation and order of the world by Ahura Mazda, embrace the current semi-chaotic world, and end with the healing of the world. Many of these myths are from the time before Zarathustra. The *Yasna* include the *Yashts* (= *Yašts*, hymns), which are a collection of liturgical texts used in Zoroastrian rituals in the preparation and offering of *haoma* (see 11.1.2). The *Yashts*, which contain 21 hymns, are the longest subtext of the Avesta. A part of the more recent Avesta is the *Videvdat*, which includes texts and instructions for healing and purification ceremonies, to keep *daevas* (bad gods) away, but also contains rules for food laws and punishments.[10]

Linguistic analysis indicates that the oldest parts of the Avesta, the Old Avestan, probably date to the time of Zarathustra himself or, more likely, come from his successors. Parts of the Young Avestan date to the late Achaemenid period or even to the beginning of the Seleucid era.[11] These texts, not always easy to translate or even to understand, make interpretation of the belief especially challenging. A basic and important understanding of Zoroastrianism was made by the research of Mary Boyce, who edited three important works on the religion: *A History of*

Zoroastrianism, Vols. 1–3. A lot of further research has been done since then. One standard work today is the *Companion to Zoroastrianism*, published in 2015.[12]

Until the beginning of the Achaemenid Empire there was no written deposition of the contents of the faith. In the Achaemenid period, the Avesta certainly spread further in Iran, which is likely to have continued in the Parthian Empire. Under Alexander the Great, the most important written records of the Avesta were destroyed, as we are told by ancient writers, but were later reassembled by using pieces of text that had been preserved in writing or had been transmitted orally.[13]

According to the *Dēnkard*, there is evidence that in Parthian times the Avesta was rewritten under Vologases I (c. 51–79 AD). This presumably later became the basis for the Sasanids, when Zoroastrianism was introduced as the state religion. Even today, this religion has over 120,000 followers, mostly in Iran and India. One of the most important basic principles of Zoroastrianism is the demand to think well, to say well and to do well. Before going into the evidence of a Zoroastrian faith among the Parthians, a brief overview of the concept of Zoroastrianism is given.

11.1.1 The religious concept of Zoroastrianism

On the one hand, Zoroastrianism involves a religious concept in which beliefs are linked to specific acting gods, such as Ahura Mazda, who created the world. On the other hand, it contains universally valid principles, such as 'good' or 'evil'. Aša is a key word in the Old Avesta, meaning 'truth', but it is also connected with fire. It is a cosmic principle responsible for order in the world. The religion's principles are primarily not directly associated with a deity, but even gods can have such positive or negative characteristics.

This becomes clear in the Zoroastrian pantheon, a term based on Greek and Latin sources, which embodies divine principles such as 'truth' or 'proper behaviour towards other people', but also gods.[14] In this pantheon, Ahura Mazda is the supreme deity, the spirit that created the sky, the sun, the moon and the stars, as well as the earth, the people, animals and plants, and water. This story is very similar to the creation myth told in the Bible, and researchers have pointed out that there are most likely close ties here. Ahura Mazda's features are omniscience, kindness and creativity. The pantheon is made up of Ahura Mazda, Amesha Spenta, Anahita, Mithra and 'other individual gods or ideas'.[15] To the latter belong the god Verethragna, the idea of the *khvarenah* (see 11.1.10), but also the god Tistrya (Tiri), symbolising the star Sirius, and Travasis, the spirit of the dead. The Amesha Spenta embodies the seven benevolent immortals; they have the same good thoughts, speak the same words and do the same deeds. They are responsible for the humans, the earth, the animals, the plants, the metals, the water and the fire.

Like good, evil is found in the world. Although this basic idea can already be found in the Old Avesta, it is mainly highlighted in the Pahlavi books.[16] Ahriman is the adversary of Ahura Mazda, he embodies evil (see Fig. 4.10) and is the chief of all the *daevas*. The *daevas* are mentioned in the Young Avestan; they form a group of several gods with negative attributes. A central issue in Zoroastrianism is that, in

our world, goodness competes with evil. In the Zoroastrian creation myth, in the first phase, the 'good' Ahura Mazda inhabits the light and the 'evil' Ahriman inhabits the dark, both initially separate from each other. In the second phase, in our world, these forces of good and evil intermingle with each other. Man as the creature of Ahura Mazda must choose between good and evil, so the outcome of the struggle between Ahura Mazda and Ahriman lies in the hands of men. After death, the good go to heaven and the bad go to hell until they have atoned for their sins. In the third phase, when the good in the world has triumphed, a virgin gives birth to a Redeemer whose task is to finally liberate the world from all evil. The dead will then be resurrected. Parts of this creation story are very similar to that of the Christian faith, as researchers have confirmed.

Scientists have discussed intensively whether Zoroastrianism is a monotheistic, dualistic or polytheistic religion. As Ahura Mazda is the supreme god, this would point to a monotheistic view. But with Ahriman as Ahura Mazda's evil counterpart, it could be considered a dualistic system. But then there are the other gods, suggesting a polytheistic religion. It would be almost impossible to enumerate all the arguments, but Almut Hintze concludes in her article 'Monotheism of the Zoroastrian Kind' that all three elements are necessary and present in this religion.[17]

11.1.2 Magi – priests of the Medes – the wise men from the east

One of the most well-known texts of the New Testament is the journey of the wise men from the east who go to Bethlehem to pay homage to Jesus, bringing with them gifts of gold, frankincense and myrrh. The Greek text (Matthew 2:1 to 2:2) speaks of 'magoi', which has been translated as 'the wise' or 'magicians':

> Now when Jesus was born in Bethlehem of Judaea in the days of Herod the king, behold, there came wise men from the east to Jerusalem, saying: Where is he who is born King of the Jews? For we saw his star in the east, and have come to worship him.

It was only in the 3rd century AD that the wise men were reinterpreted as the Three Magi, and their names Caspar, Melchior and Balthazar were not given until the 6th century AD (Fig. 11.1). So, if the story of the wise men from the east was to have a historical background and they moved from the east to Bethlehem, they came from an area that at that time corresponded to the Parthian Empire.

Four hundred years earlier, Greek texts from the 4th century BC spoke of the 'magoi', the Magi, meaning Zoroastrian priests. The term 'magoi' has a direct relationship to today's term 'magician'. Zarathustra is also called a magician. The magicians, however, have a much older story. The term 'magician' comes originally from the Medes or 'Madai',[18] because members of the median priestly caste bore that name (see 2.2). The Magi were priests with several different functions. On the

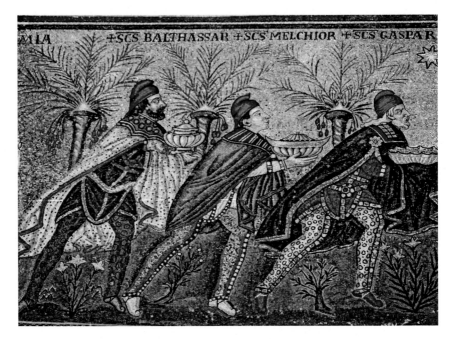

FIG. 11.1 The Three Magi, Byzantine mosaic, c. 565 AD, Basilica of Sant'Apollinare Nuovo, Ravenna, Italy (restored during the 18th century). Here, the Magi are shown in typical Iranian trousers, wearing typical Phrygian caps.

one hand they were responsible for interpretation of the royal dreams. On the other hand they were said to have skills in divination – by looking into a fire, they were able to tell the future.[19]

In their priestly function, the Magi performed their rituals in the open air, using a barsom, a bundle of sacred twigs wrapped in palm leaves.[20] These bundles of barsom might have symbolised growth or even of immortality. Presumably, the drug *haoma* was also used, where herbs with hallucinatory effects were added to a sacred fire. It is also thought that they brewed drinks that had such effects.

11.1.3 Zoroastrianism in Achaemenid times

The current religious studies of Iranian history continue to discuss intensively and sometimes controversially what religious beliefs the Achaemenid kings shared, what kind of religious policy they pursued, and whether they were Zoroastrians and how they practised their religion.[21] The Magi must have played an important role in the Achaemenid Empire. As related by ancient writers and confirmed by Elamite sources, we are informed that the Magi were responsible for guarding the tomb of the Achaemenid king Cyrus at Pasagardae.[22] The start of the Zoroastrian calendar, which replaced the Babylonian calendar, is further proof that Zoroastrianism spread in this period. However, it is safe to assume that Zoroastrianism in its original form

underwent transformations in the time of the Achaemenids, such as the inclusion of the Spring Festival (Nowrūz). Clear evidence exists to suggest that the culture of the Elamites (see 2.1), but also of the Medes and their priests, the Magi, influenced the Zoroastrian belief of the Achaemenids.[23]

We at least know that the Achaemenid king Darius preferred the Iranian god Ahura Mazda, from whom he hoped for significant political support.[24] Later, the importance of Ahura Mazda seemed to fade, when Artaxerxes II preferred the goddess Anahita, who thus became the most important goddess in the Empire.[25] Despite extensive archaeological exploration, no temples to the cult of Anahita dating to Achaemenid times have yet been found in Iran.

The aforementioned transformations might have influenced the fire temple cult in the later empire, a cult that did not exist at the beginning of the kingdom. This could have been the period when fire temples were introduced into the Achaemenid Empire. Albert de Jong, a leading researcher into Zoroastrian religion at the University of Leiden, writes:

> Priests who were opposed to the unheard-of (and foreign) practice of cult statues would have responded to this by developing a variety of temple cults that would be acceptable to Zoroastrians. This suggestion has not been widely adopted, but it remains the only hypothesis to have been put forward to explain the origin of fire-temples.[26]

11.1.4 References to the Zoroastrianism of the Parthians

Without a doubt, it must be assumed that the religions of the Achaemenid and Seleucid kingdoms exerted an influence on religious development in the Parthian kingdom. A multitude of religions existed side by side in the Parthian Empire. Crucial to the scientific discussion is the consensus that the Parthians practised religious tolerance during their reign, which included many areas and people of diverse cultures.[27] They accepted and tolerated the different religions in the newly conquered territories. Thus mutual influence between the religions is considered assured. Three important groups of peoples can be distinguished who lived in the Parthian Empire, the Iranian, the Semitic and the Greek tribes, and it can be assumed that each of these groups adhered primarily to their own religious orientation.[28] An example of Babylonian faith in the Parthian era might be seen in the goddess Ishtar, who is possibly depicted in certain small figurines (Fig. 11.2).

We know nothing about the original faith of the Parthians that existed before the beginning of their empire, but it is believed that they were polytheists. While in the west Babylonian gods (Fig. 11.2), Judaism and later Christianity competed with the postulated Zoroastrian faith practised by the Parthians, the picture in the east was different again. The Zoroastrianism practised there had been in contact with the Greek religion ever since the conquest of Alexander the Great. The two influenced each other. Further influence on the Parthian faith may have come from Buddhism, which spread in the Kushan kingdom no later than the middle of the

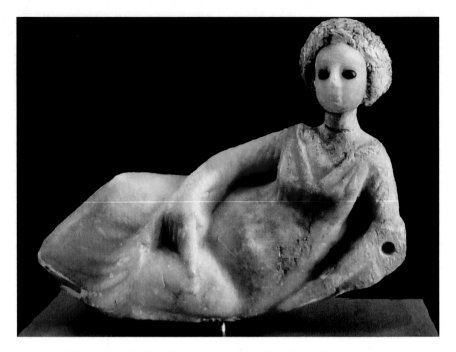

FIG. 11.2 Woman in a half-reclining position, possibly the goddess Ishtar, Mesopotamia, Parthian period, c. 3rd century BC–3rd century AD. Inv. No.: AO 20130, Louvre, Paris.

2nd century AD.[29] So, we can only guess how complex the religious changes may have been in the Parthian Empire and its neighbouring countries, especially if we take into account the long-lasting influence of the nearly 500-year-old Parthian Empire.

An overview is given below of hints at the existence of a Zoroastrian faith in the Parthian kingdom. These include, for example, archaeological finds, the representation of gods on coins and the use of the Zoroastrian calendar. Also of significance are the religious changes and references to the Zoroastrian faith in Parthian vassal states, such as Commagene. We do not have much information from Parthian times about the Magi and their function. At least in the first half of the existence of the Parthian Empire, the Magi were part of the royal council (synhedrion) mentioned by Strabo,[30] which could select or confirm the new king. Thus, the Magi exercised political influence, but this influence seems to have diminished in the second half of the empire.

The fact that the Sasanians introduced Zoroastrianism as the state religion clearly shows that Zoroastrianism must have existed in the Parthian Empire. The most important question, however, is whether the beliefs of the Parthians and Sasanids were equal or similar. De Jong assumes that the Zoroastrianism known by the Sasanians may well have differed from the Parthian-Zoroastrian faith, but with the

current finds, a more accurate picture cannot be drawn.[31] Zoroastrian names for months were used on ostraca excavated in Nisa. The oldest written date was c. 100 BC, the most recent from the year 12 AD.[32] The use of a Zoroastrian calendar is a further indication that Zoroastrianism in the first phase of the Parthian Empire, at least in Nisa and the Parthian heartland, may have played a key role, and that the kings and the Parthian elite believed in the Zoroastrian faith. The structure of the Parthian dynasty, which had gained more and more power over time, was probably crucial to the spread of Zoroastrianism.[33] Elements of Zoroastrian faith are also found in the epics attributed to the Parthians. This applies in particular to the Hymn of the Pearl, which is discussed in more detail in 9.2.1.

In the search for the faith of the Parthians, changes of religion in the Parthian vassal states or in states under Parthian influence also need to be examined. Helpful in this case are investigations into belief in the gods in Commagene, where, from 65/ 64 BC, a syncretism between Greek and Zoroastrian gods can be proven (see 5.2). There, the god Mithra is shown together with Antiochus I, king of the Commagene (Fig. 11.4). More information about the equating of Mithra with the god Apollo is given in the next section. In addition to Mithra, Anahita and Verethragna, the most important deities in Zoroastrianism in Parthian times were the goddesses Nana and Ardochscho, which will be discussed in more detail below.[34]

The study of Armenia in pre-Sasanian times reveals that there was an abundance of temples, dedicated to different Zoroastrian gods: Aramazd (= Ahura Mazda), Anahit (Anahita), Tir (the scribe of the gods) and Vahagn (= Verethragna). After the fall of the Parthian Empire, the Sasanians conquered Armenia and tried to establish their version of Zoroastrianism, which was in many aspects different to the former Armenian Zoroastrian belief. From the existence of these temples, de Jong states, 'we know more about Parthian Zoroastrianism than we do from anywhere else'.[35]

11.1.5 Mithra

Mithra is portrayed as the sun god and a keeper of contracts, a function he already held in the ancient Indian Vedic religion (Figs. 11.3 and 11.5). As guardian of the law, he protects the law and punishes those who break it. He brings victory and prosperity to the righteous. The Indo-Iranian god Mithra is also a god of soldiers and men's friendship. He is depicted as a warrior and drives a chariot. Mithra is also linked with the *khvarenah*, as Zoroastrian texts reveal.[36] Of particular interest is the legend according to which Mithra was born on 25 December in a rock cave. Caves, rocks and rivers were therefore sacred to the Zoroastrians. Because of this coincidence of date, the mention of a birth grotto and other parallels, theologians have suggested that the story of the birth of Jesus on 25 December replaced that of the birth of the sun god Mithra.[37]

The finds in Commagene in Nemrud Dagh (Turkish: Nemrut Dağı, see 5.2) already mention the syncretism that existed between Greek and Iranian gods. Importantly, in a first phase, the gods depicted there received only their Greek names: Zeus, Apollo and Artemis. In a second phase, from about 65/64 BC, figures

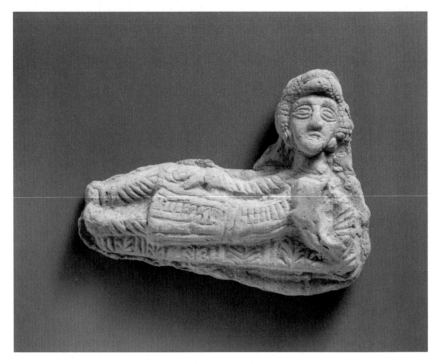

FIG. 11.3 Terracotta representation of a reclining Parthian, Iran or Mesopotamia, c. 1st century BC–1st century AD. Dimensions: 10.16 × 13.34 cm. Gift of E.S. David, 1955. Accession Number: 55.162.2, Metropolitan Museum of Art, New York. A similar terracotta with a reclining Parthian, which contains an inscription honouring the god Mithra, is presented in the British Museum, London, Inv. Nr. 1928,0716.76; c. 1st century BC–1st century AD.

Note: https://research.britishmuseum.org/research/collection_online/search.aspx.

then received Graeco-Iranian double names (Fig. 5.3). Thus, Zeus was equated with Ahura Mazda (Oromasdes, also written Oromazdes), Heracles with his Iranian counterpart –Verethragna. Mithra found his Greek equivalent in the sun god Helios as well as in Apollo and the god Hermes. In inscriptions, all four names are set in parallel: Mithra–Apollo–Helios–Hermes. With the introduction of Ahura Mazda, Mithra and Verethragna, the influence of the Zoroastrian faith becomes clear. In Bactria, Mithra appears as Mirh.

The name Mithradates as well as Mithradatkart (for the royal residence of Old Nisa) also supply clear reference to the god Mithra. A Parthian inscription, honouring the god Mithra, which was found on a clay tablet, can also be taken as evidence of a connection to Zoroastrianism (Fig. 11.3) in Parthian times. The worship of Mithra and the practice of Zoroastrianism continued in the Sasanian Empire. An example of this is the relief that depicts King Ardashir II (379–383 AD) with the god Ahura Mazda, who stands on the right and hands him the ring

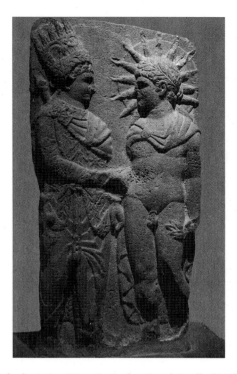

FIG. 11.4 Relief stele depicting King Antiochus I and Apollo/Epekoos, find spot: Sofraz Köy. Archaeological Museum, Gaziantep.

Note: Wagner. J., 2012: p. 50. Although this relief bears no inscription equating Apollo with Mithra, Helios or Hermes, the representation with the crown of rays very closely resembles the relief at Seleucia on the Euphrates (Zeugma) (Wagner, J., 2012: fig. 55).

of power, while behind the king the god Mithra is depicted with the sun wreath (Fig. 11.5).

11.1.6 Anahita

Anahita (Ardivi Sura Anahita) was already worshipped in Indo-Iranian times. In Asia Minor she was the best-known goddess of the Persians.[38] She is the goddess of fertility, for men and women alike. Considered the source of life,[39] the goddess was called on by her warriors for help when they went to battle. She is described as very young and pretty. In the Avesta, a whole chapter of the hymns is devoted to Anahita (Yasht 5). Anahita is equated with several other goddesses, such as the goddess Aschi (also written Ashi, see 11.1.8), but also the Greek goddess Artemis and Athena, the Greek goddess of war. The Mesopotamian goddess Ishtar, known to us as the goddess of love but also the goddess of war, also has features in common with Anahita. It is difficult to answer the question of what significance

FIG. 11.5 Investiture of the Sasanian king Ardashir II (379–383 AD), rock relief, Tag-e-Bostan, Iran. Mithra, with the sun wreath, played an important role in the religion of the Sasanids.

the goddess Anahita really had in the Parthian kingdom. On this, see the discussion on the figurine of a semi-nude woman found in Nisa, who could represent Anahita (Chapter 10, Fig. 10.11).

11.1.7 Nana – Nanaia

The goddess Nana – Acadian spelling: Nana-a (a) – is a Central Asian goddess, who originated in Uruk and was also worshipped in Susa from the middle until the end of the 3rd millennium BC. Her increasing influence to the east as far as Bactria may have taken place at the time of the Oasis culture (also called BMAC = Bactria-Margiana Archaeological Complex) around 2200–1700 BC.[40] This goddess Nana should not be confused with the Sumerian goddess Inanna/Ištar (also Ishtar, this is the Acadian name), who is often depicted standing on lions and who was also worshipped in Uruk.[41] There are essential relationships between the two goddesses. Like Ishtar, Nana is a goddess of love and fertility, and – like Ishtar – also displays the attributes of a goddess of war. Likewise, she shares with Ishtar the astral relation to the planet Venus. Over time, Nanaia, as she is named in Parthian documents, became the most important Zoroastrian goddess in Central Asia and was closely associated

with the kingdom. In Parthian times, a temple dedicated to her is mentioned on an ostracon from Nisa, and her name is also found in Parthian names.

However, in Parthia there are only a few references to the goddess Nana, while in the Sogdian neighbouring language 'Nanai' is one of the most popular elements.[42] King Kanishka I (c. 101–110 AD) obtained his kingship not only from Nana, but also from other gods. His successor Huvishka even calls her 'royal Nana' and kneels in front of her, as a coin shows.[43] She is mentioned and depicted by name on coins of the Kushan kingdom.

11.1.8 Ardochscho (= Ashi)

The goddess Ardochscho, who was worshipped in the Kushan Empire, was the goddess of fortune, and she corresponds to the Zoroastrian goddess Ashi, the daughter of Ahura Mazda.[44] Iconographically, she resembles the Parthian Tyche, as she likewise is represented on Kushan coins with a cornucopia. The cornucopia also suggests an essential relationship with the Zoroastrian goddess Anahita and the Roman goddess Fortuna.

How many syncretistic influences existed at the time can be seen from the connection between Ardochscho and the Indian goddess Lakshmi, as comparisons with Indian coins demonstrate.

11.1.9 Verethragna – Heracles

Verethragna is another important Zoroastrian god. He is a god of war, a symbol of power (also sexual) and of victory as well as a protector of the royal dynasty. From Commagene we learn that Verethragna can be equated with Heracles and Ares, the god of war, as inscriptions reveal (Fig. 11.6).

Of outstanding importance is the bronze Heracles statue found in Seleucia/ Tigris in 1984 (see Fig. 11.7 A + B).

Three reasons make this statue a special archaeological find: firstly, it contains the only Greek-Parthian inscription known to us; secondly, the inscription refers to a historical event (written documents from the Parthian Empire referring to an historical event are extremely rare); and thirdly, it gives us an insight into Parthian belief, as the names of gods used either in Greek or Parthian languages differ.

The Greek-Parthian bilingual inscription names a historic event (150/151 AD): the victory and the expulsion of Miradate (Meredat), king of Characene (c. 130/ 131–150/151 AD) by the Parthian king Vologases IV. After this victory, the Parthian king ordered this statue be brought to Seleucia and placed in the temple of Apollo.

The Greek text on the legs reads as follows:

> In the year 462, as the Greeks count [year 462 = Seleucid Era = 150/151AD] the king of kings Arsaces Ologasos [in Parthian: wlgšy MLK = king Vologases IV, c. 147–191 AD], the son of Miradates [in Parthian: mtrdt = Mithradates], made war in Mesene against king Miradates [= Meredat of Mesene], son

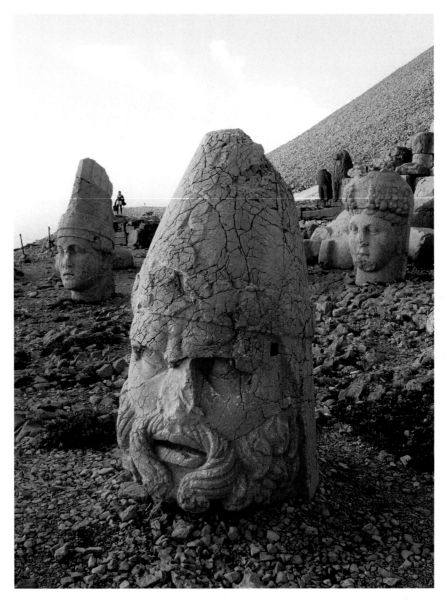

FIG. 11.6 Nemrud Dagh, Head of Heracles, who is equated with Ares, the god of war and thus also to be identified with Verethragna.

of Pacorus, who had reigned before him, and after having banished king Miradates from Mesene, he became king of the whole of Mesene, and this bronze image of the god Hercules, that he had carried from Mesene, he dedicated to this temple of the god Apollo, Hercules now standing before the bronze door.

According to the Parthian text, the bronze image of the god is dedicated to the Zoroastrian god 'Verethragna', whereas the Greek text speaks of Heracles. The same difference applies to the name of the temple: in the Parthian text the temple is dedicated to the Zoroastrian god 'Tir',[45] the god of the star Sirius (note: Tir is part of the name of the Parthian king Tiridates). In the Greek text the temple is dedicated to the god Apollo. The bilingual inscription thus reveals the syncretism of Hellenistic and Parthian Gods and that the Greeks saw their deities in the images of gods, while the Parthians associated them with their beliefs.

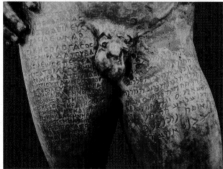

FIG. 11.7 A Bronze Heracles statue found in Seleucia on the Tigris in 1984. Height: 85.5 cm.

FIG. 11.7 B Detail of Fig. 11.7 A. A Greek–Parthian bilingual inscription is found on the thighs of this bronze statue of Heracles. The Greek inscription speaks of Heracles, while the Parthian inscription calls him Verethragna.

A Hellenistic relief, possibly showing Verethragna, (Fig. 11.8), depicts a bearded man (god), who has attributes of the god Mercury, as he is depicted with winged legs and a bag in his hand.

The importance of Verethragna in the Parthian kingdom is further underlined by the considerable number of personal names associated with the name Verethragna.

In the Zoroastrian calendar we find the name Bahram, which is the equivalent to Verethragna, to which the 20th day of the month is dedicated. The importance of Zoroastrianism in the Sasanian kingdom is further underlined in the use of this name by kings, such as Bahram I, son of the first Sasanian king Shapur I, and some of his successors. Other syncretic references can also be found. Thus, we know about the equation of Verethragna with Ares, the Greek god of war, as can be demonstrated from the inscriptions in Commagene. Another connection between the Roman god of war Mars, who corresponds to the Greek god Ares, and Verethragna can be found in the astronomical writings of the Sasanids – for example, the planet Mars is named Bahram here.

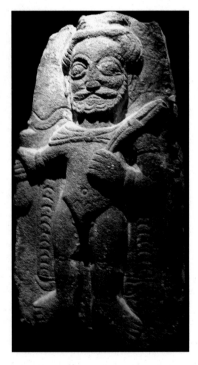

FIG. 11.8 Heracles – Verethragna (?),* limestone, find spot: Masjid-e Suleiman, Iran. The figure, which has wings on his legs and a bag in his hand, is reminiscent of the god Mercury. Inv. Nr.: 1920,1120.1, British Museum, London.

* Curtis, J.E., 2000 (2): p. 69, fig. 77, speaks of Heracles – Verethragna.

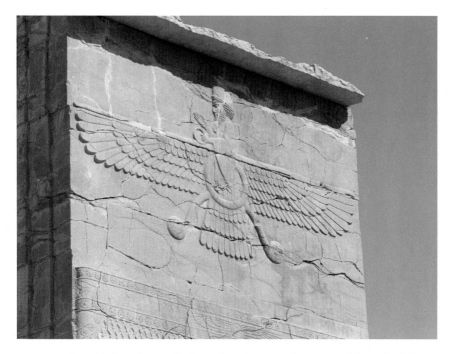

FIG. 11.9 Royal Palace, Persepolis. Faravahar, the winged man, possibly symbolising god-given glory.

11.1.10 Khvarenah

As mentioned above, the *khvarenah* (also *farnah* or *xvarenah* or *hvarnah*) is the God-given glory or fortune bestowed on kings by the *yazatas* (divine beings).[46] The *yazatas*' task is to make sure that the *khvarenah* is only given to the rightful and legitimate ruler. Accordingly, this roughly corresponds to the concept of a king's divine right, though it does not mean that the king is divine. For details on this see 4.1.4.

The tasks of the *yazatas* are described in the Yashts, which are part of the Avesta and contain hymns to ancient Iranian deities. According to these hymns, the goddess Anahita possesses *khvarenah*, while Mithra has the task of protecting it. The symbol of Faravahar, the winged man, which is still used by Zoroastrians today, has references to ancient oriental representations of a sun god with a winged sun disc (Middle Assyrian period, middle of the 2nd millennium BC), and was also used by Persian kings in Persepolis. It is also depicted on coins of the Frataraka and presumably represents the *khvarenah*, the royal glory (Fig. 11.9).

Among the Kushans, a separate god represents the royal dignity and splendour, the god Pharro, depicted on coins of Kanishka II (between 200 and 222 AD, possibly also 20 years later).[47] Pharro belonged to the pantheon of Kushan gods. It is believed that this god was already worshipped by the Scythians, the Medes and the Parthians.

FIG. 11.10 A Fire holder with a bowl for the sacred fire, bone plaque, Mele Hairam, inv. no. MH08-12802-1.

FIG. 11.10 B Drawing of the bone plaque shown in Fig. 11.10 A.

11.1.11 *The sacred fire of the Zoroastrians – archaeological finds*

The sacred fire plays a significant role for Zoroastrians and is still revered today. For many hundreds of years – they themselves speak of more than a thousand years – a sacred fire has been constantly kept aflame and guarded. Only priests have access to this holy fire. The representations of fire altars, only known from the Achaemenid, Parthian and especially Sasanid periods, are an important feature of later Zoroastrianism. The fire is a pure substance for the faithful; only in its presence should prayers be addressed to Ahura Mazda. This may be the reason why Zoroastrian priests are often mistakenly called 'fire worshipers'. Among the Parthian sources on the subject of a fire cult, Isidore of Charax deserves mention. He states in his work that the 'eternal fire' of the Zoroastrians was protected in the city of Asaak, in which Arsaces I was proclaimed king.[48] Apparently, a significant change occurred in the practice of fire cults: in the Achaemenid period, the royal fire was ignited with the beginning of the reign of a new king and extinguished at his death. In Parthian times, however, there was an ever-burning fire, the 'eternal fire', of which Isidore of Charax speaks.[49]

That the fire had a direct connection with the kingship is also supported by other sources from the Achaemenid period and information in literature about the Scythians from the Black Sea region.[50] For them, the goddess Hestia is of importance, being associated with the 'hearth fire' and representing the Scythian kingship in divine form (compare Fig. 10.7). Fire temples in which priests guarded and maintained the royal fire were probably built in small numbers, and only in the Achaemenid period. A fire altar is depicted in the façade showing the tomb of Xerxes I (or Artaxerxes I; see Fig. 11.18), the king standing opposite it. A similar scene is depicted in a rock relief on the tomb of Artaxerxes III (359–338?).

FIG. 11.11 A Ritual implements, bone plaque, Mele Hairam, inv. no. MH08-12802-2.

FIG. 11.11 B Drawing of the bone plaque shown in Fig. 11.11 A.

11.1.12 Fire cult: archaeological evidence in the Parthian Empire

An important find for a Parthian royal fire cult is the 'Vologases Relief' in Bisotun, Iran, where the king performs a sacrifice on an altar (Fig. 10.22). Such fire altars are also depicted on Parthian bronze coins from Phraates IV (S 41.49) and Artabanus II (S 63.22) and on a drachm from Phraataces (S 56.13).

Of particular importance are the archaeological finds dating back to the late Parthian era and found in Mele Hairam, because they give an indication of a Zoroastrianism fire cult practised there.[51] The excavation site is located in the Serakhs oasis of southern Turkmenistan (south of Mary), where the remnants of a Zoroastrian fire temple were found, dating back to the 1st–4th century AD. Four small pieces of bone with engravings are dated to the late Parthian period. One of them depicts a fire holder with a bowl for the sacred fire (Fig. 11.10).

Another illustration portrays vessels that can be identified as mortars with pestles, while the stand is a *mah-rui*, which holds the barsom (Fig. 11.11 A). The barsom, a sacred bundle of twigs, is a ritual implement which from the beginning played an important part in Zoroastrian religious practices. Such ritual implements are still in use.[52] Another plaque depicts two males (Fig. 11.12 A), dressed in Parthian costumes, one of them holding the hilt of a long sword. The fourth bone fragment shows a Zoroastrian priest in front of the mortar (Fig. 11.13 A). Thus, the temple from Mele Hairam, together with the remnants of the bones, prove that the Zoroastrian religion was well established within the Arsacid Empire. Although fire cults are detectable during the Parthian era, they only achieved extensive dissemination in the Sasanian Empire.

It is interesting that the first Sasanian kings destroyed the dynastic fire of some of the local Parthian kings who had maintained their regional rule following the collapse of the Parthian Empire.[53] This too is an indication of the existence of a fire cult in the Parthian Empire.

FIG. 11.12 A Worshippers, one holding a longsword, bone plaque, Mele Hairam, inv. no. MH08-12802-4.

FIG. 11.12 B Drawing of the bone plaque shown in Fig. 11.12 A.

FIG. 11.13 A Zoroastrian priest in front of the mortar, bone plaque, Mele Hairam, inv. no. MH08-12802-3.

FIG. 11.13 B Drawing of the bone plaque shown in Fig. 11.13 A.

11.1.13 Funerals performed by Zoroastrians

The funerary traditions of the Zoroastrians are prescribed in the Vendidat: the corpses must be exposed to the open air, where the flesh is eaten by birds or dogs. The place where the dead are to be exposed must be barren, with the dead being fixed to the earth, so that no parts can be taken away or brought to places where

plants or water exist.[54] The remaining bones, after further preparation, are then to be placed in an ossuary. According to the Vendidat, inhumation was forbidden, and the burning of the corpses was considered a sin.

Even in modern Iran, this procedure was customary practice until 1970. The 'Towers of Silence', located on a hillside near Yazd (in Iran and still a centre of Zoroastrianism), bears eloquent testimony to it (Fig. 11.14). M. Rashad, an eye-witness, reports:

> The dead were brought to these towers and placed naked in a walled area. The vultures nibbled the bodies so far that the bones could then be collected and ritually cleaned. The bones were then placed in the nearby mountains in small stone tombs, which were closed with cover plates.[55]

After the cessation of this burial ritual in 1970, vultures disappeared from the city of Yazd and have no longer been sighted in the area. In India, Zoroastrians, who are called Parsees there, still practise this custom and hand the dead over to the vultures.

This funeral practice, which was practised until recently, was mentioned by ancient writers, such as the Roman historian Justinus, who noted that the Parthians were feeding the deceased to birds (vultures) or dogs.[56] Even older indications

FIG. 11.14 'Towers of Silence', Yazd. In former times, at this site, Zoroastrians exposed the dead to the vultures.

appear in the Young Avestan, where instructions for such a practice are given. Treatment of the dead as described could explain the fact that so far only a few Parthian grave sites have been found.

11.1.14 Burials in Parthian times

On the question of whether the Parthians preferred certain burial methods, which could give a clue to their religion, no simple answer can be given. Archaeologically, the existence of different burial forms in the Parthian era would prove certain regional traditional forms exercised their influence. The search for tombs of the Parthian kings has so far been fruitless. One explanation for this would be cremation of the kind said to have taken place in Nisa and later in Arbela (a city in Adiabene, today a city in northern Iraq), as Greek texts inform us.[57] It is also conceivable, according to the Zoroastrian cult, however, that dead bodies were exposed to birds or wild animals and the bones stored in ossuaries, as is proven for the Parthian period in Central Asia.

Another form of funerary culture in Parthian times, mainly found in Mesopotamia, was the burial of the dead in glazed, fired-clay coffins (Fig. 11.15).[58] Such coffins are termed 'slipper sarcophagi', as they had the shape of a slipper.[59] More than 1500 slipper coffins have been excavated so far – their length is about 1.50–2.21 metres.[60] Many of these coffins were found in Nippur, others in Uruk,[61] Nineveh and Babylon. Only 16 slipper coffins were found in the Parthian capital of Seleucia on the Tigris, dating from 141 BC to 43 AD.[62]

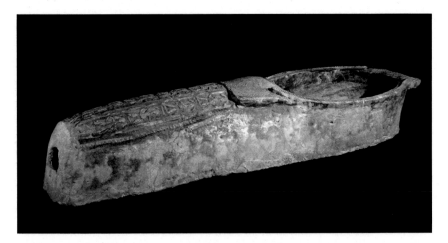

FIG. 11.15 Glazed fired-clay coffin, possibly for a child or a teenager, find spot: Warka, southern Iraq, c. 1st–2nd century AD, dimensions: length 134 cm, width 47 cm. The exterior of the coffin was modelled in low-relief, incised and impressed with specially made fired-clay stamps and then covered with a blue-green glaze. Inv. Nr.: 1851,0101.2, British Museum, London.

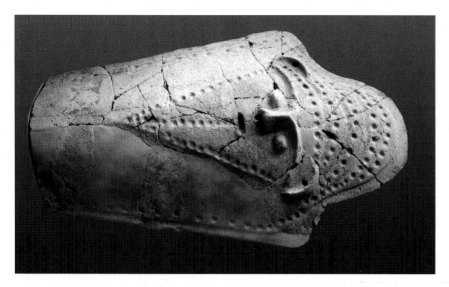

FIG. 11.16 Parthian coffin lid, c. 3rd century AD. Coffin lid designed as a face with tapered beard. Inv. No.: SB 14393, Louvre, Paris.

The coffins had openings at the foot, which could possibly be to let out gases formed by the decomposition of the bodies. Most lids were decorated with small figures about 15 cm in length, those found in Uruk representing soldiers carrying a sword by their side. Others, found in Nippur, show naked women-goddesses. The coffins were made of glazed clay of a bluish (Fig. 11.15) or greenish colour, a technique that dates back to Babylonian traditions. To fire coffins of this size required a sophisticated technique and large ovens, in which temperatures of over 900 degrees had to be generated. Other coffins were trough-shaped with coffin lids in which faces were formed (Fig. 11.16). Excavations have revealed that the coffins were let into the soil of the still inhabited houses.

During excavations in Jarryk Tepe, a large Parthian fortress, which was found in present-day southern Turkmenistan, archaeologists discovered a special burial custom from Parthian times.[63] The dead were buried in catacombs found under mounds and mostly wore gold-embroidered clothing. Other items found in the graves included iron swords, daggers and Parthian arrows, of which, however, mostly only the arrowheads were found. Clay and stone vessels were also placed in the graves of the deceased. One of these vessels contained traces of wine, apparently made not from grapes, but from raisins.

A Parthian necropolis, which has been badly ruined over time, dating to the late 3rd–early 2nd century BC, was discovered at the city wall in the north–eastern part of the city of New Nisa, located close to Old Nisa (Fig. 11.17). One or two small funerary chambers built of sun-baked bricks were found at the site.[64] The remains contained fabric remnants of gold-embroidered ribbons, a mirror, a sword, a dagger and arrowheads, visible signs of the prosperity of the Parthians buried here. It is

FIG. 11.17 New Nisa, badly ruined Parthian ramparts. In the background are the Kopet Dagh Mountains.

unclear whether the entire corpses were originally deposited there, or, what seems more probable, that only the excarnated bones were laid in the funeral chambers. This necropolis was used well into the late Parthian period or even later.

Other burial forms dating to Parthian times have also been found by archaeologists. Thus, skeletons were found in vessels, stone chambers or stone graves. Archaeological research revealed that bodies of ordinary people were buried only in the soil, whereas people of a higher social status were buried in chambers with grave goods. A communal grave of 21 dead dated to the Parthian period was found in Valiran, located on the highest mountain in the Elburz range. The coins found in the tomb, minted by Mithradates II, Orodes I and Artabanus II, indicate that the funeral took place at the beginning of the 1st century AD. The age of the dead was between 5 and 70 years. Mohammad-Reza Nemati, director of the excavation, describes the use of the tomb as follows:

> Every time a dead person had to be buried, the tomb was opened in the middle. The bones of the previously deceased were gathered together and placed in niches in the walls. Only then could the actual funeral take place.[65]

Research suggests that children were mostly buried in urns.

Another form of burial, dating to the 1st century AD, was discovered in Palmyra, which at that time was influenced by the Parthians, although it was under Roman rule. During this time, the dead were buried in rich graves, partially built as grave towers or as underground grave sites, so-called hypogea. They were placed in niches, which were then closed with limestone reliefs, which depicted portraits of the deceased. Some of the persons depicted wear Parthian clothing (Figs. 7.24 and

7.25), others are shown in Roman-style robes – an indication of the influence of both empires.

Burial forms in the Parthian Empire differed regionally, as we have seen. However, it is not clear what influence the Parthian-Zoroastrian religion exercised on funeral rites in the Parthian Empire. The funerary traditions of the Zoroastrians, as we know them from the scriptures of the Avesta (see 11.1.13), could have changed in Parthian or, probably even earlier, in Achaemenid times. Achaemenid kings (Artaxerxes I, Xerxes I, Darius I, Darius II) were buried in a sarcophagus, which was placed in their tombs carved in stone in Naqsh-e-Rostam (Fig. 11.18). Cyrus II the Great was buried in Pasagardae, located approximately 80 km north-east of Persepolis, but in a royal tomb, which was built from stone blocks. Arrian tells us that Alexander the Great visited the tomb and found there a golden coffin in which the body of Cyrus was placed. His body was embalmed. As Olbrycht states, 'Such burials could most probably be considered orthodox in Zoroastrianism.'[66]

The use of Parthian slipper coffins could have been in the same tradition of Zoroastrian funerals, because in this way too the Zoroastrian principle would be observed that the body should not come into contact with earth or water. This

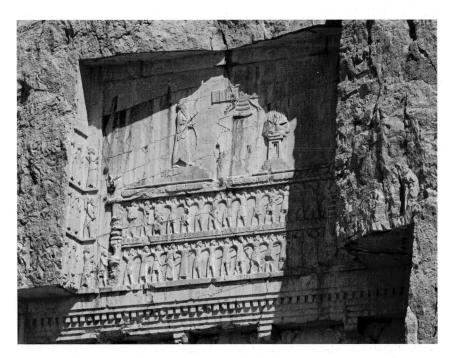

FIG. 11.18 Tomb of Xerxes I (or Artaxerxes I), Naqsh-e-Rostam, Iran. The king stands opposite a fire altar, above is the winged man, the symbol of Faravahar, possibly symbolising god-given glory.

may have developed under Artabanus II (c. 8/9–39/40 AD), when the Parthians had established their power in the cities of Babylonia and a greater number of soldiers, merchants and Parthian officials lived there.[67] The majority of the population living there may still have adhered to their own faith and so it is conceivable that the Parthians chose this burial form to allow them to practise the Zoroastrian rules of burial. Even if we assume that the Parthian-Zoroastrian religion exercised great influence on funerary rites in the Parthian Empire, not all questions can yet be answered. It is to be hoped that further scientific research will eventually result in greater clarity on the subject.

11.2 Iconography of Parthian coins – references to the Zoroastrian faith

As noted earlier, any meaningful testimonies that could provide information about the belief of the Parthians are lacking. One important avenue for answering the question of faith is provided by Parthian coins, as they depict different goddesses and gods. Ellerbrock demonstrates that an analysis of which gods and when are portrayed on the coins of the Parthian kings at least reveals changes that took place during the history of the Parthian Empire (Table 11.1).[68] It is striking in the analysis that Greek gods such as Zeus, Athena, Apollo or Heracles are shown on silver coins only up to the beginning of the 1st century BC; thereafter, they only appear rarely on small coins. This is equally true for the types of coins on which astral symbols (sun, moon, stars) are shown. These are indications of divine references, as we already know from former oriental empires (Table 11.3). Inscriptions on coins that contain divine references also help, if they are placed in chronological order (Table 11.2). Thus, the terms ΘΕΟΥ (god), ΘΕΟΠΑΤΟΡΟΣ (of divine origin) or ΕΠΙΦΑΝΟΥΣ (the manifest, epiphany of god[69]) are only minted at certain times on Parthian coins. A total of four phases are recognisable and are considered in more detail below. These changes give hints about the Parthian religion, but they do not provide proof in the proper sense.

11.2.1 Deities on Parthian coins

11.2.2 Phase 1: Arsaces I to Phraates I (c. 247–171 BC)

In the first phase, from Arsaces I to Phraates I, no gods are depicted on Parthian coins. Likewise, there are no inscriptions with religious references.[70] Since in the second phase images of gods are to be found on the coins, we must ask why this did not happen in the first phase. In the beginning, Arsaces I (about 247–211 BC) and his successors had to stabilise the newly formed Parthian Empire, which had to fight for recognition and was still unstable after further conquests. The confrontation with the Greek world of faith, as can be seen in the second phase, was probably not yet to the fore at this time.

TABLE 11.1 Representation of gods and goddesses on Parthian tetradrachms and drachms as they occur at different periods, except for the goddess Tyche, who, from Phraates III onwards, regularly appears on Parthian tetradrachms. X = silver coins (tetradrachms/drachms).

Dates (according to Sellwood)	King	Type (according to Sellwood)	Nike	Athena	Hercules	Zeus	Apollo	Artemis
c. 247–211 BC	Arsaces I	1–5						
c. 211–191 BC	Arsaces II	6						
c. 191–176 BC	Phriapatius	No coins						
c. 176–171 BC	Phraates I	No coins						
c. 171–138 BC	Mithradates I	7–13	X		X	X	X	
c. 138–127 BC	Phraates II	14–17	X				X	
c. 127–125 BC	Inter-regnal	18						
c. 127–124 BC	Artabanus I	19–22	X		X			
c. 123–88 BC	Mithradates II	24–29	X	X			X	X
c. 95–90 BC	Gotarzes I	33	X				X	
c. 90–80 BC	Orodes I	31	X					
c. 80 BC	Unknown King I	32						
c. 80–70 BC	Unknown King II	30	X					
c. 57–38 BC	Orodes II	42, 48	X					
c. 39 BC	Pacorus I	49	X					
c. 38–2 BC	Phraates IV	50	X					
c. 2 BC–4 AD	Phraataces/ Musa	56–58	X					
c. 8–12 AD	Vonones I	60	X					

TABLE 11.2 Inscriptions with divine epithets on Parthian coins.

Dates (according to Sellwood)	King	Inscriptions with divine epithets		
c. 247–211 BC	Arsaces I			
c. 211–191 BC	Arsaces II			
c. 191–176 BC	Phriapatius			
c. 176–171 BC	Phraates I			
c. 171–138 BC	Mithradates I		ΘΕΟΠΑΤΟΡ	ΘΕΟΥ
c. 138–127 BC	Phraates II		ΘΕΟΠΑΤΟΡΟΣ	
c. 127–125 BC	Interregnum/ Bagasis			
c. 127–124 BC	Artabanus I	ΕΠΙΦΑΝΟΥΣ	ΘΕΟΠΑΤΟΡΟΣ	
c. 121–91 BC	Mithradates II	ΕΠΙΦΑΝΟΥΣ		
c. 95–90 BC	Gotarzes I		ΘΕΟΠΑΤΟΡΟΣ	
c. 90–80 BC	Orodes I	ΕΠΙΦΑΝΟΥΣ		
c. 80 BC	Unknown King I	ΕΠΙΦΑΝΟΥΣ		
c. 80–70 BC	Unknown King II	ΕΠΙΦΑΝΟΥΣ	ΘΕΟΠΑΤΟΡΟΣ	
c. 77–70 BC	Sinatruces	ΕΠΙΦΑΝΟΥΣ		
c. 70–57 BC	Phraates III	ΕΠΙΦΑΝΟΥΣ		ΘΕΟΥ
c. 70 BC	Darius of Media Atropatene	ΕΠΙΦΑΝΟΥΣ	ΘΕΟΠΑΤΟΡΟΣ	
c. 57–54 BC	Mithradates III	ΕΠΙΦΑΝΟΥΣ		ΘΕΟΥ
c. 57–38 BC	Orodes II	ΕΠΙΦΑΝΟΥΣ		
c. 39 BC	Pacorus I	ΕΠΙΦΑΝΟΥΣ		
c. 38–2 BC	Phraates IV	ΕΠΙΦΑΝΟΥΣ		
c. 29–26 BC	Tiridates I	ΕΠΙΦΑΝΟΥΣ		
c. 2 BC–4 AD	Phraataces – Queen Musa	ΕΠΙΦΑΝΟΥΣ	Musa: ΘΕΑΣ ΟΥΡΑΝΙΑΣ	
c. 6 AD	Orodes III	ΕΠΙΦΑΝΟΥΣ		
c. 8–12 AD	Vonones I	ΕΠΙΦΑΝΟΥΣ		
c. 10–38 AD	Artabanus II	ΕΠΙΦΑΝΟΥΣ		
c. 35–36 AD	Tiridates II			
c. 40–47 AD	Vardanes I	ΕΠΙΦΑΝΟΥΣ		
c. 40–51 AD	Gotarzes II	ΕΠΙΦΑΝΟΥΣ		
c. 51 AD	Vonones II			
c. 51–79 AD	Vologases I	ΕΠΙΦΑΝΟΥΣ		
c. 55–58 AD	Son of Vardanes	ΕΠΙΦΑΝΟΥΣ		
c. 75–110 AD	Pacorus II	ΕΠΙΦΑΝΟΥΣ		
c. 80–82 AD	Artabanus III	ΕΠΙΦΑΝΟΥΣ		
c. 105–147 AD	Vologases III	ΕΠΙΦΑΝΟΥΣ		
c. 109–129 AD	Osroes I			
c. 116 AD	Parthamaspates			
c. 129–140 AD	Mithradates IV			

TABLE 11.2 Cont.

Dates (according to Sellwood)	King	Inscriptions with divine epithets
c. 140 AD	Unknown King III	
c. 147–191 AD	Vologases IV	ΕΠΙΦΑΝΟΥΣ
c. 190 AD	Osroes II	
c. 191–208 AD	Vologases V	ΕΠΙΦΑΝΟΥΣ
c. 208–228 AD	Vologases VI	ΕΠΙΦΑΝΟΥΣ
c. 216–224 AD	Artabanus IV	
c. 224–228? AD	Tiridates III?	

TABLE 11.3 Distribution of sun-star-moon symbols on Parthian silver coins. After Vologases I, these symbols are rarely shown on coins of later kings. X = silver coins (tetradrachms/drachms).

Dates (according to Sellwood)	King	Types (Sellwood)	Star on the obverse	Star on the reverse	Crescent on the obverse	Crescent on the reverse	Star and crescent on the obverse	Star and crescent on the reverse
c. 70–57 BC	Phraates III							
c. 57–54 BC	Mithradates III	40–41	X		X		X	
c. 57–38 BC	Orodes II	42–48	X	X	X	X	X	X
c. 39 BC	Pacorus I	49			X			
c. 29–26 BC	Tiridates I	55						
c. 38–2 BC	Phraates IV	50–54	X	X	X	X	X	X
c. 2 BC–4 AD	Phraataces + Queen Musa	56–58	X			X	X	X
c. 6 AD	Orodes III	59						
c. 8–12 AD	Vonones I	60						
c. 6 AD	Orodes III	59						
c. 51 AD	Vonones II	67	X					
c. 10–38 AD	Artabanus II	61–63						
c. 40–51 AD	Gotarzes	65	X		X		X	
c. 51 AD	Vonones II	67	X					
c. 51–78 AD	Vologases I	68–71						

11.2.3 Phase 2: Mithradates I to Phraates III (c. 165–70 BC)

In the second phase, starting with the conquest of Mesopotamia by Mithradates I in 141 BC, a clear shift towards the Greeks in both the religious and cultural-political spheres can be seen over a period of 20 years. This marked the start of a period during which the Parthians had to deal intensively with the culture and religion of the Greeks, otherwise their claims to rule would not have been

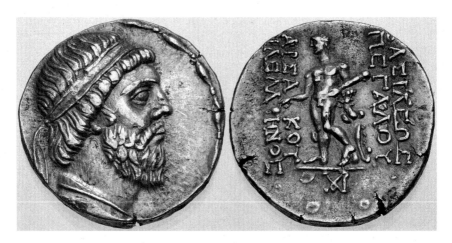

FIG. 11.19 Mithradates I, tetradrachm, S 13.2. Reverse: Heracles with club and lion's skin. Original size: 28 mm, weight 13.4 g.

successful. The Greek-influenced clothing of the kings as shown on coins and inscriptions such as ΒΑΣΙΛΕΩΣ ΜΕΓΑΛΟΥ ΑΡΣΑΚΟΥ ΦΙΛΕΛΛΗΝΟΣ ([coin of the] Great King Arsaces, the Greek's friend) clearly reflect the attitude described. Various Greek male gods were then represented, e.g., Zeus, Apollo and Heracles, on tetradrachms (Fig. 11.19).

In addition to the depiction of Nike on Parthian tetradrachms, a seated goddess, who resembles the female figure on the coins of the Seleucid king Demetrius I Soter (162–150 BC), is impressive.[71] There were different interpretations of whom she represented – sometimes she was called Tyche, sometimes simply a goddess and sometimes Demeter. According to recent research, she represents Tyche, who for the sake of distinguishing her more clearly should be referred to as the 'Hellenistic Tyche'.[72] Further details can be found in 11.2.7.

In addition to depicting Greek deities, various religious inscriptions such as ΘΕΟΥ (god) or ΘΕΟΠΑΤΟΡΟΣ (of divine origin) were also minted on the coins during this phase. What did the term ΘΕΟΠΑΤΟΡΟΣ – of divine origin/whose father is a god – mean for the Parthians? Did it signify that the king saw himself as a god and allowed himself to be worshipped as a god? Or is the term ΘΕΟΠΑΤΟΡΟΣ to be understood in another sense, meaning 'divine grace', in which the king receives his legitimacy from a god? Is the king's son also divine? Why then are not all kings titled ΘΕΟΠΑΤΟΡΟΣ in the period after Artabanus II?

The term ΕΠΙΦΑΝΟΥΣ, which appears for the first time on the coins of Artabanus I (c. 127–124 BC) and is then used throughout to the end of the empire by the Parthian kings, might help to answer this question. ΕΠΙΦΑΝΟΥΣ can be translated as 'the manifest, epiphany of god' or 'the appearance of god' and was already part of the style and title of the Seleucid king Antiochus IV Epiphanes

(c. 175–164 BC). Recent research has proved that Antiochus IV did not call himself a god, but wanted to point out that he owed his position to a divine presence and that his election as king was confirmed by a deity.[73]

Confirmation of the king's inauguration by a goddess was depicted on coins for the first time in Parthian times (for Phraates III, c. 70–57 BC).

Unique in this second phase is the representation of a deity with both masculine and feminine attributes on a tetradrachm of Phraates II (c. 138–127 BC; Fig. 11.20). There was and still is the question of whether the deity depicted is a god or a goddess. The image is confusing because the deity clearly wears a beard, but on the other hand, female attributes such as the shape of the breasts or the typical dress of a woman are also clearly identifiable. The illustration indicates both Zeus and Tyche.[74] There is no convincing explanation of why such an ambiguous representation came about. However, the representation of Greek deities on Parthian tetradrachms is detectable only for a period of about 20 years (c. 141–120 BC), after which no Greek deities will be minted on tetradrachms for the next 50 years. Only some Parthian drachms still show deities. This makes the assumption that the Parthians would have turned to the Greek faith or even accepted it unlikely. This is also supported by the fact that in this second phase the names of the Parthian kings (Mithradates I, II and III) are directly related to the Zoroastrian god Mithra.

11.2.4 Phase 3: Phraates III to Vonones II (c. 70 BC–51 AD)

In the third phase, depictions of Apollo, Zeus, Heracles, Athena and Hermes disappeared from silver coins. Only Nike appears on silver coins until the reign of

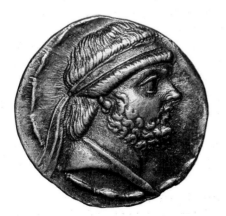
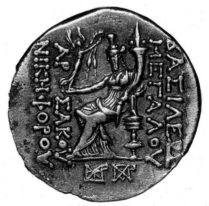

FIG. 11.20 A + B Phraates II, tetradrachm, S 17.1. Reverse: Bearded goddess with Nike. Inscription: ΒΑΣΙΛΕΩΣ ΜΕΓΑΛΟΥ ΑΡΣΑΚΟΥ ΝΙΚΗΦΟΡΟΥ, [Coin of the] Great King Arsaces, the one who brings victory. Original size: 20 mm, weight 13.8 g.

Artabanus II – until 38 AD. After that, she is depicted only on low-quality bronze coins. It is crucial that on Parthian coins from 70 BC onwards a goddess is shown. Although she resembles the 'Hellenistic Tyche', she can be clearly distinguished from her.

The new image of Tyche, which should now be termed the 'Parthian Tyche', features two major differences from the goddess Tyche as previously depicted. The 'Parthian Tyche' is shown for the first time with a mural crown and a sceptre; furthermore, a new pictorial formula in which the king is shown in direct relation to the goddess has developed. It is important to notice that the king now sits on the throne previously occupied by the gods Zeus or the 'Hellenistic Tyche'. Thus, the Parthian king symbolically pushed the Greek deities off the throne. The goddess Tyche now stands behind the king and hands over a tiara as a sign of the transfer of divine power.

The transfer of the 'divine glory' and 'royal splendour' to the legitimate ruler is a central element in the relationship between the gods and the king in Zoroastrianism and is termed *khvarenah* – see 11.1.10.[75] With this new pictorial formula, the shift of the Parthians towards Zoroastrianism becomes clearly visible. Because of her new function and presentation, the goddess should now be referred to as 'Parthian Tyche' in reference to the Zoroastrian faith. With the wearing of a mural crown, she is also identified as a city goddess.[76]

A new image programme with religious references appears in the drachms of Orodes II (c. 57–38 BC). For the first time, a Nike, identified by the wings, is shown on the obverse of drachms, crowning the king with a wreath. The first investiture scenes performed by Nike are to be found on drachms of Phraates IV and his son Phraataces, and lastly on coins of Vonones II, thus only during a period of 100 years, from 57 BC to 51 AD. On the tetradrachms of Orodes II and his successors, the image on the coins' reverses changes again. Tyche now faces the seated king, an image that remains dominant until the end of Parthian Empire.

Comparing the coins of Phraates IV, it is evident that there are three different images of goddesses. One goddess looks like Athena, with a helmet and a sceptre (S 52). Another goddess is shown with a polos, while she has a cornucopia (S 51) in her left arm. The third image shows a woman kneeling before the king (S 53); she wears a mural crown and a sceptre. The last of these is meant to be the personification of the city, which subordinates her to the king (which a deity would not accept).[77] One difficult question to answer is whether the two other women represented are different goddesses – an idea favoured by Sinisi – or whether they are the same goddess (Tyche) but have divergent functions – an idea favoured by the author.[78] The goddess depicted with a polos and cornucopia[79] is responsible for the personal happiness of the individual, while the goddess with the mural crown and the sceptre is responsible for the well-being of the entire city.[80]

On the coins of the kings following Phraates IV, a more uniform image is to be seen of Tyche, who for the Parthians remains the most important goddess

until the end of the Parthian Empire. On the coins of later kings, the 'Parthian Tyche' is represented only with a mural crown, which would speak for the author's theory that the goddess had two divergent functions, one of which was abandoned. Only on the coins of Phraates IV is the investiture of the king performed by an eagle.

As the eagle is equated in the Zoroastrian faith with the god Verethragna, this could also be evidence of Parthian Zoroastrianism. A different way of depicting an investiture scene can be found on coins from the time of Orodes II (Fig. 3.3) to Vologases I – that is, for a period of about 100 years (Table 11.3). Here, the sun, stars and/or a crescent moon are shown behind or in front of the head of the ruler. The astral divine reference is easily recognisable. In this third phase, especially during the reign of Orodes II, warfare began with the Roman Empire, which until then had regarded the Parthian Empire as insignificant and not of equal rank. The Battle of Carrhae, which resulted in a massive defeat for the Romans, not only lastingly damaged the Romans' image of themselves as rulers of the world, but led to a new self-confidence among the Parthians. The iconography of the coins from this period reflects this new power and self-confidence by building a new image of the rulers: the kings show themselves in Parthian costumes and carrying daggers and swords, originally weapons of the steppe peoples. These changes testify to the political self-confidence of a world power that no longer has to base itself on the Greeks, but can draw on its own nomadic and cultural origins. This turning away from Hellenism goes hand in hand with a shift towards Zoroastrianism.

11.2.5 Phase 4: Vologases I to Artabanus IV (c. 51 AD to the end of the Parthian Empire in 224 AD)

The final turning away from the Greeks and the presentation of their own Zoroastrian beliefs characterise the fourth phase. In this fourth phase, for a period of about 200 years, the depiction of 'Parthian Tyche', presenting a wreath or tiara to the seated king, dominates on silver coins. The inscriptions on Parthian coins likewise reveal the Parthians' greater alienation from the Greeks, as the Greek writing is increasingly illegible. With the absence of depictions of Greek deities and the constant use of images showing a divine investiture, it becomes clear that the Parthians now had a Zoroastrian background.

11.2.6 Inscriptions with divine epithets

11.2.7 The transformation from the 'Hellenistic Tyche' to the 'Parthian Tyche'

In the early days of Greek mythology, Tyche, the daughter of Zeus, is the goddess who brings positive messages to the people on matters over which they have no influence. Only in the course of time does Tyche's character change, becoming

ambivalent and incorporating negative fate. Unpredictability and moodiness are now ascribed to the goddess. A typical iconographic attribute of Tyche is the cornucopia in her left arm. Other attributes may be a rudder, a wheel or wings.

The goddess Tyche also resembles the Greek goddesses Artemis – goddess of hunting, guardian of women and children – and Demeter, both of whom also hold in their left arm a cornucopia as a typical symbol of the fertility of the earth. Fortuna is the Roman equivalent of Tyche, and parallels have been found with the Egyptian goddess Isis.

In the Hellenistic era, when the conquests of Alexander the Great shook the world, and in the years thereafter, which were associated with struggles, death, defeat and the feeling of insecurity, people began to feel abandoned and accepted that a higher power directed the fates. The Olympian gods lost their power, and Tyche now filled the resulting vacuum. From the middle of the 3rd century BC, the image of Tyche changed in the Middle East. Previously considered to have been only a divine force, the embodiment of the term fate, Tyche took on a new meaning, taking on the traits of a personal goddess who determined the destinies of the individual.[81] This finds its expression, for example, in the coins of the Seleucid ruler Demetrius I Soter (162–150 BC), who represents the goddess Tyche as a new image on the reverses of coins. Demetrius I had escaped imprisonment in Rome with a sailboat and returned home under fortunate circumstances. As an indication of this voyage, the goddess Tyche, who saved his life, sits on a chair, one of the chair legs formed as a triton. Previously, the goddess depicted was identified as Demeter.

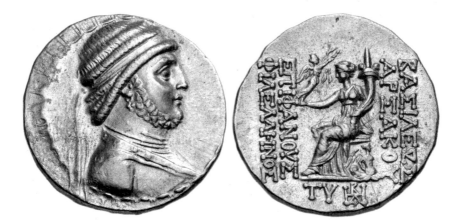

FIG. 11.21 Mithradates II, tetradrachm, S. 23.2. Obverse: image of the youthful king. Reverse: the 'Hellenistic Tyche' with a cornucopia in her left arm and a Nike on her right hand crowning her with a wreath. One of the legs of the chair is shaped like a winged female that in the lower part looks like a triton. Assar assigns this coin to a son of Artabanus I.* Inscription: ΒΑΣΙΛΕΩΣ ΑΡΣΑΚΟΥ ΕΠΙΦΑΝΟΥΣ ΦΙΛΕΛΛΗΝΟΣ: [Coin of] the king Arsaces, the manifest, the friend of the Greek. Original size 29 mm, 14.3 g.

* Assar, G.R.F., 2005: p. 49 ff.

Although the name 'Demetrios' refers to this goddess, who also holds a cornucopia in her hand, she should now be referred to as the 'Hellenistic Tyche' owing to the aforementioned change in her function.[82]

From the end of the 3rd century BC, there is a further transformation of the characteristics of Tyche, who is now not only responsible for personal fate, but for the welfare of the whole city and its inhabitants.[83] Thus, Tyche becomes the figure with whom people identify their sense of optimism and the construction of new cities, as was proven for Antioch and Alexandria. A statue of Tyche was found there, now wearing a mural crown. With the personification of the city, a new image was created that rapidly spread to Asia Minor. However, the mural crown is not a primary feature of Greek art but can also be interpreted as having been adopted from the Orient.

This development was continued by the Parthians. After the conquest of Mesopotamia, they depict the 'Hellenistic Tyche' on their coins (Fig. 11.22), pictured almost in the same manner as the Tyche portrayed on coins of Demetrius I. Parthian coins with this goddess were minted for a period of only about 20 years. After that, this goddess disappears for a period of 50 years on tetradrachms. In the third phase, starting from Phraates III (about 70 BC), she reappears as the 'Parthian Tyche', who is still depicted in a Hellenistic robe! – but now with a new function, since she invests the Parthian king with the *khvarenah*, the God-given glory. In such a function she is the dominating goddess shown on Parthian coins for about 200 years to the end of the empire. Here we are looking into a phase of the Parthian Empire in which the Parthians incorporated the pictorial representation of a Greek goddess into their world of beliefs, albeit with new functions.

Since the 'Parthian Tyche' shown on coins that were minted in Seleucia wears the mural crown, she has now become the goddess of the city. But as she is the only goddess of the entire empire to be depicted on Parthian coins over the last 200 years of the empire, the idea has arisen that in later times she was responsible not only for the city of Seleucia, but in logical consequence also for the entire empire. That this thought is not outlandish is shown by the development of Commagene. There Tyche had already taken over the function of the 'all-nourishing goddess of the Commagene' (Fig. 11.22).[84] It is therefore conceivable that the 'Parthian Tyche' had a double function in the Parthian Empire: on the one hand, she provided the *khvarenah* to the legitimate Parthian king of kings and supported him in his battles; and on the other, she was responsible for the well-being of the entire Parthian Empire.

11.2.8 Gods in Hellenistic robes – Parthian deities?

For a long time there has been discussion about whether the deities depicted on coins, statues or reliefs, which are presented like Hellenistic gods, actually represented Parthian deities. As shown by the coin analyses explained in detail above, we still find between c. 140 and 120 BC (i.e., Phase 2) the image of the 'Hellenistic Tyche'. Based on the iconographic analyses, at least from the reign of Phraates III – from

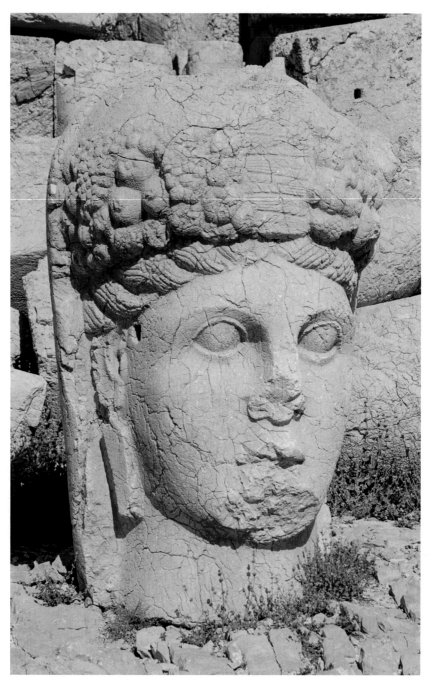

FIG. 11.22 Tyche, goddess of Commagene, Nemrud Dagh, Commagene, 1st century BC, height c. 170 cm.

70 BC onwards – the 'Parthian Tyche' was presented on their coins, showing their Zoroastrian goddess.

We do not know whether the Parthians portrayed their gods anthropomorphically before they built their empire, because material evidence is missing, but we do know that the Scythians' gods were shown anthropomorphically in the 4th century BC, influenced by Hellenistic art. At the latest after the conquests of Mesopotamia and by the time of intensive contact with Hellenism, the Parthians presented their gods anthropomorphically. Presumably, Greek artisans – more experienced than Parthian artists in the art of making images or sculptures of the deities – were commissioned to depict Parthian gods. They used their Greek models because it was from these that they had learned their skills. It can be assumed that the Greeks saw their own deities in the images, while the Parthians associated them with their beliefs. The opportunity given to the people to interpret the representations of the gods according to their own beliefs was certainly a skilful, statesmanlike act on the part of the Parthian kings in the territories conquered, and could thus defuse political tensions emanating from religious affiliations.

11.2.9 The 'Parthian Tyche' – which Zoroastrian goddess is meant to be portrayed?

No direct testimonies exist that would provide information about which Zoroastrian goddess is intended to be portrayed by the 'Parthian Tyche'. Most likely it would be the Zoroastrian goddess Anahita or Ardochscho (Ashi),[85] but the goddess Nana has also been discussed.[86] One overall view suggests that the Parthians never turned their back on their own religion and that they maintained a Zoroastrian faith, in whatever form it was exercised.[87] According to the coinage, the 'Parthian Tyche' is at the centre of their belief. Until the end of the Parthian Empire, however, her portrayal as a Zoroastrian goddess on coins is largely Hellenistic.

11.2.10 Summary: Zoroastrianism among the Parthians

Based on the archaeological finds presented, the fire temples, the ostraca with the Zoroastrian dates, and the inscription on terracotta that refers to the Zoroastrian god Mithra, it would be reasonable to assume the presence of a Zoroastrian faith. This is underlined by external written sources, including those in Greek and Latin. Even analysis of the coins, which shows that the image of the goddess Tyche transformed to become a Parthian deity, reinforces this view. Further understanding of what the Parthian-Zoroastrian faith may have looked like in detail eludes our knowledge.

11.3 Manichaeism – religion with Parthian origins

Mani (c. 216–274 AD), a member of the Parthian nobility born in or near Ctesiphon, was the founder of Manichaeism. His father belonged to a Jewish-Christian sect and his mother was of Parthian descent. In his early life, Mani had visionary experiences calling him to preach the message of Jesus. He later

studied Zoroastrianism, Hinduism, different philosophers and Buddhism, all religions being the basis for his new religion. In 242 AD, he dedicated his works, the Shabuhragan, the sacred book of the Manichaean religion, written in Middle Persian, to the Sasanian king Shapur I (c. 215–270 AD). Shapur I, who took Mani into his court, favoured his ideas, but retained his Zoroastrian faith. Under the Sasanian king Bahram I (271–274) Mani was imprisoned until his death in 274 AD. His followers were persecuted under the Magi Kerdīr (also written Kartir, see Fig. 11.24), who promoted Zoroastrianism.

Writings found in the Turfan Oasis (mentioned above in connection with the Avesta, see 1.2 and 11.1) have been of crucial importance for the analysis of Mani's teachings. They contained fragments of text that were original writings of Manichean communities and date from the late 3rd to the 6th century. Most of the writings found there, however, come from the 8th–11th century.[88]

Mani's aim was to bring together the different religions of his time.[89] In Manichaeism, Jewish, Christian, Zoroastrian and even Buddhist elements were assembled. At the heart of the religion was the struggle between good and evil. The aim of humans should be to free themselves from the darkness of evil and to strive for the purity of light.[90] The various elements of religion introduced into Manichaeism have led to discussions among scientists about which of the afore-mentioned religions constitute the main share in the teachings of Mani. Depending on the perspective, more emphasis was placed on Christian, Jewish or Zoroastrian portions. So the question still cannot be answered with certainty. More recently, the Manichaean scriptures have been more intensively discussed with regard to the study of faith among the Parthians, since parts of the Manichean religion presumably have Parthian origins.[91]

For Albert de Jong, in any case, it is clear that Mani had Iranian Zoroastrian roots, which influenced his early life and which have their background in the Parthian faith. Those roots can be found in Parthian epics, such as 'The Hymn of the Pearl' (see 9.2.1). De Jong therefore states:

> As long as scholars continue to treat the Iranian presence in Mesopotamia as a foreign intrusion, which does not merit too much interest, such a scenario – that various religions make use of a crucial Zoroastrian narrative to account for the origins of their own organizations – will strike most colleagues as contrived. It has recently become clear, however, how crucially important Parthian epic traditions were in all parts of the Parthian commonwealth.[92]

The Manichaean faith was supported and propagated by the first ruler of the Sasanids, Ardashir I. Manichaeism then spread into many countries of the ancient world, in the west to Rome and North Africa and in the east to China. From 762 to 840 AD Manichaeism even became the state religion in the Uighur Empire – a Turk people in the Chinese Empire, near today's Xinjiang. Pushed back by persecutions and wars, Manichaeism disappeared completely in the 14th century, but testimonies and remnants of Manichaean literature have been found in many different languages.

11.4 Mithraism – Mithras cult

Mithraism, which emerged at the end of the 1st century AD, was erroneously thought to be closely associated with the Zoroastrian god Mithra. It has been postulated that Roman soldiers in Asia Minor, having worshipped the god Mithra, adopted Zoroastrianism and then spread that belief further into the Roman Empire. But recent research suggests that there are few connections between the Iranian god Mithra and the Mithras cult.[93] Manfred Clauss, a German scholar and expert on Mithraism, claims that 'a direct continuity of the Persian-Hellenistic Mithra cult to the Roman Mithras mysteries cannot be proved either generally or in detail'.[94] Most likely, this cult originated in Rome. It was a mystery cult centred on the figure of Mithras killing a bull (Fig. 11.23). It included a rite of initiation known only to the initiate and not allowed to be made public. Women were not admitted; it was a purely male bond. The followers gathered in a Mithraeum (Latin pl. *Mithraea*), a temple, which was usually created underground. The cult quickly spread in the Roman Empire and reached, as finds of Mithraea in Trier or Heidelberg show, Germania and Britannia, as illustrated by the Mithraeum in London, which was reopened in 2017.[95] A special representation of Mithras is to be found in Dura-Europos. A temple, dedicated to Mithras, was found there, which also included a relief dated to 168/169 AD (Fig. 11.23). The relief is a unique example since it shows a man (Mithras) dressed in Parthian costume. A bilingual text, in Palmyrian and Greek, refers to the founder, who is a Palmyrian commander of the Roman archers. Clauss assumes that the Mithras cult was established there by Roman soldiers. This probably happened during Lucius Verus' war (starting in 162 AD) against the Parthians.[96]

11.5 Judaism in Parthia

Before discussing the role played by Judaism in Parthia, it will be useful to consider the preceding spread of it in Mesopotamia and the Persian Empire. The settlement of Jews in the west of Zoroastrian Iran inevitably led to conflicts, but also an interplay, between the two religions. It should be noted that there is a great similarity between Yahweh, who in the Jewish belief is the creator of the world, and Ahura Mazda, creator of the world in the Zoroastrian belief.[97] Jews had already settled in 700 BC around the Tigris and the Euphrates (see the Bible: 2 Kings 17:6). The exact size of the Jewish population that settled there is unknown. However, considerably more Jews arrived in Mesopotamia solely on account of exile.

According to the Bible, the Babylonian king Nebuchadnezzar II (c. 640–562 BC) besieged the city of Jerusalem for ten years before defeating it, setting it on fire and destroying the temple. The Jews were exiled to Babylon, and the sufferings of the Jews began: 'we sat and wept at the waters of Babylon' (Psalm 137). The Jews captured by Nebuchadnezzar in the conquest of Jerusalem were not only taken to Babylon but also settled in what is today Isfahan. Tens of thousands of Jews lived in exile in the north of Adiabene and an equal number in areas beyond the Euphrates in Seleucia-Ctesiphon. The idea that the Israelites lived in slavery throughout their

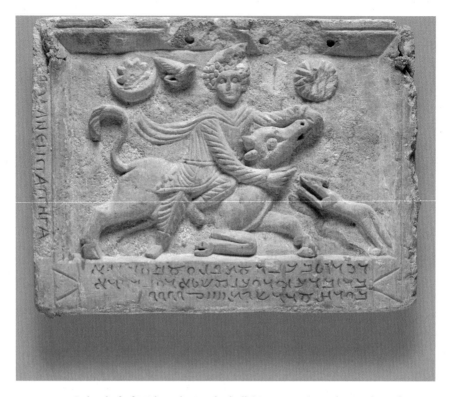

FIG. 11.23 Cult relief of Mithras slaying the bull (Tauroctony), Mithras is dressed in a Parthian costume, limestone, 168/169 AD, dimensions: 41.4 × 56.3 × 14.2 cm, 72.58 kg. Yale-French Excavations at Dura-Europos, 1935.97, Yale University Art Gallery.

Note: Mathiesen, H.E., 1992: vol. 1, pp. 78–80, appendix II, fig. 52; vol. 2, pp. 196–197, fig. 172.

time in Babylon is, according to current knowledge, incorrect. Later, they could form communities and practice their faith.[98] The archaeological data differ significantly from the events witnessed in the Old Testament. Neither the destruction of Jerusalem, nor mass deportation can be proven. However, the abduction of the upper class from Jerusalem created a profound rupture in the minds of the Israelites and their scriptures. Babylon was interpreted as a symbol of sin, and the Jews were called to confess their faith and to return to their promised land.

Further references to Jews in the Neo-Babylonian and Persian Empires can be found in the Old Testament in the Book of Judith, the Book of Esther and the Book of Daniel, though these books are to be regarded as narratives rather than representations of historical events. In the New Testament, we find references to Parthians, Jews, Medes and Elamites in Acts 2:9. Jerusalem at the time of Jesus Christ at Pentecost is a multicultural site of trouble in which the Romans play a decisive role. After the destruction of Jerusalem in 70 AD, many Jews fled to Mesopotamia. According to Josephus, one Jewish centre in the Parthian Empire

was in Nehardea (Babylonia). Jews maintained close and positive relations with the Parthian royal family, as evidenced by the participation of Jews in the rebellions against Trajan (AD 116).

With the approval of the Parthian king, they also played a decisive role in the organisation of the silk trade.[99] At the dawn of the Christian era, Ecbatana was one of the cities with a Jewish community that enjoyed considerable respect and great influence. Jews are also documented in the cities of Ctesiphon and Seleucia on the Tigris and also settled in the Parthian-influenced city of Dura-Europos. In Dura-Europos archaeologists found a Jewish synagogue, which is decorated with many magnificent frescoes, which were created around the middle of the 3rd century. It is significant that the frescoes still betray a Parthian influence. They represent the largest cycle of images known from that period (Figs. 7.15, 10.25 and 10.27).

11.6 Christianity in Parthia: the proselytising of the Apostle Thomas

Information about the spread of Christianity and about the practice of this faith in Parthia is sparse. The New Testament relates how Jesus sends the disciples in pairs to proselytise. Details of the missionary destinations and disciples are not included. Further references to proselytising can be found in the apocryphal Gospel of Thomas (not included in the New Testament), which is said to have been written c. 200 to 240 AD in Edessa. This tells the story of the apostle Thomas, who was one of the 12 disciples of Jesus Christ and who came to Parthia and India.[100] In the form of a legend, Thomas is reported to have been sold by Jesus to a merchant, who takes him to Taxila, capital of the Indo-Parthian Empire (now Pakistan). Thomas becomes a slave to King Gondophares. At court, thanks to his abilities, Thomas is finally made overseer, who supervises the construction of the palace. As the work does not continue because Thomas spends the money on the poor, he is held accountable by the king

Thomas defends himself, relating that he, symbolically, has built a palace in heaven for the king, but the king condemns him to death. Gad, brother of the king, dies that same night, goes to heaven and there sees the palace promised by Thomas. Gad recovers life again, returns to the earth and tells King Gondophares of what he has seen. His brother Gad's message causes the king to reconsider, and he lifts the death sentence against Thomas and gives him his freedom. Apostle Thomas thereafter continues his missionary work and accomplishes many miracles in the following years. The miracle stories in the Gospel of Thomas have made it difficult for researchers to find a true core in the information. However, his story reveals a multitude of historically accurate details that make missionary activity by him in Parthia and India credible.[101] After completing his missionary work in Taxila, Thomas travelled to Parthian provinces before evangelising in India. Another disciple of Jesus, the apostle Matthew, is also believed to have proselytised in Parthia.

Christianity had already spread in the 2nd century into the Parthian-dominated Mesopotamia. Edessa, the capital of Osrhoene, must have played an important role as a Christian mission centre. Abgar VIII (c. 177–212 AD) was king in Edessa and had

a boyhood friend named Bardasanes, who lived with him at the court. Bardasanes was converted to Christianity by Bishop Hystaspes – an Iranian name based on the Parthian language – who lived in Edessa. This might have influenced King Abgar VIII, who converted to Christianity about 202 AD. Thus, he may have been the first Christian king.[102] When exactly Christianity took hold in the Parthian Empire is not known. Christian communities probably already existed in the middle of the 2nd century AD. The first churches were probably built at the beginning of the 3rd century AD. At this time, the first bishops will have taken over their offices.[103] One of the oldest Christian churches, which resembled a normal house, was found by archaeologists in Dura-Europos, dating back to the middle of the 3rd century AD. Frescoes found there likewise betray Parthian influence. Their quality, however, does not match that of the frescoes found in the synagogue in Dura-Europos. Although it is said of the Parthians that they exercised religious tolerance as an essential element of their politics, Christians occasionally experienced persecution, whereas this was not the case with Jews.[104]

The decisive spread of Christianity to the east took place only after the end of the Parthian Empire, when the Sasanid king Shapur I (about 239–270 AD) had conquered Syria and deported several hundred thousand people, mostly Christians, to Mesopotamia and the Sasanian Empire. However, there were soon persecutions of Christians by Bahram II (276–293 AD, Fig. 11.24).

FIG. 11.24 Relief of the Magi Kirdīr, who promoted the spread of Zoroastrianism among the Sasanids, but also persecuted Christians, from the reign of Bahram II (276–293 AD), Naqsh-e Rajab, south-western Iran, near Persepolis.

Notes

1 Colledge, M.A.R., 1986: p. 4.
2 De Jong, A., 2008: pp. 17–27.
3 Hintze, A., 2015: pp. 31–38.
4 De Jong, A., 1997: p. 39 gives the date as c. 1000 BC.
5 Cantera, A., 2011: p. vii.
6 Hintze, A., 2012: p. 63 ff.
7 Kreyenbroek, P.G., 2012, www.iranicaonline.org/articles/exegesis-i.
8 De Jong, A., 2015 (2): p. 99.
9 De Jong, A., 2015 (2): p. 87 ff.
10 Skjærvæ, P.O., 2007: p. 105.
11 De Jong, A., 2015 (2): p. 87 ff.
12 Edited by Michael Stausberg, Yuhan Sohrab-Dinshaw Vevaina with the assistance of Anna Tessmann (Wiley, 2015).
13 Hintze, A., 1998: p. 147.
14 Stausberg, M., 2011: p. 36 ff.
15 De Jong, A., 1997: p. 263 ff.
16 Stausberg, M., 2011: p. 66 f.
17 Hintze, A., 2012: pp. 63–92; see also: Stausberg, M., 2002: p. 98.
18 Henning, K., 1990: p. 552.
19 De Jong, A., 1997: p. 396 ff.
20 Hannemann, U., 2011: p. 68: garnet, tamarisk or date branches were also used.
21 Wiesehöfer, J., 2005: p. 139.
22 De Jong, A., 2010: p. 543.
23 De Jong, A., 2015 (2): p. 91 ff.
24 Wiesehöfer, J., 2005: p. 147.
25 Boyce, M., Chaumont, M.L., Bier, C., 2011: Anahid: www.iranicaonline.org/articles/anahid.
26 De Jong, A., 2010: p. 552.
27 Wiesehöfer, J., 2010: p. 33.
28 Colledge, M.A.R., 1986: p. 4.
29 A gold jewellery box (Bimaran relic) was found in the Gandhara area of Afghanistan. The Azes II coins found therein can be dated to the period of c. 50 AD. The box contains the earliest depictions of Buddha and the Hindu gods Brahma and Sakra. Striking in this casket is the Graeco-Romanesque style – the find shows the mingling of the use of Hellenistic styles with early representations of the Buddhist faith. See: www.britishmuseum.org/explore/highlights/highlight_objects/asia/b/bimaran_reliquary.aspx.
30 Strabo 11.9.3; see Jacobs, B., 2010: p. 78, who concludes that 'the nobility at least had an affirmative function'.
31 De Jong, A., 2012 (1): p. 24 ff.
32 Weber, D., 2010: p. 561.
33 De Jong, A., 2015 (2): p. 95.
34 Also written Ardochsho or Ardokhsho.
35 De Jong, A., 2012 (2): p. 35 ff.
36 Olbrycht, M., 2016 (1): p. 99.
37 Lütge, M., 2008: p. 207.
38 De Jong, A., 1997: p. 268.
39 Curtis, V.S., 1994 (2): p. 19.

40 Potts, D.T., 2001: pp. 23–35; Sinisi, F., 2008: p. 236 f.; Dirven, L., 1999: p. 133 ff. (see *Ann.* 514).

41 Dirven, L., 1999: p. 133 ff.

42 Weber, D., 2010: pp. 155 and 160; for the Kushan coins, see: Amboß, C., 2003: p. 255 ff.

43 Kaizer, T., 2010: p. 114.

44 Also written Ashi.

45 Thommen, L., 2010: p. 461; Weber, D., 2010: p. 569. English translation by the author.

46 Curtis, V.S., 2007 (3): p. 422 ff.

47 Cribb. J., 1999: p. 188.

48 Isidore of Charax, Jacoby, F., 1940: p. 781; see Thommen, L., 2010: p. 190 ff.; Olbrycht, M., 2016 (1): p. 93.

49 Olbrycht, M., 2016 (1): p. 97.

50 Jacobs, B., 2010: p. 145 ff.

51 Kaim, B., 2015: p. 201 ff. Photos courtesy of Mrs B. Kaim.

52 www.avesta.org/ritual/barsom.htm.

53 De Jong, A., 2015 (2): p. 96.

54 De Jong, A., 1997: p. 432 ff.

55 Personal correspondence, Mr Mahmoud Rashad (author of the travel guide *Iran*, published by DuMont Germany).

56 Wiesehöfer, J., 2005: p. 204.

57 Colledge, M.A.R., 1967, pp. 109–114.

58 Olbrycht, M.J., 2017: pp. 301–331.

59 Rawlinson, G., 1976: p. 385; Olbrycht, M.J., 2017, p. 301 f. William Kennett Loftus, a British archaeologist of the 19th century, used this term first; the corresponding German term is 'Pantoffelsarkophag'.

60 Richter, C.H., 2011, provides an excellent overview on slipper sarcophagi.

61 Potts, D., 2006: pp. 267–278.

62 Olbrycht, M.J., 2017: p. 310.

63 Masson, V.M., 1987: p. 117.

64 Olbrycht, M.J., 2017: p. 306.

65 www.parthia.com/parthia_news_2006.htm#Communal_Grave.

66 Olbrycht, M.J., 2017: p. 305.

67 Olbrycht, M.J., 2017: p. 311.

68 Ellerbrock, U., 2013 (1): pp. 253–311.

69 De Callataÿ, F., Corber, C., 2011, p. 450 ff. translates epiphanies as: 'visible, manifest'. Wick, P., 2008: p. 14: ΕΠΙΦΑΝΟΥΣ can be translated as: 'The epiphany of God'.

70 On copper coins of Arsaces II, an eagle is depicted above a bull. This can be described as an Iranian motif of the middle to late 2nd millennium BC. It is not, therefore, a compelling reference to the Zoroastrian religion. See: Ellerbrock, U., 2013 (1): p. 255 f.

71 Found on coins of Bagasis (the brother of Mithradates II), Artabanus I (c. 127–124 BC) and Mithradates II (c. 123–88 BC).

72 For discussion, see: Ellerbrock, U., 2013 (1): p. 262 f.

73 Mittag, P.F., 2006: p. 137 ff. However, it should be remembered that King Antiochus I, who called himself 'ΘΕΟΥ ΕΠΙΦΑΝΟΥ', built up a ruler's cult, and shakes hands with the gods, as seen on reliefs in Commagene.

74 Curtis, V.S., 2007 (3): p. 420 f.; Sinisi, F., 2008: p. 235, refers to scriptural texts in which the goddess Nanaia is described as bearded.

75 Curtis, V.S., 2007 (3): p. 413 ff.

76 Meyer, M., 2006: p. 354 ff. For discussion, see: Ellerbrock, U., 2013 (1): p. 262 f.

77 Sinisi, F., 2008: p. 237 ff.; Ellerbrock, U., 2013 (1): p. 288 ff.

78 Sinisi, F., 2008: p. 237 ff.; Ellerbrock, U., 2013 (1): p. 288 ff.

79 De Callataÿ, 1994: p. 47 ff.

80 See: Sinisi, F., 2008: p. 241 f., who, however, calls the figure kneeling before Orodes II only a personification of the city of Seleucia. For discussion, see also: Ellerbrock, U., 2013 (1): p. 281 ff.

81 Meyer, M., 2006: p. 342 ff.

82 Meyer, M., 2006: p. 359 ff.; for the 'Hellenistic Tyche', see: Ellerbrock, U., 2013 (1): p. 263 ff.

83 Meyer, M., 2006: p. 8.

84 Waldmann, H., 1973: p. 20 ff.

85 Curtis, V.S., 2007 (3): p. 429.

86 Sinisi, F., 2008: p. 244 ff.

87 De Jong, A., 2012 (1): p. 17 ff.

88 Reck, C., 2013: p. 171 ff.

89 Widengren, G., 1961: p. 7 f.

90 An overview of the religion and its sources is to be found in: Reck, C., 2013: pp. 171–184.

91 Turanforschung: www.bbaw.de/forschung/turfanforschung/uebersicht.

92 De Jong, A., 2013: p. 147.

93 Clauss, M., 2012: p. 7 ff.

94 Clauss, M., 2012: p. 17. Mitra, as Clauss calls the Persian-Hellenic god, is always written here as 'Mithra'.

95 www.londonmithraeum.com.

96 Clauss, M., 2012: p. 42 ff.

97 Albertz, R., 2006: p. 179.

98 Leicht, B., 2008: p. 6.

99 Wiesehöfer, J., 2005: p. 197.

100 Zehnder, M., 2010: p. 237 – what is meant is probably the eastern part of today's Iran.

101 Schnabel, E.J., 2002: p. 854 ff.

102 Heichelheim, F.M., 1996: p. 210.

103 Schnabel, E.J., 2002: p. 874; Yarshater, E., 1983: p. 927.

104 Hackl, U., 2010: p. 129.

BIBLIOGRAPHY

Albertz, R.: Die Perser in der Bibel, in: Historisches Museum der Pfalz Speyer (ed.), Das persische Weltreich: Pracht und Prunk der Großkönige, K. Theiss Verlag, Stuttgart, 2006, pp. 74–185.

Alföldy, G.: Die Hilfstruppen der römischen Provinz Germania inferior, Rheinland-Verlag, Düsseldorf, 1968.

Alram, M.: Die Geschichte Ostirans von den Griechenkönigen in Baktrien und Indien bis zu den iranischen Hunnen (250 v. Chr. – 700 n. Chr.), in: Seipel, W. (ed.), Weihrauch und Seide, Eine Ausstellung des Kunsthistorischen Museums, Vienna, 1996, pp. 119–140.

Alram, M.: Stand und Aufgaben der arsakidischen Numismatik, in: Wiesehöfer, J. (ed.), Das Partherreich und seine Zeugnisse, Franz Steiner Verlag, Stuttgart, 1998, pp. 365–388.

Alram, M.: Indo-Parthian and early Kushan chronology: the numismatic evidence, in: Alram, M., Klimburg-Salter, D. (eds), Coins, Art and Chronology, Verlag der Österreichischen Akademie Der Wissenschaften, Vienna, 1999, pp. 19–48.

Alram, M.: The history of the Silk Road as reflected in coins, Parthica, Istituti editoriali e Poligrafici internazionali MMV, Pisa, Rome, 2004, pp. 183–191.

Alram, M.: Münzprägungen in Baktrien und Sogdien - von den graeco-baktrischen Königen bis zu den Kuschan, in: Ausstellungskatalog 'Alexander der Große und die Öffnung der Welt', Reis-Engelhorn Museen, Mannheim, 2009, pp. 183–192.

Alram, M., Klimburg-Salter, D.: Coins, Art and Chronology, Verlag der Österreichischen Akademie Der Wissenschaften, Vienna, 1999.

al-Salehi, W.: Hercules-Nergal at Hatra, Iraq 33, 1971, pp. 111–115.

Altheim, F.: Geschichte der Hunnen. Von den Anfängen bis zum Einbruch in Europa, Walter de Gruyter, Berlin, 1959.

Amboß, C.: Nanaja - eine ikonographische Studie zur Darstellung einer altorientalischen Göttin in hellenistisch-parthischer Zeit, Zeitschrift für Assyriologie und vorderasiatische Archäologie 93, 2, 2003, pp. 231–272.

Amiet, P.: La sculpture Susienne à l'époque de l'empire Parthe, Iranica Antiqua 36, 2001, pp. 239–291.

Andrae, W.: Zwei Kalksteinstelen aus Assur, Mitteilungen der Deutschen Orientgesellschaft 22, 1904, pp. 48–52.

Andrae, W.: Hatra I. Allgemeine Beschreibung der Ruinen, nach den Aufnahmen von Mitgliedern der Deutschen Orientgesellschaft, Wissenschaftliche Veröffentlichung der Deutschen Orientgesellschaft, Leipzig, 1908.

Andrae, W.: Hatra II. Einzelbeschreibung der Ruinen, nach den Aufnahmen von Mitgliedern der Deutschen Orientgesellschaft, Wissenschaftliche Veröffentlichung der Deutschen Orientgesellschaft, Leipzig, 1912.

Andrae, W.: Die deutschen Ausgrabungen in Warka (Uruk), Wissenschaftliche Veröffentlichung der Deutschen Orientgesellschaft, Berlin, 1935.

Andrae, W.: Das wiederentstandene Assur, Wissenschaftliche Veröffentlichung der Deutschen Orientgesellschaft, Leipzig, 1938.

Andrae, W., Lenzen, H.: Die Partherstadt Assur, Hinrichs-Verlag, Leipzig, 1933.

Assar, G.R.F.: Recent studies in Parthian history, Part I, The Celator: Journal of Ancient Coinage 14, 12, 2000, pp. 6–21.

Assar, G.R.F.: Parthian calendars at Babylon and Seleucia on the Tigris, Iran 41, 2003, pp. 171–191.

Assar, G.R.F.: Genealogy and coinage of the early Parthian ruler, Part I, Parthica 6, Istituti editoriali e Poligrafici internationali MMV, Pisa, Rome, 2004, pp. 69–93.

Assar, G.R.F.: Genealogy and coinage of the early Parthian ruler, Part II, Parthica 7, Istituti ditoriali e Poligrafici internationali MMV, Pisa, Rome, 2005, pp. 29–63.

Assar, G.R.F.: A revised Parthian chronology of the period 165–91 BC, Electrum 11, 2006 (1), pp. 87–158.

Assar, G.R.F.: A revised Parthian chronology of the period 91–55 BC, Parthica 8, Istituti editoriali e Poligrafici internationali MMV, Pisa, Rome, 2006 (2), pp. 55–104.

Assar, G.R.F.: Some remarks on the chronology and coinage of the Parthian 'Dark Age', Electrum 5, 2009, pp. 195–234.

Assar, G.R.F.: Iran under the Arsakids, 247 BC – AD 224/227, in: Nelson, B.R. (ed.), Sunrise Collection, Classical Numismatic Group, Lancaster, London, 2011, pp. 113–212.

Azizi, M.-H.: Gondishapur school of medicine: the most important medical center in antiquity, Archive of Iranian Medicine 11, 1, 2008, pp. 116–119.

Bader, A.N., Bailey, M.N., MacKenzie, D.N. et al.: Corpus Inscriptionum Iranicarum, Lund Humphries, 1976–2001. Available at: https://iranicaonline.org/articles/corpus-inscriptionum-iranicarum-c.

Bader, A.N., Gaibov, V., Košelenko, G.: New evidence of Parthian sphragistics: bullae from the excavations of Göbekly-depe in Margiana, Mesopotamia 25, 1990, pp. 61–78.

Bader, A.N., Gaibov, V., Košelenko, G.: Monarchic ideas in Parthian Margiana as shown on seals, in: Curtis, V.S., Hillenbrand, R., Rogers, J.M. (eds.), The Art and Archaeology of Ancient Persia: New Light on the Parthian and Sasanian Empires, I.B. Tauris, London, New York, 1998, pp. 24–37.

Baur, P.V.Ch., Rostovtzeff, M.I.: The Excavations at Dura-Europos Conducted by Yale University and French Academy of Inscriptions and Letters, Preliminary report of first season of work, Yale University Press, New Haven, CT, 1928.

Baur, P.V.Ch., Rostovtzeff, M.I.: The Excavations at Dura-Europos Conducted by Yale University and French Academy of Inscriptions and Letters, Preliminary report of second season of work October 10–28, April 1929, Yale University Press, New Haven, CT, 1931.

Baur, P.V.Ch., Rostovtzeff, M.I., Bellinger, A.: The Excavations at Dura-Europos Conducted by Yale University and French Academy of Inscriptions and Letters, Preliminary report of 4th season of work, Yale University Press, New Haven, CT, 1933.

Bernhard, P.: Die griechische Kolonie Ai Khanoum und der Hellenismus in Zentralasien, in: Gerettete Schätze Afghanistan, Ausstellungskatalog, Ausstellung Bonn, Kunst- und Ausstellungshalle der Bundesrepublik Deutschland, Bonn, 2010, pp. 45–55.

Betz, O., Schramm, T.: Perlenlied und Thomas-Evangelium, Benzinger Verlag, Zurich, 1985.

Bivar, A.D.H.: Seal Impressions of Parthian Qumis (Qumis commentaries No. 4), Iran 20, 1982, pp. 161–176.

Bivar, A.D.H.: The political history of Iran under the Arsacids, in: Yarshater, E. (ed.), The Cambridge History of Iran, volume 3.1, Cambridge University Press, Cambridge, 1983, pp. 21–99.

Bivar, A.D.H.: Gondopjares and the Indo-Parthians, in: Curtis, V.S., Stewart, S. (eds.), The Age of the Parthians, I.B. Tauris, London, 2007, pp. 26–35.

Black, J.: Parthian Rhyta at Home and Abroad: Reconsidering the Ivory Rhyta of Nisa in the Light of First Century BCE, MA thesis, University of California, Berkeley, 2018.

Boardman, J.: The Diffusion of Classical Art in Antiquity, Thames and Hudson, London, 1994.

Böck, B.: Keilschriftliche Texte, in: Hackl, U., Jacobs, B., Weber, D. (eds.), Quellen zur Geschichte des Partherreiches, volume 3, Vandenhoek & Ruprecht, Göttingen, 2010, pp. 1–174.

Boillet, P.-Y.: Quantifying monetary production: Ecbatana and media in Parthian times, in: Curtis, V.S., Pendleton, J.E., Alram, M., Daryae, T. (eds.), The Parthian and Early Sasanian Empires: Adaptation and Expansion. Proceedings of a Conference Held in Vienna, 14–16 June 2012, Oxbow Books, Oxford, 2016, pp. 109–122.

Bopearachchi, O.: Indo-Parthians, in: Wiesehöfer, J. (ed.), Das Partherreich und seine Zeugnisse, Franz Steiner Verlag, Stuttgart, 1998, pp. 389–406.

Boyce, M.: A History of Zoroastrianism, 3 volumes, Brill, Leiden, Cologne, 1975, 1982, 1991.

Boyce, M., Chaumont, M.L., Bier, C.: Anāhīd, 2011, available at: www.iranicaonline.org/articles/anahid.

Brentjes, B.: Die iranische Welt vor Mohammed, Koehler & Amelang, Leipzig, 1967.

Brentjes, B.: Incised bones and a ceremonial belt: finds from Kurgan-Tepe and Tillia-Tepe, Bulletin of the Asia Institute 3, 1989, pp. 39–44.

Brentjes, B.: Zu den Reiterbildern von Kurgan-Tepe, Iranica Antiqua 25, 1990 (1), pp. 173–182.

Brentjes, B.: Steppenreiter und Handelsherren. Die Kunst der Partherzeit in Vorderasien, E.A. Seemann Verlag, Leipzig, 1990 (2).

Brentjes, B.: Waffen der Steppenvölker - I: Dolch und Schwert im Steppenraum vom 2. Jh. v. Chr. bis zur alttürkischen Zeit, Iranica Antiqua 26, 1991, pp. 5–45.

Brosius, M.: The Persians, Routledge, London, 2006.

Caley, E.R.: Analysis of Ancient Metals, Elsevier, Amsterdam, 2013.

Canepa, M.: 2017: Rival images of Iranian kingship and Persian identity in post-Achaemenid Western Asia, in: Strootman, R., Versluys, M.J. (eds.), Persianism in Antiquity, Franz Steiner Verlag, Stuttgart, pp. 201–222.

Cantera, A.: Preface, in: Pongratz-Leisten, Beate (eds), Reconsidering the Concept of Revolutionary Monotheism, Eisenbrauns, Winova Lake, IN, 2011.

Cech, B.: Technik in der Antike. Theiss Verlag, Imprint WBG, Darmstadt, 2017.

Chantraine, H., Gechter, M., Horn, H.G., Knörzer, K.-H., Müller, G., Rüger, C., Tauch, M.: Das römische Neuss, Konrad Theiss Verlag, Stuttgart, 1984.

Clauss, M.: Mithras, Kult und Mysterium, WBG, Darmstadt, 2012.

Cohen, G.M.: The Hellenistic Settlements in the East from Armenia and Mesopotamia to Bactria and India, University of California Press, Berkeley, CA, 2013.

Colledge, M.A.R.: The Parthians, Thames and Hudson, London, 1967.

Colledge, M.A.R.: The Art of Palmyra, Thames and Hudson, London, 1976.

Colledge, M.A.R.: Parthian Art, Elek Books, London, 1977.

Colledge, M.A.R.: The Parthian Period, Iconography of Religions, Iran, 3, Institute of Religious Iconography, E.J. Brill, Leiden, 1986.

Cribb. J.: The early Kushan kings: new evidence for chronology. Evidence from the Rabatak - Inscription of Kanishka I, in: Alram, M. (ed.), Coins, Art and Chronology, Verlag der Österreichischen Akademie Der Wissenschaften, Vienna, 1999, pp. 177–206.

Cumont, F.: Fouilles de Doura-Europos, Atlas, in: Bibliothèque archéologique et historique, Comptes rendue de l'academie des inscription et belles-lettres, P. Geuthner, Paris, 1939, pp. 330–339.

Curtis, J.E. (ed.): Ancient Persia, British Museum, London, 2000.

Curtis, V.S.: A Parthian statuette from Susa and the bronze statue from Shami, Iran 31, 1993, pp. 63–69.

Curtis, V.S.: More Parthian finds from ancient Elymais in Southwestern Iran, Iranica Antiqua 29, 1994 (1), pp. 201–214.

Curtis, V.S.: Persische Mythen, Reclam, Stuttgart, 1994 (2).

Curtis, V.S.: Parthian costume and headdress, in: Wiesehöfer, J. (ed.), Das Partherreich und seine Zeugnisse, Franz Steiner Verlag, Stuttgart, 1998, pp. 61–73.

Curtis, V.S.: Parthian culture and costume, in: Curtis, J. (ed.), Ancient Persia, British Museum, London, 2000, pp. 23–34.

Curtis, V.S.: Parthian belts and belt plaques, Iranica Antiqua 36, 2001, pp. 298–327.

Curtis, V.S.: The Frataraka coins of Persis, in: Curtis, J. and Simpson, St. J. (eds.), The World of Achaemenid Persia, Conference at the British Museum, October, I.B. Tauris, London, 2005, pp. 379–394.

Curtis, V.S.: Introduction, in: Curtis, V.S., Stewart, S. (eds.), The Age of the Parthians, British Museum, I.B. Tauris, London, 2007 (1), pp. 1–6.

Curtis, V.S.: The Iranian revival in the Parthian period, in: Curtis, V.S., Stewart, S. (eds.), The Age of the Parthians, British Museum, I.B. Tauris, London, 2007 (2), pp. 7–25.

Curtis, V.S.: Religious iconography on ancient Iranian coins, in: Cribb, J. and Herrmann, G. (eds), After Alexander: Central Asia before Islam, The British Academy, Oxford University Press, Oxford, 2007 (3), pp. 413–434.

Curtis, V.S.: Parthian coins: kingship and divine glory, in: Wick, P., Zehnder, M. (eds.), Das Partherreich und seine Religionen, Computus Druck Satz & Verlag, Gutenberg, 2012, pp. 67–79.

Curtis, V.S.: Birth of the Persian Empire: The Idea of Iran, volume 1, I.B. Tauris, London, 2015.

Curtis, V.S., Hillenbrand, R., Rogers, J.M. (eds.): The Art and Archaeology of Ancient Persia: New Light on the Parthian and Sasanian Empires, I.B. Tauris, London, New York, 1998.

Curtis, V.S., Pendleton, J.E., Alram, M., Daryae, T. (eds.): The Parthian and Early Sasanian Empires: Adaption and Expansion, The British Institute of Persian Studies, Archaeological Monographs Series V, Oxbow Books, Oxford, 2016.

Curtis, V.S., Stewart, S.: The Age of the Parthians, British Museum, I.B. Tauris, London, 2007.

Dąbrowa, E.: Zeugnisse zur Geschichte der parthischen Susiane und Elymais, in: Wiesehöfer, J. (ed.), Das Partherreich und seine Zeugnisse, Steiner Verlag, Stuttgart, 1998, pp. 417–424.

Dąbrowa, E.: The political propaganda of the first Arsacids and its targets (from Arsaces I to Mithradates II), Parthica 10, Istituti editoriali e Poligrafici internationali MMV, Pisa, Rome, 2008, pp. 25–31.

Dąbrowa, E.: Mithradates I and the beginning of the ruler-cult in Parthia, Electrum 15, 2009, pp. 41–51.

Dąbrowa, E.: Studia Graeco-Parthica: Political and Cultural Relations between Greeks and Parthians, Philippika, Marburger altertumskundliche Abhandlungen 49, Harrassowitz Verlag, Wiesbaden, 2011.

Dąbrowa, E.: The Arsacids and their state, in: Rollinger, R. et al. (eds.), Altertum und Gegenwart: 125 Jahre Alte Geschichte in Innsbruck, Vorträge der Ringvorlesung, Innsbruck 2010, Insbrucker Beiträge zur Kulturwissenschaft, Innsbruck, 2012, pp. 21–51.

Dąbrowa, E.: God or godlike creatures?, in: Divinizzazione, culto del sovrano e apotesi, Tra Antichità e Midioevo, a cura di Tommaso Gnoli e Federicomaria Muccioli, Bononia University Press, Bologna, 2014, pp. 149–159.

Dąbrowa, E.: Sacral kingship in Parthia, Studi Ellenistici 31, 2017, pp. 287–297.

Dąbrowa, E.: Arsacid dynastic marriages, Electrum 25, 2018, pp. 73–83.

Dani, A.H., Masson, V.M. (eds.): History of Civilizations of Central Asia, volume 1: The Dawn of Civilization: Earliest Times to 700 B.C., Unesco, Paris, 1992.

Dani, A.H., Masson, V.M. (eds.): History of Civilizations of Central Asia, volume 2: The Development of Sedentary and Nomadic Civilizations: 700 B.C. to A.D. 250, Unesco, Paris, 1996.

Daryaee T.: Ardaxsir and the Sasanians' rise to power, Anabasis, 1, 2010.

Daryaee, T.: From terror to tactical use: elephants in the Partho-Sasanian Period, in: Curtis, V.S., Pendleton, J.E., Alram, M., Daryae, T. (eds.), The Parthian and Early Sasanian Empires: Adaption and Expansion, The British Institute of Persian Studies, Archaeological Monographs Series V, Oxbow Books, Oxford, 2016, pp. 36–41.

Davis, D.: Shahnameh: The Persian Book of Kings, Penguin Books, London, 2004.

Debevoise, N.C.: A Political History of Parthia, The University of Chicago Press, Chicago, IL, 1938.

Debevoise, N.C.: The origins of decorative stucco, American Journal of Archaeology (AJA) 45, 1941, pp. 45–61.

De Callataÿ, F.: Les Tetradrachmes d'Orodès II. Et de Phraate IV. Études du rythme de leur production monétaire à la lumiere d'une grand trouvaille, Cahiers de Studia Iranica 14, 1994.

De Callataÿ, F., Corber, C.: The pattern of royal epithets on Hellenistic coinages, Studia Hellenistica 51, 2011, pp. 417–456.

De Jong, A.: Traditions of the Magi: Zoroastrianism in Greek and Latin Literature, Religions in the Graeco-Roman World, 133, Brill, Leiden, New York, Cologne, 1997.

De Jong, A.: Regional variation in Zoroastrianism: the case of the Parthians, Zoroastrianism and Mary Boyce with Other Studies, new series 22, 2008, pp. 17–27. Available at: www.jstor.org/stable/i24046710.

De Jong, A.: Religion at the Achaemenid court, in: Jacobs, B., Rollinger, R. (eds.), Der Achämenidenhof, Akten des 2. Internationalen Kolloquiums (2007) zum Thema 'Vorderasien im Spannungsfeld klassischer und altorientalischer Überlieferungen'. Harrassowitz Verlag, Wiesbaden, 2010, pp. 533–558.

De Jong, A.: Regional variation in Zoroastrianism: the case of the Parthians, Bulletin of the Asia Institute 22 (Zoroastrianism and Mary Boyce with Other Studies), 2012 (1), pp. 17–27.

De Jong, A.: Religion in Iran, the Parthian and Sasanian period (247 BCE–654 CE), in: Stausberg, M., Vevaina, Y.S.-D. (eds.), The Wiley Blackwell Companion to Zoroastrianism, Wiley-Blackwell, Chichester, 2012 (2), pp. 22–53.

De Jong, A.: Hatra and the Parthian commonwealth, in: Dirven, L. (ed.), Hatra: Politics, Culture and Religion between Parthia and Rome, Steiner Verlag, Stuttgart, 2013, pp. 143–160.

De Jong, A.: The Cologne Mani Codex and the life of Zarathustra, in: Herman, G. (ed.), Jews, Christians and Zoroastrians: Religious Dynamics in a Sasanian Context, Judaism in Context 17, Gorgias Press, Piscataway, NJ, 2015 (1) pp. 129–147.

De Jong, A.: Religion and politics in pre-Islamic Iran, in: Stausberg, M., Vevaina, Y.S.-D. (eds.), The Wiley Blackwell Companion to Zoroastrianism, Wiley-Blackwell, Chichester, 2015 (2), pp. 85–102.

Dirven, L.: The Palmyrenes of Dura-Europos: A Study of Religious Interaction in Roman Syria, Religions in the Graeco-Roman World, Brill, Leiden, 1999.

Dirven, L.: Hatra - un exemple exceptionnel de l'art parthe, Dossiers d'Archéologie 334, 2009, pp. 46–55.

Dirven, L.: Religious frontiers in the Syrian-Mesopotamian desert, in: Hekster, O., Kaizer, T. (eds.), Frontiers in the Roman World, Proceedings of the Ninth Workshop of the International Network Impact of Empire (Durham, 16–19.4.2009), Brill, Leiden, 2011, pp. 157–174.

Dirven, L. (ed.): Hatra: Politics, Culture and Religion between Parthia and Rome, Franz Steiner Verlag, Stuttgart, 2013 (1).

Dirven, L.: Italian studies on Parthian Nisa (Mithradatkert), Bibliothekca Orientalis 70, 5–6, 2013 (2), pp. 632–642.

Don, T.: Warts and the kings of parthia: an ancient representation of hereditary neurofibromatosis depicted in coins, Journal of the History of the Neurosciences 17, 2, 2008, pp. 141–146, available at: www.tandfonline.com/doi/abs/10.1080/09647040601079607.

Dornblüth, O.: Klinisches Wörterbuch, de Gruyter, Berlin, 1927.

Dörner, F.K. (ed.): Antike Welt, special issue: Kommagene, 1975.

Dörner, F.K.: Kommagene – Götterthrone und Königsgräber am Euphrat, Lübbe, Bergisch-Gladbach, 1989.

Dörner, F.K., Goell, Th.: Arsameia am Nymphaios, Istanbuler Forschungen 23, Berlin, 1963.

Dörner, F.K., Goell, Th.: Zur Rekonstruktion der Ahnengalerie des Königs Antiochos I. von Kommagene, Istanbuler Mitteilungen 17, 1967, pp. 195–210.

Dörner, F.K. et al.: Arsameia am Nymphaios. Bericht über die 1963 und 1964 ausgeführten Ausgrabungen, Archäologischer Anzeiger (AA), 1965, pp. 188–235.

Dörner, F.K. et al.: Arsameia am Nymphaios. Bericht über die Grabungskampagne 1965, Istanbuler Mitteilungen 16, 1966, pp. 130–156.

Dörner, F.K. et al.: Kommagene, Forschungsarbeiten von 1967 bis 1969, Istanbuler Mitteilungen 19/20, 1969/70, pp. 255–288.

Downey, S.: Mesopotamian Religious Architecture: Alexander through the Parthians, Princeton University Press, Princeton, NJ, 1988.

Drijvers, H.J.W.: Hatra, Palmyra und Edessa. Die Städte der syrisch-mesopotamischen Wüste in politischer, kulturgeschichtlicher und religionsgeschichtlicher Bedeutung, Aufstieg und Niedergang der römischen Welt 2, 8, 1977, pp. 799–906.

Drijvers, H.J.W.: Cults and Beliefs at Edessa, Brill Archive, Leiden, 1980.

Ehlers, J.: Ferdausi: Schāhnāme, die Rostam Legenden (deutsche Übersetzung), Reclam, Stuttgart, 2010.

Ehrhardt, N.: Parther und parthische Geschichte bei Tacitus, in: Wiesehöfer, J. (ed.), Das Partherreich und seine Zeugnisse; Beiträge des internationalen Colloquiums, Eutin (27.–30. Juni 1996), Franz Steiner Verlag, Stuttgart, 1998, pp. 295–307.

Ellerbrock, U.: Religiöse Ikonographie auf parthischen Münzen: Der Einfluss politisch-gesellschaftlicher Veränderungen auf das Bild der Göttin Tyche im Parthischen Reich, Iranica Antiqua 48, 2013 (1), pp. 253–311.

Ellerbrock, U.: Review of: Studia Graeco-Parthica, Political and Cultural Relations between Greeks and Parthians, by Edward Dąbrowa, Philippika Marburger Altertumskundliche Abhandlungen 49, 2013 (2).

Ellerbrock, U.: Parthisch: die Sprache der Gegner Roms im Osten, Antike Welt 2, 17, 2017, pp. 6–7.

Ellerbrock, U., Winkelmann, S.: Die Parther, Die vergessene Großmacht, Zabern Verlag, Darmstadt, 2012.

Ellerbrock, U., Winkelmann, S.: Die Parther, Die vergessene Großmacht, revised and expanded second edition, Zabern Verlag, Darmstadt, 2015.

Engels, D.: 'Je veux être calife à la place du calife'? Überlegungen zur Funktion der Titel 'Großkönig' und 'König der Könige' vom 3. zum 1. Jh. v. Chr., in: Cojocaru, V., Coşkun, A., Dana, M. (eds.), Interconnectivity in the Mediterranean and Pontic World during the Hellenistic and Roman Periods, Mega Publishing House, Cluj-Napoca, 2014, pp. 333–362.

Fabrégues, Ch.: The Indo-Parthian beginnings of Gandhara sculpture, Bulletin of the Asian Institute 1, 1987, pp. 33–43.

Frenschkowski, M.: Frühe Christen in der Begegnung mit dem Zoroastrismus, in: Wick, P., Zehnder, M. (eds.), Das Partherreich und seine Religionen, Computus Druck, Satz & Verlag, Gutenberg, 2012, pp. 163–194.

Frenschkowski, M.: Christianity, in: Stausberg, M., Vevaina, Y.S.D., Tessmann, A. (eds.), The Wiley Blackwell Companion to Zoroastrianism, Wiley, Chichester, 2015.

Fukai, S.: The artifacts of Hatra and Parthian art, East and West 11, 2–3, 1960, pp. 135–181.

Gaibov, V.A., Košelenko, A.: Temples of fire on the territory of the southern Turkmenistan, Parthica 14, 2012, Istituti editoriali e Poligrafici internationali MMV, Pisa, Rome, 2013, pp. 161–170.

Gall, H. von: Beobachtungen zum arsakidischen Diadem und zur parthischen Bildkunst, Istanbuler Mitteilungen 19/20, 1970, pp. 299–318.

Gall, H. von: Das Reiterkampfbild in der iranischen und iranisch-beeinflussten Kunst parthischer und sasanidischer Zeit, Teheraner Forschungen, Berlin, 1990.

Gall, H. von: Architektur und Plastik unter den Parthern, in: Wiesehöfer, J. (ed.), Das Partherreich und seine Zeugnisse; Beiträge des internationalen Colloquiums, Eutin (27.-30. Juni 1996), Franz Steiner Verlag, Stuttgart, 1998, pp. 75–94.

Garaboldi, A.: Royal ideological patterns between Seleucid and Parthian Coins. The case of Theopátor, 2004 (1), available at: www.aakkl.helsinki.fi/melammu/pdf/gariboldi2004a.pdf.

Garaboldi, A.: Astral symbology on Iranian coinage, East and West 54, 1–4, 2004 (2), pp. 31–53.

Gawlikowski, M.: The development of the city of Hatra, in: Dirven, L. (ed.), Hatra, Politics, Culture and Religion between Parthia and Rome, Franz Steiner Verlag, Stuttgart, 2013, pp. 73–79.

Ghirshman, R.: Firuzabad, Bulletin de l'Institut français d'archéologie orientale du Caire 46, 1947, pp. 1–28.

Ghirshman, R.: Persian Art, 249 B.C. – A.D. 651: The Parthian and Sasanian Dynasties, C.H. Beck, New York, 1962 (1).

Ghirshman, R.: Iran, Parther und Sasaniden, Universum der Kunst, Munich, 1962 (2).

Ghirshman, R.: Terrasses sacrées de Bard è Néchandeh et Masjid i Solaiman, MDAI 45, Paris, Brill, Leiden, 1976.

Ghirshman, R.: La ceinture en Iran, Iranica Antiqua 14, 1979, pp. 167–196.

Ginters, W.: Das Schwert der Skythen und Sarmaten in Südrussland, De Gruyter, Berlin, 1928.

Göbl, R.: The Rabatak inscription and the date of Kanishka, in: Alram, M., Klimburg-Salter, D. (eds), Coins, Art and Chronology, Verlag der Österreichischen Akademie Der Wissenschaften, Vienna, 1999, pp. 151–175.

Godard, A.: Les statues parthes de Shami, Athār é Irān 2, 1937, pp. 285–305.

Golze, U., Storm, K.: S. 482 Chinesische Quellen zum Partherreich, in: Hackl, U., Jacobs, B., Weber, D. (eds.), Quellen zur Geschichte des Partherreiches, volume 3, Vandenhoek & Ruprecht, Göttingen, 2010, pp. 482–511.

Gregoratti, L.: A Parthian port on the Persian Gulf: Characene and its trade, Anabasis 2, 2011, Studia Classica et Orientalia, pp. 209–229.

Gregoratti, L.: The importance of the mint of Seleucia on the Tigris for the Arsacid history, Mesopotamia 47, 2012 (1), pp. 129–136.

Gregoratti, L.: The Parthians between Rome and China, Akademisk quarter 4, 2012 (2), pp. 109–119.

Gregoratti, L.: The journey east of the Great King: East and West in the Parthian Kingdom, Parthica 15, 2013, pp. 43–52.

Gregoratti, L.: The Parthian Empire: Romans, Jews, Greeks, Nomads, and Chinese on the Silk Road, in: Walter, N.M., Ito-Adler, J.P. (eds.), The Silk Road: Interwoven History, volume 1: Long-distance Trade, Culture, and Society, Cambridge Institutes Press, Cambridge, 2014, pp. 43–70.

Gregoratti, L.: The kings of Parthia and Persia: some considerations on the 'Iranic' Identity in the Parthian Empire, Dabir 1, 1, 2015, pp. 14–16.

Gregoratti, L.: Legendary and real wealth in the Arsacid Kingdom, in: Santangelo, F., Bissa, E. (eds.), Studies on Wealth in the Ancient World, Institute of Classical Studies, London, 2016 (1), pp. 82–92.

Gregoratti, L.: Dura-Europos: a Greek town of the Parthian Empire, in: Kaizer, T. (ed.), Religion, Society and Culture at Dura-Europos, Cambridge University Press, Cambridge, 2016 (2), pp. 16–29.

Gregoratti, L.: Corbulo versus Vologases: a game of chess for Armenia, Electrum 24, 2017, pp. 107–121.

Gregoratti, L.: Indian Ocean trade: The role of Parthia, in: Cobb, M.A. (ed.), The Indian Ocean Trade in Antiquity: Political, Cultural and Economic Impacts, Routledge, Abingdon, 2018 (1), pp. 52–72.

Gregoratti, L.: Mithradates I, in: Bagnell, S. Broderson, K. Champion, C.B. Erskine, A. (eds.), Encyclopaedia of Ancient History, John Wiley & Sons, Chichester, 2018 (2). Available at academia.edu.

Gregoratti, L.: Tacitus and the great kings, in: Bagot, D., Whiskin, M. (eds.), Iran and the West, IB Tauris, London, 2019, pp. 21–34.

Gzella, H.: Die Wiege der ersten Weltsprache: Die altaramäische Sprache Syriens im 9. bis 8 Jh. v. Chr., Antike Welt 2, 2016, pp. 6–7.

Hackl, U.: various chapters in: Hackl, U., Jacobs, B., Weber, D. (eds.), Quellen zur Geschichte des Partherreiches, volume 1, Vandenhoek & Ruprecht, Göttingen, 2010: Die hellenistische Zeit (pp. 7–20), Schriftquellen zur Geschichte des Partherreiches (pp. 21–30), Das Partherreich und Rom seit dem 1. JH v. Chr. (pp. 56–77), Handel und Wirtschaft (pp. 111–124), Gesellschaft (pp. 124–129), Zeugnisse der Schriftquellen (pp. 135–144), Das Partherreich im Spannungsfeld zwischen griechisch-römischer und orientalischer Kultur (pp. 174–181).

Hackl, U., Jacobs, B., Weber, D. (eds.): Quellen zur Geschichte des Partherreiches, 3 vols, Vandenhoek & Ruprecht, Göttingen, 2010.

Haerinck, E.: La céramique en Iran pendant la période parthe (ca. 250 av. J. Chr. à 225 aprés J. C.), Iranica Antiqua, Ghent, 1983.

Hannemann, U.: Das Zend-Avesta, Volume 1, Weißensee Verlag, Weißensee, 2011.

Hansen, S., Wieczorek, A., Tellenbach, M. (eds.): Alexander der Große und die Öffnung der Welt – Asiens Kulturen im Wandel, Ausstellungskatalog, Schnell & Steiner, Mannheim, 2009.

Hansman, J.: Charax and the Karkheh, Iranica Antiqua 7, 1967, pp. 23–58.

Hansman, J.: The problems of Qūmis, Journal of the Royal Asiatic Society, 1968, pp. 111–139.

Hansman, J., Stronach, D.: Excavations at Shahr-i Qūmis, 1971, Journal of the Royal Asiatic Society, 1974, pp. 8–22. Available at: www.cambridge.org/core/journals/journal-of-the-royal-asiatic-society/article/excavations-at-shahri-qumis-1971/D4D331A21B1A38E1E 7DA0DC3AA259C4A.

Harmatta, J.: History of Civilizations of Central Asia: The Development of Sedentary and Nomadic Civilizations: 700 B.C. to A.D. 250, Motilal Banarsidass, Delhi, 1999.

Harnack, D.: Parthische Titel, vornehmlich in den Inschriften aus Hatra. Ein Beitrag zur Kenntnis des parthischen Staates, in: Altheim, Franz, Stiehl, Ruth (eds.), Geschichte Mittelasiens im Altertum, Walter de Gruyter, Berlin, 1970, pp. 537–540.

Hart, G.D.: The diagnosis of disease from ancient coins, Archaeology 26, 1973, pp. 123–127.

Hartmann, U.: Wege durch Parthien – Straßen, Handelsrouten und Kommunikation im Arsakidenreich, in: Woytek, B. (ed.), Infrastructure and Distribution in Ancient Economies. Proceedings of a Conference Held at the Austrian Academy of Sciences, 28–31 October 2014, Vienna, 2018, pp. 445–472. Available at: www.academia.edu/38557271.

Hauser, S.R.: Hatra und das Königreich der Araber, in: Wiesehöfer, J. (ed.), Das Partherreich und seine Zeugnisse; Beiträge des internationalen Colloquiums, Eutin (27.-30. Juni 1996), Franz Steiner Verlag, Stuttgart, 1998, pp. 491–528.

Hauser, S.R.: Die ewigen Nomaden? Bemerkungen zur Herkunft, Militär, Staatsaufbau und nomadischen Traditionen der Arsakiden, in: Meißner, Burkhard, Schmitt, Oliver, Sommer, Michael (eds.), Krieg – Gesellschaft – Institutionen: Beiträge zu einer vergleichenden Kriegsgeschichte, Akademie Verlag, Berlin, 2005, pp. 163–208.

Hauser, S.R.: Was there no fresh standing army? A fresh look on military and political institutions, in: Mode, M., Tubach J. (eds.), Arms and Armor as Indicators of Cultural Transfer, Reichert Verlag, Wiesbaden, 2006, pp. 295–319.

Hauser, S.R.: 'Parthian art' or 'arts in the Arsacid Empire': Hatra and Palmyra as nodal points for cultural interaction, in: Jacobs, B. (ed.), Parthische Kunst-Kunst im Partherreich, Wellem Verlag, Duisburg, 2014, pp. 127–178.

Hauser, S.R.: Münzen, Medien und der Aufbau des Arsakidenreiches, in: Luther, Andreas, Binder, Carsten, Börm, Henning (eds.), Diwan: Studies in the History and Culture of the Ancient Near East and the Eastern Mediterranean. Festschrift für Josef Wiesehöfer zum 65. Geburtstag, Wellem Verlag, Duisburg, 2016, pp. 433–492.

Heichelheim, F.M.: Geschichte Syriens und Palästinas von der Eroberung durch Kyros II. bis zur Besitznahme durch den Islam, in: Dietrich, A., Widengren, G., Heichelheim, F.M. (eds.), Orientalische Geschichte Von Kyros Bis Mohammed, Brill, Leiden, 1996, pp. 99–190.

Heim, M.: Von Ablass bis Zölibat: kleines Lexikon der Kirchengeschichte, C.H. Beck, Munich, 2008.

Heinrich, E.: Sechster vorläufiger Bericht über die von der Deutschen Forschungsgemeinschaft in Uruk Warka unternommenen Ausgrabungen. Abh. der Preußischen Akad. der Wissenschaften, phil. hist. Kl. 2, Berlin, 1935.

Henning, K.: Jerusalemer Bibel-Lexikon, Jerusalem Publishing House, Neuhausen-Stuttgart, 1990.

Herz, Peter: Die Ala Parthorum et Araborum, Bemerkungen zur römischen Heeresgeschichte, in: Germania, Anzeiger der Römisch-Germanischen Kommission der Deutschen Archäologischen Instituts, Jg. 60, 1. Halbband, Philipp von Zabern, Mainz am Rhein, 1982, pp. 173–182.

Herzfeld, E.: Reisebericht, ZDMG 80, 5, 1926, pp. 225–284.

Herzfeld, E.: Sakestan, Geschichtliche Untersuchungen zu den Ausgrabungen am Kuh-e Khwadja, AMI 4, 1931–32, pp. 1–116.

Herzfeld, E.: Iran in the Ancient East: Archaeological Studies Presented in the Lowell Lectures at Boston, London, and New York, Oxford University Press, Oxford, 1941, Reprint 1988.

Hettner, F.: Die Steindenkmäler des Provinzialmuseums zu Trier, Kommission der Fr. Lintz'schen Buchhandlung, Trier, 1893.

Hintze, A.: The Avesta in the Parthian period, in: Wiesehöfer, J. (ed.), Das Partherreich und seine Zeugnisse, Franz Steiner Verlag, Stuttgart, 1998, pp. 147–161.

Hintze, A.: Monotheismus zoroastrischer Art, in: Assmann, J., Strohm, H. (eds.), Echnaton und Zarathustra, Genese u. Dynamik des Monotheismus, Fink Verlag, Munich, 2012, pp. 63–92.

Hintze, A.: Zarathustra's time and homeland: linguistic perspectives, in: Stausberg, M., Vevaina, Y.S.-D. (eds.), The Wiley Blackwell Companion to Zoroastrianism, Wiley-Blackwell, Chichester, 2015, pp. 31–38.

Hoepfner, W.: Das Hierothesion Mithradates I. von Kommagene. Ergebnisse der jüngsten Ausgrabungen in Arsameia am Nymphaios, Archäologischer Anzeiger (AA), 1966, pp. 528 ff.

Hoepfner, W.: Arsameia am Nymphaios II. Das Hierothesion des Königs Mithradates I. Kallinikos von Kommagene nach den Ausgrabungen von 1963 bis 1967, Istanbuler Forschungen 33, Ernst Wasmut, Tübingen, 1983.

Homès-Fredericq, D.: Hatra et ses sculptures parthes, étude stylistique et iconographique, Historisch archeologisch Instituut, Istanbul, 1963.

Hopkins, C. (ed.): Topography and Architecture of Seleucia on the Tigris, University of Michigan Press, Ann Arbor, MI, 1972.

Hornig, H.: Leben und Sterben im nordmesopotamischen Magdala (Syrien), Dissertation, Berlin, 2008, available at: www.diss.fu-berlin.de/diss/receive/FUDISS_thesis_000000003741.

Huber, I., Hartmann, U.: Die Position der Frauen am Hof der Arsakiden, in: Panaino, A., Piras, A. (eds.), Proceedings of the 5th Conference of the Societas Iranologica Europaea, Ravenna, 6–11. Oktober 2003, volume 1: Ancient and Middle Iranian Studies, Mimesis, Milan, 2006, pp. 485–517.

Huff, D.: Takht-i Suleiman: Vorläufiger Bericht über die Ausgrabungen im Jahr 1976, AMI n.s. 10, 1977, pp. 211–230.

Huff, D.: Takht-i Suleiman: Der 'Thron des Salomo' in den iranischen Bergen, Bild der Wissenschaft 7, 1982, pp. 30–40.

Huff, D.: Takht-i Suleiman: Tempel des sassanidischen Reichsfeuers Atur Gushnasp, in: Archäologische Entdeckungen: Die Forschungen des Deutschen Archäologischen Instituts im 20. Jahrhundert I, Deutsches Archäologisches Institut, Mainz, 2000, pp. 103–109.

Imanpour, M.T.: The function of Persepolis: Was Norooz celebrated at Persepolis during Achaemenid period?, in: 5th conference of the Societas Iranologica Europeae, 2006, pp. 115–121.

Ingholt, H.: Inscriptions and sculptures from Palmyra I, Berytus 3, 2, 1936, pp. 83–125.

Ingholt, H.: Inscriptions and sculptures from Palmyra II, Berytus 5, 1938, pp. 13–140.

Ingholt, H.: Parthian Sculptures from Hatra: Orient and Hellas in Art and Religion, The Academy, New Haven, CT, 1954.

Invernizzi, A.: The excavations at the Archives Building, Mesopotamia 7, 1972, pp. 13–16.

Invernizzi, A.: The excavations at the Archives Building, Mesopotamia 8, 1973–1974, pp. 9–14.

Invernizzi, A.: Die Kunst der Partherzeit, in: Seipel, W. (ed.), 700 Jahre persische Kunst, Meisterwerke aus dem Iranischen Nationalmuseum in Teheran, Kunst und Ausstellungshalle der Bundesrepublik Deutschland, Bonn, 10.8.2001–6.1.2002, Kunsthistorisches Museum, Bonn, 2002, pp. 231–261.

Invernizzi, A.: Representation of gods in Parthian Nisa, Parthica 7, Istituti editoriali e Poligrafici internationali, Pisa, Rome, 2005.

Invernizzi, A.: The Culture of Parthian Nisa between Steppe and Empire, Proceedings of the British Academy 133, 2007, pp. 163–177.

Invernizzi, A.: Nisa partica. Le sculture ellenistiche, Monografie di Mesopotamia, XI, Le Lettere, Florence, 2008.

Invernizzi, A.: Nisa. Encyclopædia Iranica, 2000/2010. Available at: www.iranicaonline.org/articles/nisa.

Invernizzi, A.: A note on the Nisa rhytons, in: Invernizzi, A. (ed.) «Mnème», Documenti, culture, storia del Mediterraneo e dell'Oriente Antico, 9, Edizioni dell'Orso Alessandria, Alessandria, 2013, pp. 87–101.

Invernizzi, A.: A note on architectural traditions in Arsacid Parthia: the round hall at Nisa, in: Curtis, V.S. et al. (eds.), The Parthian and Early Sasanian Empires, Oxbow Books, Oxford, 2016, pp. 83–90.

Invernizzi, A.: Le portait chez les Parthes, in: Boschung, D., Queyrel, F. (eds.), Bilder der Macht. Das griechische Portrait und seine Verwendung in der antiken Welt, Brill, Paderborn, 2017, pp. 269–303.

Jacobs, B.: various chapters in: Hackl, U., Jacobs, B., Weber, D. (eds.), Quellen zur Geschichte des Partherreiches, volume 1, Vandenhoek & Ruprecht, Göttingen, 2010: Historische Geographie des Steppenraumes (pp. 1–7), Parthien - Von der seleukidischen Provinz zum unabhängigen Königreich (pp. 31–40), Die Zeit der Eroberungen (pp. 40–50), Die Ausdehnung von nach Norden und Osten (pp. 50–56), Herrscherhaus und Hof, Verwaltung (pp. 77–100), Militärwesen (pp. 104–110), Architektur und Kunst (pp. 129–135), Zur Religion der Parther (pp. 145–153), Das Ende der Arsakidenherrschaft (pp. 168–173).

Jacobs, B.: chapters in: Jacobs, B. (ed.): Repräsentative Bildkunst im Partherreich. Parthische Kunst - Kunst im Partherreich, Akten des Internationalen Kolloquiums in Basel, 9. Oktober 2010, Wellem Verlag, Duisburg, 2014: Einleitung (pp. 3–10), Repräsentative Bildkunst im Partherreich (pp. 77–126).

Jacoby, F. (ed.): Fragmente Griechischer Historiker, Brill, Berlin, Leiden, 1940.

Jahanian, D.: Medicine in Avesta and Ancient Iran, n.d., available at: www.facebook.com/note.php?note_id=470719406511.

Jakubiak, K.: A note on the inscriptions and architectural decorations from the small temples, in: Dirven, L. (ed.), Hatra: Politics, Culture and Religion between Parthia and Rome, Franz Steiner Verlag, Stuttgart, 2013, pp. 91–105.

Junkelmann, M.: Die Reiter Roms, Teil II: Der militärische Einsatz, Verlag Phillip von Zabern, Mainz am Rhein, 1991.

Kaim, B.: New evidence of Zoroastrian iconography of the late Parthian Period, Iranica Antiqua 51, 2015, pp. 201–213.

Kaim, B.: Women, dance and the hunt: splendour and pleasures of court life in Arsacid and early Sasanian art, in: Curtis, V.S. Pendleton, E. Alram, M., Daryaee, T. (eds.), The Parthian and Early Sasanian Empires: Adaption and Expansion, Oxbow Books, Oxford, 2016, pp. 90–108.

Kaizer, T.: Reflections on the dedication of the Temple of Bel at Palmyra in AD 32, in: de Blois, L., Funke, P., Hahn, J. (eds.), The Impact of Imperial Rome on Religions, Ritual and Religious Life in the Roman Empire, Proceedings from the Fifth Workshop of the International Network Impact of Empire (Roman Empire, 200 BC–AD 476), Münster 30. Juni–4. Juli 2004, Brill, Leiden, 2006, pp. 95–105.

Kaizer, T.: Kings and Gods, in: Kaizer, T. and Facella, M. (eds.), Kingdoms and Principalities in Roman Near East, Franz Steiner Verlag, Stuttgart, 2010, pp. 113–124.

Kaizer, T.: The Religious Life of Palmyra: A Study of the Social Patterns of Worship in the Roman Period, Franz Steiner Verlag, Stuttgart, 2012.

Kaizer, T.: Questions and problems concerning the sudden appearance of the material culture of Hatra in the first centuries CE, in: Dirven, L. (ed.), Hatra: Politics, Culture and Religion between Parthia and Rome, Franz Steiner Verlag, Stuttgart, 2013, pp. 57–72.

Kaizer, T.: Religion, Society and Culture at Dura-Europos, Cambridge University Press, Cambridge, 2016.

Karamian, G., Farrokh, K.: A unique Parthian sword in the Bonyad-e Mostazafan Museum, 2019, available at: https://doi.org/10.34739/his.2019.08.15.

Karomatov, F.M., Meškeris, V.A., Vyzgo, T.S., Mittelasien: Musikgeschichte in Bildern, volume 2: Musik des Altertums, Lfg 9, Dt. Verl. für Musik, Leipzig, 1984.

Karras-Klapproth, M.: Prosopographische Studien zu Geschichte des Partherreiches auf der Grundlage antiker literarischer Überlieferung, Habelt, R, Bonn, 1988.

Karvonen-Kannas, K.: The Seleucid and Parthian Terracotta Figurines from Babylon, Monografie di Mesopotamia, IV, Casa editrice le lettere, Florence, 1995.

Kawami, T.S.: Kuh-e Khwaja, Iran and its wall paintings: the records of Ernst Herzfeld, Metropolitan Museum of Art Journal 22, 1987 (1), pp. 13–52.

Kawami, T.S.: Monumental Art of the Parthian Period in Iran, Acta Iranica 26, E.J. Brill, Leiden, 1987 (2).

Kawami, T.S.: Ernst Herzfeld, Kuh-i Khwaja, and the study of Parthian art, in: Gunter, A.C., Hauser, S.R. (eds.), Ernst Herzfeld and the Development of Near Eastern Studies, 1900–1950, Brill, Leiden, 2005, pp. 181–214.

Keall, E.J.: Archaeology and the fire temple, in: Adams, C.J. (ed.), Iranian Civilization, McGill University Institute of Islamic Studies, Montreal, 1973, pp. 15–22.

Keall, E.J.: Some thoughts on the early Eyvan, in: Kouymjian, D.K. (ed.), Near Eastern Numismatics, Iconography, Epigraphy and History: Studies in Honour of George C. Miles, American University of Beirut, Beirut, 1974, pp. 123–130.

Keall, E.J.: Qal'eh-i Yazdigird: an overview of the monumental architecture, Iran 20, 1982, pp. 51–72.

Keall, E.J., Leveque, M.A., Willson, N.: Qal'eh-i Yazdigird: its architectural decorations, Iran 18, 1980, pp. 1–41.

Keller, D.: Die arsakidischen Münzen, in: Hackl, U., Jacobs, B., Weber, D. (eds.), Quellen zur Geschichte des Partherreiches, volume 2, Vandenhoek & Ruprecht, Göttingen, 2010, pp. 613–632.

Kennedy, D.L.: Parthian regiments in the roman army, in: Fitz, J. (ed.), Limes: Akten des XI. Internationalen Limeskongresses (Székesfehérvár, 30.8.-6.9.1976), Akadémiai Kiado, Budapest, 1977, pp. 520–531.

Kettenhofen, E.: Die Arsakiden in armenischen Quellen, in: Wiesehöfer, J. (ed.), Das Partherreich und seine Zeugnisse, Franz Steiner Verlag, Stuttgart, 1998, pp. 325–354.

Kettenhofen, E.: Orbis Parthicus. Studies in Memory of Professor Józef Wolski edited by Edward Dąbrowa, FeRA 13, 2010, available at: http://s145739614.online.de/fera/ausgabe13/Kettenhofen.pdf.

Khurshudian, E.: Die parthischen und sasanidischen Verwaltungsinstitutionen, Verlag des Kaukasischen Zentrums für Iranische Forschungen, Yerevan, 1998.

Klose, D.: Die Grundlegung der modernen Welt in der Antike: Lehrerhandreiche für den Geschichtsunterricht nach neuem Rahmenlehrplan für die Sekundarstufe II, Universitätsverlag Potsdam, Berlin- Brandenburg, 2008.

Klose, O.A., Müseler, W.: Statthalter-Rebellen-Könige; Die Münzen aus Persepolis von Alexander dem Großen bis zu den Sasaniden, Staatlichen Münzsammlung, Munich, 2008.

Koch, H.: A Hoard of Coins from Eastern Parthia, The American Numismatic Society, The J. Paul Getty Museum, New York, 1990.

Korn, A.: S. Parthian month names and calendars, Parthica 8, Istituti editoriali e Poligrafici internationali, Pisa, Rome, 2006, pp. 153–167.

Koshelenko, G.A., Gaibov, V.A.: The Avestan vara and the early towns of Central Asia, Parthica 16, 2014, pp. 69–91.

Kreyenbroek, P.G.: Exegesis, 1999/2012. Available at www.iranicaonline.org/articles/exegesis-i.

Kuhlke, H., Rothermund, D.R.: Geschichte Indiens, Von der Induskultur bis heute, Beck historische Bibliothek, Munich, 2010.

Landskron, A.: Parther und Sasaniden: Das Bild der Orientalen in der römischen Kaiserzeit, Phoibos Verlag, Vienna, 2005.

Lehmann, G.A.: Alexander der Große und die 'Freiheit der Hellenen', de Gruyter, Berlin, 2015.

Leicht, B.: Mythos und Wahrheit einer Stadt – Babylon, Ausstellung in Berlin, Welt und Umwelt der Bibel 49, 3, 2008, pp. 3–7.

Lenzen, H.J.: Ausgrabungen in Hatra, Archäologischer Anzeiger 70, 1950, pp. 334–375.

Lenzen, H.J.: Architektur der Partherzeit in Mesopotamia und ihre Brückenstellung zwischen der Architektur des Westens und des Ostens, in: Boehringer, E. (ed.), Festschrift für Carl Weickert, Staatliche Museen Berlin, Berlin, 1955, pp. 121–136.

Leriche, P.: Das Baktrien der tausend Städte, in: Alexander der Große und die Öffnung der Welt, Ausstellungskatalog, Publikationen der Reis-Engelhorn Museen Mannheim, Schnell & Steiner, Mannheim, 2010, pp. 158–167.

Le Rider, G.: Séleucie du Tigre, Les monnaies séleucides et parthes, Monografie di Mesopotamia 6, Le Lettere, Florence, 1998.

Lerner, J.D.: The Impact of Seleucid Decline on the Eastern Iranian Plateau, Franz Steiner Verlag, Stuttgart, 1999.

Lerner, J.D.: Mithradates I and the Parthian Archer, in: Schulde, J.M., Rubin, B.B. (eds.), Arsacids, Romans and Local Elites, Oxbow Books, Oxford and Philadelphia, PA, 2017, pp. 1–24.

Lerouge, Ch.: L'image des Parthes dans le monde gréco-romain: Du début du Ier siecle av. J.-C. jusqu'a la fin du Haut-Empire romain, Oriens et Occidens 17, Franz Steiner Verlag, Stuttgart, 2007.

Lippolis, C.: Notes on Parthian Nisa in the light of new research, Journal of Historical, Philological and Cultural Studies, Moscow, 2010.

Lippolis, C.: La Sala rotunda, in: Gli spendori di Nisa Partica, 4–29 maggio, Istituto San Guiseppe, Torino, 2011 (1), pp. 21–22.

Lippolis, C.: Old Nisa: The Turkmen-Italian Archaeological Project, in: Mamedov, M. (ed.), Monuments of History and Culture of Turkmenistan: Discoveries, Researches and Restoration for 20 Years of Independence, National Department of Protection, Research

& Restoration of Historical and Cultural Sites, Ashgabat, 2011 (2), pp. 286–301, available at: www.academia.edu/1481260/C_Lippolis_Old_Nisa_the_Turkmen_Italian_Archaeological_Project.

Lippolis, C.: Parthian Nisa: landscape, topography and settlement planning, in: Baumer, C., Novák, M. (eds.), Urban Cultures of Central Asia from the Bronze Age to the Karakhanids, Harrassowitz Verlag, Wiesbaden, 2019, pp. 73–84.

Lippolis, C., Davit, P., Turco, F.: Stucco and clay in the decoration of the monumental buildings of old Nisa, Syria, Supplément 5, 2017, pp. 1–12.

Loeschner, H.: Hidden kingdoms of Adiabiane, The Shekel, American Israel Numismatic Association, 45 3 & 4 (Cons. No 237, 238), May-August, 2011, pp. 19–26.

Lukonin, W.G.: Persien II, Dt. Bearbeitung, Walter, H. Nagel Verlag, Munich, Geneva, Paris, 1967.

Lütge, M.: Der Himmel als Heimat der Seele. Visionäre Himmelfahrtspraktiken und Konstrukte göttlicher Welten bei Schamanen, Magiern, Täufern und Sethianern. Iranische Spuren im Zostrianos von Nag Hammadi, Habilitation, July 2008.

Luther, A.: Die syrische Chronik des Josus Stylites, Walter de Gruter, Berlin, 1997.

Luther, A.: Überlegungen zur defectio der östlichen Satrapien vom Seleukidenreich, Göttinger Forum zur Altertumswissenschaft, 2, 1999, pp. 5–15.

Luther, A.: Osrhoener am Niederrhein, Drei altsyrische Graffiti aus Krefeld-Gellep, Marburger Beiträge zur antiken Handels-, Wirtschafts- und Sozialgeschichte, 27, 2009, pp. 11–30.

Luther, A.: Das Königreich Adiabene zwischen Parthern und Römern, in: Baltrusch, E., Wilker, J. (eds.), Amici-socii-clientes, abhängige Herrschaft im Imperium Romanum, Humboldt Universität, Berlin, 2015, pp. 275–300.

Madreiter, I., Hartmann, U.: Women at the Arsacid court, in: Carney, E., Müller, S. (eds.), Companion to Women and Monarchy in the Ancient Mediterranean, Routledge, London, forthcoming. Available at: www.academia.edu/40339523/.

Mairs, R.: Bactrian or Graeco-Bactrian kingdom, in: MacKenzie, J. (ed.), Wiley Blackwell Encyclopedia of Empire, Wiley-Blackwell, London, 2015, pp. 1–3, available at: www.academia.edu/23031604.

Manassero, N.: Meanings of rhyta and meanings of Old Nisa, in: Muradov, R. (ed.), Traces of Empires: Ancient and Medieval Culture of Central Asia (Festschrift G.A. Pugačenkova), Ashgabat, 2016. available at: www.academia.edu/1207356.

Marciak, M.: The cultural environment of Adiabene in the Hellenistic, Parthian and Sasanian Periods, Parthica 16, 2014, pp. 111–150.

Marciak, M.: Das Königreich Adiabene in hellenistisch-parthischer Zeit, Gymnasium 122, 1, 2015, pp. 57–74.

Martinez-Sève, L.: La ville de Suse à l'époque hellénistique, Revue Archéologique, 2002, pp. 31–54.

Masson, V.M.: Das Land der tausend Städte, Udo Pfriemer Buchverlag in der Bauverlag, Wiesbaden, Berlin, 1987.

Masson, M.E., Pugachenkova, G.A.: The Parthian Rhytons of Nisa, Monografie di Mesopotamia I, Le Lettere, Florence, 1982.

Mathiesen, H.E.: Sculpture in the Parthian Empire, 2 volumes, Aarhus University Press, Aarhus, 1992.

Maxfield, V.: The Military Decorations of the Roman Army, University of California Press, Berkeley, CA, 1981.

McGuire, Gibson: Parthian seal style: a contribution from Nippur, Mesopotamia 29, 1994, pp. 89–105.

Merkelbach, R.: Mithras: ein persisch-römischer Mysterienkult, W. de Gruyter, Munich, 1994.

Merkelbach, R., Stauber, J.: Jenseits des Euphrat, Walter de Gruyter, Munich, 2005.

Messina, V.: Seleucia al Tigri. Il monumento di Tell 'Umar. Lo scavo e le fasi architettoniche, Monografie di Mesopotamia XIII, Le Lettere, Florence, 2010.

Messina, V.: Seleucia on the Tigris: the Babylonian polis of Antiochus I, Mesopotamia 46, 2011, pp. 157–168.

Messina, V.: A new proposal for identifying the kings represented on the Hung-e Azhdar rock relief, Iranica Antiqua, 49, 2014, pp. 331–345.

Metzler, D.: Kommagene von Osten her gesehen, in: Wagner, J. (ed.), Gottkönige am Euphrat, Zabern, Mainz am Rhein, 2000, pp. 51–55.

Meyer, M.: Die Personifikation der Stadt Antiocheia: ein neues Bild für eine neue Gottheit, Walter de Gruyter, Berlin, 2006.

Mielczarek, M.: Cataphracti and Clibanarii: Studies on the Heavy Armoured Cavalry of the Ancient World, Studies on the History of Ancient and Medieval Art of Warfare 1. Oficyna Naukowa MS, Lodz, 1993.

Minns, E.H.: Parchments of the Parthian period from Avroman in Kurdistan, Journal of Hellenic Studies 35, 1915, pp. 22–65.

Mitchiner, M: Indo-Greek and Indo-Scythian Coinage, volume 4: Contemporaries of the Indo-Greeks, Hawkins Publication, London, 1975.

Mitchiner, M: Indo-Greek and Indo-Scythian Coinage, volume 5: Establishment of the Scythians in Afghanistan and Pakistan, Hawkins Publication, London, 1976 (1).

Mitchiner, M.: Indo-Greek and Indo-Scythian Coinage, volume 6: The Dynasty of Azes, Hawkins Publication, London, 1976 (2).

Mitchiner, M.: Indo-Greek and Indo-Scythian coinage, volume 7: The Decline of the Indo-Scythians, Hawkins Publication, London, 1976 (3).

Mittag, P.F.: Antiochos IV. Epiphanes. Eine politische Biographie, Klio-Beihefte N.F., Akademie Verlag, Berlin, 2006.

Momenzadeh, M.: Metallische Bodenschätze in Iran, in: Persiens antike Pracht, volume 1, Katalog der Ausstellung des Dt. Bergbaumuseums, Dt. Bergbaumuseum, Bochum, 2004, pp. 8–21.

Moorey, P.R.S.: Archaeological sites in media, in: Boardman, J. (ed.), Cambridge Ancient History: Plates to Volume IV, Cambridge University Press, Cambridge, 1988, pp. 5–10.

Muccioli, F.: La rappresentazione dei Parti nelle fonti tra II e I seculo a.C. e la polemica di Livio contro i levissimi ex Graecis, in: 'Incontri tra culture nell Oriente ellenistico e romano', Ravenna 11–12 marzo 2005, Mimesis Edizioni, 2007, pp. 87–115.

Muccioli, F.: Il problema del culto del sovrano nella regalità arsacide: appunti per una discussione, Electrum 15, 2009, pp. 83–104.

Musche, B.: Vorderasiatischer Schmuck zur Zeit der Arsakiden und der Sasaniden, E.J. Brill, Leiden, New York, Copenhagen, Cologne, 1988.

Nabel, J.: The Arsacids of Rome: Royal Hostages and Roman-Parthian Relations in the First Century CE, Dissertation, Cornell University, 2017.

Nikonorov, V.P.: The use of musical percussion instruments in ancient Eastern warfare: the Parthian an Middle Asian evidence, in: Hickmann, E., Laufs, I., Eichmann, R. (eds.), Studien zur Musikarchäologie II, Verlag Marie Leidorf, Rhaden, 1998, pp. 71–81.

Nikonorov, V.P.: The parade hatchet-klevets from Old Nisa, Anabasis 4, 2013, pp. 179–232.

Oberleitner, W.: Zum Parthermonument von Ephesos. Anmerkungen zum Artikel A. Landskron: Antike Bildsprache und das sog. Partherdenkmal von Ephesos, Forum Archaelogiae 31, 6, 2004, available at: http://homepage.univie.ac.at/elisabeth.trinkl/forum/forum0604/31parther.htm.

Olbrycht, M.J.: Das Arsakidenreich zwischen der mediterranen Welt und Innerasien, in: Dabrowa, E. (ed.), Ancient Iran and the Mediterranean World, Kracow, Jagiellonian University Press, 1996, pp. 123–160.

Olbrycht, J.M.: Vardanes contra Gotarzes II – Einige Überlegungen zur Geschichte des Partherreiches ca. 40–51 n.Chr., Folia Orientalia 33, 1997, pp. 81–100.

Olbrycht, M.J.: Die Kultur der Steppengebiete, in: Wiesehöfer, J. (ed.), Das Partherreich und seine Zeugnisse, Steiner Verlag, Stuttgart, 1998 (1), pp. 11–43.

Olbrycht, M.J.: Parthia et ulteriores gentes. die politischen Beziehungen zwischen dem arsakidischen Iran und den Nomaden der eurasischen Steppen, uduv-Verlagsgesellschaft, Munich, 1998 (2).

Olbrycht, M.J.: Das Arsakidenreich zwischen der mediterraneren Welt und Innerasien, Electrum 2, 1998 (3), pp. 113–159.

Olbrycht, M.J.: Bemerkungen zur parthischen Münzprägung unter Vologases I. und Pakorus II, Notae Numismaticae, Krakow, 1999.

Olbrycht, M.J.: Parthia and nomads of Central Asia: elements of steppe origin in the social and military developments of Arsacid Iran, in Orientwissenschaftliche Hefte, Mitteilungen des SFB 'Differenz und Integration' 5, Militär und Staatlichkeit, 12, Orientwissenschaftliches Zentrum der Martin Luther Universität, Halle, 2003, pp. 69–109.

Olbrycht, M.J.: Parthians, Greek culture and beyond, in: Twardowska, K. Salamon, M. Sprawski, S. Stachura, M. Turlej, S. (eds.), Within the Circle of Ancient Ideas and Virtues, Studies in Honour of Professor Maria Dzielska, Historia Iagielonica, Krakow, 2014 (1), pp. 129–142.

Olbrycht, M.J.: The genealogy of Artabanos II (AD 8/9–39/40), King of Parthia, Miscellanea Anthropologica et Sociologica 2014 (2) pp. 92–97.

Olbrycht, M.J.: The sacral kingship of the early Arsacids I: Fire cult and kingly glory, Anabasis 7, 16, 2016 (1), pp. 91–106.

Olbrycht, M.J.: Vologases I, Pakoros II and Artabanos III, Iranica Antiqua 51, 2016 (2), pp. 215–233.

Olbrycht, M.J.: 2017: Slipper coffins and funerary practices in Parthia, Anabasis, Studia Classica et Orientalia, 8, 2017, pp. 301–331.

Overtoom, N.L.: The power-transition crisis of the 240s BCE and the creation of the Parthian state, The International History Review, 38, 5, 2016, pp. 984–1013.

Overtoom, N.L.: The Parthians' unique mode of Warfare: a tradition of Parthian Militarism and the battle of Carrhae, Anabasis 8, 2017 (1), pp. 95–122.

Overtoom, N.L.: The Parthian rival and Rome's failure in the East: Roman propaganda and the stain of Crassus, Acta Antiqua Academiae Scientiarum Hungaricae 57, 2017 (2), 1–22.

Overtoom, N.L.: The power-transition crisis of the 160s–130s BCE and the formation of the Parthian Empire, Journal of Ancient History 7, 1, 2019, pp. 111–155.

Overtoom, N.L.: Reign of Arrows: The Rise of the Parthian Empire in the Hellenistic Middle East, Oxford University Press, Oxford, 2020.

Palasca. K.: The portrait of a Parthian queen ('Musa'), Archäologisches Korrespondenzblatt 32, 3, 2002, pp. 407–414.

Pappalardo, E.: Nisa Partica – I Rhyta Ellenistici, Monografie di Mesopotamia XII, Casa Editrice Le Lettere, Florence, 2010.

Paul, L.: Handbuch der Iranistik, Reichert Verlag, Wiesbaden, 2013:

Perkins, A.: The Art of Dura-Europos, Oxford University Press, Oxford, 1973.

Pognon, H.: Inscriptions sémitiques de la Syrie, de ls Mésopotamie et de la région de Mossoul, Librairie V. Lecoffre, Paris, 1907.

Posch, W.: Baktrien zwischen Griechen und Kuschan, Harrassowitz Verlag, Wiesbaden, 1995.

Posch, W.: Chinesische Quellen zu den Parthern, in: Wiesehöfer, J. (ed.), Das Partherreich und seine Zeugnisse, Steiner Verlag, Stuttgart, 1998, pp. 355–364.

Potts, D.T.: Nana in Bactria, Silk Road Art and Archaeology 7, 2001, pp. 23–35.

Potts, D.T.: Disposal of the dead in Planquadrat U/V XVIII at Uruk: a Parthian enigma?, Baghdader Mitteilungen 37, 2006, pp. 267–278.

Potts, D.T.: Elam, Elamites: ancient Near East, in: Klauck, H.-J. et al. (eds.), Encyclopaedia of the Bible and Its Reception, volume 7, Berlin, Boston, MA: De Gruyter, 2013, pp. 571–576.

Rakic, Yelena: Discovering the art of the Ancient Near East. Archaeological excavations supported by the Metropolitan Museum of Art, 2010.

Rawlinson, G.: The Sixth Great Oriental Monarchy or the Geography, History, and Antiquities of Parthia, Dodd, Mead & Company, New York; reprint April 1976, Imperial Organisation for Social Services, Tehran.

Reck, C.: Der Manichäismus als iranische Religion, in: Paul, L. (ed.), Handbuch der Iranistik, Reichert Verlag, 2013, pp. 171–184.

Rettelbach, G.: Chronologie und Kalender: Fragen der mathematischen und technischen Chronologie, Osterberechnungen, Kalender des Nahen und Mittleren Ostens, Umrechnungsprogramme, available at: www.nabkal.de/impressum.html.

Richter, C.H.: Parthische Pantoffelsarkophage. Untersuchungen zu einer Sargform Mesopotamiens im Vergleich mit Tonsärgen von Ägypten über den Mittelmeerraum bis Zentralasien, Alter Orient und Altes Testament 49, Ugarit-Verlag, Münster, 2011.

Rosenfield, J.M.: The Dynastic Art of the Kushans, University of California Press, Berkeley, CA, 1967.

Rostovtzeff, M.I.: Dura-Europos and the problem of Parthian art, Yale Classical Studies 5, 1935, pp. 157–304.

Rostovtzeff, M.I.: The Sarmatians and the Parthians, Cambridge Ancient History 11, 1936, pp. 91–130.

Rostovtzeff, M.I., Bellinger, A.R., Brown, F.E.: The Excavations at Dura-Europos Conducted by Yale University and French Academy of Inscriptions and Letters. Preliminary Report of Ninth Season of Work 1935–1936. Part III. The Palace of the Dux Ripae and the Dolocheneum. New Haven, CT, 1952.

Rostovtzeff, M.I., Bellinger, A.R., Hopkins, C.: The Excavations at Dura-Europos Conducted by Yale University and French Academy of Inscriptions and Letters. Preliminary report of 6th Season of Work October 1932–March 1933, New Haven, CT, 1936.

Rostovtzeff, M.I., Brown, F.E., Welles, C.B.: The Excavations at Dura-Europos Conducted by Yale University and French Academy of Inscriptions and Letters. Preliminary Report of Seventh and Eighth Season of Work 1933–1934 and 1934–1935, New Haven, CT, 1939.

Rüger, C.B.: Eine kleine Garnisonsgeschichte des römischen Neuss, in: Chantraine, Heinrich et al. (eds.), Das römische Neuss, Theiss, Stuttgart, 1984, pp. 45–52.

Safar, F., Mustapha, M.A.: Hatra: The City of Sun God, Wizarat, Baghdad, 1974.

Sanders, D.H. (ed.): 1996, Nemrud Daği: The Hierothesion of Antiochos I of Commagene. Results of the American Excavations Directed by Theresa B. Goell, volumes 1 and 2, Eisenbrauns, Winona Lake, IN, 1996.

Sarianidi, V.: Traces of Parthian culture in the cemetery of Tillya Tepe (Afghanistan), in: Curtis, V.S., Hillenbrand, R., Rogers, J.M. (eds.), The Art and Archaeology of Ancient Persia: New Light on the Parthian and Sasanian Empires, I.B. Tauris, London, New York, 1998, pp. 20–23.

Sayles, W.G.: Ancient Coin Collecting VI: Non-Classical Cultures, Krause Publications, Iola, WI, 1998.

Schiltz, V.: Les Scythes: la civilisation nomade des steppes, Exhibition catalogue, Editions Errance, Paris, 2001.

Schippmann, K.: Die iranischen Feuerheiligtümer, Walter de Gruyter, Berlin and New York, 1971.

Schippmann, K.: Grundzüge der parthischen Geschichte, Wissenschaftliche Buchgesellschaft, Darmstadt, 1980.

Schlumberger, D.: Descendants non-méditerranéans de l'art grec, Syria 37, 1960, pp. 131–166, pp. 253–318.

Schlumberger, D.: The excavations at Surkh Kotal and the problems of Hellenism in Bactria and India, Proceedings of the British Academy 47, 1961, pp. 77–95.

Schlumberger, D.: Nachkommen der griechischen Kunst außerhalb des Mittelmeerraums, in: Altheim, Franz, Rehork, Joachim (eds.), Der Hellenismus in Mittelasien, Harrowitz Verlag, Darmstadt, 1969 (1), pp. 281–405.

Schlumberger, D.: Der hellenisierte Orient. Die griechische und nachgriechische Kunst außerhalb des Mittelmeerraumes, Holle Verlag, Baden-Baden, 1969 (2)/L'Orient Hellenise, Paris, 1970.

Schmidt, J.: XXVI. und XXVII. vorläufiger Bericht über die Ausgrabungen in Uruk Warka, Deutsches Archäologisches Institut, Deutsche Orient-Gesellschaft, Berlin, 1972.

Schmitt, R.: Parthische Sprach- und Namensüberlieferung aus arsakidischer Zeit, in: Wiesehöfer, J. (ed.), Das Partherreich und seine Zeugnisse, Steiner Verlag, Stuttgart, 1998, pp. 163–204.

Schnabel, E.J.: Urchristliche Mission, Brockhaus Verlag, Wuppertal, 2002.

Schneider, R.M.: Die Faszination des Feindes, Bilder der Parther und des Orients in Rom, in: Wiesehöfer, J. (ed.), Das Partherreich und seine Zeugnisse, Steiner Verlag, Stuttgart, 1998, pp. 95–146.

Schneider, R.M.: Friend and foe: the Orient in Rome, in: Curtis, V.S. (ed.), The Age of the Parthians, British Museum, I.B. Tauris, London, 2007, pp. 50–86.

Schottky, M.: Quellen zur Geschichte von Media Atropatene und Hyrkanien in parthischer Zeit, in: Wiesehöfer, J. (ed.), Das Partherreich und seine Zeugnisse, Steiner Verlag, Stuttgart, 1998, pp. 435–472.

Schuol, Monika: Die Characene, ein mesopotamisches Königreich in hellenistisch-parthischer Zeit, Franz Steiner Verlag, Stuttgart, 2000.

Schwertheim, E.: Kleinasien in der Antike - von den Hethitern bis Konstantin, Verlag B. Beck, Munich, 2005.

Segal, J.B.: Pagan Syriac monuments in the vilayet of Urfa, Anatolian Studies 3, 1953, pp. 97–119.

Segal, J.B.: Edessa, the Blessed City, Clarendon, Oxford, 1970.

Seipel, W. (ed.): Das Gold der Steppe, Fürstenschätze jenseits des Alexanderreiches, Ausstellungskatalog Reiss-Engelhorn-Museen, Mannheim, 2010.

Sellwood, D.: An Introduction to the Coinage of Parthia, second edition, Spink and Son, London, 1980.

Sellwood, D.: The end of the Parthian Dynasty, Spink Numismatic Circular 98, 5, 1990, p. 157.

Selzer, W.: Römische Steindenkmäler, Landesmuseum Mainz, Katalog zur Sammlung in der Steinhalle, Verlag Phillip von Zabern, Mainz, 1988.

Seyrig, H.: Armes et costumes iraniens de Palmyre, Syria 18, 1937, pp. 4–31.

Seyrig, H.: La grande statue parthe de Shami et la sculpture palmyrénienne, Syria 20, 1939, pp. 177–183.

Shayegan, M.R.: The Arsacids and Commagene, in: Curtis, V.S., Pendleton, J.E., Alram, M., Daryae, T. (eds.), The Parthian and Early Sasanian Empires: Adaption and Expansion, The British Institute of Persian Studies, Archaeological Monographs Series V, Oxbow Books, Oxford, 2016, pp. 9–22.

Sheldon, Rose Mary: Rome's Wars in Parthia: Blood in the Sand, Vallentine Mitchell, London, Portland, OR, 2010.

Shore, F.B.: Parthian Coins and History: Ten Dragons against Rome, Classical Numismatic Group, Quarryville, PA, 1993.

Simonetta, A.: Numismatic provinces and the debasement of the Parthian coinage, in: Härtel, H. (ed.), South Asian Archaeology, Dietrich Reimer, Berlin, 1979, pp. 355–368.

Simpson, St John: Merv, an archaeological case-study from the north-eastern frontier of the Sasanian Empire, Journal of Ancient History 2, 2, 2014, pp. 1–28.

Sinisi, F.: Tyche in Parthia: the image of the goddess on Arsacid Tetradrachms, in: Numismatische Zeitung 116/117, Selbstverlag der Österreichischen Numismatischen Gesellschaft, Vienna, 2008, pp. 231–247.

Sinisi, F.: Sylloge Nummorum Parthicorum, volume 7: Vologases I – Pacoros II, ÖAW, Vienna, 2012.

Skjærvæ, P.O.: The Videvdad: it's ritual-mythical significance, in: Curtis, V.S., Stewart, S. (eds.), The Age of the Parthians, British Museum, I.B. Tauris, London, 2007, pp. 105–141.

Sommer, M.: Hatra. Geschichte und Kultur einer Karawanenstadt im römisch- parthischen Mesopotamien, Verlag Philipp von Zabern, Mainz am Rhein, 2003.

Sommer, M.: Roms orientalische Steppengrenze, volume 9: Oriens et Occidens, Franz Steiner Verlag, Stuttgart, 2005.

Sommer, M.: Der römische Orient. Zwischen Mittelmeer und Tigris, Theiss Verlag, Stuttgart, 2006.

Sommer, M.: Modelling Rome's eastern frontier: the case of Osrhone, in: Kaizer, T. and Facella, M. (eds.), Kingdoms and Principalities in Roman Near East, Franz Steiner Verlag, Stuttgart, 2010, pp. 217–226.

Sonnabend, H.: Fremdenbild und Politik: Vorstellungen d. Römer von Ägypten und des Partherreichs in der späten Republik u. frühen Kaiserzeit, Lang, Frankfurt/Main, Bern, New York, 1986.

Soudavar, Abolala: The Aura of Kings: Legitimacy and Divine Sanction in Iranian Kingship, Mazda Publishers, Costa Mesa, CA, 2003; available at: www.soudavar.com/aura-text.pdf.

Spalart, R.: Historical Picture of the Costumes of the Principal Peoples of Antiquity and of the Middle Ages, volume 4, c. 1799.

Speidel, M.-P.: Die Equites singulares Augusti: Begleittruppe der römischen Kaiser des zweiten und dritten Jahrhunderts, Habelt, Freiburg/Breisgau, 1965.

Speidel, M.-P.: Riding for Caesar: The Roman Emperors' Horse Guards, B.T. Batsford, London, 1994.

Stausberg, M.: Die Religion Zarathustras, Kohlhammer, Stuttgart, 2002.

Stausberg, M.: Zarathustra und seine Religion, C.H. Beck, Munich, 2011.

Stausberg, M., Vevaina, Yuhan Sohrab-Dinshaw, Tessmann, Anna (eds.): Companion to Zoroastrianism, John Wiley & Sons, Chichester, 2015.

Stierlin, H.: Städte in der Wüste. Petra, Palmyra und Hatra - Handelszentren am Karawanenweg, Belser, Stuttgart, 1996.

Stöllner, Th., Slotta, R., Vatandoust, A. (eds.): Persiens antike Pracht, volumes 1 and 2, Bergbau Museum, Bochum, 2004.

Stronach, David, Mousavi, Ali: Irans Erbe in Flugbildern von Georg Gerster, Philipp von Zabern Verlag, Darmstadt, 2009.

Strootman, R.: Hellenistic imperialism and the idea of world unity, in: Rapp, C., Drake, H. (eds.), The City in the Classical and Post-Classical World: Changing Contexts of Power and Identity, Cambridge University Press, Cambridge and New York, 2014, pp. 38–61.

Strootman, R.: The coming of the Parthians: crisis and resilience in the reign of Seleukos II, 2018 (1), available at: www.academia.edu/37844459/The_Coming_of_the_Parthians_Crisis_and_Resilience_in_Seleucid_Iran_2018.

Strootman, R.: Memories of Persian kingship in the Hellenistic world, Paper read at the 64th Rencontre Assyriologique Internationale/12th Melammu-Symposium on 'The Intellectual Heritage of the Near East', Innsbruck, 16–20 July, 2018 (2).

Strootman, R., Versheys, J.: Persianism in Antiquity, Oriens and Occidens 25, Franz Steiner Verlag, Stuttgart, 2017.

Strothmann, M.: Feindeskinder an Sohnes statt. Parthische Königssöhne im Hause des Augustus, in: Wick, P., Zehnder, M. (eds.), Das Partherreich und seine Religionen, Computus Druck Satz & Verlag, Gutenberg, 2012, pp. 83–102.

Strugnell, E.: Thea Musa, Roman queen of Parthia, Iranica Antiqua 43, 2008, pp. 275–298.

Tanabe, K.: Sculptures of Palmyra, 2 vols., The Ancient Orient Museum, Tokyo, 1986.

Tellenbach, M.: Vorwort, in: Alexander der Große und die Öffnung der Welt, Ausstellungskatalog, Publikationen der Reis-Engelhorn Museen Mannheim, Schnell & Steiner, Mannheim, 2010, pp. 19–23.

Thommen, L.: Griechische und Lateinische Texte, in: Hackl, U., Jacobs, B., Weber, D. (eds.), Quellen zur Geschichte des Partherreiches, volume 2, Vandenhoek & Ruprecht, Göttingen, 2010, pp. 1–490.

Thonemann, P.: The Hellenistic Age, Oxford University Press, Oxford, 2016.

Traeger, J.: Renaissance und Religion: die Kunst des Glaubens im Zeitalter Raphaels, C.H. Beck, Munich, 1997.

Trümpelmann, L.: The Parthian buildings at Assur, Sumer 35, 1979, pp. 287–293.

Trusdale, W.: The Long Sword and the Scabbard Slide in Asia, Smithsonian Institute, Washington, DC, 1975.

Tubach, J.: 2013: The triad of Hatra, in: Dirven, L. (ed.), Hatra, Politics, Culture and Religion between Parthia and Rome, Franz Steiner Verlag, Stuttgart, pp. 201–215.

Tucker, D.J., Hauser, S.R.: Beyond the world heritage site: a huge enclosure revealed at Hatra, Iraq 68, 2006, pp. 183–190.

Vanden Berghe, L.: Archéologie de l'Iran ancien, Brill, Leiden, 1958.

Vanden Berghe, L.: Reliefs rupestres de l'Iran ancien, Musè Royaux, Brussels, 1984, Catalogue no. 32.

van der Spek, R.J.: Cuneiform documents on Parthian history, in: Wiesehöfer, J. (ed.), Das Partherreich und seine Zeugnisse, Steiner Verlag, Stuttgart, 1998, pp. 205–258.

van't Haaff, P.A.: Catalogue of Elymaean Coinage, Classical Numismatic Group, Lancaster, 2007.

Venco, R.: Wall paintings from building A at Hatra, Iranica Antiqua 31, 1996, pp. 127–157.

Venco R.: Pictorial graffiti in the city of Hatra, in: Dabrova, E. (ed.), Ancient Iran and the Mediterranean World, Electrum, Krakow, 1998, pp. 187–205.

Wagner, J.: Die Könige von Kommagene und ihr Herrscherkult, in: Wagner, J. (ed.), Gottkönige am Euphrat, Philipp von Zabern, Darmstadt, 2012, pp. 44–60.

Waldmann, H.: Die Kommagenischen Kultreformen unter König Mithradates Kallinikos und seinem Sohne Antiochos I., Brill, Leiden, 1973.

Walser, G.: Römische Inschriftenkunst, 2nd edition, Franz Steiner Verlag, Stuttgart, 1992.

Weber, D.: various chapters in: Hackl, U., Jacobs, B., Weber, D. (eds.), Quellen zur Geschichte des Partherreiches, 3 vols., Vandenhoek & Ruprecht, Göttingen, 2010: Anhang: Einige

Titel (vol. 1, pp. 100–104), Theophore Namen (vol. 1, pp. 154–164), Parthische Texte (vol. 2, pp. 492–588), Iranica auf arsakidischen Münzen (vol. 2, pp. 633–639).

Weidemann, K.: Untersuchungen zur Kunst und Chronologie der Parther und der Kushan vom 2. Jh. v. Chr. zum 3. Jh. n. Chr., Jahrbuch des Römisch-Germanischen Zentralmuseums 18, 1971, pp. 146–178.

Wick, P.: Hellenistische Münzen aus dem Osten. Spiegel religiöser Dynamiken im Kulturellen Austausch zwischen Ost und West, Ausstellungskatalog anlässlich der Ausstellung der Kunstsammlungen der Ruhruniversität Bochum; 6.10.2008 bis 18.01.2009, Universität Bochum, Bochum, 2008.

Wick, P., Zehnder, M. (eds.): Das Partherreich und seine Religionen, Computus Druck Satz & Verlag, Gutenberg, 2012.

Widengren, G.: Some remarks on riding costume and articles of dress among the Iranian peoples in Antiquity, Studia Ethnographica Upsalensia 11, 1959, pp. 228–276.

Widengren, G.: Iranisch-semitische Kulturbegegnung in parthischer Zeit, in: Arbeitsgemeinschaft für Forschung des Landes Nordrhein-Westfalen, 70, Westdeutscher Verlag, Opladen, 1960, pp. 13–34.

Widengren, G.: Mani und der Manichäismus, W. Kohlhammer, Stuttgart, 1961.

Widengren, G.: Die Religionen Irans, Religionen der Menschheit 14, W. Kohlhammer Verlag, Stuttgart, 1965.

Widengren, G.: Iran, der grosse Gegner Roms: Königsgewalt, Feudalismus, Militärwesen, in Temporini, H., Haase, W. (eds.), Aufstieg und Niedergang der römischen Welt II/9.1, De Gruyter, Berlin, 1976, pp. 219–306.

Wiesehöfer, J. (ed.): Das Partherreich und seine Zeugnisse: Beiträge des internationalen Colloquiums, Eutin (27.-30. Juni 1996), Franz Steiner Verlag, Stuttgart, 1998 (1).

Wiesehöfer, J.: Zeugnisse zur Kultur und Geschichte der Persis unter den Parthern, in: Wiesehöfer, J. (ed.), Das Partherreich und seine Zeugnisse; Beiträge des internationalen Colloquiums, Eutin (27.-30. Juni 1996), Franz Steiner Verlag, Stuttgart, 1998 (2), pp. 425–434.

Wiesehöfer, J.: Das antike Persien, Patmos Verlag, Albatros Verlag, Cologne, 2005.

Wiesehöfer, J.: Persien, Geschichte, Spiegelausgabe 2, 2010, pp. 28–34.

Winkelmann, S.: Eurasisches in Hatra, Ergebnisse und Probleme bei der Analyse partherzeitlicher Bildquellen, in: Herzog, Th., Holzwarth, W. (eds.), Orientwissenschaftliche Hefte. Mitteilungen des SFB 'Differenz und Integration'. 4/1, Nomaden und Sesshafte – Fragen, Methoden, Ergebnisse, Orientwissenschaftliches Zentrum, Halle, 2003, pp. 21–141.

Winkelmann, S.: Katalog der parthischen Waffen und Waffenträger aus Hatra, Materialien des SFB 'Differenz und Integration', IV, Orientwissenschaftliches Zentrum, Halle Saale, 2004.

Winkelmann, S.: Waffendarstellungen auf parthischen Münzen, Parthica 8, 2006 (1), pp. 131–152.

Winkelmann, S.: Waffendarstellungen auf parthischen Münzen, Parthica, Incontri di Culture nel Mondo antico 8, Istituti editoriali e Poligrafici internazionali, Pisa, Rome, 2006 (2), pp. 131–152.

Winkelmann, S.: Christliche Könige im heidnischen Gewand: Betrachtungen zur partherzeitlichen Herrscherikonographie der Abgariden von Edessa, in: Vashalomidze, Sophia G., Greisinger, Lutz (eds.), Der christliche Orient und seine Umwelt, Studies in Oriental Religion, 56, Harrassowitz, Wiesbaden, 2007, pp. 169–188.

Winkelmann, S.: Partherzeitliche Waffen und Waffenträger in Edessa und Umgebung, in: Tubach, J., Vashalomidze, S., Greisinger, L. (eds.), Edessa in hellenistisch-römischer Zeit. Religion, Kultur und Politik zwischen Ost und West. Beiträge des internationalen

Edessa-Symposiums in Halle, 14.–17. Juli 2005, Orientwissenschaftliches Zentrum, Halle, Ergon Verlag, Würzburg, 2009, pp. 314–365.

Winkelmann, S.: The weapons of Hatra as reflection of interregional contacts, in: Dirven, L. (ed.), Hatra: Politics, Culture and Religion between Parthia and Rome, Steiner Verlag, Stuttgart, 2013, pp. 235–249.

Winkelmann, S., Ellerbrock, U.: Die Parther, die vergessene Großmacht, Zabern Verlag, Darmstadt, 2015.

Wolski, J.: Le rôle et l'impotance des mercernaires dans l'etat Parthe, Iranice Antiqua, 1965, pp. 103–115.

Wolski, J.: Die Parther und ihre Beziehungen zur griechisch-römischen Kultur, Klio, 65, 1, Krakau, 1983, pp. 137–149.

Wolski, J.: Die gesellschaftliche und politische Stellung der großen parthischen Familien, Tyche 4, 1989, pp. 221–227.

Wolski, J.: L'empire des Arsacides, Peeters, Leuven, 1993.

Yarshater, E.: The Cambridge History of Iran, volume 3 (2): The Seleucid, Parthian and Sasanian Periods, Cambridge University Press, Cambridge, 1983.

Yartsenko, S.A.: Essays on Scythean anthropomorphic images, in Rabajiev, K. (ed.), Art and Ideology, St. Clements of Orchid University Press, Sofia, 2012, pp. 63–79.

Yon, J.-B.: 2010: Kings and princes at Palmyra, in: Kaizer, T. and Facella, M. (eds.), Kingdoms and Principalities in Roman Near East, Franz Steiner Verlag, Stuttgart, 2010, pp. 229–240.

Zehnder, M.: Aramäische Texte, in: Hackl, U., Jacobs, B., Weber, D. (eds.), Quellen zur Geschichte des Partherreiches, volume 3, Vandenhoek & Ruprecht, Göttingen, 2010, pp. 175–401.

RECOMMENDED WEBSITES

Academia.edu (various articles by different authors): www.academia.edu/

Assar, G.R.F.: Various articles, in particular on the genealogy of Parthian rulers: http://parthian-empire.com/

Circle of Ancient Iranian Studies (CAIS): Pictures, information and archaeological news on old Iran: www.cais-soas.com/index.htm

Cumont, F.: many of his articles on Greek inscriptions found in Iran are available at: www.persee.fr/authority/272960

Debevoise, N.C.: A Political History of Parthia, The University of Chicago Press, Chicago, IL, 1938: https://oi.uchicago.edu/sites/oi.uchicago.edu/files/uploads/shared/docs/political_history_parthia.pdf

Encyclopædia Iranica: Extensive information on the history and culture of ancient Iran as well as Iranian influences in Central Asia: www.iranicaonline.org/

Parthia.com: The award-winning website with the most complete representation of Parthian Empire coins as well as the most extensive further information: www.parthia.com

Rawlinson, G.: The Sixth Great Oriental Monarchy, or the Geography, History and Antiquities of Parthia, 1872: www.gutenberg.org/files/16166/16166-h/16166-h.htm#2HCH0001

Rettelbach, Dr. G.: an exciting compilation of time bills in ancient Iran (in German): www.nabkal.de/impressum.html

Soudavar, A.: The Aura of Kings: Legitimacy and Divine Sanction in Iranian Kingship: www.soudavar.com/AURA-4-TEXT.pdf

Stausberg, M.: On the State and Prospects of the Study of Zoroastrianism: www.michaelstausberg.net/Texts/Stausberg%20Study%20of%20Zoroastrianism%20NUMEN%2055.pdf

Turanforschung: www.bbaw.de/forschung/turfanforschung/uebersicht

Winkelmann, S.: Extensive information on Parthian weapons: Eurasisches in Hatra, Ergebnisse und Probleme bei der Analyse partherzeitlicher Bildquellen: www.nomadsed.de/fileadmin/user_upload/redakteure/Dateien_Publikationen/Mitteilungen_des_SFB/owh41winkelmann.pdf

GENERAL INDEX

Achaemenid Empire *see* Empire of
 Achaemenids
Achaemenids 9, 16, 18, 31, 72, 120, 138,
 170, 177, 204, 207, 259
Aglibol 153–155
agriculture 175–176, 177
Ahriman 87, 256–257
Ahura Mazda 15, 64, 80, 107, 254–257,
 259, 262
Alans 55, 60
Ala Parthorum et Araborum 94–95
Ala Parthorum Veterana 94–95
Alexander the Great 9, 18–20, 74, 100–101,
 119, 136–138, 277
Allat 147, 149, 154, 190
alfalfa (Lucerne) 159, 176
alphabet 122, 182
Anahita 256, 259, 261, 263–264, 269, 289
ancestral cult 82
Antonine plague 62
Aphrodite 214, 215, 224
Apocrypha 122
Apollo 78, 107, 140, 215, 261–263, 265,
 278, 282
Apostle 122, 293
Arabs 65, 113, 142, 147, 154
Aramaic 96, 148, 154, 181–182
Aramaic legends 111, 146, 170
archer 14, 42, 75, 78–79, 88, 172, 220–221
architecture 108, 125–130, 140, 146,
 149–150
Ardochscho 261, 265, 289
Ares 215, 265–269, 268

army (Parthian) 29, 32–33, 83–85, 87, 94
arrows 7, 10, 42, 84–86, 87–89
Arsacids 1, 28, 49, 57, 65, 82, 109, 121
Artemis 105, 143, 213, 215, 261, 263,
 279, 286
Aschi (also written Ashi) 263
Assar, G.F. 23, 161–165
Assyrian Empire 15
astrology 188
astronomy 191, 203
Athena 121, 140, 215, 227, 263, 278–279,
 283–284
Avesta 79, 187–188, 190, 193, 254–256,
 263, 269
Avestan 254–255
Avroman (parchment) 5, 97, 167, 177

Baal 232
Baalshamin 145, 153, 155
barbarians 6, 18, 45
barley 175
Barmārēn 148–149
Barsom 258, 271
bashlyk 34, 42, 73–75, 172, 198
Battle of Carrhae *see* Carrhae (Battle of)
Battle of Gaugamela 18
Battle of Hormuzdagan 64
Battle of Ipsus 20
Battle of Issus 19
Battle of Nisibis 56, 63
Battle of Philippi 38
Battle of Tigranocerta 37
bazaar 179

Behistun inscription 137
Bel 108, 146, 149, 153–154
belt buckle 188, 235, 245
bilingual 120–121, 146, 265, 267, 291
BMAC (Bactria-Margiana Archaeological
 Complex) 264
bronze statue 61, 200, 267
Bucephalus 179
Buddhism 123, 259, 290
Buddhist 7, 122, 290, 295
burials 274–278

calendar: Achaemenid 204; Babylonian 5,
 258; Greek-Macedonian 208; Gregorian
 206; Seleucid 61, 204–207, 209;
 Zoroastrian 136, 207, 258, 260–261, 268
camel 42, 48, 150, 178
caravan 113, 153, 159
Carrhae (Battle of) 1, 6, 31, 42–43, 48,
 84, 190
castle 130, 132, 139, 159, 220
cataphract 29, 42, 84–87, 118–119
cattle breeding 178–179
cavalry 42, 83–85, 94–95, 177
Celts 20
centaur 217
chalkous, value 166–167
child mortality 194
Chinese iron 159
chiton 98–100, 199, 203–204
chlamys 75–76, 196, 198
Christ 292–293
Christianity 109, 122, 153, 293–294
Chronical of Edessa 109
chume 176
circular cities 125
citadel 120, 126, 128, 137, 144, 169
clay brick 128–130
clothing 75, 77, 196–201
coffin 274–275
coins (Parthia) 160–169
composite bow 85, 88–89, 231
copper mines 175
cornucopia 46, 99, 203, 239–240, 284,
 286–287
coronation 27, 72, 78, 83
cotton 159
court 15, 19, 34, 97, 122, 127, 214
court mint 169, 185
cuisine 194
cuneiform tablets 4, 96, 181, 194

daevas 255–256
dagger 88–90, 170, 273

Dahae 25, 49, 51
deification 82, 216
deities (Parthian) 10, 82, 261, 287, 289
Demeter 121, 215, 282, 286
Dēnkard 255
denomination of Parthian coins 166
Dexiosis 105
diadem 34, 42, 46–47, 73–76, 78–79,
 99, 210
dichalkous, value 166–167
diobol, value 166–167
divine 32, 47, 79, 82, 220, 269, 278
divine epithets 280–281
dizpat 96
doctor 193
dodekatheoi 215
dome 126–127, 130–132
drachm, value 166–167
drums 87, 190

eagle 80, 82, 228, 285
earring 172, 235, 244–245
education 19, 187–188
Einkorn wheat 175
Elam *see* Empire of Elam
elephants 85, 87, 89
Empire of Achaemenids 16–18
Empire of Elam 13
Empire of the Seleucids 20
epagomene 207
epic 186
epiphany 82, 171, 278, 282
equestrian units 95
Erk Kala 136
Eros 227

fire altar 270, 277
fire cult 270–271
fire temple 259, 271
flax 175
Frataraka 112, 269
fresco 144, 231
frontality 146, 213, 238
funeral 154, 246, 273, 276–277

Gaddē (Temple) 144
garden 176
Gathas 191, 255
genealogy of Parthian kings 5, 23–24,
 160–165
geography (Parthia) 10–11
glass 235
Golden Man of Issyk 117
gold mines 175

goryth 88–90, 127
gōsān 190–191
Graeco-Bactrian Empire 31, 117, 120, 213
graffiti (graffito) 86, 95
grain 194
gravestone 95, 154–155
Greek inscriptions 171
Greeks 16, 18, 20, 75, 110, 138, 211
griffin (also spelled gryphon) 152, 170, 216, 226, 234
gryphon *see* griffin
Gyaur Kala 136
gymnasium 120, 139, 188

Hades 78
Hammurabi, Code of 14
Haoma 193, 255, 258
harbour 159
harem 97–98
hatchet 221, 228
Hatra 56, 63, 66, 112–113, 126–128, 145–150, 152, 190, 205, 248
Hekate 225
Helios 106–107, 149, 262–263
Hellenistic architecture 126
Hellenistic Period 18, 190
Hellenistic tradition 111
'Hellenistic'Tyche 99, 203, 282, 284–287
hemichalkous, value 166
hemidrachm, value 166
hemiobol, value 166–167
Heracles 61, 91, 107, 148–149, 265–268, 282–283
Heracles statue 267
Herat 25, 31, 137–138
Hermes 106–108, 121, 215, 262–263, 283
heroic legends 186
heroon 126
Hestia 216, 219–220, 225
hierothesion (plural: *hierothesia*) 105
himation 98–100, 199, 203
Hinduism 290
Hormuzdagan 64
horse 85, 93, 159, 176, 178–179
hunting 144, 188, 195, 231, 286
Hymn of the Pearl 183–184
Hyrcanians 51

iconography (coins) 278
income 193–194
Indo-Greek Kingdom 120–121
Indo-Parthian Kingdom 50, 117, 121–122
Indo-Scythian Kingdom 121
inscriptions (Greek) 169–170

inscriptions (Parthian) 170–174
investiture 63, 78–82, 220, 264, 284–285
iron 175
iron ores 159
Ishtar 259–260, 263, 288
Islamic expansion 64
Issyk (Golden man of) 117
ivory 133, 215, 221, 270
iwan 64, 108, 126–128, 142, 146–147, 149–150, 152

Jesus 257, 261, 289, 292–293
jewellery 159, 199, 234, 248
Jews 143, 257, 291–294
Judaism 108, 259, 291

Kamnaskirids 111
kandys 42, 75, 172, 196–198
Kārēn 66, 72, 83, 185
kettle drums 190
Khorasan (language) 181
khvarenah 79, 82, 184, 256, 269
king of kings (Parthia) 27, 30–32, 34–35, 72–74, 84–85, 169–170, 206
kitchen 149, 194
kurgan 117
Kushan 122–123
Kushan Empire 122–123, 159, 259, 265

language (Parthian) 7, 26–27, 49, 61, 95–97, 177, 181–182, 188, 265, 294
languages: Aramaic 96–97, 170; Avestan 255; Elamite 14; Greek 19, 43, 49, 96–97, 111, 120, 220; Iranian 26, 96; Palmyrene 145; Parthian 26–27, 49, 61, 96–97, 177, 181–182, 188, 294; Prakrit 121; Scythian 118; Sogdian 265; Vedic 265
law 14, 34, 95, 97, 187, 189, 261
leather 5, 49, 73, 100, 113, 156, 182, 194
legionary eagles 38
legionnaires 94
legions 45
liberi 83
life expectancy (Parthian) 194
linen 175
lion-gryphon 127, 152, 215
literary sources 4–5
literature (Parthian) 183–184, 186–188, 191
living conditions (Parthia) 194
lucerne (alfalfa) 159, 176
lunar year 205, 207

Macedonians 19, 120, 144–145
Magi 15, 257–260, 290, 294

magician 257
Malakbel 154
Mani 289–290
Manichaeism 182, 289–290
Māran 148–149
Mardi 28
Marduk 149, 153
markets 179, 190
marriage policy 97
Mars 268
Mārtan 149
marzpān 96
Medes 15–16, 31, 75, 138, 257, 269
medical knowledge 191
Mercury (god) 268
Merv 31, 43, 84, 129, 136–137, 158,
 185–186
metope 90, 127–129
mineral resources 159, 175
mining 175
mints (Parthia) 168–169
Mithra 79, 256, 261–264, 269, 286, 289
Mithraism 291
Mithras 291–292
Mithras cult 291
Mithridatic Wars 30
money (Denomination, Parthian) 166
money (Parthian) 167
month names (Greek) 208
mosaic 233
Moses 144
mural crown 170, 236, 284–285, 287
music 189–191

Nana – Nanaia 225, 261, 264–265, 289
Nebu 140, 154
necklaces 47, 234, 244, 247
Nergal 148–149
New Testament 15, 257, 292–293
Nike 47, 279, 282–284, 285
Nippur 195, 274–275
Nisa 4, 10, 82, 90, 92, 126, 128–136, 169,
 176–177, 207, 215–216, 220–225, 276
Nisean horses 178–179
nobility 48, 72, 83–85
nomads 1, 8, 25, 33, 116, 196, 199
Nowrūz 259

obol (value) 166–167
octochalkous (value) 166–167
oil 175
Old Testament 15, 153, 292
omphalos 34, 78–79, 198
ostracon (plural: ostraca) 4, 136, 176–177, 207

ostriches 159
overstrikes 41, 110, 160
Oxus temple 120

Pahlavi 182, 255–256
paintings (mural) 146, 214, 231
Palmyra 105, 126, 147, 152–156,
 231, 248
panpipe 190
paradise 176
parchment 5, 97, 181–182, 189, 194
Parni 1, 25–27, 166
Parthian art 213
Parthian Empire (downfall) 65
Parthian era 210
Parthian inscriptions 171–174
Parthian kings (list: Sellwood) 23–24
Parthian kings (list: Sunrise collection by
 Assar) 161–165
Parthian shot 42, 83–84
'Parthian' Tyche 79, 81, 100, 203, 265,
 284–285, 287, 289
Pentecost 15, 292
peplos 98, 100, 199, 203
peristyl 152
Persians 15–16, 18–19, 75, 196, 263
Persis 50, 56, 111–112
Pharro 269
Phrygian cap 7
polis 16
pomegranates 176
Prince of Shami 89, 91, 200, 233
prisoner 39, 117, 189
propaganda 7, 31, 73, 169
property 187, 189
protomes 215

qanats 177–178
queen (Parthian) 36, 39, 41, 45,
 46–48, 97–98

recipe 194
Red Building 130, 133
regna (singular: *regnum*) 103, 112, 147
religion (Parthian) 82, 254, 259, 261, 277
residence (royal) 4, 27, 29, 32, 262
residence (Summer/Winter) 16, 137–138
Rhine 94–95
rhyta (singular: rhyton) 197, 215–220, 250
rock relief 80, 221, 230, 264, 270
Rostam 186
Round Hall 82, 126, 130–132, 135
royal wart 42, 46, 77–78, 210
ruler's image 73

sacred fire 258, 270–271
Saka 7, 32–34, 37, 85, 117–118, 121
Sakaraukae 118
salt 175
salt desert 11
salt mines 175, 198
sarcophagus 18–19, 239, 277
Sarmatians 85, 87, 118–119, 187
Sasanian Empire 64–66, 82, 182, 262, 271
satrap 25–26, 96, 109, 119, 177
satrapy 1, 10, 21, 25–28, 125
sculptures 233
Scythians 15, 25, 85, 89, 117, 220, 269–270, 289
seal 133, 141, 176–177
Seleucid era 209
Seleucids 8–9, 20–22, 25, 27–33, 72, 98, 110, 119, 138, 140, 166, 181, 205
Sellwood, David 23–24
Semitic script 182
Shāhnāme 186
Shami (Prince of) 91, 111, 200, 233
shekel 194
Shiji 187
ships 18, 122
shipyard 159
silk 7, 159, 293
Silk Road 1, 7, 15, 105, 138, 153, 158
silver 5, 105, 159, 174–175, 196–197
silver drachm 166
Sirius 256, 267
slaves 8, 159, 187, 189
social structures 187
spāhbed 85, 96
sphinx 221, 226
stone relief 221
strategos 139
stucco 108, 126–127, 129, 133–137, 145
Sunrise collection 23, 59, 161–165
Sūrēn 41, 66, 72, 83, 178
Surena 41–42, 72
sword 79, 89, 92–93, 199, 221, 230, 237, 242, 272
synagogue 143–144, 146, 293–294
synhedrion 260
Syrian Wars 20
Syrinx 190

Taq- e Kisra 64, 126, 142
taxes 177
temple cult 259
Temple of Allat 147, 149, 190
Temple of Apollo 266

Temple of Bel 146, 153, 232
Temple of Heracles 240
Temple of Mele Harram 271
Temple of Nebu 154
Temple of Shami 233
Temple of the Gaddē 144
terracotta 90, 128–129, 191–192, 235, 241–242, 250, 262
tetrachalkous, value 166–167
tetradrachm, value 166–167
theater 105, 188
Thomas (Acts of) 122, 184
Thomas (Apostel) 293
torque 14, 42, 46, 234
trade 7, 35, 53, 109–110, 115, 122, 140, 152, 158–160
tribal structure 112
triobol, value 166
trousers (Parthian) 75–77, 137, 154, 198, 233
tunic 34, 46, 75–76, 148, 170, 198–200
Turfan texts 158, 182
Tyche ("Hellenistic") 9, 203, 282, 284–287
Tyche ("Parthian") 79, 81, 100, 203, 265, 284–287, 289

value of Parthian money 166–167, 194
vassal states (Parthian) 27, 39, 41, 71, 84, 98, 103–105, 109, 111, 260
vassal states (Roman) 37, 41, 45, 55–56, 107
vassal states (Seleucid) 22, 24
Vendidad 272–273
Verethragna 82, 107, 140, 256, 261–262, 265–268, 285
vessel 235
Videvdat 188, 255
vineyard 5, 167, 176–177, 194
Vis and Ramin 184–186

water channel 176
water management 177–178
weapons 85, 89, 93, 115, 117, 152, 159, 175, 178, 285
wine 176–177, 195, 215
wise men 72, 257

Xiongnu 116–117

Yarhibol 153
Yashts 255, 269
yazatas 79, 82, 184, 220, 269
Yüe-chi 116–117, 120–122

Zand 255
Zarathustra (Zoroaster) 254–255, 257
Zeus 105–107, 121, 145, 215, 261–262,
 278–279, 282–283, 285

Ziggurat 14
Zoroaster 182, 254
Zoroastrianism 10, 82, 126, 254–262, 268,
 270, 284, 289

NAMES INDEX

Names of the Parthian kings – see Table 3.1 'List of Parthian rulers' (according to Sellwood), p. 23–24 and Table 8.1 'Comparison of the genealogy of Parthian kings provided by Sellwood and Assar (Sunrise Collection, 2011), p. 161–165.

Abdagases 122
Abgar VII 59
Abgar VIII 109, 293–294
Abgarids 104
Alexander the Great 8–9, 18–20, 110, 119, 136–138, 256, 277
Andragoras 21, 25–27
Antiochus I (Theos) 20–21, 43, 45, 89, 91, 98, 105–107, 136, 263
Antiochus II (Theos) 20, 26, 28
Antiochus III (The Great) 26, 28, 119, 178
Antiochus IV 104, 282–283
Antiochus VII 30, 32–33, 104, 282
Antony, Mark (Marcus Antonius) 38, 45
Ardashir I 64–66, 80, 137
Ardashir II 262, 264
Ariobazanes 30
Artavasdes 43, 45
Artaxerxes I 270, 277
Artaxerxes II 259
Artaxerxes III 270
Athambelos VI 60
Augustus (emperor) 8, 38–39, 43–48
Avidius Cassius 141
Azes I 121
Azes II 121, 295

Bahram I 268, 290
Bahram II 294
Brutus 38

Caesar, Julius 45
Caracalla 56, 63, 65, 85, 108, 159
Cassius Dio 6, 56–57
Cassius Longinus 38, 43, 52
Cleopatra VII 45
Crassus, Marcus Licinius 6, 37–38, 42–43, 190
Crassus, Publius 42, 84
Cyaxares I 15
Cyrus II the Great 15, 138, 277

Darius I (The Great) 16, 111, 137, 221, 277
Darius II 277
Demetrius I Soter 29, 282, 286–287
Demetrius II 29, 32–33, 98
Diodotus I Soter 25, 119
Diodotus II 119
Eucratides I 120–121
Euthydemus 119–120

Ferdowsi 186

Gabinus 41
Gaius Caesar 46
Gondophares 121–122
Gondophares II 122
Gorgani, F.A. 185

Heliocles 32, 120
Heraios 122
Hermaeus 121
Herod 45, 257
Hyspaosines 109
Hystaspes 294

Isidore of Charax 27–28, 109, 144, 158, 270
Izates I 108
Izates II 108

Kadphises 122
Kamnaskires I Soter 110
Kamnaskires- Orodes 221, 230
Kanishka I 122, 235
Kanishka II 122
Khosrow I 142, 255
Kirdīr 294

Laodike 38, 43
Lucius Verus 55, 62, 108, 113, 141, 143, 193
Lucullus, Lucius Licinius 37

Macrinus 56, 63
Mani 289–290
Marcus Aurelius 55–56, 62, 193
Mark Antony 39, 45, 109
Maues 121
Menander I 120–121
Meredates 109
Mihran (family) 83
Mithridates VI the Great (Pontus) 30
Monobazos I 108
Monobazos II 108

Nebuchadnezzar I 14
Nebuchadnezzar II 291
Nero 57–58

Orobazos 30–31, 35
Oromasdes (also Oromazdes) 106–107
Orthagnes 122

Pabag 64–65
Pacores 122
Philip II 18
Pliny the Elder 6–7, 103, 175
Pompey (Roman general) 37–38, 41
Pompey Trogue 6
Ptolemy II 20
Ptolemy III 20

Qín Shǐhuángdì 117
Quintus Labienus 39, 94

Sanatruq I 113
Sanatruq II 113
Sargon of Akkad 111
Seleucus I 13, 20, 104, 111, 140, 143
Septimius Severus 45, 55–56, 63, 85, 105, 113, 127, 147
Shapur I 113, 182, 268, 290, 294
Shapur II 191
Strabo 6, 72, 107, 260
Straton II 121
Sulla, L. Cornelius 30–31, 35, 37
Sūrēn (family) 66, 72, 83, 178
Surena 41, 42, 66, 72, 188

Tiberius 39, 49–50
Tigranes II the Great 30, 34, 41, 107
Tigranes the Younger 40–41
Trajan 53–54, 60–66, 108, 113, 142–143, 147, 293

Uthal 151

Vadfradat II 112
Vitellius 39, 51

Wu of Han 31, 35

Xerxes I 111, 270, 277

Zeno 49

GEOGRAPHICAL NAMES INDEX

Achal oasis 178
Adiabene 34–35, 37, 55, 63, 107–109
Afghanistan 10, 19, 25, 31, 83, 118, 122, 143, 186
Ai-Khanoum 116, 120
Alexandria Margiana 136
Altai Mountains 117, 179
Amu-Darya (ancient Oxus) 176
Antioch on the Orontes 20
Apameia 169
Aral Sea 117
Arbela 56, 63, 65, 107–108, 274
Areia 169
Aria 31, 52
Armenia 9, 30, 34–35, 37, 39–41, 45–46, 49, 52–53, 55–58, 60–63, 72, 83, 182
Artemita 169
Asaak 26–27, 125, 270
Ashgabat 90, 125
Assur 15, 108, 125–126, 231
Astauene 26–27, 125, 218
Avroman (region) 181, 194

Babylon 4, 14, 16, 18 20, 31–32, 36, 41, 54, 194, 274, 291–292
Bactra 31
Bactria 16–17, 20–21, 25–26, 31, 116, 119–121, 126, 254, 262, 264
Baghdad 32, 140
Bahrain 109
Balandy 117, 127
Bard-e Nishandeh 230, 235, 238, 240
Bethlehem 257

Cappadocia 30
Carrhae (battle of) 1, 6, 31, 42–43, 48, 84, 87, 94, 190
Caspian Sea 1, 10, 21, 51, 125
Central Asia 14, 35, 115–117, 254, 264, 274
Characene 5, 34, 109–110, 184, 265
Charax 28, 158
Charax-Spasinu 109, 159
China 1, 20, 59, 115–117, 158–159, 176, 179, 182
Chogha Zanbil 14
Chorasmia 127
Cilicia 33, 40, 49, 60
Comisene 137
Commagene 38, 53, 98, 105–107, 261, 265, 288
Ctesiphon 4, 12, 55–56, 83–84, 141–143

Dura Europos 55, 86, 143–146, 189, 206, 231–232, 292

Ecbatana 15–16, 31, 138, 169, 293
Egypt 16, 18, 20, 184
Elburz Mountains 11, 28
Elymais 14, 30–31, 110–112
Euphrates 11, 30–31, 34–35, 38–39, 45–46, 53, 60, 104–105, 109, 140, 143–144, 159, 291
Eurasia 75, 85, 115

Fars 13, 15, 64–66, 111, 127, 178
Fergana valley 179
Firozabad 127

Gandhāra 120–122
Gaugamela 18
Gordyene 34–35, 37, 41, 107
Gorgan 21, 179, 181

Hamadan 15, 125, 138
Harran 42
Hatra (kingdom) 112–113
Hatra (town) 56, 93, 98, 126–127, 143–145, 147–152, 205, 248
Hecatompylos 26, 125, 137–138, 158, 169
Heidelberg 291
Herat 25, 31, 137
Hierapolis 158
Hindu Kush 11, 119–120, 137
Hormuz (Strait of) 159
Hung- i- Nauruzi 221, 230
Hyrcania 10, 21, 26–28, 32, 51, 181

India 1, 11, 20, 89, 109, 120–122, 186, 256, 293
Indus River 9
Iran 9, 11, 13, 15–17, 64, 83, 91, 96, 128, 168, 175–176, 177–178, 181, 186, 200
Iraq 10, 112, 143, 147, 271
Isfahan 16
Istakhr 64–65, 111

Jerusalem 257, 291–292
Judaea 257

Kabul 122, 186
Kangavar 169
Karun 158
Kazakhstan 116–117, 127
Kerman area 175
Kermanshah xxi–xxii
Khorasan (region) 25, 31, 137, 186
Koblenz 95, 174
Kopet Dagh Mountains 130, 276
Koy- Krylgan- Kala 126
Kurdistan (Iranian) 5, 167, 181, 194, 221
Kyrgyzstan 35, 116

Laodicea 169

Macedonia 16, 18, 20
Magnesia 26
Mansur Depe 126
Margiana 136, 169, 175, 264
Masjid-e Soleiman 238–240, 268
Mazar- i Sharif 31
Media 31–33, 63, 83, 138
Media Atropatene 37, 53, 57, 107, 109

Mele Hairam 270–272
Merv 31, 84, 126, 136–137, 158, 185
Merv Oasis 137
Mesene *see* Characene
Mēshan 208
Mesopotamia 4, 9, 11, 14, 20, 29, 33, 45, 54, 56, 61, 63–64, 139
Mithradatkart 130, 161, 169, 262
Mosul 112, 151

Naqsh- e Rajab 294
Naqsh- e Rostam 182
Nehâvand 65
Nemrud Dagh 105–106, 266, 288
Niniveh 107
Nippur 195, 274
Nisa (New) 128, 275–276
Nisa (Old) 4, 10, 27, 82, 96, 126–136, 169, 184, 195, 214–216, 221, 261
Nishapur 25
Nisibis 55, 63

Osrhoene 34–35, 38, 41, 55–56, 63, 95, 103–105, 187
Oxus river (today's Amu- Darya) 120

Pakistan 10, 18, 121, 293
Palmyra 126, 144, 147, 152–156, 199, 214, 231, 248
Parthava 21
Parthia (satrapy) 21, 25–28, 125, 166
Pasagardae 258, 277
Persepolis 111, 136–138
Persian Gulf 1, 54, 109, 140, 153, 159
Persis 39, 50, 56, 103, 111–11
Philippi 38
Phraata 109
Punjab 121

Qal'eh- i Yazdigird 127

Ray 169
Rhagae 125, 138, 169
Rhagiane 28
Rome 1, 6, 7, 30, 35, 37–42, 52–53, 57, 72, 83, 118, 147, 160, 291

Samarkand 149–150
Samosata 53, 105
Saramana 169
Sardis (Lydia) 138
Seistan 83, 176, 178, 186
Selçuk 8
Seleucia on the Eulaios 138

Seleucia on the Euphrates 105, 263
Seleucia on the Tigris 20, 31, 51, 127,
 140–141, 159, 188, 274
Shahr- e Qumis *see* Hecatompylos
Shami 111, 233, 246
Shiraz 15–16, 65, 128
Sogdia (also named Sogdiana) 16, 116,
 120, 185
Sophene 41
Susa 11, 13–14, 16, 50, 63–64, 110–111,
 138–139, 234–236
Strait of Hormuz 159
Syr-Darya 117
Syria 1, 9, 11, 29, 37, 39, 41, 43, 55, 103,
 107, 112, 139, 294
Syria (Coele) 143
Syrinx 169

Tadmor *see* Palmyra
Tag e-Bostan 264
Tajikistan 20, 35, 116, 120
Tambrax 169

Taxila 121–122, 293
Tehran 83, 91, 169
Thracia 16
Tigranocerta 37
Tigris 5, 11, 31–32, 109, 112, 140, 143,
 158–159, 175
Tillya Tepe 118, 248
Traxiane 169
Trier 174, 291
Turfan oasis 7, 290
Turkmenistan 4, 10, 25, 31, 125,
 128, 295

Uruk 4, 264, 274–275
Uzbekistan 20, 35, 117, 149–50, 179

Vologesias 58
Vologesocerta 158

Xinjiang 182

Yazd 273